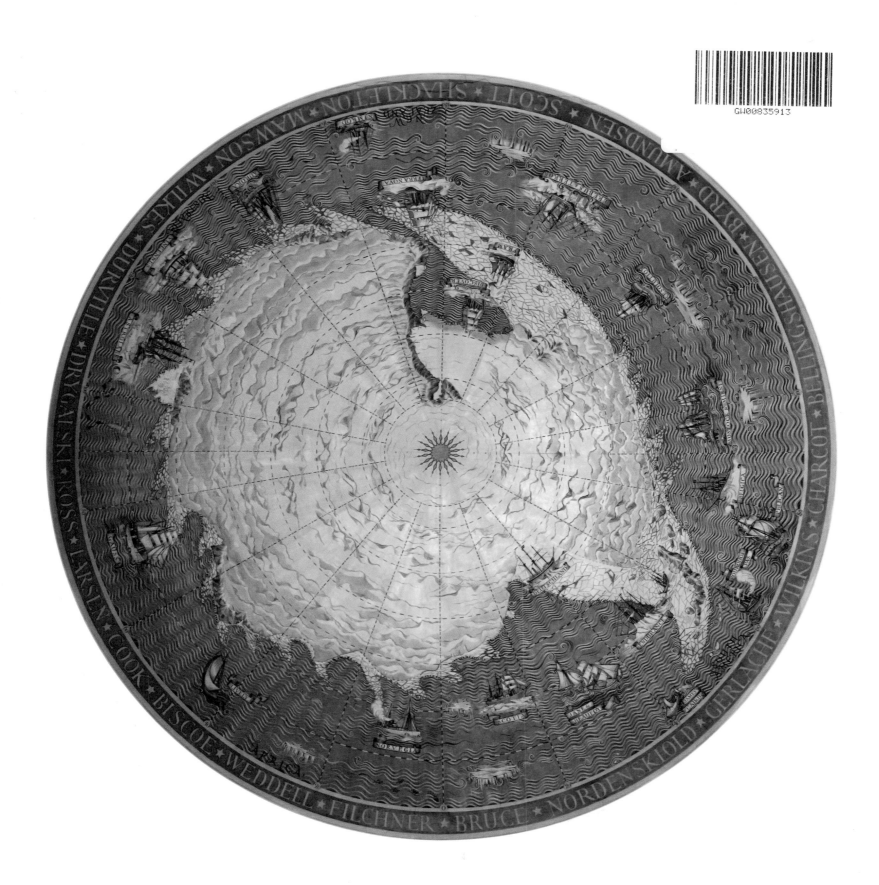

GW00835913

The Continent of
ANTARCTICA

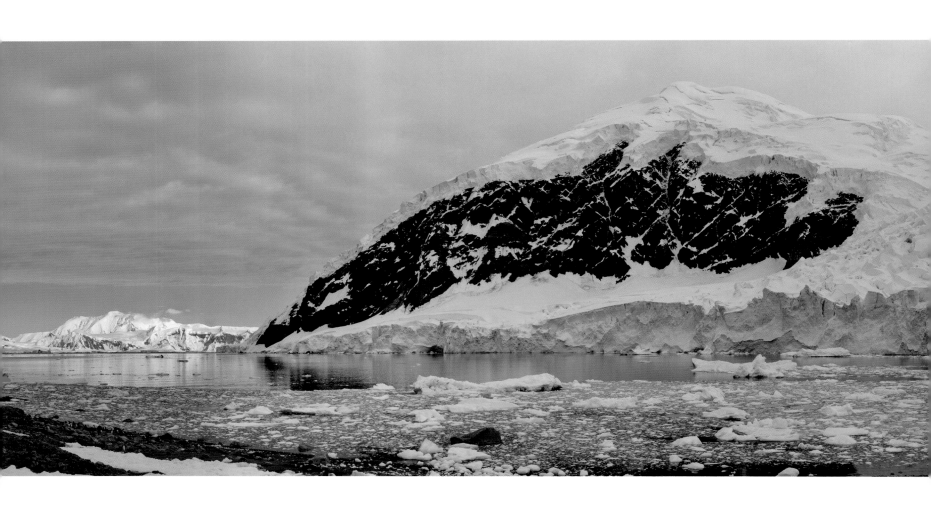

The Continent of
ANTARCTICA

Julian Dowdeswell & Michael Hambrey

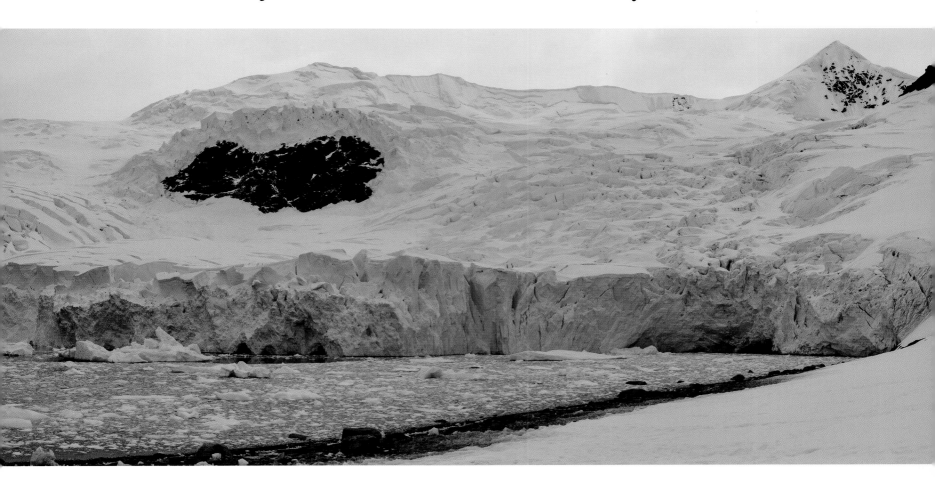

PAPADAKIS

First published in Great Britain in 2018 by Papadakis Publisher

An imprint of Academy Editions Limited

Kimber Studio, Winterbourne, Berkshire, RG20 8AN, UK
info@papadakis.net | www.papadakis.net

@papadakisbooks PapadakisPublisher

Publishing Director: Alexandra Papadakis
Design Director: Aldo Sampieri
Editor: Alexandra Papadakis
Editorial Assistant: Ilya Wray

ISBN 978 1906506 64 3

Copyright ©2018 Julian Dowdeswell, Michael Hambrey & Papadakis Publisher
All text, images, maps and tables © Julian Dowdeswell, Michael Hambrey unless otherwise stated.

All rights reserved.

Julian Dowdeswell and Michael Hambrey hereby assert their moral rights to be identified as authors of this work. No part of this publication may be reproduced or transmitted in any form or by any means, electronic or mechanical, including photocopy, recording or any other information storage and retrieval system, without prior permission in writing from the Publisher. Library of Congress Cataloging-in-Publication Data can be found at http://catalo.loc.gov."

Printed and bound in Slovenia.

Front Cover: Mountainous ice-covered terrain on the eastern side of the Princess Royal Range on Adelaide Island, viewed from Elliot Passage in Marguerite Bay, west of the Antarctic Peninsula.

Back Cover: Satellite image mosaic of Antarctica showing the shape of the continent, draped by the Antarctic Ice Sheet and fringed by relatively flat floating ice shelves. The mosaic was constructed from passive mircowave images acquired by the US National Oceanic and Atmospheric Administration (NOAA).

Endpapers: The Antarctic map on the domed ceiling of the Memorial Hall in the Polar Museum of the Scott Polar Research Institute, University of Cambridge, painted by Leslie MacDonald Gill in 1934. Here, the map is illustrated in two rotations so that the labels can be more easily read. Prominent explorers are named around the edge and their ships are illustrated on the map. Note that, in 1934, much of the coast of Antarctica was still largely unknown. The Memorial Hall in the Institute is dedicated to the memory of Captain Robert Falcon Scott, and his companions, Wilson, Bowers, Evans and Oates, who died on their return journey from the South Pole in 1912.

Previous spread: The actively calving terminal face of a grounded tidewater glacier in Neko Harbour, Andvord Bay, western Antarctic Peninsula.

CONTENTS

	Preface	6
Chapter 1	Introduction to Antarctica	8
Chapter 2	The Geography of Antarctica	17
Chapter 3	Evolution of Antarctica	30
Chapter 4	Weather, Climate and Atmospheric Effects	58
Chapter 5	Ice Sheets and Glaciers	82
Chapter 6	The Emerging Landscape	109
Chapter 7	The Southern Ocean, its Sea Ice and Icebergs	134
Chapter 8	Life in a Frigid Environment	160
Chapter 9	The Last Frontier of Exploration	196
Chapter 10	Living and Working in Antarctica	220
Chapter 11	Managing Antarctica	246
Chapter 12	The Future of Antarctica	266
	Geographical Index	286
	Subject Index	290
	Selected Bibliography	294
	Selected Websites	294
	Acknowledgements	295
	About the Authors	296

PREFACE

The Antarctic is in several ways the last continent: the last to be discovered, the last great wilderness and the last to be mapped, with areas such as the dark water-filled cavities beneath its fringing ice shelves arguably remaining the least known places on Earth. It is only just over one hundred years ago that Captain Scott, Edward Wilson and Ernest Shackleton first penetrated beyond the coastline into the continent's previously unknown icy interior. Many parts of the ice sheets that cover Antarctica have still never been visited, although today satellite imagery has allowed the ice surface to be examined in some detail from space. The continent's contemporary significance also lies in its importance as a sensitive part of the global environmental system, especially through its influence on sea-level rise and ocean-current circulation in a warming world.

For all these reasons, the Antarctic continent and its surrounding seas have held a scientific and an aesthetic interest for the authors for many years. Both of us have been fortunate enough to spend considerable time in Antarctica – at bases, in deep-field camps, and aboard ships and aircraft – undertaking scientific research. During this time, we have also experienced and enjoyed simply being there and able to admire and photograph the Antarctic landscape and its unique wildlife. We have also visited a number of the historic sites around the continent's coast, such as Scott and Shackleton's huts on Ross Island, places we first read about as children many decades ago. Simply, it has been a huge privilege to have been able to do all of this.

This book attempts to bring together our accumulated experience of the Antarctic continent, through what we hope is a combination of an accessible but informative text, supported by a series of photographs. The selection of photographs, which are mostly our own, was a particular pleasure, reminding us of the many remote and beautiful places we have seen as part of our scientific work.

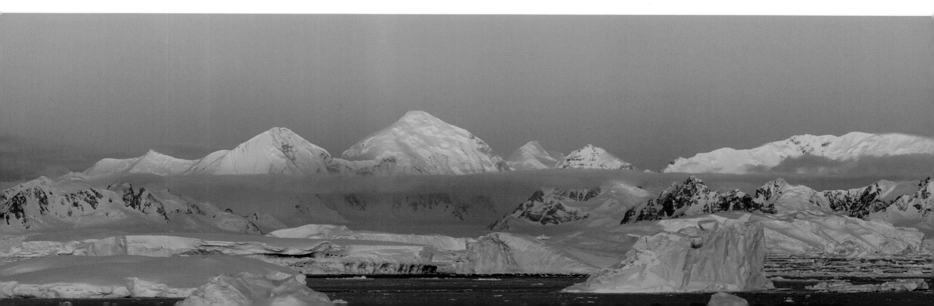

The book contains twelve chapters and begins with a short introduction to the continent and a second chapter giving an overview of its geography. Chapter 3 concerns the geological development of Antarctica and, in Chapter 4, the continent's weather and climate are discussed. Chapter 5 is concerned with the glaciers and ice sheets that cover almost the entire continent, and the restricted but unique exposed landscape of Antarctica is examined in Chapter 6. The Southern Ocean, together with its sea ice and icebergs, is the subject of Chapter 7. Wildlife, in the ocean, on land and in the air, is dealt with in Chapter 8. In each of these chapters we have tried to retain a balance between important scientific concepts and accessibility, describing phenomena from aurora to icebergs and ocean currents in words and photographs rather than equations.

By contrast, Chapters 9 to 11 relate to human activity in Antarctica: the continent's discovery and historical exploration in Chapter 9; what it is like to work there today in Chapter 10; and its management and governance in Chapter 11. Finally, Chapter 12 considers briefly the future of the Antarctic and its surrounding waters in terms of, first, its response to present and future climate change and, secondly, the challenges that face its future management and governance in terms of its preservation as a unique wilderness area. In addition, at the beginning of each of the twelve chapters, we have included brief examples of particular personal experiences during our time 'South'.

Many, including our families and scientific colleagues, have played roles in enabling us to visit and study Antarctica, and in encouraging us to write this book; we thank them in the Acknowledgements section.

Below: The late spring setting sun casts a colourful glow over the mountain-tops of Pourquoi Pas Island. This panorama was taken from the UK's Rothera Research Station on Adelaide Island, western Antarctic Peninsula.

Julian A. Dowdeswell – *Scott Polar Research Institute and Department of Geography, University of Cambridge*

Michael J. Hambrey – *Department of Geography and Earth Sciences, Aberystwyth University*

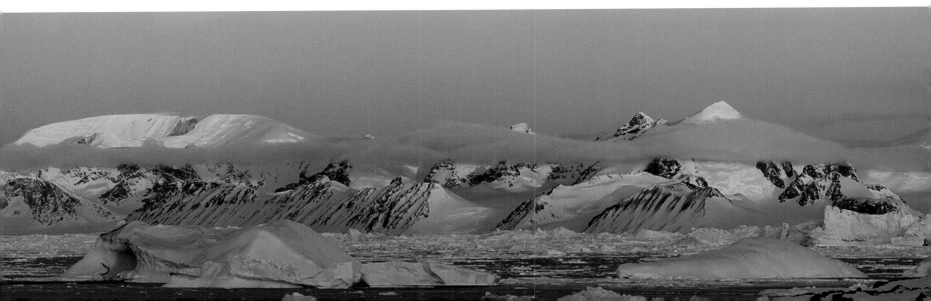

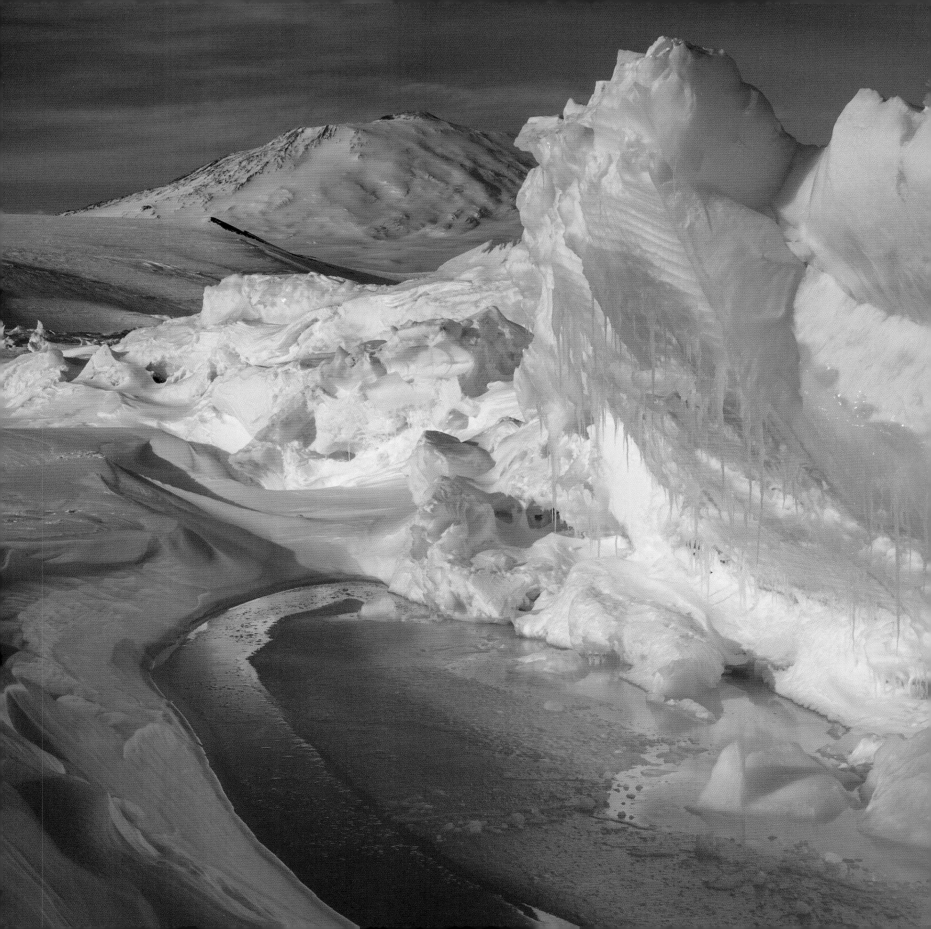

CHAPTER 1

Introduction to Antarctica

Having been brought up on a diet of books about the early Antarctic explorers, notably Captain Scott, Dr Wilson and Ernest Shackleton, I very much wanted to go to Antarctica. It proved to be a long wait – 25 years – but a chance encounter with leading New Zealand geologist, Peter Barrett, in Cambridge, led to an invitation to join his country's offshore drilling programme in 1986, the aim of which was to decipher the climatic and glacial record of the continent. Arrival in Antarctica was achieved after several false starts from Christchurch, and an uncomfortable, viewless, 8-hour flight in a noisy Hercules military aircraft. The ski-equipped aircraft landed on sea ice just off the American McMurdo Station, from where New Zealand staff took us to their nearby Scott Base. Landscape features all around seemed strangely familiar from my reading of the early expedition narratives. The majestic, ice-draped volcano of Mt Erebus dominated the scene, but views of Mt Discovery, Mt Terror, the Royal Society Range and McMurdo Ice Shelf brought to me a tangible connection with history. Subsequent weeks spent at Scott Base and at the drill site gave a fascinating insight into the changing Antarctic environment through the year. Other highlights were a close encounter with emperor penguins at the ice edge (one of whom had a rummage in my rucksack), an extra-special excursion across the sea ice to the 'Heroic Era' huts of Shackleton and Scott, and a helicopter trip to the Dry Valleys. Little did I know it at the time, but this was the start of a sequence of a dozen field season's of scientific work in Antarctica.

MJH

Antarctica in a global context

With its thick carapace of ice, the Antarctic continent represents the most extreme environment on Earth. It is the only continent that has never had any indigenous human population and, even today, despite the presence of numerous permanent research stations, few people stay over winter. Maps in atlases treat Antarctica almost as an afterthought, often distorted and spread out across the bottom of the world, yet the continent covers an area twice the size of Australia or fifty-eight times that of the British Isles. Only a third of one percent of Antarctica is ice-free and the continent is commonly portrayed as the coldest, driest, windiest and highest on Earth. It is also incredibly beautiful, drawing in increasing numbers of visitors.

Unlike the Arctic, its counterpart in the North, the Antarctic region is well-defined, being limited by the 'Antarctic Convergence' in the Southern Ocean, which marks a rapid transition from cold waters around the continent to warmer waters to the north. In this book, we define our geographical limits as the Antarctic continent and its immediately adjacent islands, together with the continental shelf and the deep waters beyond. It is a region

Opposite: Ridges forced up by pressure within a cover of sea ice offshore of New Zealand's Scott Base in McMurdo Sound, with Mt Erebus in the distance. Individual pressure ridges can be several metres high and a safe flagged route through the maze of ridges allows staff at the base to enjoy a spectacular walk. The volcano of Mt Erebus is in the background.

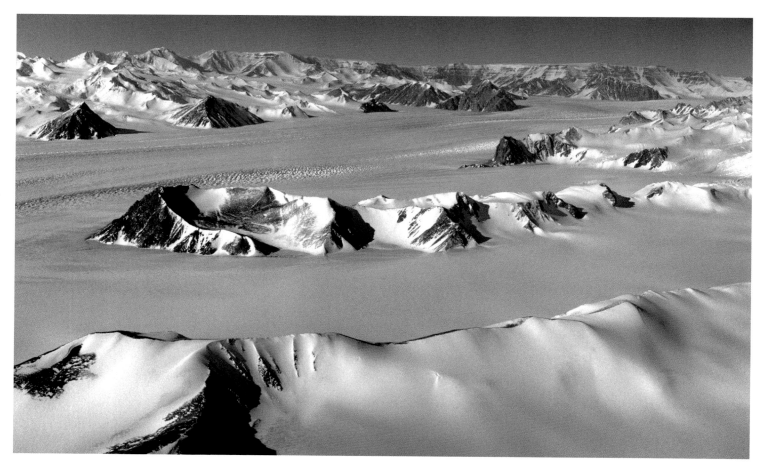

dominated by ice, and on that account we do not include discussion of the sub-Antarctic islands, which are biologically and physically distinct.

Antarctica is unique geo-politically, in being a region where international disagreements has been set aside. Indeed, although several countries have claimed segments of the continent, and some claims overlap, all these territorial claims have been suspended under the terms of one of the most successful international treaties ever agreed. Signed in 1959, the Antarctic Treaty and the subsequent environmental protection measures linked to it, provide the context in which all human activity operates today on the continent and in its adjacent seas.

Why is Antarctica important? First and foremost, this relatively unknown continent is an 'outdoor laboratory' where environmental changes of global reach can be investigated. For example, changes to climate, induced by the generation of greenhouse gases by humans, are taking place at an unprecedented rate in parts of the continent, most notably in the Antarctic Peninsula and West Antarctica. Oceanographic conditions, including water temperature, currents and acidity, are also changing on account of the increases in

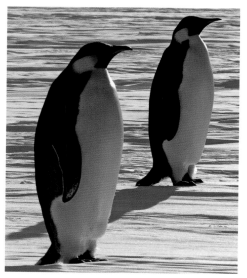

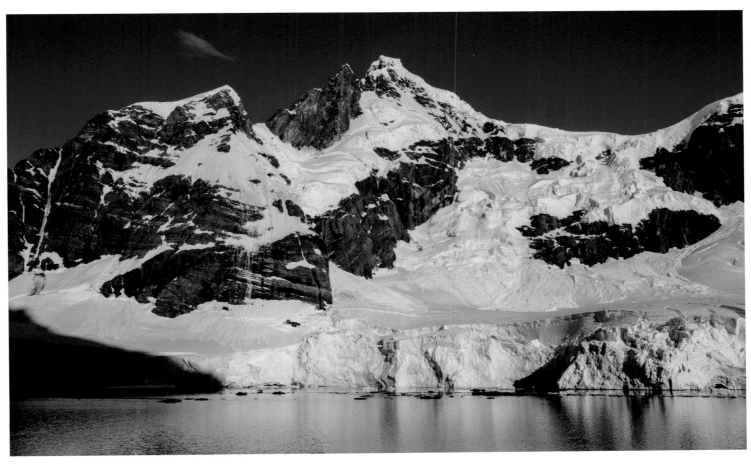

Opposite top: The Transantarctic Mountains are one of the greatest ranges on Earth. They are breached by huge glaciers, flowing from the East Antarctic Ice Sheet to the Ross Ice Shelf. Ice is flowing from right to left in this photograph of Liv Glacier.

Opposite left: Emperor penguins looking across the sea ice of McMurdo Sound near Captain Scott's historic hut at Cape Evans.

Above: The Lemaire Channel on the western side of the Antarctic Peninsula is a spectacular glacially-carved trough, bounded by precipitous mountains of volcanic rock and steep glaciers.

greenhouse gases. Global action on climate change has been slow in coming to fruition, and despite the UN's Paris Agreement of December 2016, serious impacts cannot now be avoided. Other polluting gases, such as chlorofluorocarbons (CFCs), which were used in refrigerants, led to the development of the ozone hole, an unforeseen impact discovered in Antarctica. In contrast to the so-far limited efforts to combat climate change, a global agreement to cut CFCs was achieved relatively quickly, and the successful implementation of the Montreal Protocol in 1987 is allowing slow restoration of the ozone layer.

Among the most serious impacts to humanity of these environmental changes is that of glacier and ice-sheet thinning and retreat, and its increasing contribution to global sea-level rise. In addition, changes to sea-ice production also affect ocean circulation far beyond the Antarctic. Physical changes are also having an impact on Antarctic ecosystems, and the health of iconic species such as whales, seals and penguins is being compromised. Antarctica is also a place where earth-surface processes can be monitored, providing insight into former cold conditions elsewhere on the planet. The continent is crucial for understanding geological evolution globally, and because of the clear atmosphere and its location close to the

south magnetic pole provides a unique setting for the study of astronomy and space physics. Antarctica is dominated by the 'cryosphere', which collectively refers to all the snow- and ice-covered parts of Earth. The cryosphere has such a profound impact on our well-being, that understanding the dynamics of ice sheets is crucial. Furthermore, samples taken from deep ice cores through the Antarctic Ice Sheet have provided a baseline of past climates over nearly the last million years, against which to assess humanity's likely future impact.

The make-up of Antarctica

Antarctica, as an isolated continent centred on the South Pole, is a relatively recent feature geologically, with the opening of Drake Passage completing the separation of the Antarctic Peninsula from South America some 35 to 30 million years ago. Antarctica thus became thermally isolated, and the geological record shows that the Antarctic Ice Sheet first reached the coast 34 million years ago – since then, the ice sheet has waxed and waned. The continent continues to undergo rifting today, linked to active volcanism.

Today, Antarctica is almost completely covered by ice and snow, comprising three ice sheets of differing dimensions. The Antarctic Peninsula has a mountainous glacier-covered spine and extends far to the north of the Antarctic Circle. Its western margin and northern limits are characterised by islands and mountains. Home to abundant wildlife, this is the region that the majority of visitors see. Separating the East and West Antarctica ice sheets is one of the greatest mountain ranges on Earth, the Transantarctic Mountains, although much of the range is buried by ice. Huge outlet glaciers and fast-flowing streams of ice pierce the mountain ranges, while floating masses of glacier ice extend across the ocean and produce vast icebergs, some the size of small countries. The floating ice shelves are proving to be particularly vulnerable to climate change, and some have collapsed in the last few decades. The tiny percentage of land that is exposed in Antarctica provides one of the most unusual environments on Earth – a cold polar desert, revealing the impact of past glaciation, battered by wind, and hosting a range of freshwater and saline lakes with unique life forms.

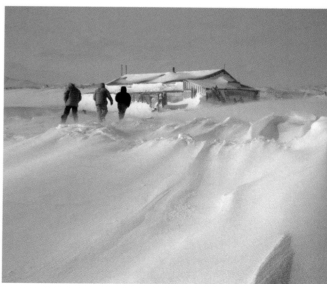

Beyond Antarctica, the Southern Ocean surrounds the continent, covering over 30 million km^2 (12 million miles2) or about 9% of the world's total ocean area. It is defined as that part of the world's ocean area lying south of the Antarctic Convergence (or Polar Front) where the cold-water mass that circulates around the frozen continent sinks beneath the warmer waters of the South Atlantic and Indian oceans. In addition to abundant icebergs, sea ice surrounds Antarctica, although varying enormously in extent between summer and winter, and indeed from one year to the next. Sea ice has profound effects on the weather, biology and oceanography of the region. The contrast between the occurrence of wildlife in the sea and on land is remarkable. Whereas the sea provides one of the richest ecosystems on Earth, the arid land areas are impoverished. Most of the animals that visitors come to see are abundant within the pack ice, and on coastal land areas, where breeding takes place.

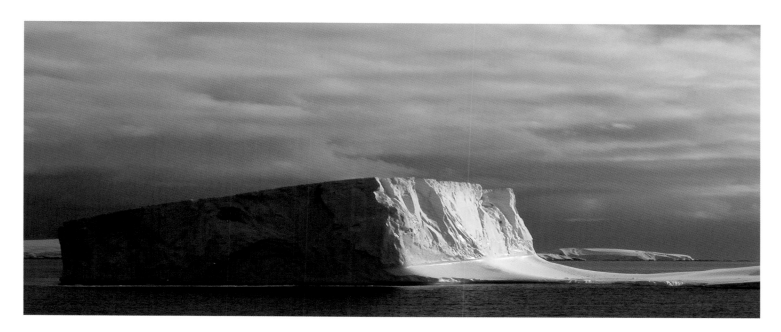

Historical background

It was living marine resources, such as seals, and then whales, that first attracted humans to Antarctica in the early 19th century for commercial profit. Scientific and geographical interest grew in the late 19th to early 20th century, reaching a peak with the national expeditions of the 'Heroic Era' of exploration. These expeditions undertook the initial mapping of the continent and included reaching the South Pole in 1911. Whaling grew in the inter-war years, whilst successive expeditions introduced aircraft into exploration of the interior of Antarctica. By the Second World War territorial claims were becoming a political issue, and the first permanent stations were established.

In the late 1950s, the most important political development in the history of Antarctica took place. The desire for international collaboration in science was growing, stimulated by the International Geophysical Year (IGY) of 1957-58. A number of research stations was established, and many co-operative research and monitoring programmes were initiated, often with shared organisation and logistics. The value of co-operation was recognised by governments, and, with territorial disputes unresolved, it was decided that a formal Treaty would best serve international interests in Antarctica in the future. Thus, in 1959 the Antarctic Treaty was born, under which all territorial claims were put in abeyance. All subsequent activity on the continent has been under the umbrella of this treaty, which has now been signed by 53 countries. The Treaty System has evolved, with increasing environmental protection of prime concern today, accompanied by a ban on mineral exploration and mining. Science is managed by the affiliated Scientific Committee on Antarctic Research, which was originally set up during the IGY. A notable

Opposite top: The Antarctic Peninsula Ice Sheet is a long, narrow mass of ice, through which mountains project above the surface as nunataks. This photograph shows largely snow-bridged crevasses, as the ice discharges via ice streams into Marguerite Bay, SW Antarctic Peninsula.

Opposite left: With spindrift blowing around their legs, three scientists approach Scott's Cape Evans hut, which served his '*Terra Nova*' expedition in 1910-1913.

Above: Iceberg in Dallmann Bay, between Anvers and Brabant islands, west of the Antarctic Peninsula.

recent development has been in tourism, especially 'expedition ship' cruising, which brings several tens of thousands of visitors to Antarctica each year.

Comparisons with the Arctic

The Arctic and Antarctic are quite different, despite the fact that they are both located at high latitudes and that ice is a dominant feature of such cold environments. The Arctic is a deep ocean surrounded by continental land masses. The Antarctic is the opposite, a continent surrounded by an ocean. The Arctic has had indigenous human populations for thousands of years, unlike Antarctica, and has been economically exploited for several centuries. Only the marine realm in Antarctica has been subject to the scale of predation on animals that is a feature of the Arctic's history.

The Arctic land masses are the sovereign territory several nations: Norway, Sweden, Finland, Russia, Greenland, the USA and Canada, and the carving up of rights to the sea bed of the Arctic Ocean is an ongoing political issue. The Arctic has a resident land-mammal population, including polar bear, reindeer/caribou, musk ox, Arctic hare, Arctic fox and wolf. In Antarctica, mammals (whales, seals) occur only offshore. Finally, the land in the Arctic supports vegetation above a permafrost layer whose upper metre or so thaws each summer, whilst Antarctica is mainly a cold desert where only algae, lichen and mosses are to be found.

Nonetheless, despite being at opposite ends of the Earth, investigations in many fields benefit from a bi-polar approach. This is evident from the many scientists who work in both polar regions, and who interact readily and exchange their ideas and experiences in the context of international research.

Organisation of the Book

The Continent of Antarctica is divided into eleven further chapters, dealing with the physical and human aspects of the continent and its surrounding seas. The geography of Antarctica is described in Chapter 2 and its geological evolution in Chapter 3. Chapter 4 considers the weather and climate of the continent. The form and flow of ice sheets and glaciers that cover the vast bulk of the continent are discussed in Chapter 5. The landscape of both the exposed fringes of Antarctica and that which lies beneath the present ice sheets is outlined in Chapter 6. The Southern Ocean and its ice-infested waters form the subject of Chapter 7, with the mainly marine wildlife of the Antarctic considered in Chapter 8. Chapter 9 concerns the history of Antarctic exploration and Chapter 10 deals with living and working in Antarctica today. In Chapter 11 the way that Antarctica is managed is outlined, from governance under the Antarctic Treaty to the modern tourist industry. Some discussion of the future of Antarctica, in terms of both environmental change and geopolitics, is offered in the concluding Chapter 12.

Opposite: An expedition ship, the *National Geographic Explorer* approaches a calving glacier on the north side of Elephant Island (South Shetland Islands) near Cape Wild, where Shackleton's men awaited rescue after the crushing of their ship *Endurance* in 1915.

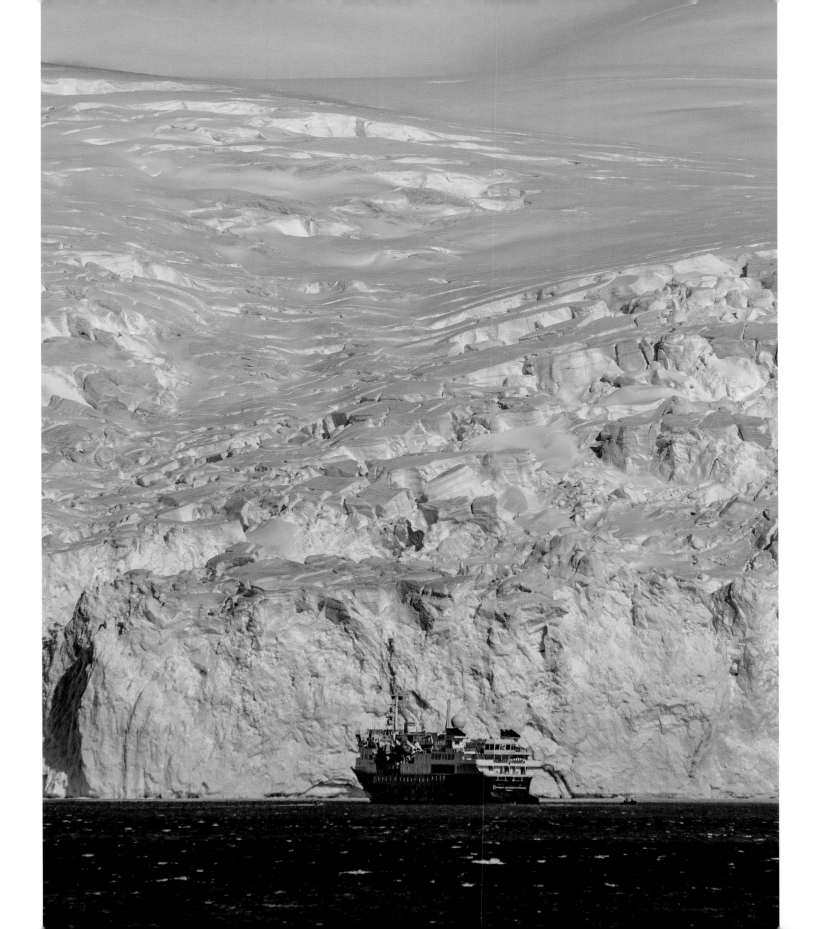

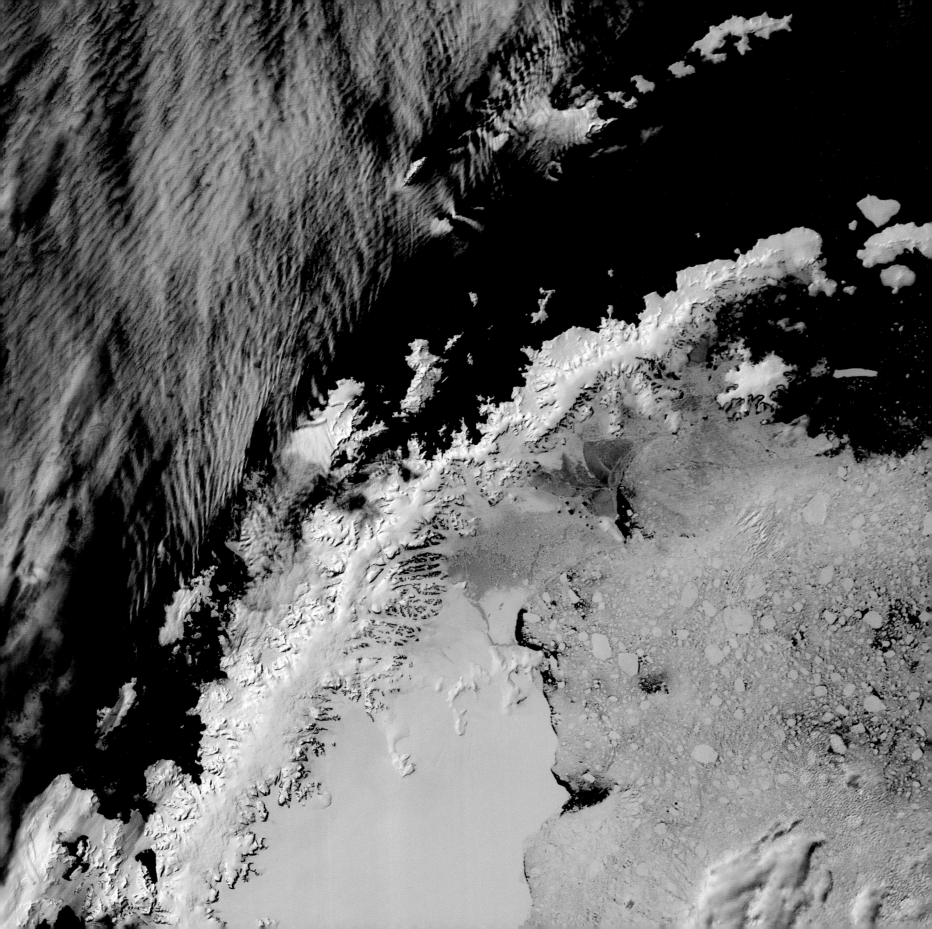

CHAPTER 2

The Geography of Antarctica

On the wall of my office in Cambridge is a beautiful painting by Edward Seago. It is entitled 'The first iceberg'. Not only is it a spectacular impression of the stormy Southern Ocean, but it also reminds me of the first time I went to Antarctica. From Britain, the flight from RAF Brize Norton left late at night, stopping for a couple of hours at the near-equatorial Ascension Island (with its splendidly named Wide-Awake airfield), before a further long leg to the Falkland Islands. From Stanley harbour we joined the British research ship James Clark Ross for the passage South. It is unusual to cross the Drake Passage in calm weather, and this was no exception. But, almost three days later, the air was crispy clear in the sunrise as we approached the Antarctic Peninsula. And then, as my binoculars scanned the horizon, there was that first iceberg. Soon we encountered sea ice, too, and the wildlife that goes with it – my first Antarctic penguins riding the ice floes. Finally, the horizon was cut by mountain tops, and lower ice-covered slopes emerged as we sailed on. There were the fringing islands of Anvers, Smith and Brabant, and then the distant outline of Graham Land, the Antarctic Peninsula itself. I thought of the early explorers, led by John Rymill, who mapped the area, travelling mainly by dog-sledges in the 1930s, and then back to the splendid Seago painting in Cambridge. This was a superb visual introduction to Antarctica for me – the progress of the ship slowly revealing the ragged ocean, the first bergs and sea ice, and then the unfolding icy landscape.

JAD

The Antarctic Continent

The continent of Antarctica is about 13.8 million km^2 (5.3 million miles2) in area or about the size of the USA and Mexico combined, with a coastline of about 30,000 km (18,600 miles) in length – almost 90% being made up of ice cliffs. It is isolated from other major landmasses by the Southern Ocean, and the currents and winds that constantly move from the west around it. The Drake Passage, between the tip of the Antarctic Peninsula at 63° S and Tierra del Fuego in southernmost South America at 55° S, is the shortest distance to another continent at about 1,000 km (620 miles).

The continent is divided into three parts, the first two of which are East and West Antarctica, divided by the Transantarctic Mountains which run for 3,500 km (2,200 miles) right across the continent from the Ross Sea to the Weddell Sea. The third part is the Antarctic Peninsula, about the size of Britain, which extends into the Southern Ocean towards South America from West Antarctica between about 55° and 70° W and north of about 75° S. It is

Opposite: Satellite image of the northern part of the 1,300 km (800 mile) long Antarctic Peninsula, known as Graham Land, on an unusually clear day (8 January 2016). The Peninsula and adjacent islands to the west (left) are almost entirely covered by glacier ice, and the smooth flat expanse of ice to the east is one of the remaining ice shelves, Larsen C. The South Shetland Islands are visible in the uppermost right of the image. There is an area of cloud over the sea at the top left and a broken cover of pack ice at the bottom right. (Courtesy of NASA)

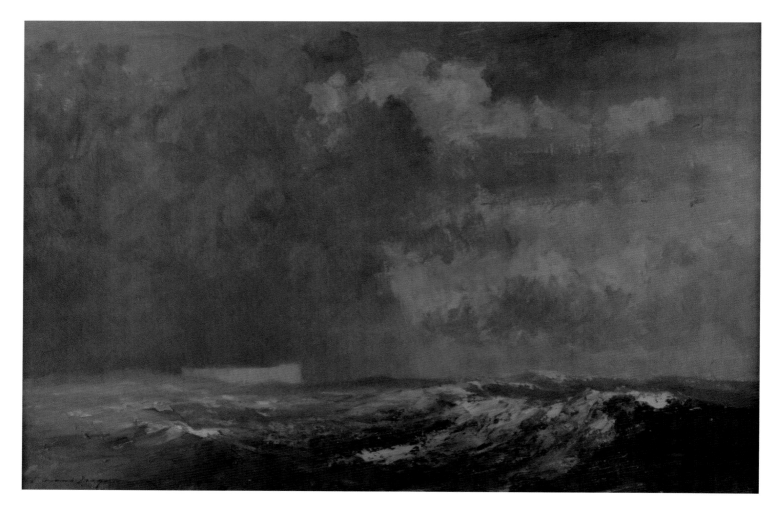

sometimes known as the 'Antarctic Riviera' because of the relatively mild temperatures especially on its western side.

Many islands are found immediately offshore of the Antarctic continent, particularly around the Antarctic Peninsula, whereas others are attached to the continent directly by glaciers or floating ice shelves, for example Thurston Island in West Antarctica. The archipelagoes of the South Shetland, South Orkney and South Sandwich islands are located further offshore of the Peninsula. There are also several very isolated sub-Antarctic islands in the Southern Ocean between about 45 and 55° S.

Over 99% of Antarctica is covered by ice. The ice sheet is a maximum of 4.7 km (almost 3 miles) thick and depresses the underlying Earth's crust, as a rule of thumb, by about one third of the ice thickness. If this ice were to melt completely, which would take at minimum of tens of thousands of years, global sea-level would rise by about 60 m (200 ft). The removal of ice would reveal a continent beneath much of East Antarctica and an

Above: Edward Seago's painting 'The first iceberg seen from *Britannia*, Dec 26th, 1956', produced during Seago's trip to the Antarctic Peninsula with HRH The Duke of Edinburgh aboard the Royal Yacht *Britannia*. (Courtesy of the Scott Polar Research Institute and Portland Gallery)

Opposite: Map of Antarctica showing its three major elements: East Antarctica, West Antarctica and the Antarctic Peninsula, along with other place names. The inset (top right) shows the position of Antarctica relative to South America, Africa and Australia. (Courtesy Papadakis Publisher)

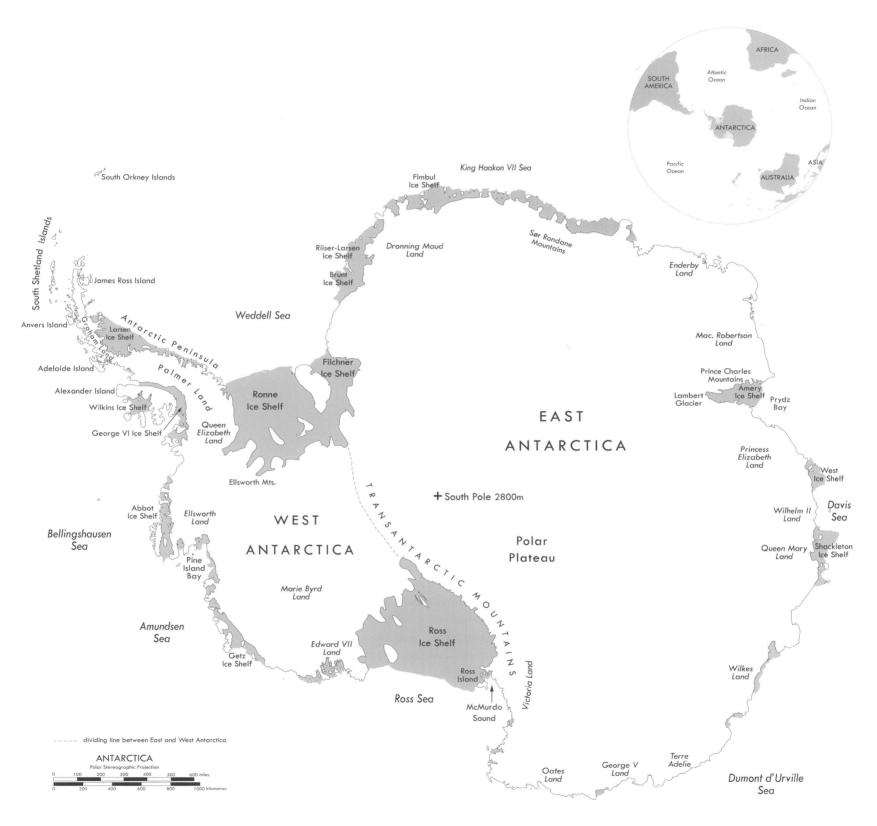

South Orkney Islands

King Haakon VII Sea

Fimbul
Ice Shelf

Riiser-Larsen
Ice Shelf

Dronning Maud
Land

Sør Rondane
Mountains

South Shetland Islands

James Ross Island

Anvers Island

Adelaide Island

Graham Land

Larsen
Ice Shelf

Antarctic Peninsula

Palmer Land

Brunt
Ice Shelf

Weddell Sea

Enderby
Land

Mac. Robertson
Land

Alexander Island

Wilkins Ice Shelf

George VI Ice Shelf

Queen
Elizabeth
Land

Filchner
Ice Shelf

Ronne
Ice Shelf

Prince Charles
Mountains

Lambert
Glacier

Amery
Ice Shelf

Prydz
Bay

EAST
ANTARCTICA

Ellsworth Mts.

+ South Pole 2800m

Princess
Elizabeth
Land

West
Ice Shelf

Abbot
Ice Shelf

Ellsworth
Land

WEST
ANTARCTICA

Bellingshausen
Sea

Pine
Island
Bay

Marie Byrd
Land

TRANSANTARCTIC MOUNTAINS

Polar
Plateau

Wilhelm II
Land

Davis
Sea

Queen Mary
Land

Shackleton
Ice Shelf

Amundsen
Sea

Getz
Ice Shelf

Edward VII
Land

Ross
Ice Shelf

Ross
Island

Ross Sea

McMurdo
Sound

Victoria Land

Wilkes
Land

- - - - dividing line between East and West Antarctica

ANTARCTICA
Polar Stereographic Projection

0 100 200 300 400 500 600 miles

0 200 400 600 800 1000 kilometres

Oates
Land

George V
Land

Terre
Adelie

Dumont d'Urville
Sea

AFRICA

Atlantic
Ocean

SOUTH
AMERICA

Indian
Ocean

ANTARCTICA

Pacific
Ocean

ASIA

AUSTRALIA

island archipelago in the West Antarctic and Antarctic Peninsula regions. Major mountain ranges, such as the Gamburtsev subglacial Mountains, which are over 3,000 m (almost 10,000 ft) high, lie completely buried beneath the East Antarctic Ice Sheet. The highest point in Antarctica is Mt Vinson, whose summit is 4,892 m (16,050 ft) high, rising above the surface of the West Antarctic Ice Sheet in the Ellsworth Mountains.

The geographical South Pole is located in East Antarctica. It was first reached by the Norwegian Roald Amundsen and a team of four in December 1911, followed by Captain Scott and his four companions a month later, and is located on the high polar plateau formed by the East Antarctic Ice Sheet at about 2,700 m (almost 9,000 ft) above sea level. The ice is 2.8 km (1.75 miles) thick beneath the Pole. The magnetic South Pole, first visited by Douglas Mawson, Edgeworth David and Alistair Mackay in 1909 during Ernest Shackleton's *Nimrod* expedition, is now beyond the Antarctic coastline at 64.28° S 136.59° E (in 2015) and is migrating northwest at about 9 km (5.5 miles) each year.

East Antarctica

East Antarctica makes up about three-quarters of the continent and is about 10 million km² (4 million miles²) in area. It is almost entirely ice-covered, apart from a number of restricted ice-free areas or 'oases' located close to the coast – the Vestfold Hills and the Shirmacher Oasis are examples, present in part due to downslope-flowing dry winds that remove any snowfall. The boundaries of East Antarctica are its coastline, of which much is fringed by floating ice shelves, and the Transantarctic Mountains. Although these mountains form an impressive barrier to ice flow from the Polar Plateau to the Ross and Ronne-Filchner ice shelves, large outlet glaciers breach the mountains in numerous places. Of these, Beardmore Glacier was used by Scott and Shackleton on their polar journeys, and Axel Heiberg Glacier by Amundsen. Several outlet glaciers now bear the names of famous Antarctic explorers, such as the Scott, Shackleton, Amundsen and Byrd glaciers. The Transantarctic Mountains also have a number of ice-free areas, the most notable of which are the Dry Valleys – one of the driest places on Earth.

The ice-sheet surface is almost flat in the areas of the three subdued ice domes that define its summits, and is less than about a degree over vast areas of the interior – slopes that are almost imperceptible to those few who travel across it. Only close to the coast, and where mountains known as 'nunataks' pierce the surface, are surface slopes steeper and the scenery more varied. Some subsidiary, but nonetheless substantial and independent ice domes are also present on the fringes of East Antarctica – Law Dome is among the largest at roughly 10,000 km² (4,000 miles²).

The ice sheet is divided into a number of huge drainage basins. Of these, the Lambert Glacier Basin is arguably the largest, covering more than 1 million km² (400,000 miles²). The basins are defined by the direction of the ice-surface

Below: The best-known area of ice-free ground in Antarctica is the Dry Valleys region of Victoria Land. It is almost entirely surrounded by glacier ice, and is characterised by bare ground with wind-blown sand, small streams, and saline lakes. This view of Victoria Valley is from the inland edge of Victoria Lower Glacier, the receding margin of which is visible on the right.

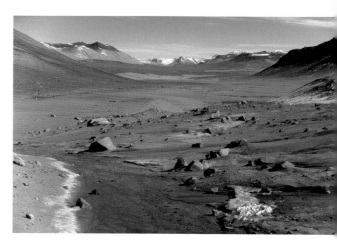

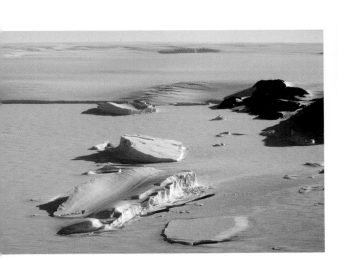

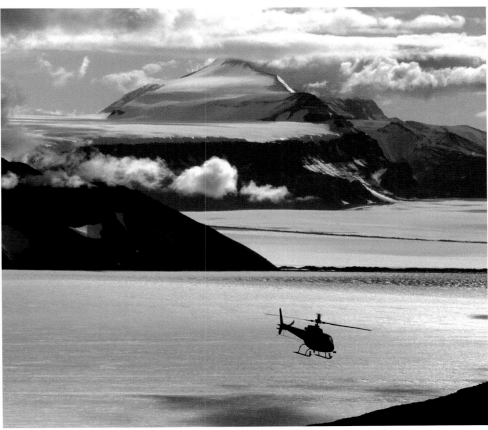

slope and ice flow, and are similar to watersheds on land. In addition, fast-flowing filaments of ice, known as ice streams, flowing at kilometres rather than metres per year, penetrate deep into these basins and feed ice into extensive flat, floating ice shelves that fringe about 90% of the coastline.

Over much of its interior, the East Antarctic Ice Sheet is between three and almost 5 km (3 miles) in thickness, burying even high mountains such as the 1,200 km (750 mile) long Gamburtsev chain beneath it. Under the ice, the subglacial terrain is mainly above sea level and would form land if the ice were removed. By contrast, several huge areas, the Aurora, Wilkes and Astrolabe basins, form depressions that extend over 2 km (1.2 miles) below sea level, although ice sheet is grounded in these areas preventing seawater from penetrating beneath the ice. There are several large, and many small, subglacial lakes beneath the ice, the largest of which is Vostok Subglacial Lake near the centre of the ice sheet. The lake occurs under 3,740 m (12,270 ft) of ice, is about 14,000 km² (5,000 miles²) in area and contains a volume of about 2,000 km³ (500 miles³) of water. This makes it one of the largest freshwater bodies in the world, approaching the size of the 19,000 km² (700 miles²) Lake Ontario.

Above: The coastal edge of the vast expanse of ice known as the East Antarctic Ice Sheet, just east of the Amery Ice Shelf. The edge is marked by a grounded ice cliff (the dark blue horizontal line), beyond which the ice sheet rises to over 3000 m (10,000 ft); crevasses punctuate the ice surface. In the foreground (lower ²/₃ of image) are winter sea ice and grounded icebergs.

Top right: The Transantarctic Mountains are breached by outlet glaciers from the East Antarctic Ice Sheet, which flow into the Ross Ice Shelf. In this view of upper Shackleton Glacier, a helicopter is arriving to pick up a geological field party.

West Antarctica

There are two main differences between West and East Antarctica. First, West Antarctica is smaller in area, at almost 2 million km² (0.75 million miles²); its ice cover averages about a kilometre (0.6 miles) less in thickness than that of its eastern neighbour. It is a little larger that the Greenland Ice Sheet. Secondly, much of its bed is located significantly below sea level, by up to about 2,000 m (6,500 ft). In fact, the floor of the Byrd Subglacial Basin reaches 2,870 m (9,416 ft) below sea level, making it the lowest point of any continent on Earth. It is effectively a great depression, a rift valley surrounded by the mountains of Marie Byrd Land and Ellesworth Land to either side.

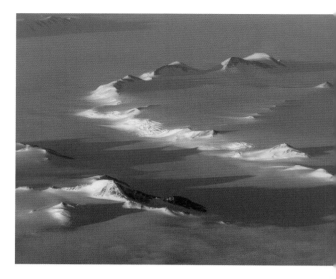

Otherwise, the form of the West Antarctic Ice Sheet resembles that of East Antarctica, with interior drainage basins of up to a million square kilometres, flat in the interior and dissected by fast-flowing ice streams nearer to the coast, where floating ice shelves are fed from the parent ice sheet along much of its margin. The enormous Ross and Ronne ice shelves, which cover much of the Ross Sea and Weddell Sea embayments, are fed by ice flowing from both the West and East Antarctic ice sheets.

Antarctic Peninsula

The Antarctic Peninsula is a largely ice-covered, 500,000 km² (200,000 miles²) and 1,800 km (1,000 mile) long spine of mountains and surrounding fjords and islands located between about 60 and 70° W. Its tip is about 1,000 km (600 miles) south of southernmost South America. The base of the Peninsula merges into the Ellsworth Mountains of West Antarctica. The highest peak on the Peninsula is Mt Jackson at an elevation of 3,184 m (10,446 ft). The narrow Antarctic Peninsula Ice Sheet rests on an undulating plateau and often being just a few hundred metres thick is much thinner than the huge West and East Antarctic ice sheets. Glaciers, some steep and fast-flowing, drain the upland icefields to the sea and floating ice shelves fringe the area on its eastern, Weddell Sea side in particular.

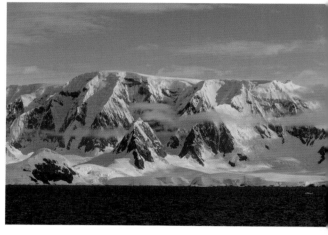

Immediately offshore of the Peninsula itself are many islands, such as the Palmer Archipelago of which Adelaide, Anvers, and Brabant islands are among the largest. Alexander Island – at 49,000 km² (19,000 miles²) about 20% larger than Iceland – is connected to the mainland of the Peninsula by the floating George VI Ice Shelf. Bransfield Strait, an area of active geological rifting, separates the Peninsula and its inner islands from those of the South Shetlands; the horseshoe-shaped crater rim of Deception Island defines an active volcano linked to this rift zone.

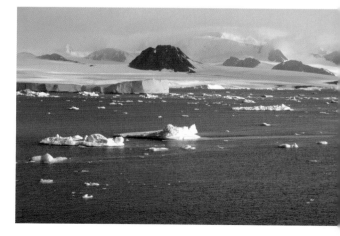

Bases and airstrips provide scientific access to the Peninsula, particularly for British, Chilean and Argentine nationals and their international colleagues, since this is the part of Antarctica claimed by these three countries. In view of its proximity to South America, the northern Antarctic Peninsula, and especially the islands on its western and northern coasts are also those parts of Antarctica most frequently visited by tourist ships.

Opposite top: Nunataks pierce the ice-sheet surface in Northern Victoria Land, East Antarctica.

Opposite centre: The long linear Antarctic Peninsula Ice Sheet typically terminates on the edge of a high-level plateau. The view is of Flandres Bay, southern Gerlache Strait.

Opposite bottom: The eastern slopes of the Peninsula are less steep, and the longer glaciers here feed extensive ice shelves which have been collapsing in recent decades. The photograph shows the northern part of the Antarctic Peninsula Ice Sheet, known as Trinity Peninsula, bordering the Prince Gustav Channel. This strait was occupied by the former Prince Gustav Ice Shelf until 1995, when the ice shelf collapsed.

Right: Map of the Antarctic Peninsula. The areas in blue are floating ice shelves, fed by ice flow from inland glaciers. (Courtesy Papadakis Publisher)

Elephant I.

South Shetland Islands

King George I.

Bransfield Strait

Joinville I.

Deception I.

James Ross I.

Brabant I.

Gerlache Strait

Graham Land

Anvers I.

Lemaire Channel

Weddell

Sea

Adelaide I.

Larsen Ice Shelf

Rothera Stn.

Marguerite Bay

Bellingshausen

Sea

P a l m e r L a n d

Alexander I.

Wilkins Ice Shelf

George VI Ice Shelf

Eltanin Bay

ANTARCTIC PENINSULA
Polar Stereographic Projection

100 50 0 kilometres 100

50 0 miles 50

Ronne Ice Shelf

Antarctic and Sub-Antarctic Islands

Several chains of islands, associated with plate-tectonic activity and volcanism, are found north of the Antarctic Peninsula and in the adjacent Scotia Sea. These are, from west to east, the South Shetland, South Orkney and South Sandwich islands, forming the so-called Scotia Arc. The South Sandwich Islands contain active volcanoes, whereas Deception Island is a single volcanic caldera with subsidiary cones.

A further series of isolated sub-Antarctic islands is also present in the windswept Southern Ocean that encircles the Antarctic continent, many discovered by early navigators and commercial whalers. Of these, South Georgia in the South Atlantic at 3,900 km^2 (1,500 miles2) and Kerguelen south of the Indian Ocean at 6,700 km^2 (2,500 miles2) are among the largest; they are British and French possessions, respectively. Other isolated islands between 45 and 55° S, and the nations to which they belong, include Bouvet Island (Norway), Prince Edward Island (South Africa), Crozet Island (France), and Heard and Macquarie islands (Australia). Many of these islands house research stations that provide important meteorological observations from a geographical sector of the Southern Hemisphere in which data are sparse.

The larger sub-Antarctic islands in particular are mountainous and contain fjords, produced by past and present glacial activity. Most have an unusual ecology and vegetation, given their isolated locations, and are sites of very active sea mammal and bird life, providing breeding and nesting areas adjacent to the rich feeding grounds of the Southern Ocean.

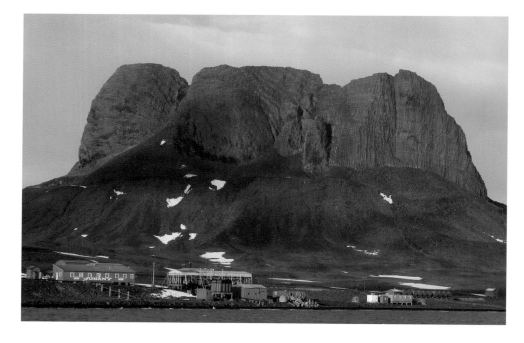

Left: The Argentine Carlini Base, formerly known as Jubany, on King George Island in the South Shetlands.

Opposite top left: The hangar at Rothera air strip with de Havilland Twin Otter (*left*) and Dash-7 (*right*).

Opposite top right: The Royal Navy's icebreaker, HMS *Protector* in Croft Bay, James Ross Island, where it is supporting the fieldwork of a geological party.

Opposite bottom: Boeing C-17 Globemaster just landed on the ice near the US McMurdo Station.

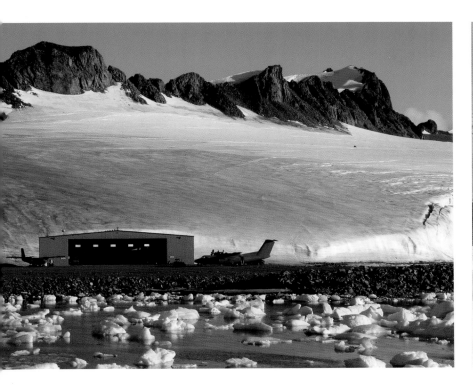

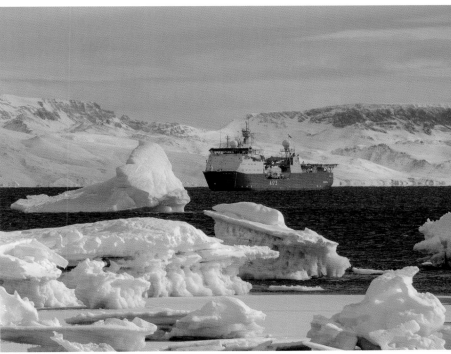

Gateways to Antarctica

The main gateways to the continent and its surrounding islands are from the closest landmasses to the north across the Southern Ocean, which are the southern tips of South America and Africa together with Australia and New Zealand. The distance from Ushuaia in Argentina and Punta Arenas in Chile to the closest bases on the Antarctic Peninsula is about 1,000 km (620 miles), and from the Falkland Islands to the British base at Rothera is 1,850 km (1,150 miles). From South Africa to the coast of East Antarctica is almost 4,000 km (2,490 miles). By aeroplane from Christchurch in New Zealand to McMurdo Station at the edge of the Ross Ice Shelf is 3,900 km (2,400 miles) and a 5-hour flight in a C-17 Globemaster jet – or about 8 hours in a C-130 Hercules turbo-prop aircraft. Today, going from Hobart in Australia to Casey Station in East Antarctica by ship is approximately 3,500 km (2,180 miles) and takes about a week. Captain Scott's fateful last expedition to Antarctica took about three weeks to sail from Lyttelton Harbour in New Zealand to McMurdo Sound aboard the *Terra Nova* in 1910-11.

Most scientific research stations are located around the coast of Antarctic, for ease of access and resupply by ships. The bases of many nations who are members of the Antarctic Treaty System are located on the islands off the northern Antarctic Peninsula, or along its western shore, with King George Island being the most frequented site.

This is because this part of Antarctica is closest to the ports of southernmost South America and the offshore waters are more easily navigated given that sea-ice conditions are less severe than elsewhere around the continent. The bases of Argentina, Australia, Chile, France, New Zealand, Norway and Britain are positioned within the sectors of Antarctica to which their historical territorial claims relate. The United States operates the largest base on the continent, at McMurdo Sound, and both America and Russia have bases in the deep interior of Antarctica, with the US Amundsen-Scott base positioned at the South Pole itself and the Russian Vostok Station near the Pole of Inaccessibility (the point farthest from the Antarctic coast).

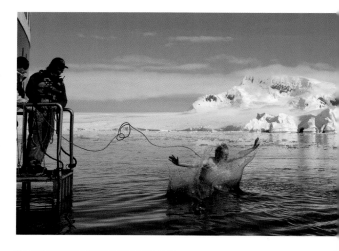

Nowadays, tourist cruises to Antarctica depart mainly from southernmost South America for the Antarctic Peninsula and the adjacent islands. The round trip usually takes between about one and two weeks and sometimes includes a visit to the dramatic scenery of South Georgia and even Elephant Island, from which Shackleton and Worsley set out on their epic open-boat journey after the crushing of their ship, *Endurance*, a century ago. For passengers wishing to avoid the rough waters of Drake Passage, they can now fly to an airstrip on King George Island, and embark aboard ship there. Some cruise ships also go to the Ross Sea region and McMurdo Sound, and occasionally circum-navigations of Antarctica are offered. There have been few tourist sightseeing flights to Antarctica since the crash of an Air New Zealand DC10 aircraft on the slopes of Mt Erebus above McMurdo Station in 1979, although some now depart from Australia. Ice runways near the Patriot Hills, and later at Union Glacier in West Antarctica provide an inland access point for mountaineers, tourists and private expeditions flying into the ice-sheet interior or the Ellsworth Mountains from South America.

Frequently visited areas

The bulk of tourist visits to Antarctica, which had reached 45,000 by the season of 2016-17, are to the western Antarctic Peninsula and its adjacent islands. Elephant Island is a sought-after island destination, with its historic Shackleton connections. Visits to the Peninsula are almost exclusively by cruise ships, which are regulated by the International Association of Antarctica Tour Operators (IAATO) ensuring that the sites visited are protected from environmental damage and wildlife disturbance. The areas most frequented are Antarctic Sound, between the tip of the Peninsula and Joinville Island, together with Gerlache Strait, and Neumayer and Lemaire channels which are all on the western side of the Peninsula. Penguin rookeries are popular sites for Zodiac visits to shore, for example those on Cuverville, Danco and Petermann islands, along with the flooded volcanic caldera of Deception Island in the South Shetlands, with its steaming hot-springs and fumaroles. The Post Office and shop at Port Lockroy, a former British Base close to Wiencke Island at the southern end of Neumayer Channel, is also a common shore visit. Neko Harbour, deep in the fjord of Andvord Bay, and Paradise

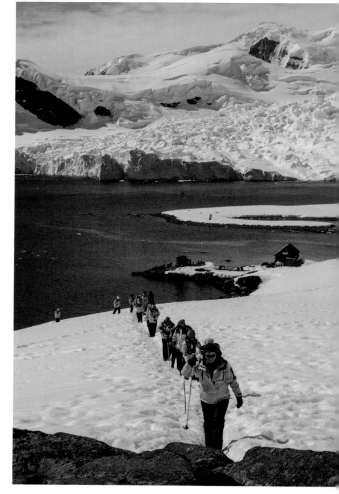

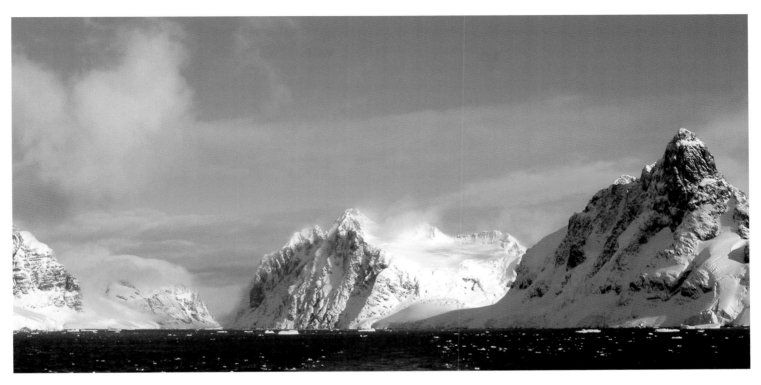

Opposite top: Many passengers on tourist vessels celebrate their furthest south with a 'polar plunge'. One of the authors (MJH) takes advantage of this opportunity in Crystal Sound, secured to the ship by a cord. (Photography courtesy of Adrian Boyle)

Opposite bottom: A short hill climb over snow allows cruise-ship passengers to gain spectacular views over Paradise Harbour in southern Gerlache Strait, in the vicinity of the Argentine Station, Almirante Brown.

Top: Northern entrance to Lemaire Channel with the Antarctic Peninsula on the left and Booth Island on the right. The passage is 11 km (7 miles) long and only 1.6 km (1 mile) wide at its narrowest point.

Right: Cuverville Island in Errera Channel, a branch of Gerlache Strait, is a popular tourist destination on account of its large Gentoo penguin rookeries. A very wet day on the island testifies to the changing climate in this part of the Antarctic Peninsula, which is warming faster than anywhere else on Earth.

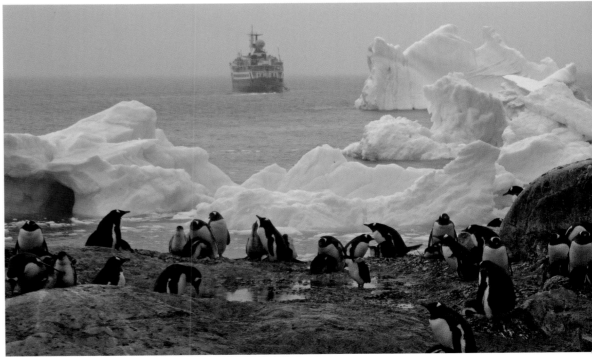

Harbour, enable both a landing on the continent of Antarctica itself and close-up views of iceberg-calving glaciers. Most ships go no farther than the Antarctic Circle at 66°33'46" S, although a few penetrate beyond to Crystal Sound, where brave passengers can experience a 'polar plunge' in the freezing waters. Even fewer vessels round the southern tip of Adelaide Island and reach the British base at Rothera.

Elsewhere in Antarctica, a handful of cruise ships venture into the McMurdo Sound area of the Ross Sea in most years, depending on sea-ice conditions. Here, tourists view the historic Scott and Shackleton huts of the 'Heroic Era' of Antarctic exploration with the active volcano Mt Erebus as a backdrop. In addition, small groups also fly to the interior of Antarctica direct from South America by private charter, to an ice runway at Union Glacier, located in the southern Ellsworth Mountains. From here, some advance to the South Pole itself, often skiing the last degree to the Pole, while others climb Antarctica's highest mountain, Mt Vinson (4,892 m / 16,050 ft).

Opposite: The sun sets behind a decaying iceberg on Rothera Peninsula, looking across Marguerite Bay towards Jenny Island, off the western Antarctic Peninsula

Below: The 9 km (6 mile)-long Two Hummock Island, Gerlache Strait, western Antarctic Peninsula.

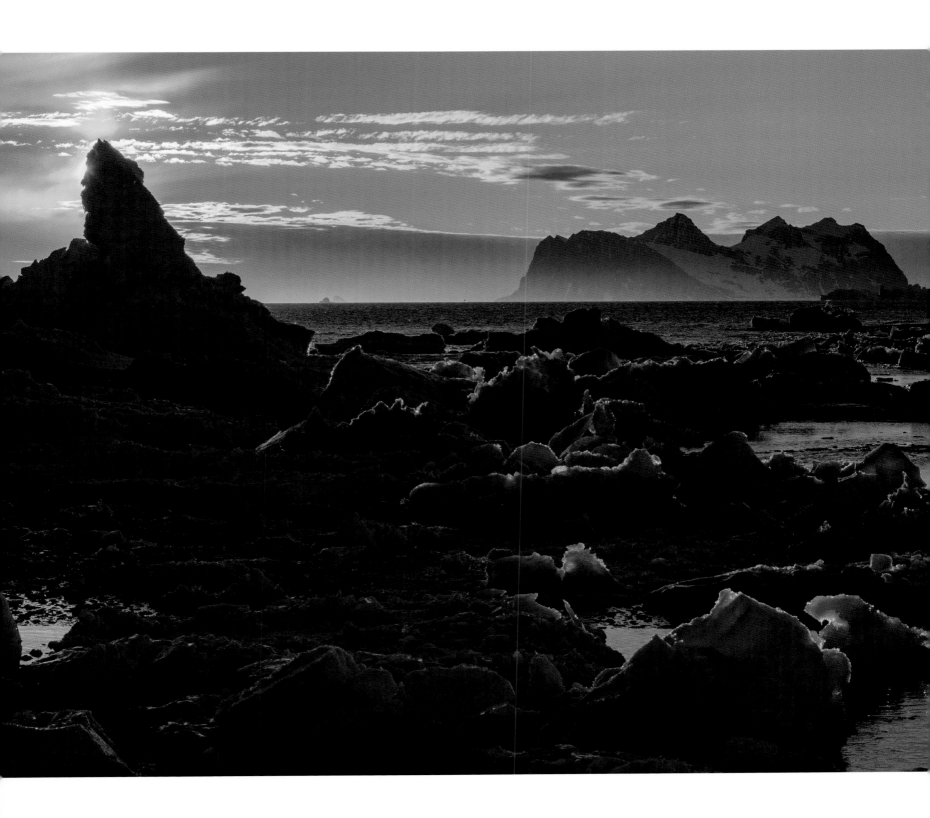

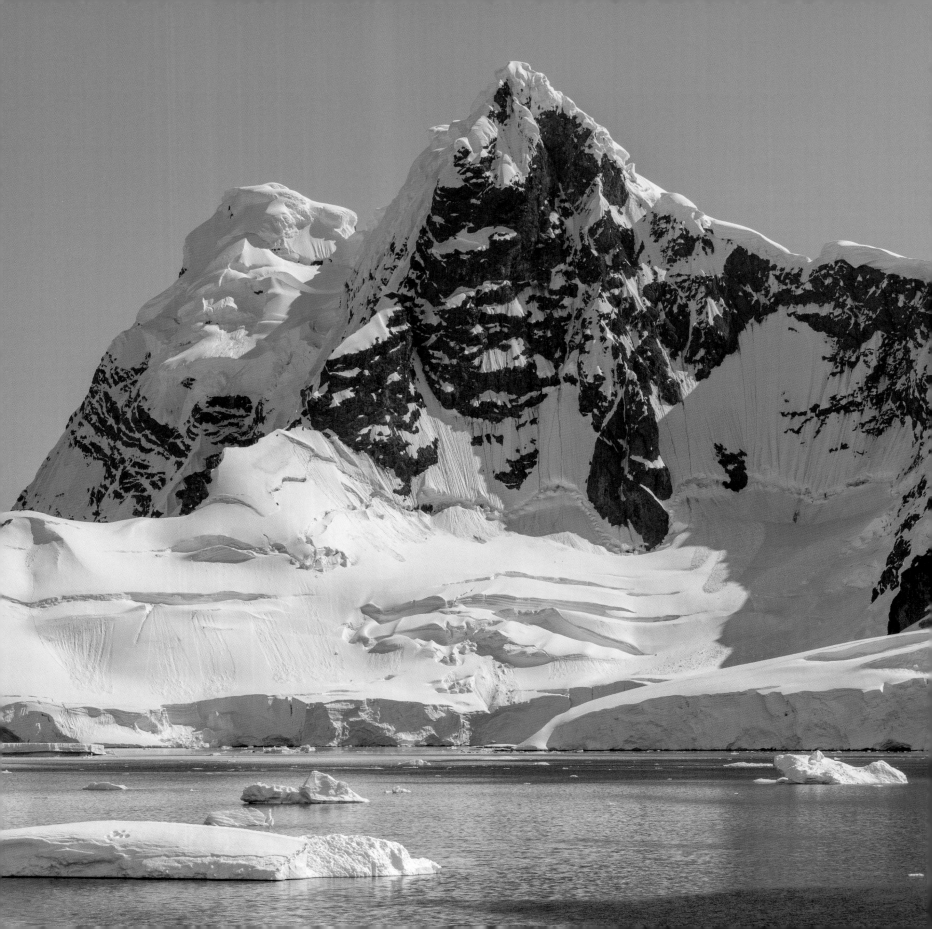

CHAPTER 3

Evolution of Antarctica

During the field season of 1995-96, I had the good fortune to join colleagues from Ohio State University as part of the U.S. Antarctic Program's Shackleton Glacier Project. This massive logistical operation supported 12 earth science projects comprising 46 scientists for two months. A camp was established on the snow-covered McGregor Glacier, a tributary of the Shackleton Glacier in East Antarctica. Eight Jamesway huts, tents for scientific staff and buildings for housing generators were set up. Transport from McMurdo Station was by ski-fitted C-130 Hercules aircraft, whilst access to field sites was by two Squirrel helicopters, a Twin Otter aircraft, and an array of over-snow vehicles Soon after arriving, our party of five flew by helicopter to our first field area, a nunatak named Roberts Massif near the head of Shackleton Glacier, and set up a tent camp. This arid, rocky and moraine-covered outpost, only about 500 km (300 miles) from the South Pole, represents among the southernmost rock outcrops on Earth. Later we moved down-glacier by helicopter to Bennett Platform to work on a rather loose cliff section of glacial deposits, studded with large boulders. The work was challenging; on one occasion, it involved abseiling down a steep shady gully, measuring the strata layer-by-layer, whilst falling stones occasionally whizzed by, narrowly missing our helmets. Mid-way through the field season, we were allocated the use of the Twin Otter to undertake a wide-ranging reconnaissance for possible new field sites. One flight included Liv Glacier, Axel Heiberg Glacier (Amundsen's route to the South Pole) and the Beardmore Glacier (Shackleton and Scott's route to the Pole). The highlight for me was traversing most of the Beardmore Glacier, seeing many of the landscape features so well described by Shackleton, Scott and Wilson. The overriding impression was of huge respect for these early pioneers, who had no fore-knowledge of the crevasses, glazed ice and soft snow that they had to face.

<div align="right">MJH</div>

Discovering the geological history of Antarctica

Geologically speaking, Antarctica is unlike any other continent, in that it is 99% ice covered. Thus, geologists have relied on investigations of limited ice-free areas and isolated nunataks where bedrock protrudes through the ice. Crucially, however, the quality of rock exposure is unsurpassed, owing to the lack of any vegetation cover. The most extensive areas for studying geology are arid coastal regions such as the McMurdo Dry Valleys, the fringes of the Antarctic Peninsula and adjacent islands, and the 'oases' of ice-free land at the edge of the East Antarctic Ice Sheet. In addition, geologists have obtained snapshots of the interior from exposures of rock in mountain ranges, notably the Transantarctic Mountains, the Ellsworth

Opposite: Volcanic rocks form spectacular mountains along the Danco Coast, Gerlache Strait, Antarctic Peninsula.

Mountains and the Prince Charles Mountains, and in numerous large volcanoes that have thrust up through the ice sheet in Marie Byrd Land.

The geological history of Antarctica is a story of drifting, separating and colliding continents, and of climatic change and biological evolution, spanning 3,000 million years. Geologists have provided data of global importance, including evidence for continental drift and its successor, plate tectonics, notably through the matching of fossils, plants, animals and rock types between modern continents.

Although Antarctica had been circumnavigated by James Cook as early as 1773-74, it is only since the turn of the 20th century that geological work has been undertaken on land, when a spate of national expeditions surveyed several parts of the continent. The early geologists, such as Hartley Ferrar on Captain Scott's 1901-04 expedition, suffered severe hardship while using ponies, dog teams or just plain walking to investigate the rocks. The Swedish South Polar Expedition of 1901-03 led by Otto Nordenskjöld defined many of the major geological subdivisions of the Antarctic Peninsula, whilst the British expeditions of Scott during 1901-04 and 1910-13, and of Shackleton during 1907-09 focused on the Ross Sea and Transantarctic Mountain regions of East Antarctica. These expeditions produced an outline of the geological history of the Transantarctic Mountains and Ross Island that demonstrated connections

Below: Ferrar Glacier and Cathedral Rocks. This region of Victoria Land was first explored by the British National Antarctic Expedition (1901–04) under the leadership of Captain Robert Falcon Scott. The glacier was named after Hartley Ferrar, the geologist on the expedition who made pioneering observations of the rocks during their journey. Volcanic activity several million years ago is evident from small cones of basaltic (black) material on the flanks of the glacier.

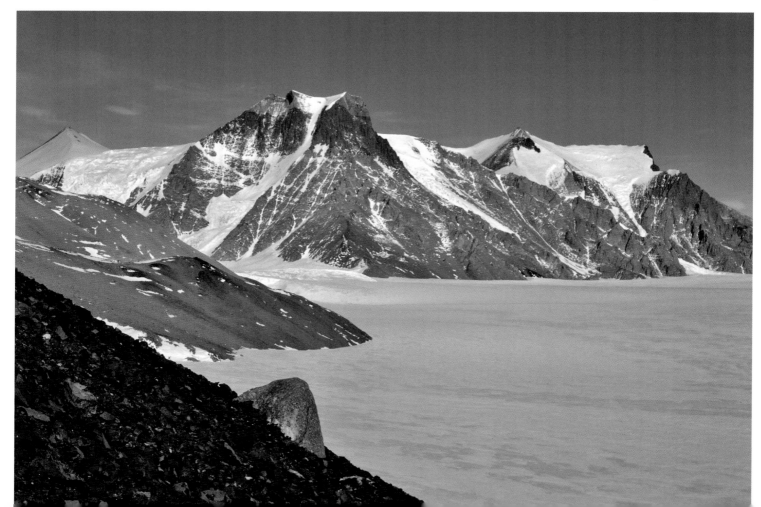

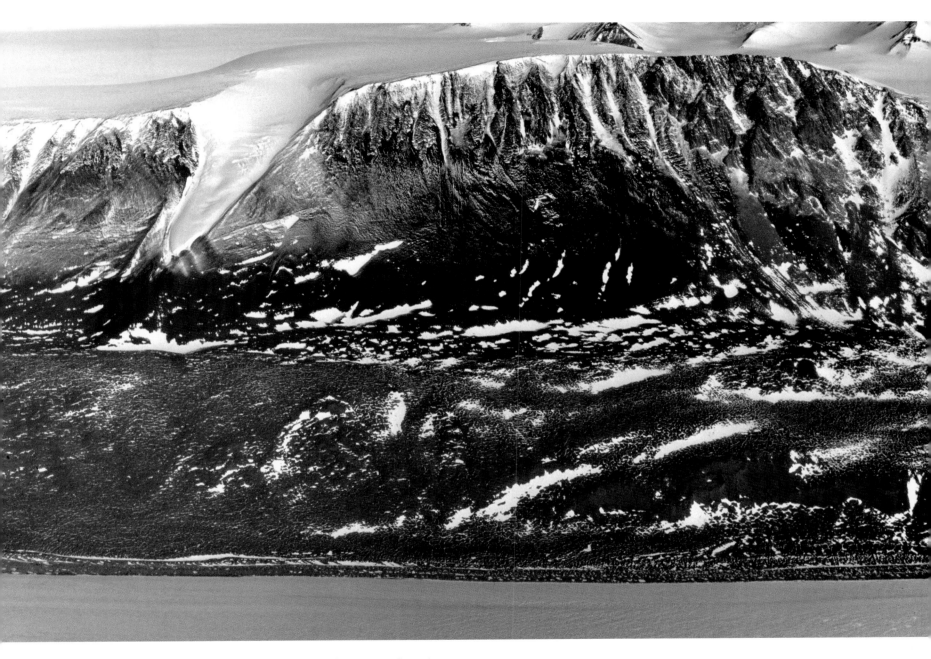

Above: The Cloudmaker (2680 m / 8800 ft) is a prominent mountain on the west side of Beardmore Glacier, discovered by Shackleton on the British Antarctic Expedition of 1907-09. In addition to discovering this major route to the South Pole, Shackleton perceptively recorded that the glacial sediments draping the lower one-third of the mountain were indicative of very old glaciation. The glacial sediments are known to be several million years old, and today are referred to as the 'Sirius Group'.

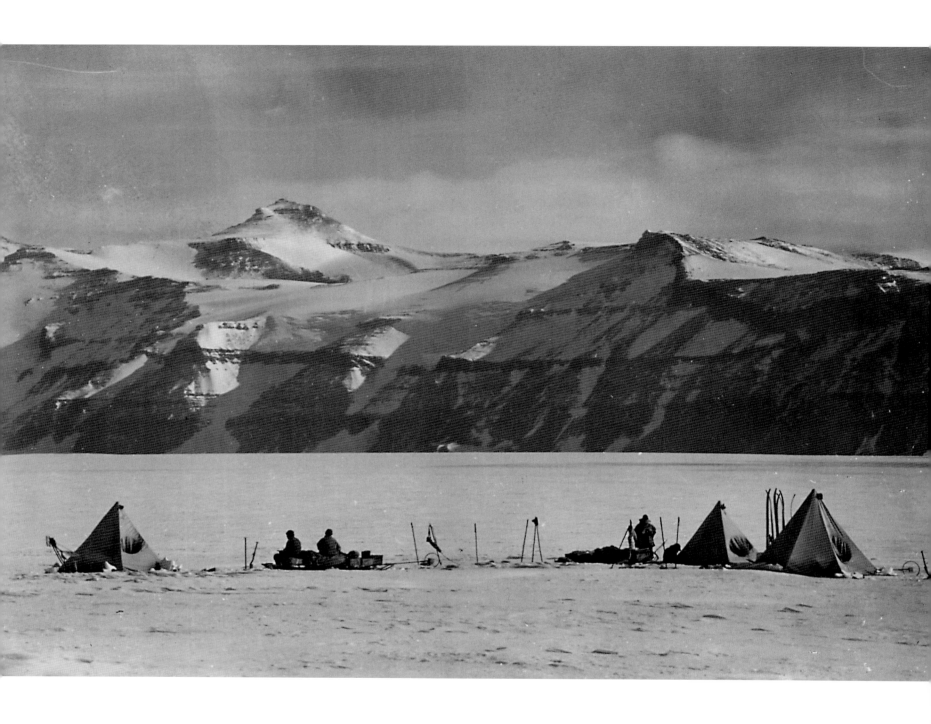

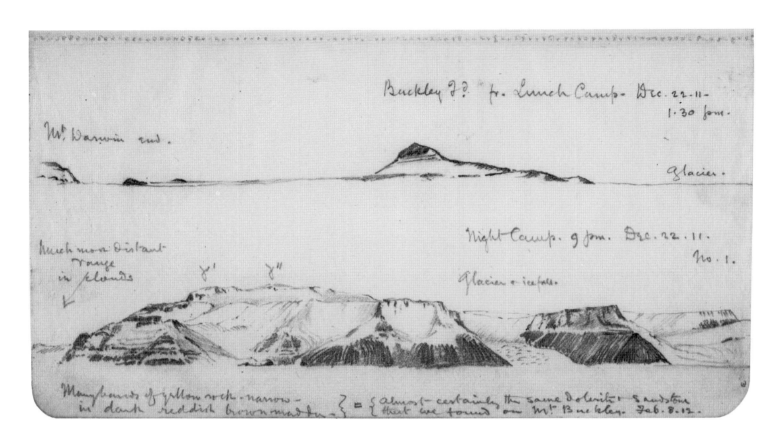

Buckley ?? fr. Lunch Camp. Dec. 22.11. 1.30 p.m.

Mt. Darwin end.

glacier.

Much more distant range in clouds

Night Camp. 9 pm. Dec. 22.11. No. 1.

γ' γ"

Glacier + icefall.

Many bands of yellow rock - narrow - in dark reddish brown matrix } = { almost certainly the same dolerite + sandstone that we found on Mt Buckley. Feb. 8. 12.

Above: Although a biologist and doctor by training Dr Edward Wilson made many geological observations during his ill-fated polar journey with Scott. The care taken in accurate sketching and description of rocks is evident from this example drawn on the Beardmore Glacier. The rocks include the Beacon Supergroup, a sedimentary sequence from Devonian to Triassic age, and intrusions of dolerite of Jurassic age. (© Scott Polar Research Institute)

Opposite: Photograph of the Beardmore Glacier and Queen Alexandra Mountains of the Transantarctic Mountains, taken by Captain Scott, during his 5-man journey to the South Pole. The rocks are similar to those depicted in the sketch by Edward Wilson, with a dolerite sill cutting through and following the Beacon sandstone on the right-hand side of the mountain. (© Scott Polar Research Institute)

with other Southern Hemisphere continents. By 1913 Nordenskjöld also recognised that Antarctica had strong similarities with the Andes of South America.

The Australian, Douglas Mawson, was one of the key figures in early Antarctic geological exploration. His first Antarctic work was with Shackleton in 1907 in the Ross Island area. He then organized the Australian Antarctic Expedition of 1911-14, working in Commonwealth Bay in Adélie Land, East Antarctica. Later (1929-31) he led the British, Australia, New Zealand Expedition to Mac. Robertson Land and Princess Elizabeth Land on either side of Prydz Bay and the Amery Ice Shelf. Through this work, major advances in understanding of the rocks of the East Antarctic shield along the coast facing the southern Indian Ocean were made.

Relatively early in this era of geological exploration it was recognized that Antarctica shared a common history with other Southern Hemisphere continents, such as South America, Africa, Arabia, India and Australasia. The famous South African geologist, Alexander du Toit, used these common geological histories to formulate the concept of a 'supercontinent' named Gondwana or Gondwanaland. These once-united continental masses were subsequently rent apart by 'continental drift', the initially controversial hypothesis proposed by the German scientist, Alfred

Wegener in 1912. Studies in Marie Byrd Land by F.A. Wade in the 1930s provided further documentation that the Andes were a continuation of the Antarctic Peninsula and the Pacific coast of West Antarctica.

Despite these achievements, geological knowledge of Antarctica remained very limited until the International Geophysical Year (IGY) of 1957-58. Until then, apart from attempts to reach the South Pole, the vast interior of the continent remained unknown. The IGY stimulated new interest in Antarctica, and many nations, if they had not already done so, established permanent bases there. Aided by new geophysical tools, ski-equipped aircraft and over-snow vehicles opened up the interior of the continent. Today, most outcrops of major significance have been visited, while the broad aspects of the geology and even the general shape of the landscape beneath the ice sheet have also become known using ice-penetrating radar techniques.

Since the IGY, attention has not just focused on the onshore areas. Large international teams have also undertaken bathymetric mapping and scientific drilling operations on the continental shelf and the surrounding seas, largely to gain insight into the climate of the continent and the record of glaciation over the last few tens of millions of years.

Above: Geological investigations of the late 20th century. The climatic record of the last few tens of millions of years (in the Cenozoic Era) was the target of New Zealand's CIROS-1 drillhole (CIROS = Cenozoic Investigations of the Ross Sea) in 1987. Established on the winter sea ice in McMurdo Sound, the drilling recovered 702 m (2,303 ft) of high quality core, extending the then known glacial record to the Eocene/Oligocene boundary at about 34 million years old.

Opposite top: Plate tectonic map of the world, illustrating the relationship between the Antarctic Plate and others in the Southern Hemisphere. Land/sea boundaries are shown in black, and active plate margins in red. Based on Open University map on 'OpenLearn'.

Opposite bottom: The Scotia Arc, which represents the largely submarine ridge that links the Antarctic Peninsula to South America, via the island of South Georgia. This extract from the General Bathymetric Chart of the Oceans (GEBCO) shows shallow water in white, deepening through green and light blue to deep water (ocean trenches) in dark blue.

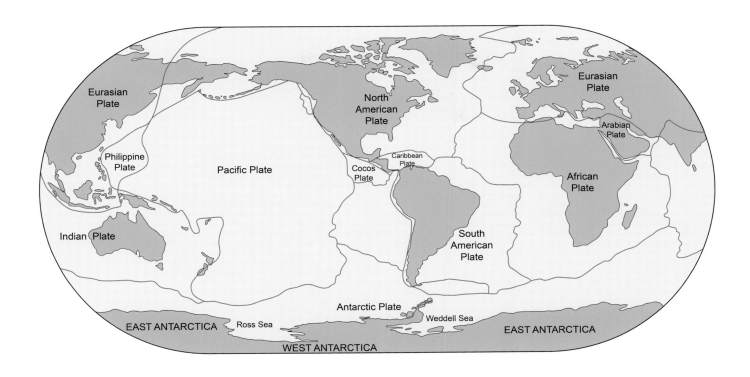

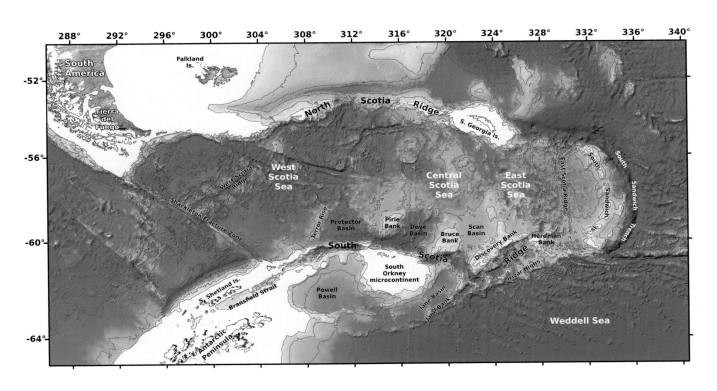

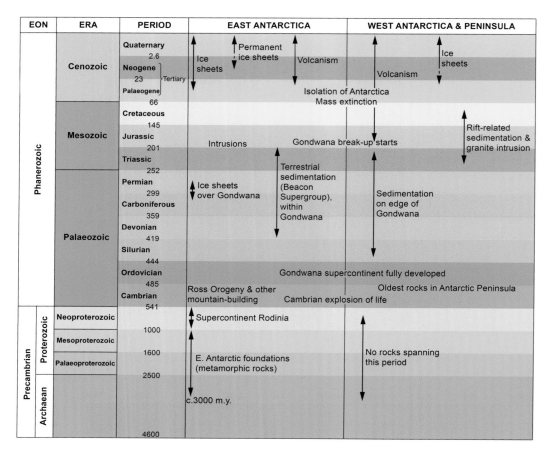

EON	ERA		PERIOD	EAST ANTARCTICA	WEST ANTARCTICA & PENINSULA
Phanerozoic	Cenozoic		Quaternary	Ice sheets / Permanent ice sheets / Volcanism	Volcanism / Ice sheets
			2.6		
			Neogene ⎱ Tertiary		
			23 ⎰		
			Palaeogene	Isolation of Antarctica	
			66	Mass extinction	
	Mesozoic		Cretaceous		
			145		Rift-related sedimentation & granite intrusion
			Jurassic	Intrusions Gondwana break-up starts	
			201		
			Triassic		
			252	Terrestrial sedimentation (Beacon Supergroup), within Gondwana	
	Palaeozoic		Permian	Ice sheets over Gondwana	Sedimentation on edge of Gondwana
			299		
			Carboniferous		
			359		
			Devonian		
			419		
			Silurian		
			444		
			Ordovician	Gondwana supercontinent fully developed	
			485		Oldest rocks in Antarctic Peninsula
			Cambrian	Ross Orogeny & other mountain-building Cambrian explosion of life	
			541		
Precambrian	Proterozoic	Neoproterozoic		Supercontinent Rodinia	No rocks spanning this period
			1000		
		Mesoproterozoic	1600	E. Antarctic foundations (metamorphic rocks)	
		Palaeoproterozoic	2500		
	Archaean			c.3000 m.y.	
			4600		

Left: A summary of the principal geological events in East and West Antarctica, plotted alongside the International Chronostratigraphic Chart (version 2017/2). Ages next to the Period column are in millions of years.

Opposite top left: Crystalline rock, over a billion years old, referred to as gneiss, near Australia's Casey Station, East Antarctica.

Opposite centre: Strongly folded pelite (a mud-dominated metamorphic rock) with quartz veins. The deformation was the result of the 500 million-year-old (Early Palaeozoic) Ross Orogeny; Dunlop Island, McMurdo Sound.

Opposite bottom: Granite from the Ross Orogeny, showing a texture characterised by the light-coloured minerals of quartz (grey) and feldspar (white and pink). This igneous rock forms part of a small island in Granite Harbour, western Ross Sea.

Opposite top right: The pale-coloured ancient gneisses in the Vestfold Hills near Australia's Davis station in East Antarctica are Archaean in age (over 2500 million years). Here, the gneiss was cut by dark grey basaltic dykes in three phases (400, 1800 and 1300 million years) during the succeeding Proterozoic Eon.

Antarctica's contemporary global connections

Although Antarctica is the most isolated continent on Earth, the theory of plate tectonics explains how Antarctica relates to the other continents. The Earth's crust consists of seven major and many minor tectonic plates, which move around relative to one another over a fluid mantle. The plates are created at mid-oceanic ridges, and destroyed when they collide and one plate dives down beneath another in what geologists call subduction zones. Active plate margins are marked by volcanoes and powerful earthquakes, such as the 'ring of fire' around the Pacific Ocean.

The Antarctic continent today forms part of the much larger Antarctic Plate, comprising both continental crust of the land mass and its continental shelf, and ocean floor forming the surrounding deep Southern Ocean. The Antarctic Plate is bounded mainly by mid-oceanic spreading ridges in the Pacific, Indian and southern South Atlantic oceans. Here new crust is formed as basalt (a dense volcanic rock) from the mantle is extruded at the surface. In the South America-Antarctica Peninsula region the plate boundary is less

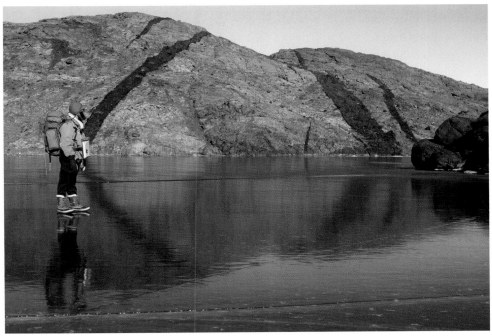

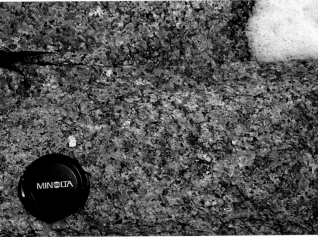

clearly defined and the intervening Scotia Sea consists of at least two smaller microplates. In this region, the South American Plate is being destroyed at a zone of subduction known as the South Sandwich Islands trench, and the Antarctic Plate is being driven slowly beneath the southern Andes; earthquakes and volcanism take place in these locations.

The Antarctic continent itself consists of two contrasting tectonic provinces, in other words regions with different geological histories: these are East Antarctica and West Antarctica, separated by the Transantarctic Mountains. East Antarctica is a region of ancient Precambrian rocks, older than 600 million years and possibly up to 3 billion years old. These rocks are mainly metamorphic, formed under high temperature and pressure deep in the Earth's crust. Above these metamorphic rocks lie distinctly bedded sedimentary rocks representative of the last 600 million years (spanning the Palaeozoic to Early Cenozoic eras). West Antarctica and the Antarctic Peninsula, in contrast, are a complex series of mountain belts representing the last 500 million years or so, comprising volcanic and intrusive igneous rocks, the latter being the source of the former when molten), formed when former continents collided. This chapter outlines the geological history of Antarctica, beginning with the oldest rocks.

The foundations of Antarctica

The complexity of metamorphic rocks in East Antarctica, together with limited exposure, has prevented geologists from deriving a coherent early history for the period prior to

about 500 million years ago. Nevertheless, geologists have demonstrated that Antarctica's early evolution matches well with that of Western Australia and southern Africa, supporting their connectivity within the former supercontinent of Gondwana. The rocks represented by this period are predominantly schist and gneiss, metamorphic rocks with layers of segregated minerals such as quartz, feldspar, mica and hornblende. These were originally sedimentary rocks, formed by earth-surface processes, and igneous rocks, formed by volcanism. These rocks, in turn, were intruded by vertical sheets (or dykes) of a dense dark coloured rock called basalt. This period of evolution spans the greater proportion of geological time, from at least 3,100 to 500 million years ago. Antarctica was then part of one of the earliest supercontinents that have been hypothesised for late Precambrian time (1,000 to 600 million years ago). Named Rodinia, most of the recognisable elements of early continental crust formed one massive land-mass, in which East Antarctica was joined to western North America before splitting apart.

Around 600 to 500 million years ago, a mixture of marine sediments and volcanic rocks was deposited in the Transantarctic Mountain region. From 543 million years, the start of the Cambrian Period, onwards, rocks record active and rapid evolution of multicellular plants and animals. Plate-margin activity culminated in a series of mountain-building events, called orogenies, during which these rocks were folded and metamorphosed, and intruded by granites. The resulting continental collisions produced mountain ranges of alpine proportions, the deeply eroded remnants of which today protrude through the ice sheet as nunataks. Superb exposures of these rocks occur in the Transantarctic Mountains, as well as in the Ellsworth and Prince Charles mountains.

The heart of Gondwana

By about 400 million years ago, in the Devonian Period, several continents had re-assembled themselves into the new supercontinent of Gondwana. If we recombine Africa and South America, along with Antarctica, Australia and India, there is a good fit of continental outlines, but the relationships between South America and the Antarctic Peninsula, and that between the Pacific margin of Gondwana with New Zealand and Australia, remain unclear. A solution to this problem involves considering West Antarctica as a composite of several microplates, which were rearranged when Gondwana eventually broke up.

The continental block of East Antarctica had by now stabilized above sea level, within the heart of Gondwana. The old mountain chains produced during the so-called Ross and Beardmore mountain-building episodes were worn down to their roots, forming a flat plain known as the Kukri Erosion Surface. It was on this surface that, from Devonian time up to around 180 million years ago (in the Jurassic Period), a flat-lying sequence of sedimentary rocks, named the Beacon Supergroup, was deposited.

Top: High in the Transantarctic Mountains, near Shackleton Glacier, the 'Kukri Erosion Surface', (red arrow) separates metamorphic and igneous rocks of the Ross Orogeny at the base from horizontally layered Palaeozoic sedimentary rocks of the 'Beacon Supergroup' on top.

Above: The Beacon Supergroup contains widespread evidence of 280 million-year-old global (Permian) glaciations in the form of poorly sorted rocks called 'tillites', as here, near Beacon Valley in the Transantarctic Mountains of Victoria Land.

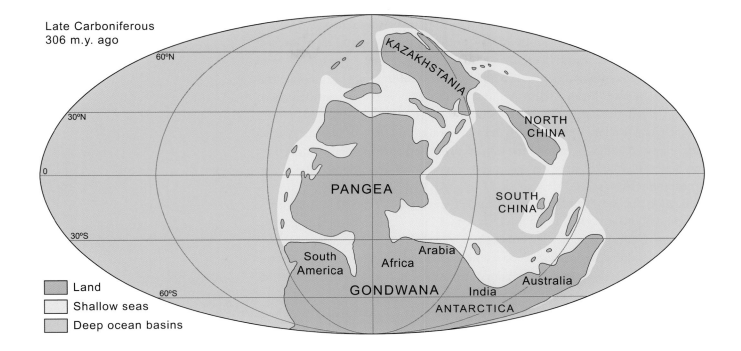

Late Carboniferous
306 m.y. ago

60°N

30°N

0

30°S

60°S

KAZAKHSTANIA

NORTH CHINA

PANGEA

SOUTH CHINA

Arabia

South America

Africa

Australia

GONDWANA

India

ANTARCTICA

Land

Shallow seas

Deep ocean basins

Above: A geographical reconstruction of the Earth during the Late Carboniferous Period, about 306 million years ago. Land areas, shallow seas (continental shelves) and the deep ocean are shown. Antarctica is located in a South Polar position, nesting within the supercontinent of Gondwana, which in turn is connected to Pangaea. Simplified from a reconstruction by C.R. Scotese PALAEOMAP Project, published online in Encyclopedia Britannica.

Early in this phase, in Devonian time, the Antarctic environment was one of large rivers, lakes and shallow seas, with fish being the most distinctive fossil. In the Carboniferous and Permian periods, starting around 300 million years ago, an ice sheet developed, leading to the deposition of thick glacial deposits (called tillites) throughout Antarctica and adjacent co-joined continents. These deposits are indicative of a Gondwana-wide glacial phase that started in the early Carboniferous Period in South America and finished in late Permian time in Australia, as the supercontinent moved progressively across the South Polar region. This glacial phase had global impacts. As the ice sheet over Gondwana waxed and waned, sea levels fell and rose. In Carboniferous time, Gondwana was joined to all the other continents to form a single even larger supercontinent called Pangaea, which lasted until about 175 million years ago when it split apart and the Gondwana landmass broke free again.

After the period of Carboniferous-Permian glaciation, which spanned several tens of million years, the climate warmed, and temperate swamps with a rich flora developed in late Permian and Triassic time. Coal formed from the sediment that accumulated in the swamps, and seams several metres thick occur in the Transantarctic and Prince Charles mountains. These swamp deposits preserve a unique deciduous tree fossil, *Glossopteris*. Samples were collected on both of Scott's expeditions, but the fossils were not identified at the time. Interestingly, the sample on Beardmore Glacier was collected from a moraine by Edward Wilson, on the ill-

fated return journey from the South Pole. This sample was later identified as being equivalent to similar fossils in South Africa, and was instrumental in providing support for the continental drift theory. Subsequently, other trees fossils were found, including ginkgoes and conifers, which provided additional continental links to India, Australia and South Africa. Around 250 million years ago, at the end of the Permian Period, the biggest mass extinction in Earth's history occurred, wiping out *Glossopteris*, as well as 70% of terrestrial vertebrates and 96% of marine species across the globe. A range of causes have been proposed for this mass extinction, including meteorite impact, massive volcanism or a runaway greenhouse effect from sea-floor methane release.

Following the end-Permian extinction event, a new flora evolved in Antarctica, Australasia and South America during the Triassic and Jurassic periods, including ferns, podocarps, new conifers and ginkgoes, horsetails and cycadophytes. The climate became increasingly hot and dry, and species showed increasing resistance to drought. On the alluvial plains where lush vegetation remained, fish and other vertebrates flourished, and reptiles and dinosaurs evolved.

The extensive, albeit fragmentary fossil record of Gondwana indicates an evolutionary succession of plants and animals comparable in complexity to that on other

Below: The Beacon Supergroup is dominated by impressive cliffs of buff sandstone as here in the Olympus Range in the Victoria Land Dry Valleys region. A US military Huey helicopter gives a sense of scale.

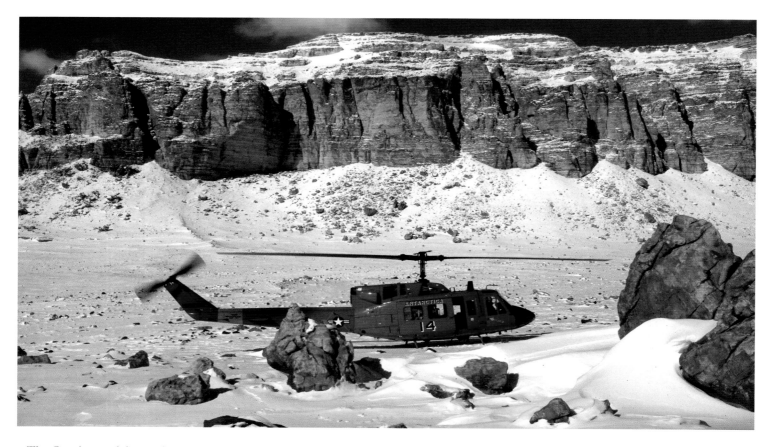

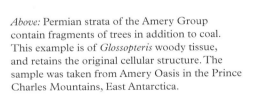

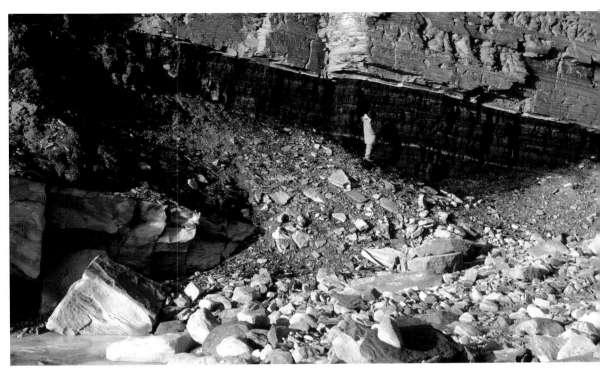

Above: Permian strata of the Amery Group contain fragments of trees in addition to coal. This example is of *Glossopteris* woody tissue, and retains the original cellular structure. The sample was taken from Amery Oasis in the Prince Charles Mountains, East Antarctica.

Top right: A Permian coal seam within buff-coloured sandstone of the Amery Group, in Glossopteris Gully, Amery Oasis, Prince Charles Mountain, East Antarctica.

Bottom right: The base of a silicified Triassic tree stump fossilised in braided river sandstone of the Beacon Supergroup at Collinson Ridge, Shackleton Glacier, Transantarctic Mountains (85° S).

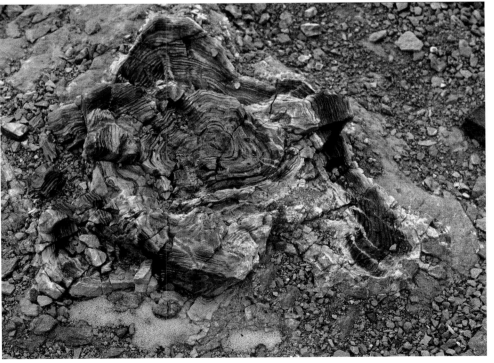

continents. This evolution over several hundred million years was aided by favourable climatic and environmental conditions. Several plant and animal groups originating in Antarctica dispersed throughout Gondwana.

The break-up of Gondwana

In early Jurassic time, around 183 million years ago, intensive volcanism developed along a belt through what is now Southern Africa into Antarctica (along the Transantarctic Mountains) and into Tasmania and New Zealand, a distance of 3,000 km (1,860 miles). Although lasting only 1 million years, this volcanic event heralded the break-up of Gondwana, and with it the whole of Pangaea. The event has produced some of the most spectacular geological phenomena on Earth. Intrusions of hot magma from the mantle, typically a dense black dolerite, invaded the buff-coloured Permian sandstones as vertical 'dykes' and horizontal or low-angle 'sills'. These sills are spectacularly exposed in the vertical rock walls of ice-carved valleys throughout the Transantarctic Mountains. In addition, hot mantle spreading out radially from a centre somewhere beneath southern South Africa caused volcanic 'flare-ups' throughout the Antarctic Peninsula, comprising highly explosive eruptions of a pale-coloured lava type known as rhyolite.

Some geologists have argued that the magma which supplied this volcanic event came from unusually hot parts of the Earth's mantle, known as 'hot spots' or 'mantle plumes', where magma rose towards the surface in convection currents, a bit like those that occur when a kettle is boiled. Another hypothesis invokes a local source for these magmas in the mantle beneath the exposed dykes and sills. Whatever the precise cause, the Antarctic plate underwent rifting, allowing magma from the mantle to penetrate crustal rocks and reach the surface, producing the spectacular bodies of rock we see throughout the Transantarctic Mountains today.

Rifting of Gondwana took place at different times in different places, and Antarctica was therefore separated from its neighbours in a piecemeal fashion: southern Africa first (145 million years ago) and South America last (about 35-30 million years ago). Rifting of the Antarctic continent has, however, continued to this day, and it is still splitting apart at a rate of a few millimetres per year. In the last 40 million years of the Cenozoic Era, rifting has been accompanied by numerous volcanic eruptions, but before we consider this late stage of Antarctica's evolution, what has been happening in West Antarctica, and especially the Peninsula region, requires evaluation.

The West Antarctic geological jumble

West Antarctica represents a jumble of micro-continents that are difficult to fit together. As Gondwana broke up into the major continents of the Southern Hemisphere, several

Above: Sills of black dolerite (a basic igneous rock) intruded into buff-coloured Beacon sandstones, Finger Mountain, Victoria Land. These rocks herald the break-up of Gondwana in the Jurassic Period, around 183 million years ago.

Overleaf: Part of the granite intrusion, known as the 'Antarctic Peninsula Batholith', that runs the length of the Antarctic Peninsula, Mt Bagshawe region, Palmer Land.

small microplates formed in the South Atlantic sector. These microplates rotated as they split from the main mass. One of these was the Ellsworth Mountain block, which contains the highest mountains in Antarctica. This block rotated ninety degrees clockwise relative to the Transantarctic Mountains. Why this style of fragmentation occurred is unknown. The same process of rotating microplates is also evident in the final separation of South America from the Antarctic Peninsula, and the opening of the Drake Passage, the wild and stormy sea that confronts most ships sailing to this part of the continent.

The Antarctic Peninsula is the best known of these fragments, owing to greater rock exposure than elsewhere in Antarctica. The story here is one of continental collision on the Pacific margin of Gondwana. As Gondwana was breaking up by rifting, its Pacific margin was the focus of collision between the ancient Pacific Ocean and the Antarctic tectonic plates. Since the oceanic plate was denser than that of Antarctica it was forced underneath, by subduction. In the offshore region marine mudstones and sandstones were deposited. However, slivers of sedimentary material were scraped off the subducting slab and added to the western margin of Gondwana, a region that coincides with Alexander Island, the South Shetland Islands, the South Orkney Islands

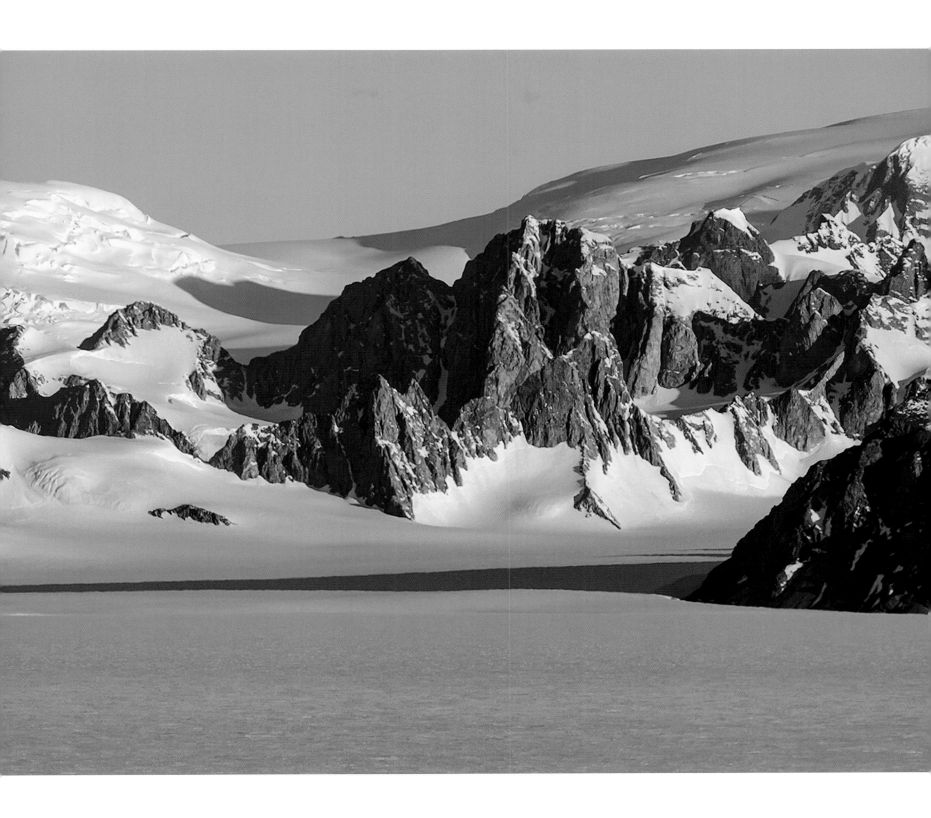

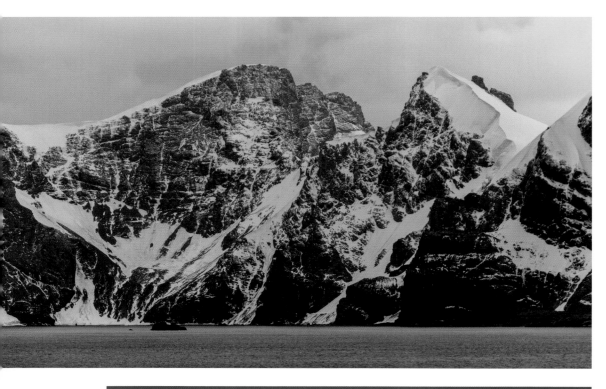

Left: The 'Scotia Metamorphic Complex' comprising metamorphosed deep marine sediments about a hundred million years old from the Cretaceous Period, scraped off from the subducting Pacific oceanic plate onto the Scotia Arc, north coast of Elephant Island in the South Shetland Islands.

Below: Mesozoic volcanic rocks in Lemaire Channel, west Antarctic Peninsula. The large-scale folding was the result of collision between the Pacific oceanic tectonic plate and the continental plate making up West Antarctica.

Opposite: Fossils in strata near Fossil Bluff, Alexander Island, SW Antarctic Peninsula.

Opposite top: Sample of sandstone with Jurassic belemnites from Belemnite Valley near Fossil Bluff. Belemnites were a marine fauna, similar to today's squid and cuttlefish.

Opposite centre: Imprint of a fern frond of Cretaceous age in sandstone, in Kufu Corrie, near Fossil Bluff, illustrating a transition to terrestrial conditions.

Opposite bottom left: Sandstone concretions of Cretaceous age, near Terrapin Hill, James Ross Island. These strange solid lumps represent local zones of cementation in the sediment and are weathered out from the softer surrounding sand. They have been carved into remarkable shapes by wind erosion.

Opposite bottom right: The sequences of Jurassic – Cretaceous sandstones, shales and volcanic rocks of eastern Alexander Island are folded and tilted as here at Ablation Lake, adjacent to George VI Ice Shelf. The snow-filled gullies have formed along faults with displacements of a few metres. Note the small figure of a geologist on the gravel spur in the lower middle of the photograph.

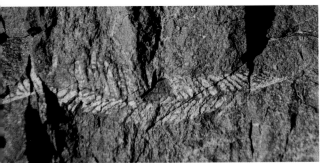

and New Zealand today. The process lasted through much of the Mesozoic Era (250 to 65 million years ago) and produced an impressive chain of volcanic mountains, the rocks typically being andesite, such as found in the Andes and Western Cordillera of North America, with which they are connected. The volcanoes are still visible as eroded remnants along the spine of the Antarctic Peninsula and adjacent islands. In addition, intrusions of granite (a coarse-grained, light-coloured igneous rock), originally solidified deep underground, are now exposed intermittently throughout Palmer Land and Graham Land, including some of the islands off the west side of the Peninsula. A consequence of collision was the deformation and metamorphism of the rocks. This plate margin is no longer active, except along the South Shetland Trench at the tip of the Peninsula. In this region subduction is still occurring, albeit slowly and lacking any associated volcanism.

Overall, then, Antarctica today is almost devoid of active plate boundaries, leading to an absence of significant earthquake activity and only a few active volcanoes, as noted below. However, subduction at the northern Peninsula may have caused extension in Bransfield Strait leading to splitting of the continental crust and development of several mainly submarine volcanoes, a few of which are still active, including Deception Island, described below.

The Antarctic Peninsula region has two important sedimentary sequences, unconnected to those in East Antarctica. To the west of the Peninsula, on Alexander Island, is a 7 km (4.3 mile)-thick early Jurassic to mid-Cretaceous sequence (200 – 100 million years old) of richly fossiliferous sedimentary and volcanic rocks, standing proud in cliffs at the edge of a younger rift that contains the George VI Ice Shelf. Unlike most rocks in the Peninsula, they are not metamorphosed and only gently folded. A wide variety of marine fossils in the lower part of the sequence indicates

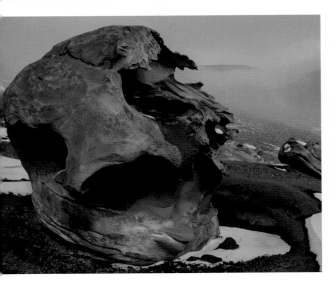

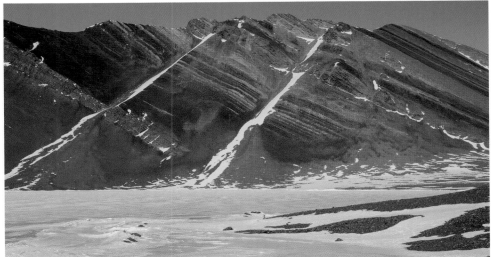

a shallow marine environment, whereas fossil plants, including upright tree trunks suggest that fluvial conditions prevailed in the latest stages of basin-infilling. To the east of the Peninsula, the islands and offshore sedimentary basins record deposition of highly fossiliferous Cretaceous mudstones and sandstones of both marine and terrestrial origin.

Late Cenozoic volcanic activity: the last 50 million years

The most recent stage of rifting is represented by a zone of crustal stretching and thinning known as the West Antarctic Rift System, which stretches from the Ellsworth Mountains to the Ross Sea. The timing of rifting is indicated by explosive volcanism in Marie Byrd Land from 36 million years ago onwards. At least eighteen large volcanic centres have been discovered on the flank of the rift system. They reach relative heights of 2,000-4,000 m (6,500-13,000 ft) above sea level, although most are largely buried beneath the West Antarctic Ice Sheet. There is limited evidence of recent volcanic activity, some of which takes place beneath the ice, but which is more visibly represented by an active lava lake in the crater of Mt Erebus, and layers of volcanic ash in ice cliffs surrounding Mt Melbourne on the western side of the Ross Sea. Amongst the most recent activity was an eruption 2,300 years ago, when a subglacial volcano melted a hole in the ice sheet, spreading ash over 20,000 km^2 (7,700 miles2) of the ice-sheet surface.

One edge of the rift system was uplifted to form the Transantarctic Mountains, a spectacular range, 3,500 km (5,600 miles) long and up to 4,500 m (14,800 ft) high. This uplift was the result of 'curling up' of one of the flanks (or 'shoulders') of the rift system. Uplift began around 55 million years ago, and has occurred sporadically since then, exposing the igneous rocks that were associated with the initial break-up of Gondwana, as well as their host sedimentary and older metamorphic rocks.

Associated with this rift margin is another basaltic volcanic field, the McMurdo Volcanic Province. Along the Transantarctic Mountain front are the well-known cones of Mt Discovery and Mt Morning, which are older than five million years. To the east are the Ross Island volcanic cones, including Mt Erebus, Mt Terror and Mt Bird, with Mt Melbourne to the north, all of which are younger than five million years. Of these, Mt Erebus has the distinction of being not only the highest volcano in Antarctica (3,794 m; 12,448 ft), but also the world's southernmost active one. Erebus stands in splendid isolation, overlooking the historic and modern bases around McMurdo Sound. When James Clark Ross discovered the volcano in 1841, and named it after one of his ships, a small ash eruption draped the summit area and a lava flow may have been pouring down its slopes. However, Erebus has not produced any violent eruption in recorded history, but the persistent lava lake in its summit crater generates frequent small eruptions, and geothermal activity is widespread. There are many indications of former volcanic activity around McMurdo Station and Scott Base, notably several prominent black craters and

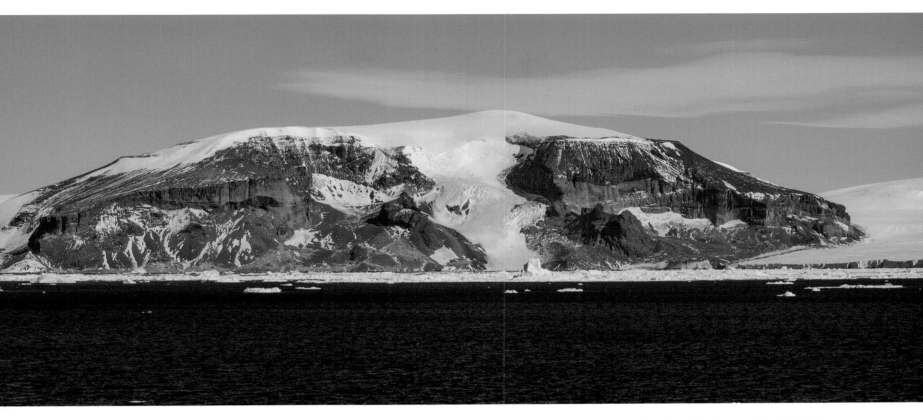

Above: Brown Bluff, a small basalt shield volcano 1.2 million years old, on the northeast side of the Antarctic Peninsula. The flat top and presence of extensive hyaloclastite in the cliffs below indicates this is a subglacial volcano, also known as a tuya, formed when the Antarctic Peninsula Ice Sheet (right) was much larger.

Right: Contorted columns of dolerite (a coarse-grained type of basalt), probably about 80 million years old (Cretaceous) form a backdrop to a Gentoo penguin rookery on Barrientos Island in the South Shetland Islands. The rocks were intruded as a sill when subduction of the Pacific Plate beneath West Antarctica was taking place.

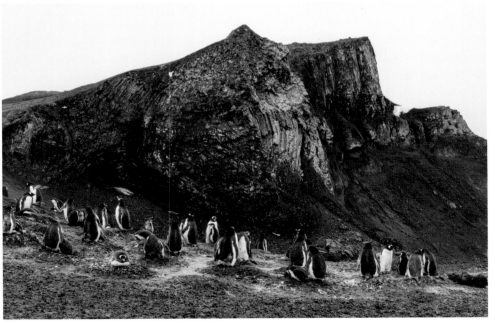

the eroded ash mound of Castle Rock, so well depicted in one of Wilson's paintings, together with an assortment of tephra deposits, including volcanic bombs.

The process of rifting in the Ross Sea sector has generated extreme topographic variations amounting to 7 km (4.3 miles) – from the depths of subglacial basins within the rift system to the tops of the mountains on the rift flanks. Within this rift system, a thick sequence of sedimentary strata has accumulated, providing a remarkable record of environmental and climatic change that demonstrates how Antarctica has cooled from a 'greenhouse' state prior to 35 million years ago, to the 'icehouse' state of today, as outlined below.

Late Cenozoic volcanic activity has also been associated with rifting southeast of the plate collision zone in the Antarctic Peninsula region and at the eastern limit of the Scotia Sea. The most active areas today are the South Sandwich and South Shetland islands. In the tectonically active Bransfield Strait, between the South Shetland Islands and the mainland, is a localised region of rifting south of the declining subduction zone of the South Shetland Trench. These rocks are mainly basaltic. Other volcanoes, composed of basalt but largely buried by ice, occur east of the northern tip of the Antarctic Peninsula, in James Ross and other islands, and in mainland bluffs. They indicate volcanic activity spanning the last eight million years. Although there is no record of recent eruptions, it is conceivable that some of these volcanoes, such as the large shield volcano on James Ross Island, are simply dormant. This region is unique in that many eruptions were subglacial, and the close association of glacial sediments and datable volcanic rocks is yielding a detailed record of glacial fluctuations. Although no actual eruptions have been documented in this area, there is some evidence to suggest that several volcanic centres are still active. Similar rocks to those on James Ross Island occur further south in the Peninsula, on Alexander Island.

Above left: Castle Rock, as depicted in this painting by Edward Wilson during the *Discovery* Expedition of 1901-04, is a prominent feature near McMurdo Station and Scott Base on Ross Island. It consists of ash and broken-up pieces of lava called lapilli, and there is a feeder dyke of basaltic rock. Geologists believe the feature was formed during a subglacial eruption about a million years ago. (© Scott Polar Research Institute)

Above right: Pieces of volcanic ejecta or bombs of basaltic composition litter the area around Ross Island. Here Evelyn Dowdeswell inspects a bomb at Crater Rim near Scott Base that has been exposed to weathering for about a million years.

Opposite: Colourful ash or tephra deposits exposed at the entrance to the flooded caldera of Deception Island, known as Neptunes Bellows

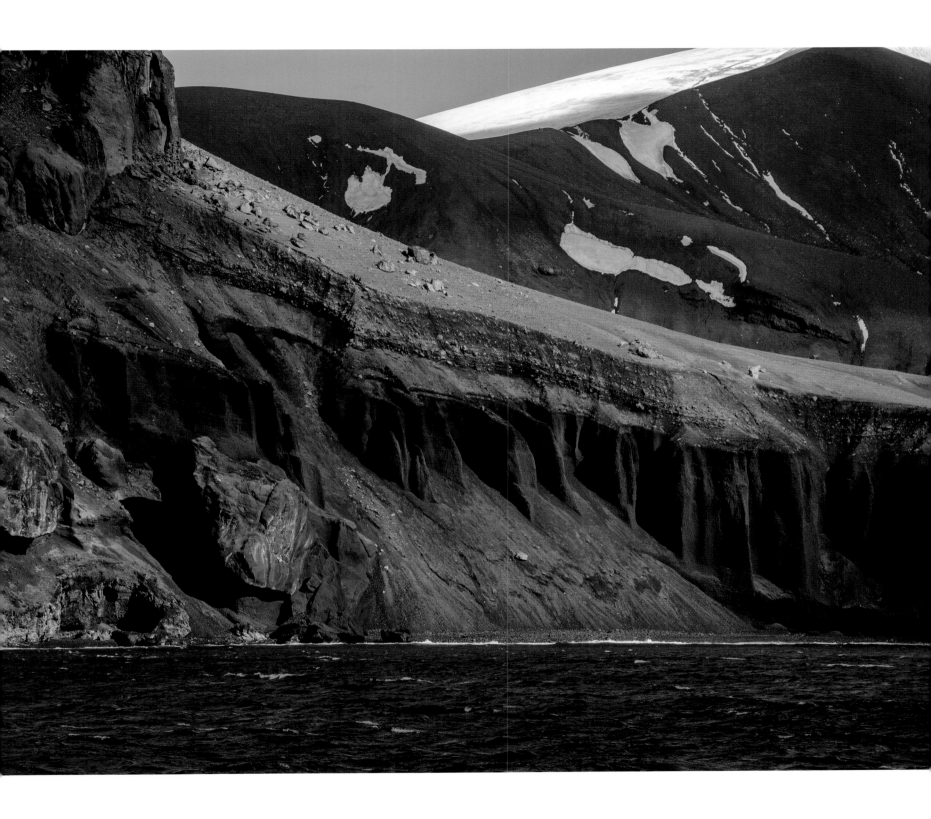

Today's active volcanoes demonstrate interaction with ice and sea water in generating explosive eruptions and abundant ash deposits. The most active of these volcanoes forms Deception Island, with its flooded caldera, that is often visited by tourist vessels. The last eruptions were in 1967, 1969 and 1970, the middle one of which destroyed a Chilean scientific station and severely damaged a British base. These eruptions resulted in the deposition of black ash throughout the South Shetland Islands, whereas earlier eruptions were responsible for the numerous black ash layers that are commonly seen in the ice cliffs of those islands.

Into the freezer: Late Cenozoic glaciation

The Cenozoic Era began 65 million years ago, following a mass-extinction event, probably caused by a meteorite crashing into Earth offshore of Mexico. The global reign of the dinosaurs, along with many other terrestrial and marine species, ended at that time. Vertebrates and reptiles continued to evolve, albeit at a much-reduced size. There was also a dramatic expansion of flowering plants and trees during the Cenozoic Era. From a climatic perspective, this was a time of global cooling. That cooling was not steady, but was interrupted by warm pulses.

Half way through the Cenozoic Era, the process of evolution slowed down dramatically, and animal and plant ranges diminished considerably with the onset of ice-sheet growth from about 34 million years ago. One species of tree that has proved to be a particularly important palaeoclimate indicator is *Nothofagus* or the southern beech. Some species, including *Nothofagus*, may have even survived through successive glaciations, possibly into the Pliocene Epoch (3-4 million years ago), but most higher plants and animals had already died out by then.

By the last 2 million years, Earth had cooled to temperatures not seen for over 250 million years, when the planet was last influenced by ice sheets. The known geological record in Antarctica is too scanty to draw up a detailed record in the first 30 million years of the Cenozoic Era. We do, however, know that during Eocene time (i.e. around fifty million years ago) the climate was warm and supported abundant vegetation. The evidence for this comes from sedimentary rocks dragged up as erratics by an expanded ice mass from the floor of the Ross Sea. The onset of large-scale glaciation about 34 million years ago is documented from deep cores drilled into the continental shelves of the Ross Sea and Prydz Bay. Here, details of a changing glacial regime have been recorded from several thousand metres of sediment core obtained from sea-ice-based drill rigs and drilling ships. The earliest glaciers were accompanied by well-established cool temperate forests of southern beech, podocarps and ginkgoes, such as are found in the Southern Alps of New Zealand and Patagonia today.

As the climate deteriorated, well-established forests were replaced by tundra vegetation by about 30 million years ago, dominated by a ground-hugging species of southern beech, similar in habit to the present-day Arctic willow. Major fluctuations

Above: Several drilling projects have been undertaken from sea ice platforms in the western Ross Sea. These have yielded a glacial record that goes back to 34 million years ago. The New Zealand drilling operation, CIROS-1, yielded a 702-metre-long core. The core was split in two lengthways, and then logged. A close-up of an 8 cm-long section of the core, from 514 m below the sea floor, shows inclined bedding punctured by pebbles; these isolated stones, called dropstones, were transported to the site by icebergs.

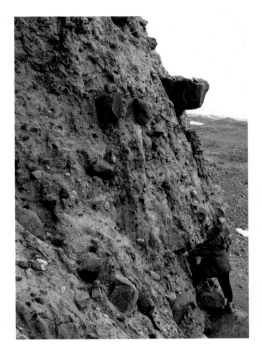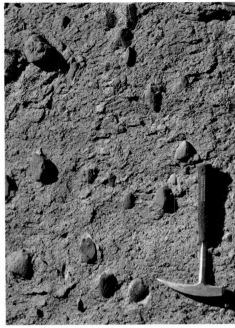

Top row: Evidence for a warmer style of glaciation than that of today is evident in multi-million year-old glacial deposits in the Prince Charles and Transantarctic mountains.

Left: The 'Pagodroma Group' in the Prince Charles Mountains of East Antarctica, comprising glacial sediments on the flanks of the Lambert Glacier system. These deposits are about 15-20 million years old, and were formed in a large fjord system. They occur on the eastern side of Fisher Massif, where they have been uplifted to about 500 m above sea level; Barrie McKelvey for scale.

Centre: The 'Sirius Group' at Shackleton Glacier, is another ancient glacial deposit (tillite). This example from Roberts Massif (85° S) shows strong alignment (parallel to hammer) of striated (ice-scratched) stones in a fine matrix, suggesting that the sediment was deposited at the base of a glacier as basal till.

Right: Commonly associated with, and underlying, the Sirius Group is a striated pavement indicative of subglacial erosion. This surface occurs extensively on Roberts Massif.

of the Antarctic Ice Sheet occurred throughout this period but, according to many scientists, Antarctica developed a cold, arid climate, similar to that of today, by about 15 million years ago. The ice sheet may even have reached its maximum size at that time, overriding all the mountains and reaching the edge of the continental shelf. These scientists have argued that since then the East Antarctic Ice Sheet has remained stable. They are supported in this by the antiquity of the landscape in the Dry Valleys of Victoria Land, where land surfaces have been dated to be many millions of years old, and thus not overridden by ice since then. However, a small group of researchers has suggested that large-scale removal of the ice sheet took place as recently as 3-4 million years ago, and rebuilt to its present size sometime after this. Their arguments are based on studies of extensive glacial deposits (called the Sirius Group) scattered throughout the Transantarctic Mountains, from which microfossils indicate this relatively young age. We find further glacial sediments, spanning 30 million years, along the flanks of the Lambert Glacier – Amery Ice Shelf system in the Prince Charles Mountains. They give clues as to the style of these early glaciations, which apparently were associated with much warmer temperatures compared with those of today. Irrespective of their age, the Sirius deposits have excited much attention because of the exceptional preservation of southern beech stems, roots and leaves, together with fresh-looking moss, beetles and flies alongside major glaciers cutting through the Transantarctic Mountains. Together, they tell of a much warmer (but still tundra-like) climate within a few hundred kilometres of the South Pole. The debate continues with vigour, but

whenever the final cooling and stabilization of the ice sheet took place, the issue is important because it offers a window on what Antarctica could look like in the future as global warming has increasing impact on the continent.

What was the trigger for glaciation in Antarctica? At one level the general global cooling trend, determined by declining carbon dioxide in the atmosphere, was bound to affect Antarctica at some stage. On a plate-tectonic scale, the drifting away of the last of the Gondwana continents, South America, and the opening of Drake Passage around 34 to 30 million years ago, led to ocean currents developing a circum-Antarctic flow pattern, thus isolating the continent thermally to some extent. Finally, the uplift of the Transantarctic Mountains, in combination with the above, would have initiated growth of ice masses at high altitude that ultimately coalesced to form the first ice sheet.

The ice sheet is believed by geologists to have remained intact through the Quaternary Period (the last two and a half million years), leaving behind scattered glacial erratics on exposed land and on the sea floor. The theme of Quaternary glacial processes is taken up more thoroughly in Chapter 6.

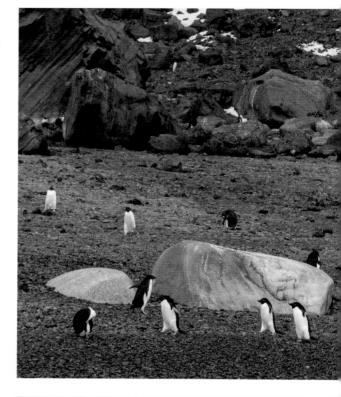

Mineral wealth of Antarctica

For lovers of wild, unspoilt landscapes, it is a joy to know that the Antarctic remains the only large part of the Earth where mineral deposits remains unexploited. Although an attempt was made in 1988 to establish a framework for the exploration of mineral wealth, through the Convention on the Regulation of Antarctic Mineral Resource Activities (CRAMRA), the protocol was not ratified and failed to come into force. Instead, with the growing recognition of the scenic, wildlife and scientific value of Antarctica, the environmental lobby gained the upper hand and in 1991 the Protocol on Environmental Protection to the Antarctic Treaty was initiated and entered into force in 1998. This protocol protects Antarctica from exploitation until 2048, when it may be reviewed (Chapter 11). This is a highly desirable outcome for most people who have experienced the grandeur of this icy continent.

Nevertheless, the economic potential of the continent was recognized in the early 20th century, and geological work on various expeditions had this as a focus. For example, on the *Nimrod* Expedition of 1907-09, coal seams were discovered near the head of Beardmore Glacier during Shackleton's attempt to reach the South Pole. Later the work of du Toit (1937), which demonstrated connections with Southern Hemisphere continents, implied that considerable mineral potential was likely. No minerals have been discovered in Antarctica that are economic at current world commodity prices, and pressures to exploit them, following the end of the current environmental protocol, would certainly increase if possible future shortages make their presence felt.

Of the likely mineral wealth, oil is arguably the most attractive. The sedimentary geology of the Antarctic continental shelves is similar in many respects to that of other

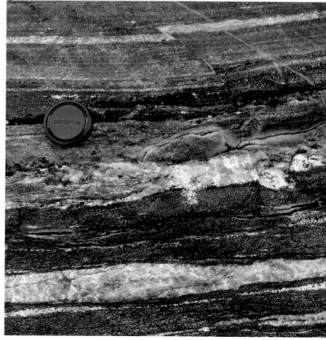

Opposite top: Glaciations of the Quaternary Period (the last 2.58 million years) were more extensive than those of today, and their legacy is in the form of glacial sediments and landforms, including scattered foreign erratics. In this location, at Brown Bluff, pale grey gneiss boulders from the spine of the Antarctic Peninsula to the Northwest, dwarf the local Adélie penguins, and contrast strongly with the local brownish volcanic rock.

Opposite bottom: Proterozoic gneiss, at least a billion years old, near Casey Station, East Antarctica (Australia), showing signs of copper mineralisation (green). Heavy metals are likely to be widespread in Antarctica, but commercial exploitation is unlikely in the foreseeable future, given that the continent is protected under an environmental protocol to the Antarctic Treaty.

Below: Satellite image of the Allen Hills area of Victoria Land, East Antarctica (approximately 20 km / 12.5 miles across), where numerous meteorites have been concentrated at the inland edge of the ice sheet. In this location ice-flow is constricted and snow-free blue ice is present. (Courtesy of NASA)

continents where major oil reserves have been found. However, there are huge obstacles to be overcome, not least the immense size of icebergs, if drilling for oil were to be undertaken on Antarctica's continental shelves. Inland, the huge thickness of the ice sheet precludes drilling for hydrocarbons.

Coal is a major feature of the Beacon Supergroup, referred to above. Horizontal seams of Permian and Triassic age occur in the Transantarctic Mountains, the black colour contrasting dramatically with the buff sandstones in cliff sections. It has been said that this region represents the world's largest coalfield. Similar strata in the Prince Charles Mountains also reveal coal. Despite the quality of the coal, it has never been seriously considered for exploitation, and probably never will be given the phasing out of coal as a fuel source in many countries.

A further group of potentially economic rocks are metallic ores. Best known is the Dufek intrusion in the Pensacola Mountains. This complex of mineral-rich rock is 9 km (5.6 miles) thick and covers at least 50,000 km^2 (19,300 miles2). It has been likened to the Bushveld Complex in South Africa, and is rich in iron ore, whilst higher value minerals are to be expected in the lower parts of the intrusion, such as cobalt, chromium, nickel, uranium, copper and platinum.

The international community currently regards the aesthetic value of Antarctica to be greater than that of minerals, so we must hope that the current 50-year moratorium on mineral exploitation holds for future generations.

Antarctic meteorites

A unique aspect of the rocks found in Antarctica is the relatively high concentration of meteorites in certain areas. Japanese expeditions were the first to identify these areas in 1969, and since then meteorites have also been collected by American and European teams. Together, the number of meteorites collected is 35,000, far more than the total collected in the rest of the world over several centuries. Deposited on the ice sheet over a million years or more, they are concentrated by ice flow in the vicinity of interior mountain ranges. Long-buried meteorites rise to the surface and are exposed as a result of loss of mass at the ice surface. Fresh specimens are particularly abundant in so-called 'blue ice' areas where there is no net accumulation of snow and wind-scour is dominant. They originate from asteroids, Mars and other planets, and the Moon, and provide information about the origin of the solar system and the planets. One such Mars meteorite from Allen Hills in the Transantarctic Mountains caused a stir in the late 20th century when it was reported that certain cell-like objects were micro-organisms, and hence indicated that life on Mars had once existed. However, although this interpretation was subsequently refuted by many scientists, the report gave added spice to later Mars missions.

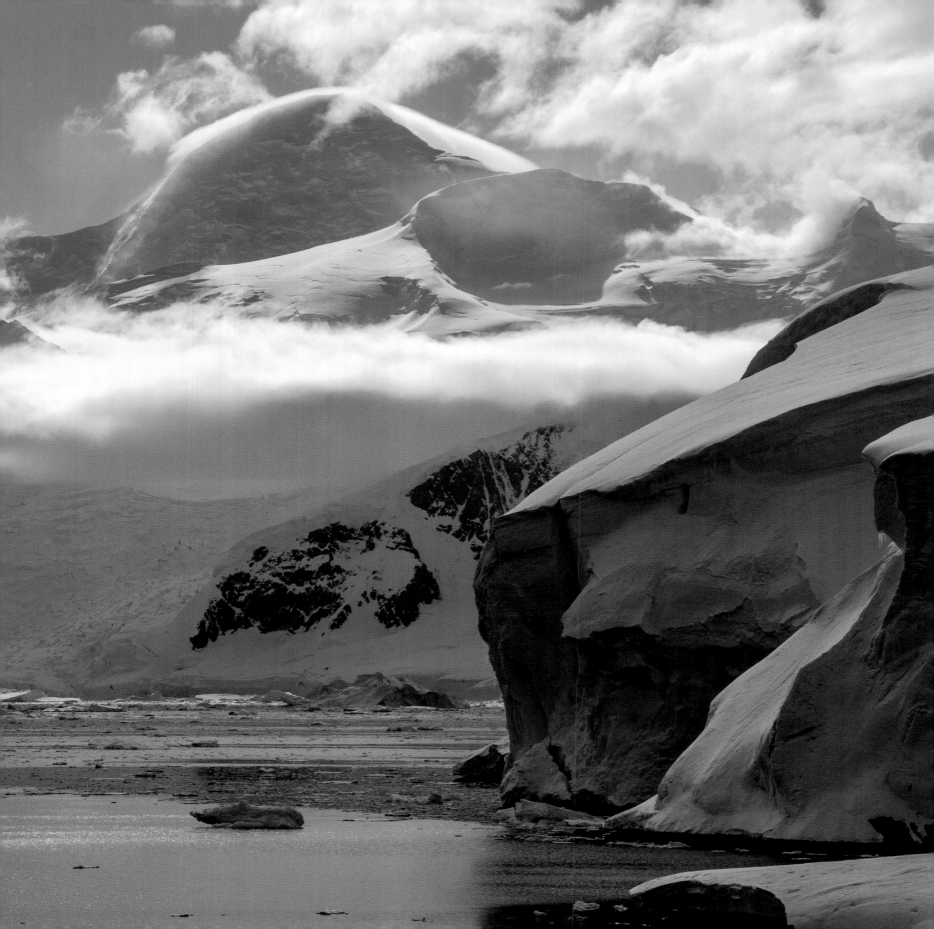

Weather, Climate and Atmospheric Effects

In 2010 I joined a New Zealand group, led by Sean Fitzsimons from the University of Otago, to investigate the structure of a small ice shelf, the southern McMurdo Ice Shelf, which borders the Ross Sea. Our camp consisted of a 'Wannigan', in effect a shipping-container with windows and insulation on a sledge. This served as our laboratory and kitchen-diner. Each person had their own pyramid tent, whilst a 'retired' pyramid tend provided toilet facilities. We had chosen a site some 8 km from the volcanic peninsula of Minna Bluff, having already experienced gale force katabatic winds with blowing snow and debris when working adjacent to the Bluff. On this particular day we had travelled in our Hägglunds tracked vehicle to a distant part of the Bluff. Soon, the tell-tale signs of an impending blizzard appeared – roller clouds pouring over Minna Bluff, accompanied by spindrift. We decided to retreat to camp promptly, and progressively the Bluff, Mt Discovery and Black Island disappeared behind swirling snow. Almost immediately after our return a maelstrom of snow engulfed us, continuing for five days except for a single four-hour lull. The aftermath of such a prolonged blizzard was severe. Our toilet tent was shredded and huge drifts extended from the other tents, the Wannigan and vehicles. Digging out was a huge task, but pleasant enough in the sun after the wind had subsided. Fortunately, by the time of the blizzard, we had fulfilled most of our scientific objectives.

MJH

Antarctica is the coldest and windiest continent on Earth. The lowest temperature ever experienced was at Vostok Station in the high interior of the East Antarctic Ice Sheet, where the measured surface temperature reached -89.2° C (-128.6° F) in mid-winter 1983 – a summer's day on Mars, as one glaciologist described it. Even lower temperatures, down to -95° C (-193° F), have been inferred from satellite evidence. Antarctica is cold because it is located at a high latitude, where the annual input of solar radiation is least, and also because much of the Antarctic is a large high-altitude continental ice-sheet plateau, which is highly reflective and where temperatures are always colder because of the height. In fact, the globe gains energy at those latitudes within 37° of the equator and loses it elsewhere. It is the poleward transfer of energy from the tropics by ocean currents and wind that prevents the Antarctic and Arctic from cooling to even more extreme low temperatures.

Antarctica is also one of the driest places on the planet. Snowfall of only a few centimetres a year is experienced in some parts of the Antarctic, and even this can be removed where high winds persist. The Dry Valleys in McMurdo Sound are an aptly named example, but dryness also characterises much of the Transantarctic Mountains to the south. In the last region of bare rock before the South Pole, the only

Opposite: Multiple cloud layers drape Mt Gaudry during changeable weather conditions at the UK's
Rothera Station, on Adelaide Island, western Antarctic Peninsula. Wormald Glacier on the right forms
a steep ice cliff, grounded on the sea bottom, adjacent to Rothera's runway.

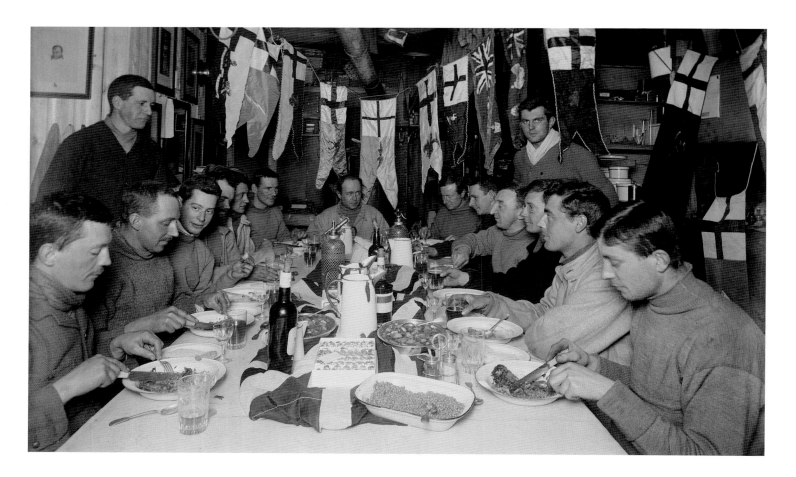

significant precipitation is snow blowing off the polar plateau. The Antarctic is very dry because it is a large continent with much of its surface far from the sea and is also surrounded by a sea-ice cover that caps the adjacent ocean moisture source for much of the year. In addition, cold air has a low absolute humidly, further restricting moisture transfer into the interior. In fact, at very low Antarctic winter temperatures, the air can hold less than 1% of the water vapour in air on a warm summer day at mid-latitudes.

The Antarctic Year

The Antarctic experiences wide fluctuations in radiation inputs from the Sun. This variation is related to the way the Earth orbits the Sun with a tilted axis. Today this tilt relative to Earth's plane of orbit around the Sun is 23.5°, but this value varies between 22.1° and 24.5° over cycles of about 40,000 years. The tilt produces seasons with extended periods of continuous dark in winter and 24-hour daylight, the Midnight Sun, in summer. At almost 78° S in McMurdo Sound, the location of several modern

Above: Midwinter Day dinner, 22 June 1911, at Captain Scott's Cape Evans hut in McMurdo Sound. It was traditional on Antarctic expeditions to boost morale by celebrating the winter solstice, the mid-point of a four-month period of darkness at 78° S. (© Scott Polar Research Institute)

Opposite top: Sunset with 'alpenglow' over the Princess Royal Range on Adelaide Island, western Antarctic Peninsula, from the UK's Rothera Base.

Opposite right: Strong katabatic winds are blowing snow off the Polar Plateau onto the desert area of Roberts Massif, which represents one of the last outcrops of rock before the South Pole at a latitude of 85° S.

bases and the historic huts of Scott and Shackleton, there is continuous darkness for about four months, from mid-April to mid-August and a similar length of continuous daylight between about mid-October and mid-February. In the depths of winter at such high latitudes the darkness is complete, with no artificial light and the stars shining brilliantly through an unpolluted atmosphere on cloudless nights when there is no Moon or auroral display. As the return of the Sun approaches in August, there is often a deep blue glow in the sky around noon, although the Sun remains below the horizon. At the moment the Sun rises and sets, sunlight has its longest path through the atmosphere, leaving only the longer-wavelength red part of the spectrum to briefly colour icebergs, mountains and clouds various shades of pink and red – an effect that is called alpenglow.

Most scientific field work and tourist visits to Antarctica take place between late October and March, the warmest months of the year, which are slightly offset from the astronomical summer given that temperature and sea-ice conditions are lagged relative to increasing solar radiation. Similarly, much of the wildlife around

the fringes of Antarctica responds to the shifting light conditions, as exemplified by seabird and penguin migration (Chapter 8).

In summer, the Midnight Sun persists for 135 days at 80° S, for 105 days at 75° S and for only a single day at the Antarctic Circle. The Antarctic Circle, at 66° 33'47" S, marks the point where on mid-winter's day (21 June in the Southern Hemisphere) the Sun just breaks the horizon at noon. In practice, the period over which the Midnight Sun is visible is actually a little longer than astronomical calculations suggest because the Sun's rays are curved slightly when they pass through the atmosphere, making it possible to see the Sun when in fact it is below the horizon. Apart from the Antarctic Peninsula, almost all of the Antarctic continent is inside the Antarctic Circle. In fact, the Antarctic Circle is migrating slowly southwards at about 15 m/yr due to very slow changes in the axial tilt of the Earth.

During the Antarctic spring, the Sun rises progressively higher in the sky until it remains above the horizon 24 hours a day for the few months of summer at high southern latitudes. Conversely, the autumn sees the end of the Midnight Sun, and the days begin to shorten. At 78° S the change in daylight hours is very rapid - between about 15 and 30 minutes a day once the midnight Sun is lost, with minimum rates of change at the spring and autumn equinoxes on 21 September and 21 March. In principle, the South Pole has six months of full sunlight and six when the Sun remains below the horizon, remembering that a long twilight exists around the equinoxes at this highest latitude.

Above: Map showing the location of the Antarctic Circle at 66° 33'47" S.

Below: Late evening sunset over Marguerite Bay and Jenny Island, west of the Antarctic Peninsula.

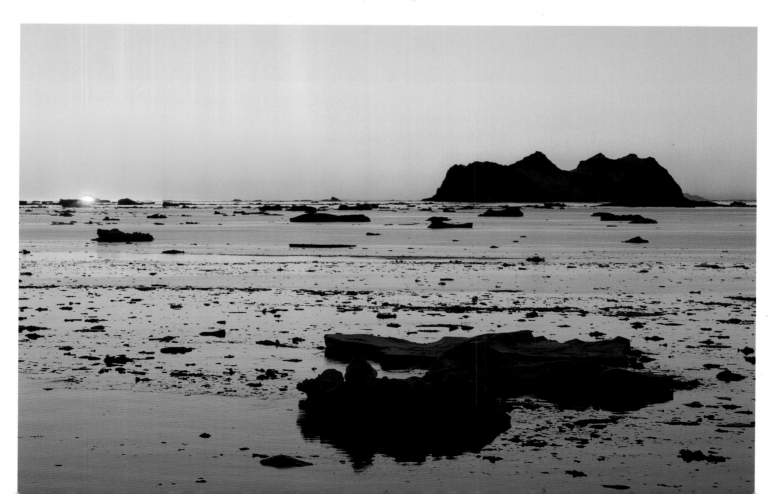

Top left: High-altitude clouds indicate approaching bad weather west of the Antarctic Peninsula.

Top right: An orographic cloud drapes a mountain top on Anvers Island on the western side of Neumayer Channel, western Antarctic Peninsula. This type of cloud is formed when air condenses as it is forced upwards by topography. In this photograph air movement is from right to left.

Above: Swirls of cloud mark a series of low-pressure areas or depressions circling Antarctica (outlined in red) on 1 June 2007. (Courtesy of UW-Madison SSEC/CIMSS)

Antarctic weather and climate

The weather experienced in Antarctica can be divided into two broad types; that affecting the coasts of East and West Antarctica, and the Antarctic Peninsula and its fringing islands on the one hand, and the ice-sheet interior dominated by the high Antarctic Plateau on the other. The coastal areas of Antarctica, and especially the northward-protruding Antarctic Peninsula, are affected by the series of westerly (i.e. coming from the west) depressions or low-pressure areas that are continually forming and circling the continent, especially in a zone from 60-65° S known as the circumpolar trough. These depressions, which can occasionally reach lower than 940 millibars in pressure, bring weather fronts, rising air, strong winds, clouds and precipitation with them, and can be identified as tight swirls of cloud on satellite imagery. Seen on the ground, depressions will bring thick stratus cloud, wind and precipitation. Local peaks sometimes generate their own cloud caps, referred to as orographic clouds, which often add drama to a landscape.

Snowfall is highest close to the coast of Antarctica, and is enhanced where mountains, such of those of the Antarctic Peninsula, cause air to rise over them from a westerly direction. Conversely, there is a strong precipitation-shadow effect east of the Peninsula, as air descends and warms. Sometimes distinctive lenticular clouds form in standing waves and eddies in the atmospheric flow after air has passed over mountains. If the temperature at the crest of the wave drops to the dew point, moisture in the air may condense to form these lenticular clouds. Maximum precipitation levels occur on the western side of the Antarctic Peninsula and the South Shetland Islands, where up to 2,000-3,000 mm of

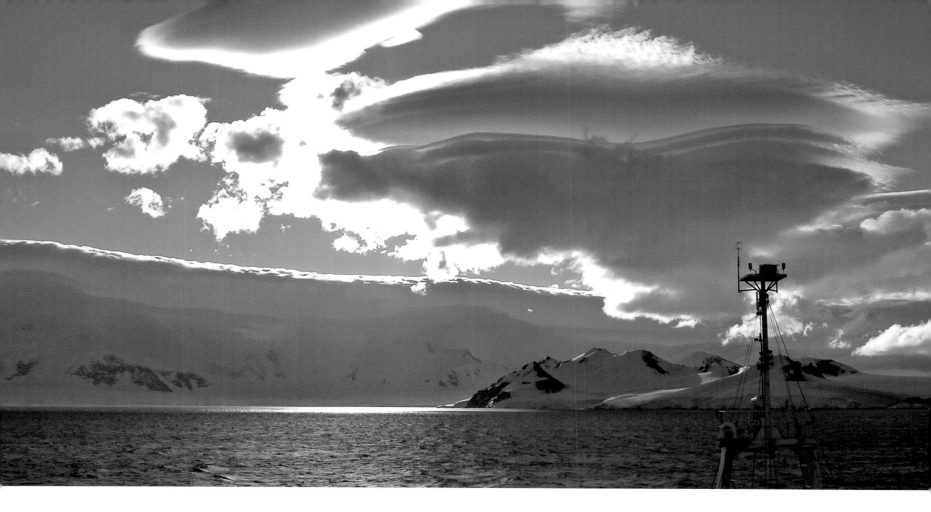

water equivalent can fall over a year. Precipitation levels of above 500 mm/yr (20 in/yr) also occur along the coastal areas of the Bellingshausen and Amundsen seas off West Antarctica and the Wilkes Land coast of East Antarctica, where atmospheric depressions tend to track closer to the coast than elsewhere around the continent. Further south in Antarctica, where precipitation levels are lower, cloudy conditions commonly prevail, both in the form of high-altitude cirrus clouds and cumulus clouds over mountains.

By contrast, the interior of Antarctica is dominated, especially in winter, by persistent and often very strong winds within the lower few hundred metres of the atmosphere, and the high elevation of the ice-sheet interior is an import influence on the climatology of the continent. Winds are generally southerly (i.e. from the south), but near the edge of Antarctica they are deflected by the Coriolis Force (related to the Earth's rotation) to produce a narrow zone of easterly winds. This easterly air flow is mirrored by the Eastwind Drift, an ocean current that flows close to the Antarctic coastline (Chapter 7). Moisture-bearing depressions seldom penetrate far into the interior of Antarctica, and rarely reach south of 70° S. This means that the continental interior is both dry and windy. Snowfall can be just a few tens of millimetres per year, equivalent to that of a hot desert.

The Continent of Antarctica

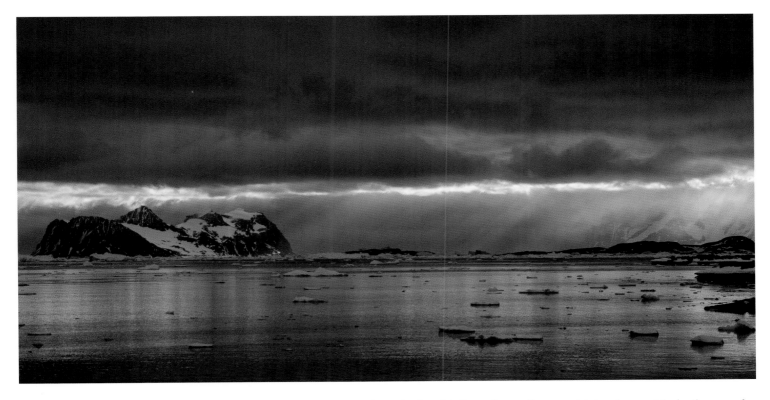

Opposite top: Lenticular clouds formed in the lee of the Princess Royal Range on Adelaide Island, viewed from the RRS *James Clark Ross* as it approaches Rothera Base.

Opposite left: Cumulus clouds developing over the highest point of Fisher Massif, a nunatak in the Prince Charles Mountains on the western margin of Lambert Glacier – Amery Ice Shelf System, East Antarctica.

Above: Shafts of sunlight illuminate heavy snow-bearing clouds over Ryder Bay and Jenny Island on Adelaide Island, western Antarctic Peninsula.

The terms 'weather' and 'climate' are often used interchangeably in the popular media and by the general public, but it is important to distinguish between the two. Climate is often known as 'average weather'; that is, the mean weather averaged over several decades, commonly thirty years. On the Antarctic Plateau winter temperatures are often below -50° C (-58° F) and summer sunshine raises the average temperature to only about -30° C (-22° F). Even at the coast, winter temperatures may only be -15° C (-5° F) or so, because persistent sea ice forms a cap over the warmer sea below, preventing heat exchange. The 0° C (32° F) isotherm, an imaginary line at which the mean annual air temperature is at zero, encircles Antarctica at approximately 60° S in summertime. Over most of the Antarctic, temperatures fall rapidly to very low values in April after a short summer and remain about this level until September, when they rise sharply. This is called a 'coreless winter', in which there is no clearly identifiable coldest month.

A windy and dry continent

The title of the early Antarctic explorer and scientist Douglas Mawson's 1915 book, 'Home of the Blizzard', exemplifies the fact that high winds are common in Antarctica. This is due to two factors: first, the constant tracking of low-pressure areas, and their associated strong pressure-gradients, around the Southern Ocean and the Antarctic

coastline; and, secondly, the prevalence of descending air flowing outward from high-pressure cells in the high-altitude and cold interior of the continent, known as katabatic winds. Indeed, meteorological data show that Mawson's base on the East Antarctic coast in Commonwealth Bay during his Australian Antarctic Expedition of 1911-14 is consistently the windiest place on Earth with an average wind speed of around 80 km/yr (about 43 knots) and gusts to at least twice this value.

Katabatic or gravity-driven winds are formed above the Antarctic Ice Sheet as cooling produces very cold and dense air that sinks and flows downslope from the ice-sheet crest towards the coast. These winds generally warm up as the air descends to lower elevations, making them very dry. The winds can be accelerated by constraining valley walls in mountainous terrain such as the Transantarctic Mountains, and tend to dissipate as they spread out over the flat sea-surface. Sometimes katabatic winds from the interior can interact with depressions close to the coast, increasing wind speeds to over 200 km/hr (almost 90 knots).

The mobilization and drifting of snow in such high winds leads to what are known as blizzards. The blowing snow may reduce visibility almost to zero, leading to so-called white-out conditions. In a white-out, it is easy to become disorientated – all distinguishing surface features disappear and it is sometimes unclear, for example, whether a person on skis is actually moving or whether it is simply the snow moving past a stationary skier. Similarly, a person walking in white-out conditions may have no sense of the ground beneath their feet or in front of them, and falls may easily occur. Such conditions are especially dangerous on crevassed glaciers. In addition, as wind increases in strength so too does the wind-chill which acts to replace relatively warmer air close to the skin with cold air, increasing the rate of body-heat loss and the risk of frostbite. The wind-chill factor is the amount by which the apparent temperature is decreased through this effect. These conditions are also dangerous, and, combined with white-out, may make surface travel almost impossible. It does not even need to be snowing to produce this situation, but simply that existing snow is remobilized by the high winds in a near-surface zone sometimes only a few metres thick. In addition, the drifting of mobile snow in the lee of tents and bases is also problematic. Tents have to be dug out regularly in field camps and bases are slowly buried by snow accumulation. The British base at Halley on the Weddell Sea coast has been rebuilt six times because of burial by snow, with the latest station designed as a series of modules on skis, so that it can be towed away from the drifting snow every few years.

Katabatic winds over uniform terrain are usually consistent in speed and direction, but may shut off over just a few minutes and are very site specific: in other words, they may die off completely over distances of only a few hundred metres. By contrast, in mountainous country, winds are commonly turbulent and unpredictable. Snow devils are whirlwinds in which snow is sucked into a spinning vortex that passes over the land surface, whipping up any loose debris and personal items as well. A similar effect may be observed at sea in stormy conditions.

Top: Flags mark a route near McMurdo Station during a blizzard with white-out conditions.

Above: The cover of Douglas Mawson's (1915) 'Home of the Blizzard' depicts a figure leaning into a strong wind and holding an ice-axe.

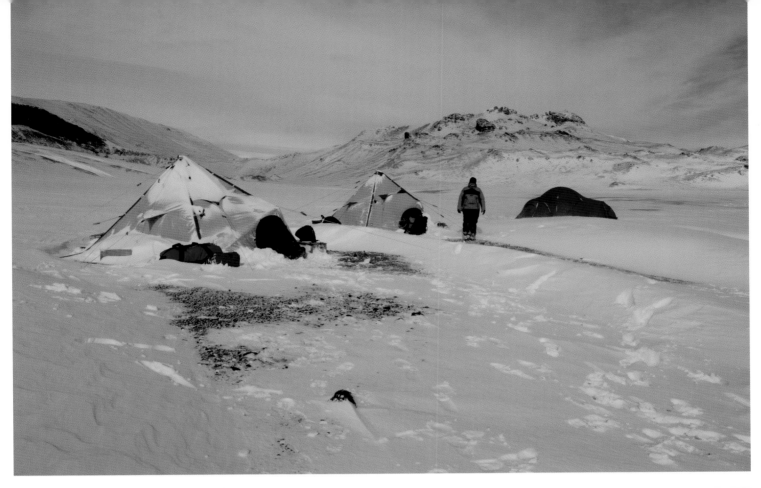

Top: A British field camp at Terrapin Hill on James Ross Island, north-east Antarctic Peninsula, following a heavy early winter blizzard. Large drifts have formed in the lee of the tents.

Right: Five C-130 Hercules aircraft are almost obscured by blowing snow at the start of a blizzard close to the sea-ice runway in McMurdo Sound.

There are many visible effects of wind action in Antarctica. In ice-free areas, wind produces banks and dunes of wind-blow sand, and scours bedrock into unique abstract sculpture-like forms (Chapter 6). Snow accumulates as dunes, referred to by the Russian word sastrugi, which may have a relief of a metre (3 ft) or more. Internally, sastrugi show groups of snow layers cross-cutting each other, just like in sand dunes in coastal areas or deserts. On mountain tops, accumulated snow may be scoured into flute-like forms. Glacier surfaces influenced by katabatic winds are commonly scoured to bare ice, which becomes highly polished and sometimes rippled or scalloped.

The air descending from the Antarctica interior is replaced by high-altitude air from further north, meaning that the Antarctic atmospheric circulation has strong influence beyond the continent itself. This circulation is often known as the Polar Cell, making up one of the three major cells of the hemispheric circulation of the Earth. The strength of the atmospheric circulation is greater in winter than in summer. This is because in summer the temperature gradient between the equator and the poles is less than during winter, given that the Antarctic warms up due to solar radiation input. Thus, in general, storms around the fringes of Antarctica are less frequent and severe in summer than in winter.

In the relatively limited periods when light winds predominate, fog can form in the lowermost few metres of the cold Antarctic atmosphere. Fog is a visible cloud of water droplets or ice crystals suspended in the air at or near the Earth's surface. Advection fog is produced when relatively warm moist air moves across a cold surface and cools below the dew point causing condensation. Upslope fog occurs when wind blows against a mountain or ridge and cools as it rises, again producing condensation. Both types of fog can yield spectacular visual effects above ice-covered Antarctic land and sea surfaces in light wind conditions - turbulent mixing at higher wind speeds dissipates the thin cool layer close to ice-covered surfaces, dispersing the fog. In sub-zero temperatures, over ice or snow surfaces, fog can sometimes condense and freeze into delicate ice crystals,

Top left: A rotating column of snow called a snow devil, formed during stormy conditions, on the frozen surface of Ablation Lake, Alexander Island, southwestern Antarctic Peninsula.

Top right: A rotating column of sea spray in Admiralty Bay near the Polish Arctowski Station, King George Island, South Shetland Islands.

Opposite top: Snow dunes on a raised gravel beach, Croft Bay, James Ross Island, formed during an early winter blizzard. A field camp is located mid-right of photograph.

Opposite bottom left: Intricate snow texture formed on sastrugi on McMurdo Ice Shelf, Ross Sea. The field of view is about 1.5 m (4.9 ft) from left to right.

Opposite bottom centre: Fluted snow, carved by wind, on the windward edge of Roberts Massif, a nunatak on the edge of the Polar Plateau, East Antarctica. These features are several metres high.

Opposite bottom right: Wind-ripple effects on the glazed surface of McMurdo Ice Shelf near Minna Bluff, where strong katabatic winds from the south scour the ice surface, leaving snow in the hollows between the ripples.

Above: A thin layer of fog covers the sea ice adjacent to a large tabular iceberg in the Amundsen Sea beyond the coast of West Antarctica. The iceberg is about 40 m (130 ft) high.

Right: RRS *James Clark Ross* approaches the fog-shrouded Booth Island and southern entrance to Lemaire Channel, western Antarctic Peninsula. Thankfully the fog lifted, allowing one of the authors a superb view of the channel, one of the most spectacular in Antarctica.

known as frost flowers. When the fog disperses and the Sun comes out, the reflected sunlight creates a magical scene of a myriad sparkling ice crystals.

Recent climate change and human-induced warming

In Antarctica, there are very few meteorological stations from which regular measurements of temperature, precipitation, humidity and other parameters are collected. Most stations are located at scientific bases and are found around the coast of the continent, although the American Amundsen-Scott base at the South Pole and the isolated Russian station of Vostok are notable exceptions. In recent years these observation points have been augmented by over 100 automatic weather stations located in remote areas across Antarctica, which transmit meteorological data via satellite links. Because the atmosphere is three-dimensional, weather balloons or radiosondes are also launched regularly from about twenty Antarctic bases to record meteorological data from the upper atmosphere. The length of time continuous records of weather have been collected is also quite limited, except for one location, the Argentinian Base Orcadas in the South Orkney Islands. The base was originally established by William S. Bruce's Scottish National Antarctic Expedition in 1903 (Chapter 9). It was then handed over to the Argentine Government, who have maintained the base and kept meteorological records ever since. Other meteorological stations were not established until much later. Many are located at bases that were first set up during the International Geophysical Year of 1957-58 and have therefore been acquiring data for only a half-century or so. Apart from the Orcadas records, earlier observations are scattered and are generally limited to runs of a few years at most, linked to overwintering expeditions by the early generation of Antarctic explorers from the late nineteenth century onwards (Chapter 9).

For the Antarctic continent itself, the longest time-series of data is only about 60 years, obtained at the former British 'Station F', established in 1947 on Winter Island adjacent to the coast of western Antarctic Peninsula. The station has been known as Vernadsky since being transferred to Ukraine in 1996. These records show that there has been a significant increase in temperature on the Antarctic Peninsula. The annual temperature at Vernadsky Station has risen by over 3° C (5.4° F) during this period. This warming, of more than 0.5° C (0.9° F) per decade, is among the most rapid on Earth, a record matched only by several regions of the Arctic. As a comparison, the global mean warming over the same period has been about 0.15° C (0.27° F) per decade. Most of the warming in the Peninsula has been during winter, although the number of summer days above freezing has also increased by almost 75% at Vernadsky Station, producing a large increase in surface melting on glaciers and the retreat of many (Chapter 5). Warming appears to have been less on the eastern side of the Peninsula, in conditions of more extensive sea-ice cover and increased continentality. Averaged over the whole Antarctic Peninsula, warming

Top: Looking across Laubeuf Fjord from the meteorological station at the UK's Rothera Base on Adelaide Island, west of the Antarctic Peninsula.

Above: A meteorological balloon about to be released at the UK's Rothera Station, Antarctic Peninsula. The balloon carries a radiosonde which sends signals back to Earth of temperature, humidity and pressure to an altitude of over 20 km (12.4 miles). A GPS sensor allows the balloon to be tracked, and the wind speed and direction calculated. The data are used in weather forecasting, and in the study of climate change.

Opposite: A large air balloon was used on Captain Scott's *Discovery* expedition to elevate observers in order to view the surrounding terrain. Smaller unmanned balloons were also deployed to make meteorological observations of the atmosphere. This photography by Charles Royds shows an inflated balloon held down by sandbags on the Ross Ice Shelf prior to attaching a passenger basket. (© Scott Polar Research Institute)

Below: Meteorological observations of wind, pressure and temperature over four days in March 1936 from the log of *Penola*, the vessel supporting the British Graham Land Expedition that undertook much of the early mapping of the Antarctic Peninsula. The observations were made while the ship was at anchor at the Debenham Islands (referred to as 'The Debs' in the log book and named after Frank Debenham, a member of the scientific staff of Scott's *Terra Nova* expedition and later the founding Director of the Scott Polar Research Institute in Cambridge). (© Scott Polar Research Institute)

has been about 2° C (4° F) since 1950. Elsewhere in Antarctica, warming has been less, at about 0.17° C (0.31° F) per decade in West Antarctica. East Antarctic temperature has changed little over the period, with a decadal average only just above zero. Since 1970, East Antarctica has experienced a very slight cooling.

In terms of snow precipitation, satellite data, obtained by a technique known as radar altimetry, which measures the elevation of the ice-sheet surface over the past decade or so, has shown that the interior of East Antarctica is thickening by a few centimetres per year. This effect may well be linked to slight warming around the East Antarctic coast and an ability to transport more moist air into the Antarctic interior, resulting in increased snowfall. However, this modest change is insufficient to balance mass loss elsewhere in Antarctica (Chapter 5).

The causes of recent warming are linked to the rapid global increase in greenhouse gases, especially carbon dioxide and methane, in the atmosphere. This increase has been driven largely by human use of fossil fuels, and has become particularly significant since the 1970s and 1980s. Enhanced levels of greenhouses gases reduce the amount of long-wave radiation that can escape from the atmosphere, resulting in warming.

Variability in the recent climate of Antarctica is also influenced by changes in the 'Southern Annular Mode' or Antarctic Oscillation. This is a belt of westerly winds and low pressure surrounding Antarctica that moves north or south through time. When the Mode is positive, the westerly wind belt shifts towards the Antarctic continent, and when negative the shift is towards the equator. At present the Southern Annular Mode is strongly positive, yielding increasing westerly wind strength and storminess close to the continent and more mixing with and penetration of warm air from lower latitudes. Meteorologists believe that this effect has led, in part at least, to the observed warming of the Antarctic Peninsula in recent decades, together with increased greenhouse gas levels, and perhaps also linked to increased ozone depletion and associated changes in the thermal structure of the Antarctic atmosphere.

Decreasing sea-ice extent and concentration west of the Antarctic Peninsula is also linked to the observed warming, with changes in sea-ice cover correlating strongly with the temperature record on the western Peninsula. Thus, changing sea-ice conditions are a further factor associated with warming in this part of Antarctica, through both increasing the absorption of solar energy by open water, and increasing the energy transfer of warm and moist air masses into the continent. It should be noted, however, that sea-ice change in Antarctica is not consistent in all areas, and the Ross Sea sector in particular has seen increasing sea-ice cover over the past decade or so.

In addition, the observed warming in parts of Antarctica, and severe warming experienced in the Arctic too, suggests that the polar regions are particularly sensitive parts of the global climate system. This is, in part at least, because of the so-called albedo effect. Much of the surface of Antarctica and the surrounding seas is covered by ice sheets and sea ice, which are highly reflective of solar radiation. If there is less

ice, then more solar energy is absorbed, leading to further warming and melting – a self-reinforcing process that is underway especially in the Arctic Ocean.

At timescales beyond the reach of modern meteorological observations, some evidence on past air temperature, pressure and wind is recorded in the logs of sealing and whaling ships, which from the 19th century extended their hunting grounds to the Southern Ocean and sub-Antarctic islands (Chapter 9). Historians are collating these early written data, which sometimes included the position of the sea-ice edge as well as weather, to extend back the time-series of meteorological records from around the continent. Further back in time, the layer-cake structure preserved in deep ice-cores through the Antarctic Ice Sheet provides the only means of reconstructing past variations in temperature and snow accumulation (Chapter 5).

The Ozone hole

Atmospheric ozone is important because it shields us from damaging short-wave ultra-violet (UV) radiation from the Sun, absorbing 97-99% of radiation at this frequency. Ozone is a gas comprising three molecules of oxygen and is produced by the action of sunlight on oxygen. It is most abundant in the stratosphere between about 15 and 30 km (9.3-18.6 miles) above the Earth's surface, where its concentration is about ten parts per million (ppm) as compared with only 0.3 ppm elsewhere. The ozone hole is an area depleted in atmospheric ozone.

The ozone hole over Antarctica, discovered in 1985, forms when very low winter temperatures allow polar stratospheric clouds, sometimes called nacreous clouds, to develop at temperatures below -78° C. The clouds are bright and many-coloured (sometimes called iridescent), and are illuminated well after sunset because of their very high altitude. When early spring light returns around the time of the spring equinox in late September, photochemical reactions on the surface of droplets and crystals in these clouds convert chlorine and bromine, which are sourced from human-produced chemicals such as chloroflourocarbons (CFCs), into active ozone-depleting chemicals. When the stratosphere continues to warm as spring progresses, the clouds disperse and ozone depletion stops. Air from beyond the hole then gradually replaces the missing ozone to fill the hole until the cycle is repeated the next winter.

In early spring 1994, Antarctic ozone reached its lowest observed concentration since global satellite observations began in 1979. These satellite observations are calibrated against ground-based spectrophotometer measurements that were first made in Britain's Halley Station in the eastern Weddell Sea in 1956. The largest ozone hole (defined as ozone reduction to a level below 220 Dobson Units (DU), where one DU is the amount of ozone molecules needed to produce a 0.01 mm layer of pure ozone) was observed in 2006 at almost 27 million km² (10.4 million miles²). Hole size has decreased since that time and has reduced by more than 20% to just under 20 million km² (7.7 million miles²) in 2017.

Above: Edward Wilson's painting of nacreous or polar stratospheric clouds over the expedition ship *Discovery* and Hut Point in McMurdo Sound on 17 August 1903 during Captain Scott's first expedition to Antarctica. Darker wisps of blowing snow can also be seen near the ground. The watercolour paints used by Wilson yield colours very similar to modern photographs of such iridescent clouds. (© Scott Polar Research Institute)

An Arctic ozone hole is less well developed than that in Antarctica, because the Arctic atmosphere is less cold, there being no landmass over the North Pole.

An excellent demonstration of the way that nations can come to together to solve a significant international environmental problem is the Montreal Protocol, first signed in 1987. By 2009 all member states of the United Nations had signed the protocol, and almost all CFC production had effectively ceased by 2010. The detrimental effects of the ozone hole on human health, and indeed on living tissue more generally, prompted this action, in which the use of CFCs in refrigeration, together with other ozone-depleting chemicals such as aerosol-can propellants, was banned by international treaty. The result of this has been a gradual reduction in the size of the Antarctic ozone hole, with predictions suggesting that it may all but disappear by the last quarter of the 21^{st} century, given that CFCs take decades to degrade. Ozone depletion is not, however, a major direct cause of global climate change because although ozone depletion allows more UV light to reach the

Earth's surface, the additional energy added is very small. Regionally, however, the ozone hole has been linked to strengthening westerly winds around Antarctica.

Optical atmospheric effects

A very simple observation made by many who visit Antarctica is that objects appear closer than they really are. The Antarctic atmosphere lacks pollutants and dust particles due to the very low levels of human emissions there, and also to the cover of ice that means sources of terrestrial dust are limited. The result is that the atmosphere in Antarctica is very clear and it is easy to underestimate the distance to an object such as an iceberg or exposed rock outcrop or nunatak. Many visitors have been deceived because, first, they are used to looking through a much more polluted atmosphere at home and, in addition, because there are few features such as trees or buildings to provide a reference scale – note Herbert Ponting's use of men, dogs and sledges to give scale to his Antarctic landscape photographs. Indeed, even the very experienced

Above: Herbert Ponting's photograph of part of the iceberg nicknamed 'Castle Berg' by members of Captain Scott's *Terra Nova* expedition, with expedition cook Thomas Clissold for scale. (© Scott Polar Research Institute)

Opposite: Ponting's photograph of a sledging party with dogs giving scale to the face of an iceberg near Scott's Cape Evans base during the *Terra Nova* expedition. (© Scott Polar Research Institute)

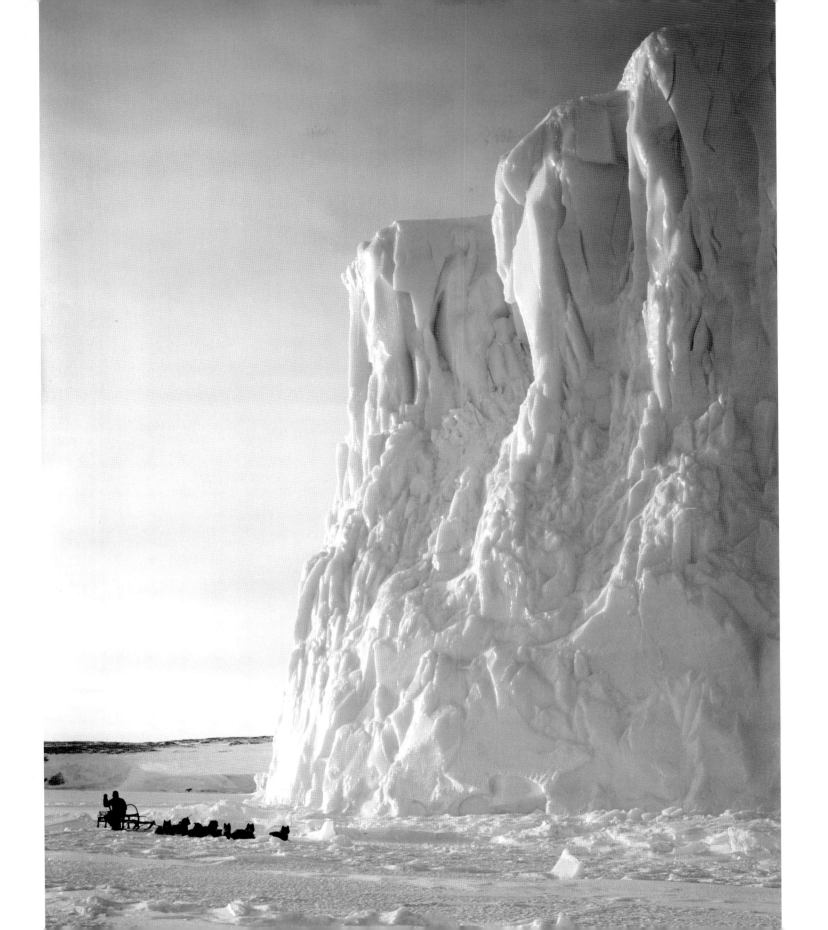

Antarctic explorer and scientist Sir Vivian Fuchs made just such a misjudgement of distance during the 1955-58 Commonwealth Trans-Antarctic Expedition. As a geologist, he wanted to take some samples from what he thought was a nearby rock outcrop exposed above the ice sheet. Half an hour later he was still walking and apparently no nearer to the rocks, which turned out to be many miles away.

A further optical effect, linked to reflected-light illumination of clouds, has been used by mariners to infer whether the Antarctic sea-surface beyond the horizon is of open water or sea ice. If open water is present beneath the clouds, they appear very dark because less than 30% of light is reflected from the water surface – this is called a water sky. Conversely, when sea ice is present more than 85% of light is reflected upwards; the clouds are bright and this is called ice blink.

The Antarctic is a spectacular setting in which it is possible to observe several other atmospheric effects that are unusual at lower latitudes. When blowing snow and ice crystals are present in the Antarctic atmosphere, especially in the lowermost few metres close to the ground, remarkable optical phenomena can sometimes be seen, especially when the Sun remains unobscured by high clouds. Mock suns, halos and sun pillars are all produced by the refraction of sunlight through this thin curtain of suspended ice crystals. Arguably the most spectacular optical effect occurs when the Sun appears to be surrounded by a large bright circle or halo with arcs and mock suns, sometimes known as sun dogs or parhelia. Haloes are among the more common optical features, forming at a radius of 22° around the Sun, or even the Moon. Inside such haloes the sky appears darker because light from here has been scattered by snow

Above left: Dark clouds known as a water sky indicate the presence of open water in the Eltanin Bay area of the Bellingshausen Sea. In the background, reflected light from the outer margin of the West Antarctic Ice Sheet produces lighter clouds onshore.

Above right: Bright clouds known as ice blink produced by light reflecting off sea ice between Cape Evans and Barne Glacier in McMurdo Sound. A dark water sky in the background indicates open water in the distance.

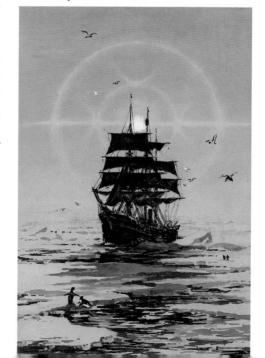

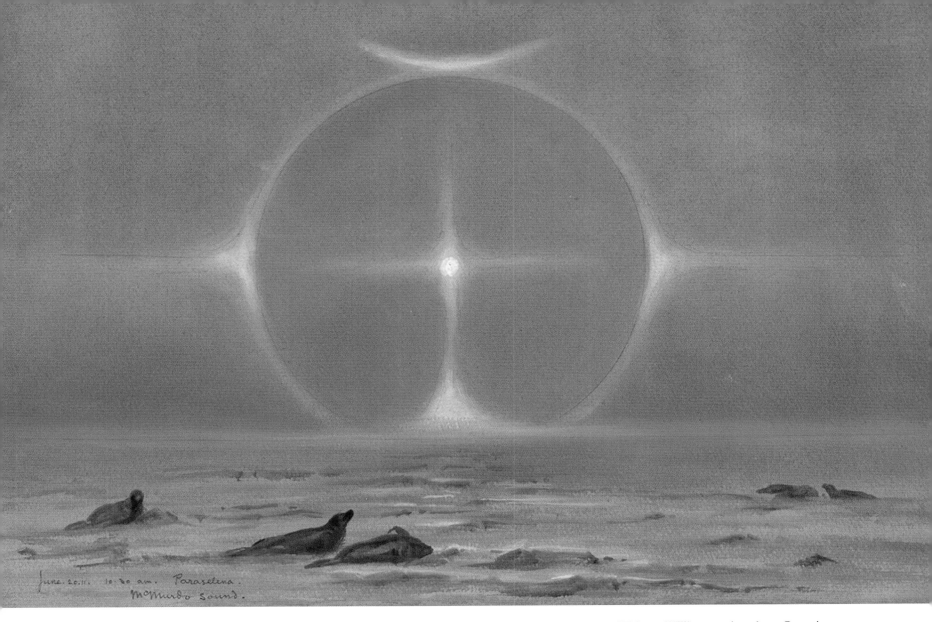

June. 20.11. 10.20 am. Paraselena.
McMurdo Sound.

Above: Edward Wilson's painting of paraselenae or 'moon dogs' and a lunar halo, optical effects produced around the Moon during the polar night on 20 June 1911. (© Scott Polar Research Institute)

Opposite bottom: Wilson's watercolour of the *Discovery* in sea ice with halo and parhelia. (© Scott Polar Research Institute)

crystals to produce the halo. The watercolours of Edward Wilson, painted on Captain Scott's two Antarctic expeditions, capture these atmospheric effects spectacularly.

By contrast, when conditions are calm, mirages and other optical effects similar to those reported from deserts can be observed in and around Antarctica. These effects relate to the warming action of the Sun on air immediately above the ice-sheet, sea-ice or ocean surface. This produces a strong near-surface temperature gradient that refracts light. Distortion and sometimes even inversion of objects can be seen, and features such as far-distant mountains may appear to show above the horizon as light rays are refracted and bent in the thin near-surface layer of the atmosphere. In windy conditions, however, atmospheric turbulence mixes this thin layer with the air above and the refractive effect disappears.

Aurora Australis

The few scientists and support staff who remain in Antarctic over winter are also treated to remarkable light displays in the upper atmosphere during the months of the polar night under cloudless conditions. This is the Aurora Australis or Southern Lights, the Southern Hemisphere equivalent of the Aurora Borealis. This name was taken by the men of Shackleton's *Nimrod* expedition for the compendium of stories, poems and drawings they produced to raise spirits and avoid boredom during overwintering at Cape Royds on Ross Island between 1907 and 1909.

The distribution of auroral activity forms an oval around the geomagnetic poles. As the level of disturbance of the Earth's magnetic field increases, the oval of auroral activity expands towards the equator and tends to be most intense around the time of maxima in the 11-year cycle of solar sunspot occurrence. The most spectacular auroral displays are associated with solar flares and storms linked to the behaviour of the Sun, sometimes called 'space weather'. Not only do particularly high discharges of solar radiation produce stunning and widespread aurora, but they have also been known to cause disruption of telecommunications on Earth and from satellites. A particularly severe solar storm was the so-called Carrington Event of 1859, with reports of Southern Hemisphere auroral displays as far north as Queensland. Telegraph systems in Europe and North America were damaged.

Above: Distortion of the sun's rays at sunset in the Amundsen Sea causes a large tabular iceberg to appear elevated above the sea. In fact, this iceberg extends about 400 m (1,300 ft) below the ocean surface.

Opposite top: The cover of 'Aurora Australis', produced by the men of Shackleton's *Nimrod* expedition during 1907-09, showing a painting of the Southern Lights that are sometimes visible during the polar night under cloud-free conditions in Antarctica. The book was printed on a portable press; its production was intended to ward off boredom during the long period of winter darkness spent in the expedition's hut at Cape Royds on Ross Island.

Opposite right: At the northeastern end of the Gerlache Strait, northwestern Antarctic Peninsula, a shaft of sunlight bursts through heavy clouds to illuminate an iceberg. The mainland, just visible in the background, rises abruptly to over 1,000 m (3,280 ft) in the clouds.

A solar storm of this size occurring today would cause widespread damage to modern global communications.

Aurora are caused through the stimulation of electrons by the solar wind at heights between about 100 and 300 km (62-186 miles) on the outer edge of the atmosphere. These rippling curtains of green, blue, purple and sometimes red move rapidly about the sky. The colour of the Southern Lights depends on the type of atom or molecule impacted by electrons, as they rain down along the Earth's magnetic field lines; yellow-green colours are produced by oxygen atoms at about 100 km (62 miles), whereas at 300 km (186 miles) the excitation of oxygen gives a red aurora. A blue aurora is produced from ionised nitrogen molecules.

The aurora occurs mainly at high latitudes, where the Earth's magnetic field lines are progressively concentrated with approach to the Geomagnetic South Pole. Beyond Antarctica and its adjacent islands, auroral displays can occasionally be seen, for example, in Tasmania in Australia, southernmost New Zealand and in South American Patagonia.

Under clear-sky winter conditions, both the Aurora Australis and the Moon provide enough light for travel over the highly reflective ice-sheet surface during the polar night, although biting winter cold and blizzards mean that longer journeys are generally unsafe at this time of year.

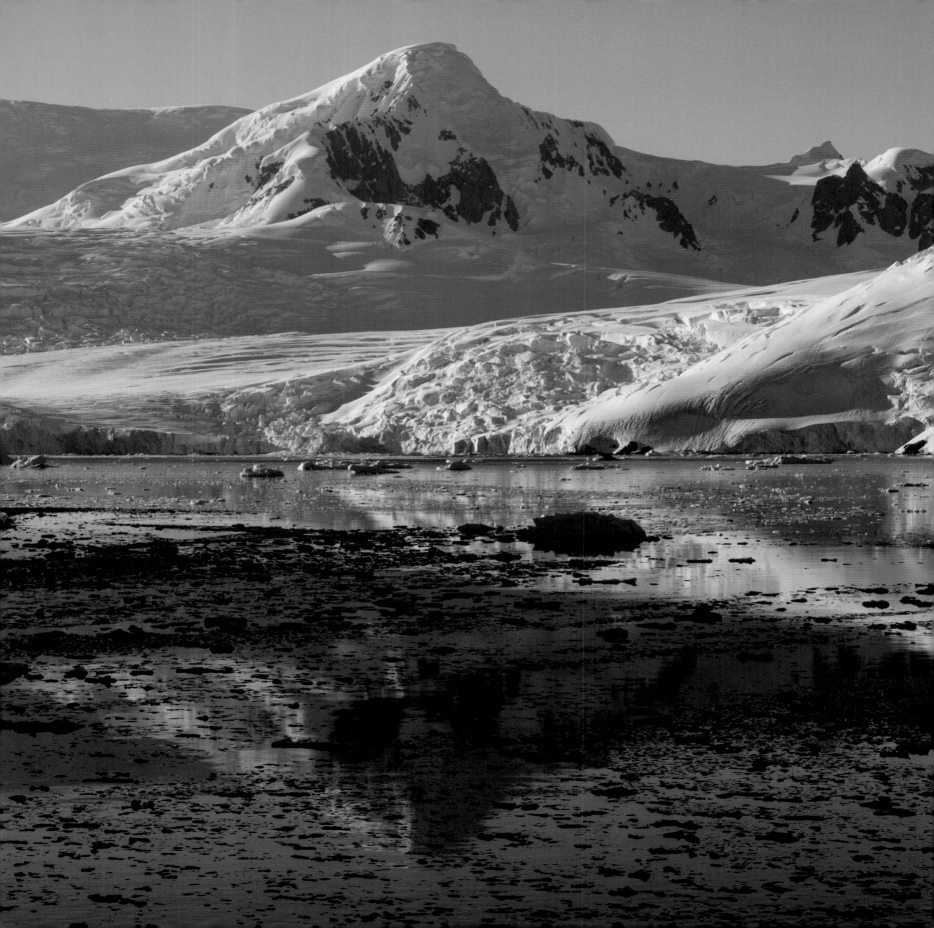

CHAPTER 5

Ice Sheets and Glaciers

When, some forty years ago, I arrived in Cambridge as a young student, I listened to lectures given by several senior staff of the Scott Polar Research Institute, including its then Director, Gordon Robin. Gordon, together with Stan Evans who was a Fellow of the college I was part of, were two of the pioneers of the technique of using radar to measure the thickness of ice. There is nothing like hearing science direct from those who are among its key practitioners, and I was enthused by this new view into the interior of the great ice sheets, about which I had known nothing previously. Three years later, I was given the chance to undertake my doctoral studies in the Institute under David Drewry, himself a past student working with Gordon and Stan. Forward thirty years, and I found myself in McMurdo Sound, at the American base, as part of a scientific team led from Texas University at Austin and using more advanced ice-penetrating radar methods to acquire new ice-thickness data from previously little-studied parts of the ice sheet. A major difference was that whereas the pioneering scientists had recorded radar pulses on photographic film and used inertial navigation for positioning, now everything was digitally recorded and navigation was by very accurate differential global positioning systems (GPS). Looking out from the McMurdo laboratory, however, the view of the ice and mountains was almost unchanged from that seen by Captain Scott from the Discovery hut, constructed nearby just over 100 years earlier.

JAD

Antarctica is a unique continent because it accounts for the majority of the 10% of Earth's land surface that is covered by glacier ice. The continent provides a wonderful array of glacial phenomena, many of which are of great beauty and fascination. The changing Antarctic Ice Sheet is an important measure of the state of environmental health of our planet. We differentiate ice sheets from glaciers purely on the basis of their enormous size (arbitrarily defined as greater than 50,000 km^2 / 19,300 miles2).

The ice sheet that covers more than 99% of the Antarctic continent reaches almost 5 km (3.1 miles) in thickness and covers an area of almost 14 million km^2 (5.4 million miles2), which is larger than Europe and about the size of the USA and Mexico combined. The only other large ice sheet present on Earth today is that on Greenland, which is much smaller at about 1.7 million km^2 (656,000 miles2), the size of Mexico, and up to about 3 km (1.9 miles) thick. If all the ice in Antarctica were to melt, global sea-level would rise by almost 60 m (197 ft). Conversely, the ice sheet expanded much further across the continental shelf in response to colder environmental conditions about 20,000 years ago at the height of the last glacial period on Earth. Along with the major ice sheets that grew in the Northern Hemisphere, this ice expansion lowered sea level globally by about 120 m (394 ft).

Opposite: Leat Glacier, and outlet from a local plateau icefield on the west side of the Antarctic Peninsula, descends into Girard Bay, just south of Lemaire Channel. The heavily ice-mantled Mt Shackleton (1,800 m / 5,905 ft) is reflected in the waters of the bay.

At much longer, geological timescales, ice first built up over Antarctica from about 34 million years ago, following a long period of global cooling, as described in Chapter 3.

What are ice sheets and glaciers?

Ice sheets and glaciers are perennial masses of ice, originating on land by the recrystallization of snow, and showing evidence of past or present flow. They are produced by snowfall and its slow buildup to form ice. The snow itself is usually produced in clouds where, if the temperature is low enough, water droplets crystalize to form snowflakes. Glacier ice begins to form when snow accumulates on a surface during winter and does not all melt the following summer. More snow then falls the next winter, and so on, with the snow becoming more dense with increasing depth of burial. New snow has a relatively low density that is dependent on factors such as air temperature, wind and humidity, which affect crystal size and shape. Freshly fallen snow can have a density as low as 50-70 kg/m³ when deposited in calm conditions. After initial settling the density increases to 200-300 kg/m³ and wind packing may cause further increase to approximately 400 kg/m³, a little less than half that of glacier ice. A simple test of this density change can be made by scooping up a handful of snow and then crushing it, and observing the change in volume that takes place.

As a given winter's snowfall becomes progressively buried, it is compressed and its density increases until all the pathways between individual grains have been closed off by compression with depth and only trapped air bubbles remain. Glaciologists refer to snow that has been present for more than one year, and is on the way to becoming glacier ice, as 'firn'. Firn typically has a density between about 400 and 830 kg/m³, reflecting its transitional nature between snow and ice. Pore close-off, as it is known, takes place at a density of about 830 kg/m³, to give ice. The compression of air bubbles within ice continues to take place at depth, but beyond a density of about 917 kg/m³ ice becomes an incompressible solid and its density cannot increase further. Glacier ice crystals range in size from a centimetre to several centimetres, have a hexagonal symmetry, but are irregular in shape. The interlocking nature of ice crystals can be seen in weathered ice such as that found at glacier margins or in icebergs.

A rough approximation of how long an ice sheet takes to form can be estimated quite simply. Given a snow accumulation rate of, say, 1 m/yr, and in the absence of any surface melting and mass loss, a 3,000 m (10,000 ft) ice sheet may form in about 6,000 years, given that settled and slightly compacted snow is very roughly half the density of ice. If the rate of snowfall is less than 1 m/yr, as would be the case over most of Antarctica, the ice sheet will take longer to form. Thus, a rule of thumb is that an ice sheet of several thousand metres in thickness would take thousands of years to build up, and probably longer in the more arid areas of Antarctica. In practice, there are number of complications to snow buildup relating, for example, to the redistribution of snow by wind and surface melting during summer that reduces net annual gains of mass.

Below: Changing snow density with depth is measured directly in snow pits dug by scientists. Here one of the authors (JAD) shows students the techniques involved in making such measurements during fieldwork in Windless Bight near New Zealand's Scott Base.

Bottom: Glacier ice crystals, around 5 cm (4 in) across, showing their typical interlocking nature. This example is from an iceberg that had calved from a tidewater glacier at Elephant Point, Livingston Island, South Shetland Islands.

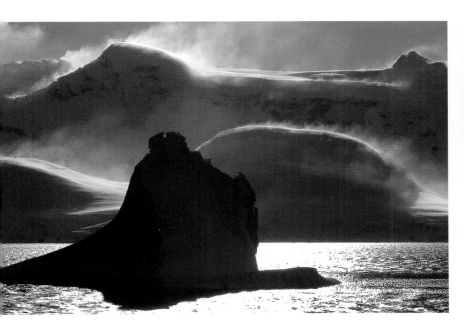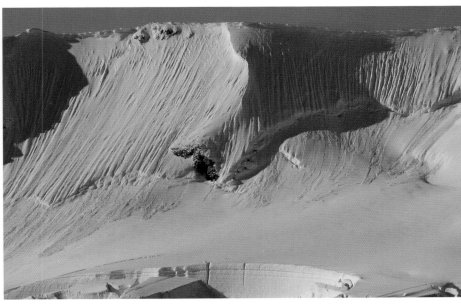

Glacier mass balance or state of health

Whether a glacier or ice sheet grows or decays depends on the balance, or lack of it, between inputs and losses of mass; if the two balance, then the ice is said to be in equilibrium with its regional climate. As a consequence of Antarctica's vast size, measurements of the changing mass balance of the ice sheet are usually made using observations from satellites, which are calibrated against detailed ground-based measurements at limited numbers of locations.

In Antarctica, mass is gained to the ice sheet almost entirely through snowfall, albeit that annual amounts of precipitation are less than 10 cm (4 inches) in much of the ice-sheet interior and there is much redistribution by wind. Rainfall which freezes subsequently in the snowpack is very uncommon, except in the Antarctic Peninsula and adjacent islands such as the South Shetlands, due to the low temperatures over most of the continent. Additionally, smaller glaciers may also acquire mass by avalanching of snow off steep valley walls onto the glacier surface. In mountainous maritime environments, such as the northern Antarctic Peninsula region, substantial ice mass is also gained from rime, the frozen condensate of clouds, which forms striking mushroom-like features on ridge crests. In many parts of Antarctica, mass is gained right down to sea level. Inland, outlet glaciers may be starved of snow, leading to blue-ice areas, where there is net ablation, but on approaching the coast the moist air delivers appreciable snowfalls which do not entirely melt each summer. Many ice shelves also gain mass by freezing on of marine waters to their base. As an example, much of the McMurdo Ice Shelf is composed of marine ice, in which marine organisms and sediment have sometimes been trapped and subsequently delivered to the surface.

Above left: Blowing snow illuminated by bright sunshine in the mountains of Anvers Island fringing Neumayer Channel, west of the Antarctic Peninsula. Remobilisation of snow by wind action is common in Antarctica.

Above right: Avalanching delivers snow onto the surface of a small glacier on Lion Island at the northern entrance to Neumayer Channel.

Overlef left: Satellite image showing the calving of a series of large tabular icebergs into Pine Island Bay from the floating terminus of Pine Island Glacier in West Antarctica on 15 December 2017. Heavy surface crevassing indicates the fast-flowing glacier, which reaches speeds of approximately 4,000 m/year (13,000 ft/year). The image is about 70 km (43.5 miles) across. (Courtesy of NASA/GSFC/METI/ERSDAC/JAROS & US/Japan ASTER Science Team)

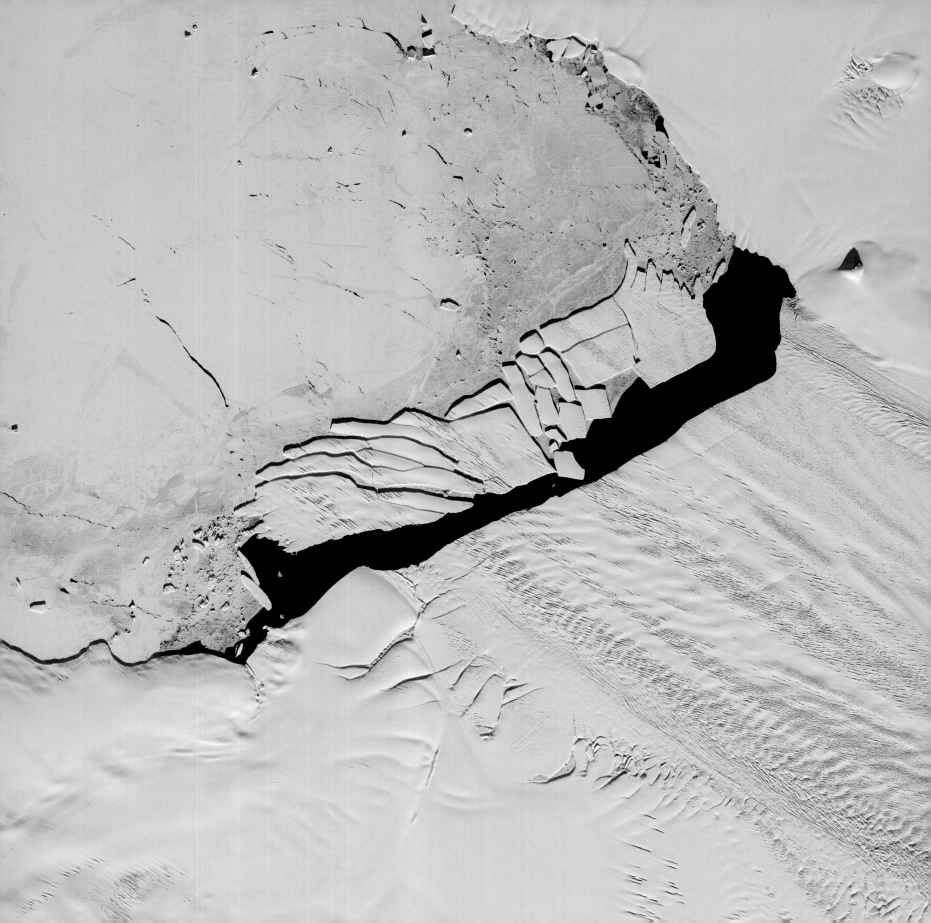

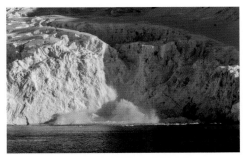

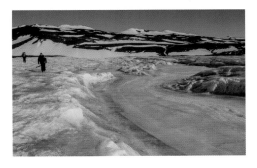

Top: The surface of the southern McMurdo Ice Shelf, with Mt Erebus in the background. The highly glazed surface of a pond has been polished by strong katabatic winds.

Centre: Calving event from Astudillo Glacier, which descends from the Antarctic Peninsula Ice Sheet into Paradise Harbour, Danco Coast on the west side of the Peninsula. The ice cliff is grounded on the sea bottom.

Bottom: Surface meltstreams are common on glaciers and ice shelves in the coastal areas of Antarctica. This example on the southern McMurdo Ice Shelf flows towards Minna Bluff in the background, but in this early-season image is still frozen.

Mass is lost by several processes, including iceberg production at the marine margins of glaciers and the ice sheet, the under-melt of floating ice shelves by ocean waters and, in some parts of the Antarctic Peninsula and adjacent islands, by surface melting and runoff to the sea. Of these processes, the most important is melting at the marine interface between ice shelves and the water-filled cavities beneath them. This is followed closely in importance by the calving of icebergs into the Southern Ocean. Surface melting is restricted to low-elevation areas of glaciers and the ice sheet and takes place over limited areas during warmer summer conditions. Even then, much of the meltwater either refreezes in the snowpack or is stored in surface lakes which drain occasionally. An additional process of mass loss is sublimation, whereby snow and ice change directly to the gaseous phase instead of melting to form liquid water. This process takes place when the air immediately above the ice sheet surface is very cold and dry. An estimated 10-15% of Antarctic precipitation is lost through sublimation.

Classification of Antarctic ice masses

Glaciers are classified by size, morphology (three-dimensional shape), topographic context or whether they have an interaction with the ocean. Ice sheets, being by far the largest masses of glacier ice, as mentioned above, are broadly dome-shaped, although they may have multiple high points. Within them are zones of fast-flowing ice, called *ice streams* through which most of the ice is discharged into the ocean. This ice flows at thousands of metres per year and is heavily crevassed, whereas the adjacent ice may flow at only a few metres per year. Today, the only ice sheets on Earth are the Greenland Ice Sheet and the Antarctic Ice Sheet. Similar in morphology, but defined as being less than 50,000 km² (19,300 miles²) in area, are *ice caps*. Law Dome (10,000 km² / 3,861 miles²), near the Australian coastal base at Casey in Wilkes Land, and the 2,000 km² (772 miles²) ice cap on James Ross Island, off the northeastern Antarctic Peninsula, are examples of independent Antarctic ice caps with radial flow outwards from their crests. The western Antarctic Peninsula is also well endowed with small ice caps, some only a few square kilometres in area, especially on the offshore islands. The South Shetland Islands also have many ice caps.

Where ice flow from ice sheets or ice caps is constrained by topography, we recognise *outlet glaciers*. These flow directly into the ocean or feed ice shelves (see below). Outlet glaciers are a feature of the Transantarctic Mountains, which form a partially breached barrier to ice flowing from the East Antarctic Ice Sheet. Such glaciers were sought out by early explorers aiming to reach the South Pole, including Shackleton, Amundsen and Scott. They named the Beardmore and Axel Heiberg glaciers after their sponsors, while other outlet glaciers were named in turn after them. The largest of all the Transantarctic Mountain glaciers is the Byrd, named after the American explorer, Admiral Richard Byrd. Even larger outlet glaciers occur elsewhere in East and West Antarctica, but their margins are less evident as the ice largely overflows the

troughs through which they flow. Of these, arguably the largest ice-drainage basin of all is the Lambert Glacier – Amery Ice Shelf System in East Antarctica, which covers an area of over a million square kilometres.

A variety of independent glacier types, largely constrained by topography in the mountainous regions, is found in near-coastal regions of Antarctica. Those on the western side of the Antarctic Peninsula are particularly stunning examples, giving rise to some of the most spectacular landscapes on Earth. Of these, the largest are *alpine* or *valley glaciers*, which are long in relation to their width, and have low-gradient long profiles. *Cirque glaciers* occupy mountain amphitheatres, which they themselves have carved out, characterized by steep rocky headwalls and sides, with width and length being similar. Many cirque glaciers flow out of their amphitheatres into the sea via spectacular *icefalls*, while many cirques form clusters close to sea level. Small Antarctic glaciers often flow out of their cirques and coalesce at the foot of the mountains, forming *expanded foot glaciers*, while other single glaciers may spread out as *piedmont glaciers* on lower ground. Some glaciers can adhere to surprisingly steep mountainside through being frozen to the bed. Known as *hanging glaciers*, they are prone to ice-avalanching, and their ice debris can be reconstituted as a *regenerated glacier*.

In terms of their form, the dimensions of glaciers are controlled in part by the mountainous valley sides that contain them. In most parts of the world, typical

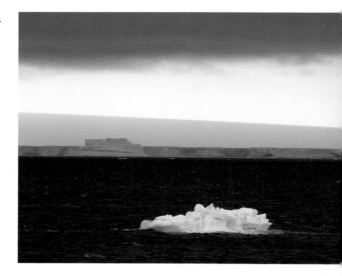

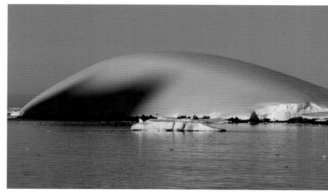

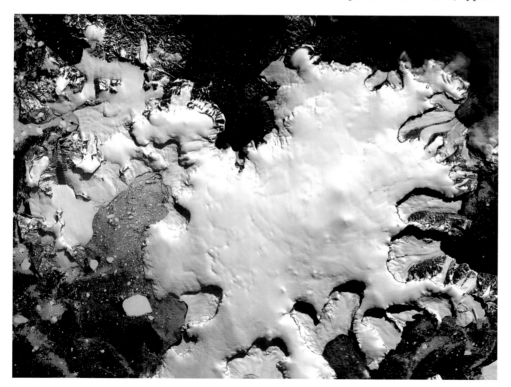

Left: Satellite image of the largely ice-covered James Ross Island, at the north-eastern tip of the Antarctic Peninsula, acquired on 3 March 2009. The image is about 60 km (37 miles) across. (Courtesy of NASA/GSFC/METI/ERSDAC/JAROS & US/Japan ASTER Science Team)

Top: The low-gradient surface profile of the West Antarctic Ice Sheet margin in the Bellingshausen Sea.

Above: A small, almost perfectly formed ice cap covering a small island off Booth Island at the northern end of Lemaire Channel, western Antarctic Peninsula.

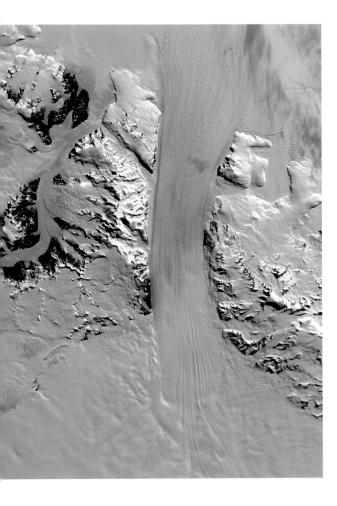

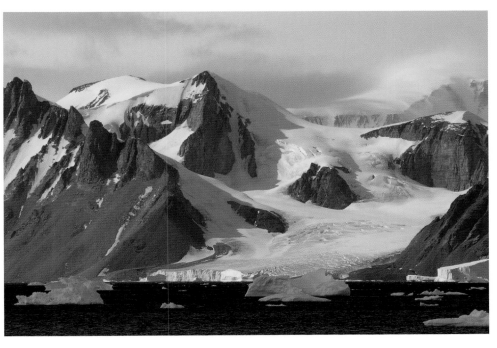

independent glaciers are often a few kilometres wide and tens of kilometres long, but many of those in Antarctica are an order of magnitude larger. By contrast, ice sheets bury the underlying bedrock topography as they grow, and their surface shape is controlled largely by the physics of ice – hence their very low surface-slope gradients and dome-like contours. Today, the only ice sheets on Earth are the Greenland Ice Sheet and the Antarctic Ice Sheet (which is subdivided in three distinct, but co-joined, ice sheets: East Antarctic, West Antarctic and Antarctic Peninsula ice sheets). The term ice cap is used for dome-shaped ice masses less than 50,000 km^2 (19,300 miles2) in area, but many are just a few square kilometres in area, but also largely bury the underlying topography.

Glacier ice originating on land, which flows into the sea, occurs in various forms, depending on how it interacts with marine waters. The main types are *ice shelves* which are slabs of ice floating on the ocean, *grounded ice walls* which rest directly on the sea bed, and *ice streams* which sometimes project outwards from the coast as *glacier* or *ice tongues*. Given that Antarctica is almost completely ice-covered, the margins of the Antarctic Ice Sheet are mainly with the adjacent ocean rather than ending on land. The ice-sheet terminus with the ocean appears as a continuous cliff of ice, comprising all three types of ice margin, which can be distinguished by their surface profile and degree of crevassing. The table overleaf indicates the lengths and proportions of the coastline represented by each type of marine ice margin. The cliffs are commonly 20-40 m (66-131 ft) high, with the exact height depending on

Above left: Satellite image of the huge Byrd Glacier (about 25 km / 15 miles across), which drains an interior ice-sheet basin of over 1 million km^2 (386,000 miles2), flowing from the polar plateau (bottom) through the Transantarctic Mountains into the Ross Ice Shelf (top). (Courtesy of NASA)

Above right: Snow-covered valley glaciers, with late summer exposures of darker ice near the terminus, drain into Bourgeois Fjord from the mountains of the western Antarctic Peninsula.

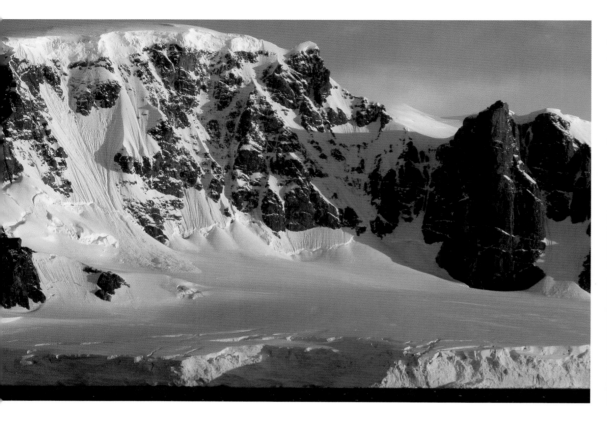

the thickness of underlying ice if the terminus is afloat. Such ice cliffs, with a low-gradient ice surface stretching inland beyond them, extend unbroken by exposed land for hundreds of kilometres around Antarctica. The length of marine termini around the whole continent exceeds 30,000 km (18,640 miles). When, in 1841, James Clark Ross first reached the ice-sheet margin in what is now known as the Ross Sea, his evocative name for it was the 'Great Ice Barrier'; it is now known as the Ross Ice Shelf. Indentations and notches sometimes provide embayments in the ice cliffs, formed by the break-off of sections of the margin as tabular icebergs. The Bay of Whales was such an indentation, from which Amundsen set off for the South Pole in 1911; the bay eventually disappeared through the subsequent calving of icebergs.

Where ice flows seaward from large drainage basins, the amount of ice discharge is very large and the ice often starts to float in deepening water to form ice shelves beyond their so-called grounding-lines. If such ice shelves are narrow relative to their length, they form distinctive filaments of ice that are known as ice tongues. The Drygalski, Erebus and Aviator ice tongues are three examples from areas of the Ross Sea that are often protected by sea ice from the swell waves that act to flex and fracture them.

These ice shelves and ice tongues are dynamically a part of the ice sheet and are fed by ice flow from the interior of the continent as well as by surface snowfall and, in

Above left: Local glaciers fed by snow and avalanches on the Danco Coast side of Gerlache Strait, western Antarctic Peninsula.

Above right: A small hanging glacier on the southeast side of Lemaire Channel, western Antarctic Peninsula. Forward movement is by ice creep under gravity, rather than sliding over the bed.

Opposite top: Edward Wilson's painting, entitled 'Tilted Berg off the Barrier. Jan 25 1902', illustrates the terminal ice cliffs of the Ross Ice Shelf which extend almost unbroken for about 500 km (300 miles) along its seaward margin. (© Scott Polar Research Institute)

Opposite centre: A long, uninterrupted stretch of coastline in Crystal Sound formed of the cliffs of coalescing mountain glaciers on Protector Heights, western Antarctic Peninsula.

Opposite bottom: The rolling contours of the crevassed ice-sheet margin, with tabular icebergs (some several kilometres across) embedded in shorefast sea ice beyond, on the Borchgrevink Coast of the Ross Sea.

Tilted Berg off the Barrier. — Jan. 25. 1902. — E.a.W.

some cases, freezing on of seawater at their base. The ice shelves spread under their own weight and form low-gradient floating extensions of the parent ice sheet. They are often several hundred metres thick and the seawater-filled cavities beneath them can be many hundreds of metres deep before the underlying sea floor is reached. These sub-ice shelf cavities are probably the least explored areas on the planet and have only occasionally been entered by unmanned and autonomous underwater vehicles. Large icebergs, discussed in Chapter 7, are broken off or calved from the marine margins of the ice sheet. In contrast to fast-flowing ice shelves and ice tongues, grounded ice walls are fed mainly by coastal snow accumulation and flow only a few metres a year, yet they represent over a third of the coastal fringes of the continent.

By contrast with the above morphological basis for classifying glaciers, they may also be distinguished according their temperature distribution, that is their thermal regime. A glacier that is at the pressure melting point throughout is referred to as

The principal types of marine ice margin in Antarctica, and their total lengths and proportions.

Glacier type	Total length (km)	% of coastline
Ice shelf	14,100	44
Ice stream/tongues	3,900	13
Grounded ice walls	12,150	38
Rock	1,650	5
Total	31,800	100

 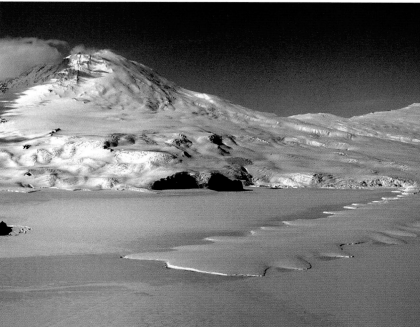

a *temperate* or *warm glacier*. These are the glaciers that most people from temperate regions will be familiar with, but they do not occur in Antarctica. A *cold* or *dry-based glacier* has ice that is below the pressure melting point, and is frozen to its bed. The best-known examples are in the Dry Valleys of Victoria Land, where measurements have yielded temperatures at the bed in the minus twenties celsius. A *polythermal glacier* is a hybrid of the two types, typically having 'warm ice' at the base (as a result of warming from geothermal heat), whilst the margins and upper parts are cold. Strictly speaking, much of the Antarctic Ice Sheet is polythermal, since nearly half of it is melting at the base, according to geophysical measurements.

Dimensions and distribution of Antarctic ice and global comparisons

The geographical distribution of the ice cover of Antarctica can be divided into three major geographical areas. The huge East Antarctic Ice Sheet (more than 10 million km² / 3.9 million miles² in area) is separated from the smaller West Antarctic Ice Sheet (almost 2 million km² / 770,000 miles²) by the Transantarctic Mountains, one of the largest mountain chains in the world. The ice cover of the Antarctic Peninsula Ice Sheet and the complexes of outlet glaciers that flow from it, at almost 0.5 million km² (193,000 miles²), represents the third area.

To demonstrate the vastness of the Antarctic Ice Sheet, comparison can be made with the major ice masses of the Arctic. The Greenland Ice Sheet is about 1.7 million km²

Above left: Satellite image of the 12 km (7.5 mile) long saw-toothed Erebus Glacier Tongue, embedded in shorefast sea ice. The Dellbridge Islands and Cape Evans, the site of Scott's *Terra Nova* hut, are at the bottom left of the image, which was acquired on 20 November 2001. (Courtesy of NASA/GSFC/METI/ERSDAC/ JAROS & US/Japan ASTER Science Team)

Above right: An oblique view of Erebus Glacier Tongue with the glaciers and volcano of Mt Erebus (left) and Mt Terror (right) looming in the background.

(656,000 miles2) has a volume of only 2.9 million km^3 (697,000 miles3), one-tenth that of Antarctica which holds 30 million km^3 (7.2 million miles3) of ice. Together, the Greenland and Antarctic ice sheets contain more than 99% of the fresh water on Earth, excluding that trapped in long-term storage as groundwater. The next largest ice masses are the Arctic ice caps on, for example, Ellesmere and Devon islands in the Canadian Arctic archipelago at 12,000-15,000 km^2 (4,600-5,800 miles2), and in Eurasia the largest modern ice mass is the Austfonna ice cap in eastern Svalbard at about 8,000 km^2 (3,000 miles2) in area.

Ice in Antarctica reaches a maximum of 4.7 km (2.9 miles) in thickness in central East Antarctica and 2.8 km (1.7 miles) deep below the South Pole itself. Typically, independent glaciers around the fringes of Antarctica are only a few hundred metres thick and a few to tens of kilometres long, contrasting with the ice sheets which are several thousand metres thick. We know the ice thickness because ice has the characteristic of being semi-transparent to radio waves at MHz frequencies. Aircraft flying over the ice sheet with ice-penetrating radars mounted beneath their wings transmit pulses of energy downwards towards the ice and record radar echoes that are returned from both the ice surface and its underlying bed; because the speed of radio waves in ice is known, if the time taken between pulse emission and return is measured, the ice thickness can be calculated over large areas of the continent systematically by flying airborne sorties.

Antarctica is also the highest continent on Earth, with an average surface altitude of 2.2 km (1.4 miles), because of the high elevation of the ice-sheet interior, sometimes known as the Antarctic Plateau. The highest point on the East Antarctic

Above: A tabular iceberg aground at the south-western edge of the Schollaert Channel which separates Anvers and Brabant islands, west of the Antarctic Peninsula. The berg is up to about 30 m (98 ft) high.

Overleaf: Satellite imagery of the ice-covered Antarctic Peninsula, its smooth fringing ice shelves, and the surrounding cover of sea-ice floes. The image is about 1200 km (750 miles) from top to bottom. (Courtesy of NASA)

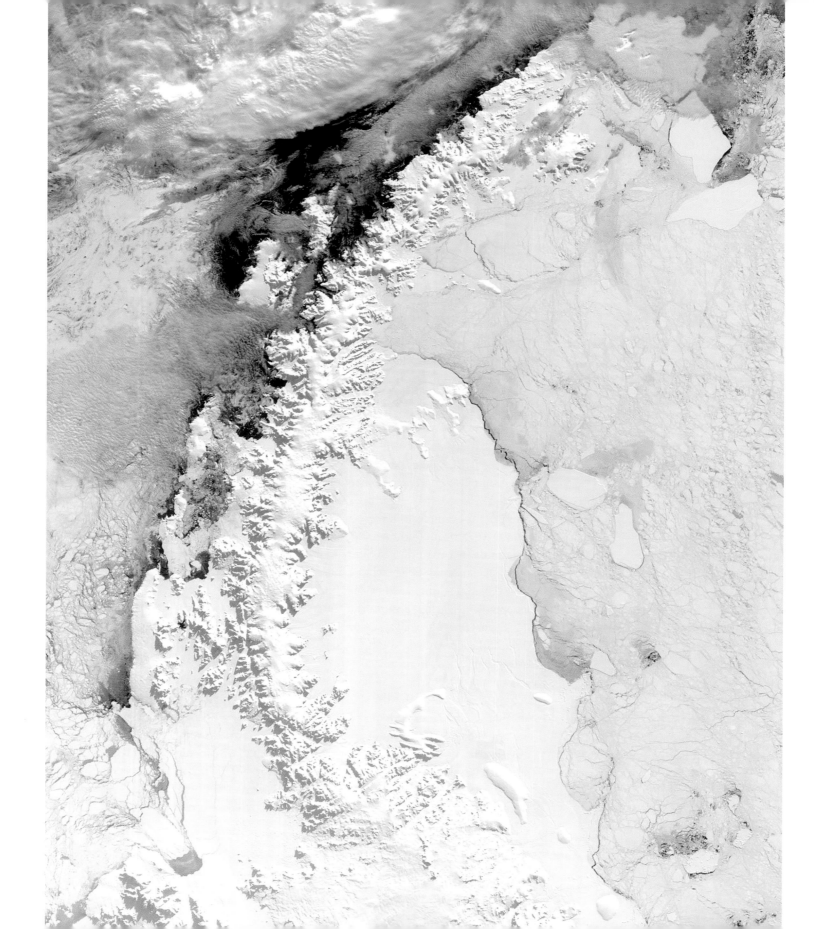

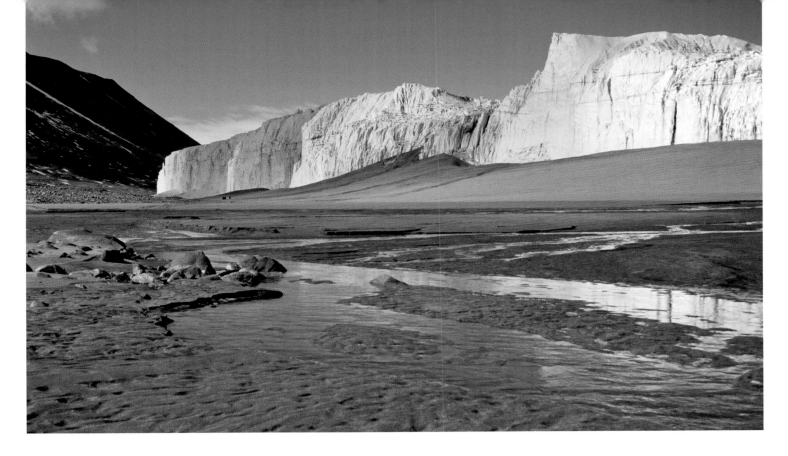

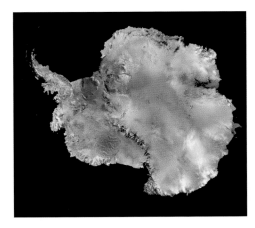

Top: The 'cold' Wright Lower Glacier and the source of the inland-flowing Onyx River in the Dry Valleys polar desert region of north Victoria Land, western Ross Sea.

Above: Satellite image mosaic showing the shape of the Antarctic continent, draped by its ice sheet and fringed by relatively flat floating ice shelves.

Ice Sheet is 4,093 m (13,428 ft) above sea level at Dome A or Argus, about 1,200 km (746 miles) from the coast.

The largest ice shelves in Antarctica are the Ross Ice Shelf and the Ronne-Filchner Ice Shelf, at 470,000 and 420,000 km^2 (181,000 and 162,000 miles2), respectively, partially filling the huge embayments of the Ross and Weddell seas. A number of smaller, but nonetheless substantial ice shelves fringe the marine margins of Antarctica, making up over 14,000 km (8,700 miles) or 44% of its coastline.

Flow of the Antarctic Ice Sheet

Glaciers, as they flow through mountain valleys, are sometimes described as 'rivers of ice'. This is strictly incorrect, as rivers flow as liquids, whereas ice flows as a solid under the influence of gravity, in a way very similar to the flow or deformation of a metal or rock close to its melting point. In practice, glaciers and ice sheets not only deform internally at slow rates of a few metres per year, but also move forward when water or soft sediments lubricate their bed. Where water lubrication takes place at the bed, the ice is effectively supported by layer of water or sediment under high water-pressure beneath, which reduces basal friction and allows motion to occur. Under these circumstances, ice may move much more rapidly than by internal deformation alone, at rates of hundreds and sometimes thousands of metres per year.

Ice flows out radially from the highest points on the ice sheet, where ice divides or crests (the glaciological equivalent of watersheds) define a series of huge drainage basins. Byrd Glacier, which drains an interior basin of 1.1 million km² (425,000 miles²) into the Ross Ice Shelf, and flows at up to 800 m/yr, has one of the largest drainage basins in Antarctica, along with the Lambert Glacier basin at over 1 million km² (386,100 miles²) which feeds the Amery Ice Shelf; both drain ice right from the crest of the East Antarctic Ice Sheet to the coast over 1,000 km (620 miles) away. Ice flow in the interior of the ice sheets is generally slow and dominated by ice creep rather than basal lubrication and sliding.

Within a few hundred kilometres of the ice-sheet margin, sometimes guided by subglacial troughs and mountains, curvilinear fast-flowing ice streams begin to develop within the Antarctic Ice Sheet – indeed, ice streams are characteristic of all ice sheets and ice caps in the Northern Hemisphere, too. Ice streams flow at much faster speeds than ice in the interior of the continent, at up to several thousand metres per year through basal sliding often over a deforming bed of sediment. They are typically tens of kilometres wide and hundreds of kilometres long, and are often heavily crevassed in contrast to the slower-moving ice at their margins. Particularly on the relatively narrow Antarctic Peninsula and its adjacent islands, a number of smaller independent ice caps or domes of a few thousand square kilometres are present, together with individual glaciers that flow between constraining valley walls and are a few to tens of kilometres in length.

One of the most striking features of the Antarctic Ice Sheet, when viewed from space, is the long linear structures that depict the flow of ice, commonly from deep within the ice sheet all the way to the coast. Called flow stripes, they indicate converging flow, when different flow units combine, and sometimes even divergence around obstacles. They also record the past dynamic history of different parts of the ice sheet. Some glaciologists think that flow stripes represent the three-dimensional structure of the ice, notably foliation, which commonly forms parallel to the ice flow direction.

In the Dry Valleys area, close to McMurdo Sound, there is no surface melting and most of the glaciers are relatively thin, frozen to their beds and are slow-flowing. Some of these glaciers are fed by ice flowing in from the East Antarctic Ice Sheet through the Transantarctic Mountains, whereas others are nourished from accumulation in adjacent local mountain ridges; there is almost never any precipitation in the valleys themselves – hence their name. Most mass loss here, unusually, is by sublimation rather than surface melting.

The ice-sheet surface

Most of the surface of the Antarctic Ice Sheet is covered by snow overlying glacier ice. Although, as was discussed in Chapter 4, the interior of Antarctica is a cold desert, with very low accumulation, the snow is mobile. Given that Antarctica is the windiest continent,

Top: Basler twin-engined turbo-prop aircraft (with a refurbished DC-3 frame) and under-wing radar antenna for ice-thickness measurement.

Above: Detail of radar antenna beneath Basler wing with C-130 in background, McMurdo Sound.

Opposite top: Map showing the speed of flow of the Antarctic Ice Sheet. The fastest-flowing areas (dark blue and purple) are floating ice shelves and the ice streams that feed them from huge drainage basins in the interior of the ice sheet (boundaries marked in black). (Courtesy of E. Rignot, J. Mouginot, B. Scheuchl, UC Irvine and NASA Jet Propulsion Laboratory)

Opposite bottom: Chapman Glacier and ice stream that descends from the Antarctic Peninsula Ice Sheet in Palmer Land into the George VI Ice Shelf, southwestern Antarctic Peninsula.

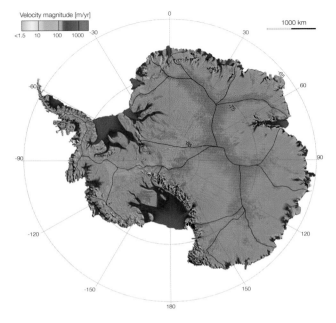

Velocity magnitude [m/yr]
<1.5 10 100 1000

snow in the metre of two above the surface is frequently mobilised and transported by wind action. The surface in many areas has sastrugi, or snow dunes, formed in the same way as sand dunes in a desert. These sastrugi can, in areas of consistently orientated strong winds, develop to be over a metre high with a very hard outer crust. The dunes have posed difficulties for past explorers and scientists travelling over-snow, and also make the landing of ski-equipped aircraft hazardous. Wind erosion, often combined with enhanced melting from rock walls warmed by summer isolation, can also produce surface features known as windscoops close to valley sides.

In some areas of Antarctica, known as 'blue ice' zones, consistent winds can also remove all the accumulated snow and, because they are very dry, even contribute to the process of mass loss by sublimation. The largest blue ice areas in Antarctica cover tens of thousands of square kilometres. By contrast with snow dunes, these areas are commonly rather smooth and have, therefore, been used as natural ice runways for aircraft attempting isolated deep-field landings in the Antarctic interior. Examples are the blue ice runways at Union Glacier in the Ellsworth Mountains, where many tour parties set out from to visit the South Pole, and the blue ice area used to resupply Norway's Troll Station in the Dronning Maud Land area of East

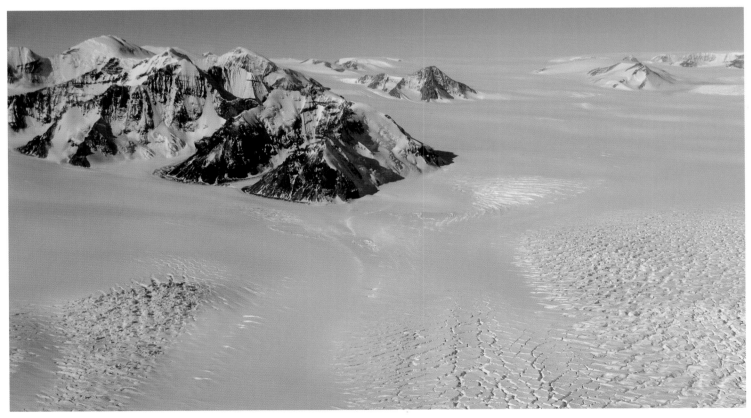

Antarctica. Blue ice areas were encountered by the early explorers Shackleton and Scott on the Beardmore Glacier. The very hard, scalloped and highly polished ice surface makes walking, even with crampons, a challenge. Some areas of bare glacier ice are actually very rough and greyish in colour. This stems from variable ablation as a consequence of the uneven distribution of wind-blown dust or entrained sediment. Depressions can form vertically sided holes, referred to as *cryoconite holes*. Such sites act as localised ecosystems for the growth of bacteria and algae (Chapter 8). Good examples of this type of rough ice are the southern McMurdo Ice Shelf and the Ablation Lake area of the George VI Ice Shelf.

Around the fringes of Antarctica, especially in the northwestern part of the Antarctic Peninsula and the archipelago of the South Shetland Islands, surface melting takes place in this warmest part of the continent. Bare ice is revealed at low elevations as all the winter snow accumulation is removed, and darker ice is exposed. A closer look at the bare ice also reveals ice structures, such as folds, foliation and crevasse traces, formed by changing stresses and crystallography in the ice.

Scientists mapping out the patterns of these features can reconstruct a record of past changes in ice deformation along glacier flow-lines from ice crest to marine margin.

Below: Satellite image of the Dry Valleys and their surrounding mountains and glaciers, located about 100 km (60 miles) west of McMurdo Station. The image is about 70 km (43 miles) across. (Courtesy of NASA/GSFC/METI/ERSDAC/JAROS & US/Japan ASTER Science Team)

Opposite top left: Marine ice cliffs and curved windscoop at the rocky edge of Back Cirque on Adelaide Island, viewed from Elliot Passage, west of the Antarctic Peninsula.

Opposite top right: Tidewater glacier ice cliffs and wind-blown snow on eastern Anvers Island, from Neumayer Channel.

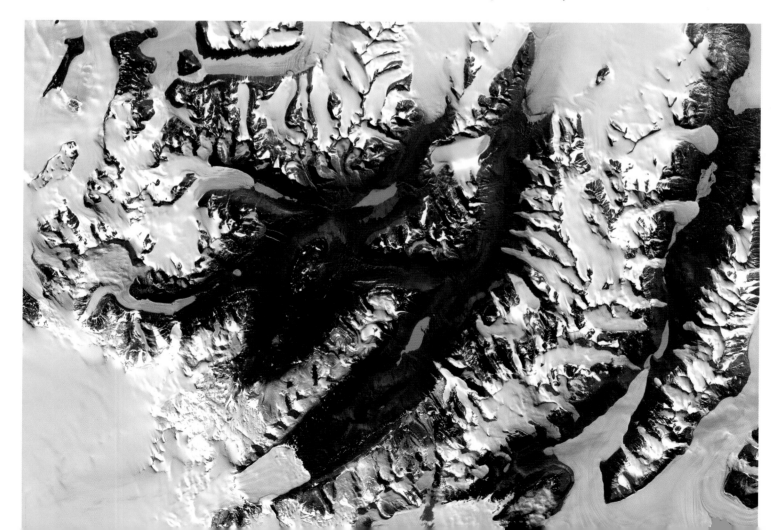

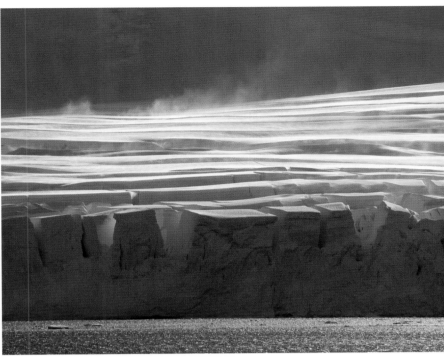

Above: Wind-scalloped snow surface, showing the intricate layered structure of sastrugi, at the edge of McMurdo Ice Shelf, southwestern Ross Sea.

Glaciers and ice sheets as conveyers of debris

Glaciers are well known for being powerful agents of erosion and creators of some of the finest landscapes on Earth, including Antarctica. But how are the products of erosion conveyed by glacier ice and removed? Compared with glaciers around the world, those in Antarctica are relatively clean. Freeze-thaw processes are less pronounced than in warmer regions; thus, exposed bedrock along the flanks of valley or cirque glaciers, or in nunataks above the ice sheet, does not deliver large amounts of debris to the ice surface. Nevertheless, where snow is removed by wind, exposing blue ice areas, surface debris bands known as medial and lateral moraines are formed from rock falls onto the glacier surface from adjacent valley walls or nunataks, and are exposed as dark linear features that follow the direction of ice flow, or there may be isolated patches of debris from single-event rock-falls. This debris is characteristically blocky and angular, containing little material of sand-grade or finer.

The bulk of debris, however, is transported near the bed and is known as 'basal glacial sediment'. It is 'entrained' by freeze-on where the ice is sliding over a water-lubricated bed, a process known as 'regelation'. The debris in this case differs markedly from surface debris in that the stones are partially rounded, sometimes striated (i.e. scratched), and are mixed with a large proportion of fine-grained

sediment. Once entrained at the bed, the debris can be raised higher into the body of the glacier by ice-tectonic processes, such as folding, shearing and thrust-faulting. Some of this material may even reach the surface in zones where the ice is strongly compressed and the debris concentrated into tightly folded layers – such debris-rich ice forms where the ice sheet abuts mountain ranges, or flows into topographic enclaves where it is trapped.

Although entrainment of most basal glacial sediment requires ice to be at the pressure-melting point – which is true for much of the Antarctic Ice Sheet, and especially its outlet glaciers and ice streams – debris can also be entrained into ice that is frozen to the bed. In this case, the large stresses imposed on the bed by internally deforming ice can dislodge blocks of bedrock or frozen sediment and move them considerable distances. This debris resembles rock-fall surface debris in being largely angular.

All these processes are well known from observations of individual glaciers and from the ice sheet margin. Several studies have been made on the individual cold-based glaciers in the Dry Valleys of Victoria Land, and along the land-terminating part of the East Antarctic Ice Sheet margin in the Vestfold Hills. Further north, where meltwater is more abundant, such as the South Shetland Islands, the suites of sediment are rather different, given the role of streams in recycling the glacial debris.

Although sediment is delivered to ice margins on land and readily visible, it is in the surrounding ocean that the true importance of the ice sheet as a conveyor of debris is to be found. Thick glacial sediments overlie the continental shelf, whose edge coincided with the termini of many former ice streams during past full-glacial periods. Beyond the shelf edge, on the continental slope, huge wedges of sediment called 'trough-mouth fans' formed. The Prydz Trough-Mouth Fan, for example, lies at the former limit of an expanded Lambert Glacier, and formed in stages over a period of 34 million years.

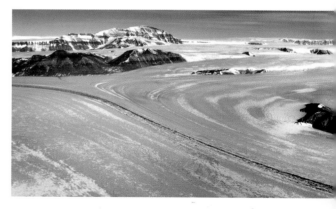

The ice-sheet bed

Understanding conditions at the base of the Antarctic Ice Sheet is of vital importance in determining its dynamics and stability in the context of global warming. A fundamental difference between the East and West Antarctic ice sheets is the elevation of their underlying beds. The East Antarctic Ice Sheet rests mainly on a bed that lies above sea level, with the notable exceptions of the Aurora, Wilkes and Astrolabe subglacial basins. By contrast, much of the bed of the West Antarctic Ice Sheet sits hundreds of metres below sea level, and this ice sheet is therefore known as a marine-based ice sheet. This difference in bed topography has major implications for the stability of the two ice sheets, in that ice retreat into deep water in West Antarctica will encourage mass loss through the calving of icebergs from a floating ice margin, whereas retreat to elevations above sea level in East Antarctica will mean that mass loss is reduced. This has led scientists to call the West Antarctic Ice Sheet 'the weak underbelly of

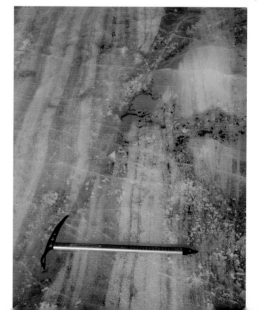

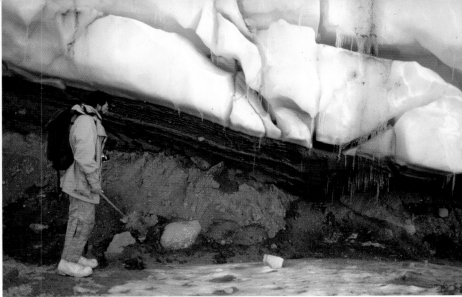

Top left: Blocks of bedrock (conglomerate) carried on the surface of a small glacier near Ablation Lake on Alexander Island, southwestern Antarctic Peninsula.

Top right: The transition from debris-rich basal ice (the dark layered structure) and till (the pale grey sediment beneath), exposed in an ice cliff at Taylor Glacier, north Victoria Land.

Opposite, from top to bottom:

The glazed, wind-polished ice surface of lower Mill Glacier, just above its confluence with Beardmore Glacier in the Transantarctic Mountains.

A cryoconite hole on the surface of McMurdo Ice Shelf, showing a radial arrangement of air bubbles in an ice lid, and a sediment/algae mix ('cryoconite') beneath. The diameter of the hole is about 30 cm (1 ft).

Shackleton Glacier, a major outlet of the East Antarctic Ice Sheet, cutting through the Transantarctic Mountains. On the surface is the prominent Swithinbank Moraine, a line of debris formed where two streams of ice combine.

Foliation, an ice structure produced by compression or shear in western George VI Ice Shelf. It is cut by a blue ice vein, originally a water-filled crevasse.

Antarctica', implying that it is the part of the continental that is at most risk of rapid regional-scale deglaciation and accompanying rapid sea-level rise.

It might be assumed that the bed of an ice sheet several kilometres in thickness was very cold and entirely frozen. In fact, temperatures within the Antarctic Ice Sheet become warner with depth. This is because the ice sheet provides effective thermal insulation from the very cold surface air temperatures, thus allowing geothermal heat from the Earth's interior to warm the ice sheet from below. Thus, the warmest basal temperatures are usually found beneath thick ice, and a significant proportion of the ice-bed interface of the Antarctic Ice Sheet is at the pressure-melting point, remembering that the melting point is depressed through increasing pressure by about 0.63° C (1.13° F) for each 1,000 m (3,280 ft) of ice thickness. A further complication to ice-sheet basal temperature is that the amount of geothermal heat varies within the continent, being two to three times greater in the volcanically active areas around the huge rift valley that underlies much of the West Antarctic Ice Sheet compared with the East Antarctic.

There are also many lakes beneath the ice sheet, fed by slow basal melting. The lakes were first identified through characteristic flat and very bright ice-penetrating radar records produced by mirror-like reflections from their smooth water surfaces. The largest subglacial lake discovered to date is Lake Vostok, located within a major bedrock valley in the interior of East Antarctica; the lake measures 250 km (155 miles) in length and 50 km (31 miles) in width and is about 12,500 km² (4,826 miles²) in area – about half the size of Switzerland or New Jersey in the USA. Most subglacial lakes are, however, less than 5 km (3 miles) across, and over 400 have so far been identified beneath both the East and West Antarctic ice sheets using a combination of bright radar returns from the bed and very flat areas of the ice-sheet surface identified from satellite altimeters.

The subglacial lakes were at first thought to contain water that had been isolated from outside contamination for very long periods, perhaps millions of years in some cases, and might therefore be sources of unusual bacteria and other ancient genetic material

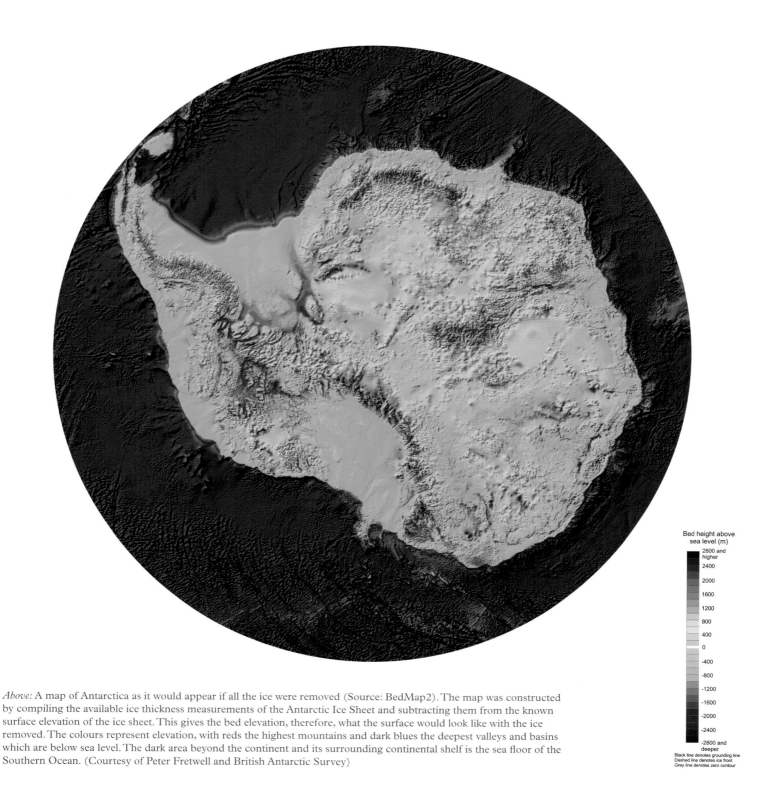

Bed height above
sea level (m)

2800 and
higher
2400

2000

1600

1200

800

400

0

-400

-800

-1200

-1600

-2000

-2400

-2800 and
deeper

Black line denotes grounding line
Dashed line denotes ice front
Grey line denotes zero contour

Above: A map of Antarctica as it would appear if all the ice were removed (Source: BedMap2). The map was constructed by compiling the available ice thickness measurements of the Antarctic Ice Sheet and subtracting them from the known surface elevation of the ice sheet. This gives the bed elevation, therefore, what the surface would look like with the ice removed. The colours represent elevation, with reds the highest mountains and dark blues the deepest valleys and basins which are below sea level. The dark area beyond the continent and its surrounding continental shelf is the sea floor of the Southern Ocean. (Courtesy of Peter Fretwell and British Antarctic Survey)

Above: Global sea-level rise, today running at about 3.4 mm/yr (0.13 inches/yr), is likely to become an increasing problem for coastal communities during the 21st century. Here, waves crash over the breakwater at Aberystwyth on the coast of Wales during a storm.

Below: The internal structure of part of the Antarctic Ice Sheet, derived from airborne ice-penetrating radar data operating at MHz frequency. The ice surface, internal layers, a subglacial lake and mountainous bedrock can all be identified, even where the ice is between 3 and 4 km (about 2 to 2.5 miles) thick. (Source: Scott Polar Research Institute)

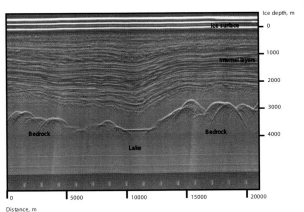

with pharmaceutical potential. Recently, however, elevation changes of a few metres in the ice-sheet surface over some subglacial lakes have demonstrated that at least some lakes drain intermittently, with connections to lakes further downstream. The lakes then fill up, accompanied by a consequent rise in their overlying ice surface. The drainage system beneath the Antarctic Ice Sheet therefore has dynamic and connected plumbing, with lakes presumably linked by subglacial channel systems. The waters of Lake Vostok have recently been penetrated by drilling through 3,768 m (12,362 ft) of overlying ice. There are plans to lower a probe into the lake, which is probably about 400 m (1,300 ft) deep with a volume of roughly 5,000 km³ (1,200 miles³). This is a huge freshwater body, comparable in volume with Lake Michigan, and vastly bigger than some of the largest surface reservoirs such as the Three Gorges in China or Lake Powell in the USA which hold a mere 35-40 km³ (8-10 miles³) of water each.

Antarctic ice-sheet decay and sea-level rise

Today, the changing extent, velocity and surface-elevation of the Antarctic Ice Sheet can be measured very accurately using repeated satellite observations, allowing the investigation of whether the ice sheet is getting larger or smaller. This is a problem of global significance, given that net loss of ice from the Antarctic continent will lead to world-wide sea-level rise.

The measurement of ice extent has been possible since satellite images of Antarctica were first collected systematically with the launch of the *Landsat* series of satellites in the 1970s. Such imagery, acquired at visible wavelengths, provides a time series of the changing area of Antarctic ice. In addition, several geophysical methods enable the changing mass of the ice sheet to be measured. Satellite radar altimeters, operating at GHz or microwave frequencies, together with the use of lasers, allow the surface elevation of the ice sheet to be measured repetitively to an absolute accuracy of a few tens of centimetres – if the surface elevation rises mass is gained and *vice versa*. This is a remarkable degree of accuracy, given that satellites such as *CryoSat-2* and *IceSat* are orbiting the Earth at altitudes of about 600 km (373 miles) and 700 km (435 miles), respectively.

The changing distribution of mass on Earth can also be assessed through the measurement of very small shifts in the gravity field around the globe, using the twin *GRACE* satellites; if ice is lost from Antarctica and redistributed as water to the global ocean, this will cause an observable change in the gravity field over the parts of the continent from which mass has been lost. Repeating such measurements over a period of years allows changes in ice extent and surface elevation to be calculated and, hence, the recent volume-change of the ice sheet to be estimated.

Changes in ice extent have been observed since the start of regular satellite monitoring of glacier fluctuations over the past four decades. Particularly striking is the retreat of over 80% of studied glaciers on the Antarctic Peninsula. More importantly

for decadal sea-level rise, the thinning of the ice sheet in some areas of West Antarctica in particular has been recorded using satellite measurements. Evidence derived using several independent satellite datasets shows that both West Antarctica and the Antarctic Peninsula have thinned and therefore lost mass over the past 15 years or so. By contrast, surface elevation and mass change in East Antarctica are close to zero over the same period, with perhaps a slight gain of mass that is close to the limit of detectable change. Between 1992 and 2011, average net loss from the West Antarctic Ice Sheet has been about 65 gigatons per year (Gt/yr) and from the Antarctic Peninsula approximately 20 Gt/yr, whereas the East Antarctic Ice Sheet may have made a small gain of about 15 Gt/yr. These average values represent an overall loss of about 70 Gt/yr from the Antarctic Ice Sheet, which is approximately half the mass loss of about 140 Gt/yr from the much smaller Greenland Ice Sheet.

The combined losses of ice from Antarctica and Greenland represent about 0.6 mm/yr or 20% of a total sea-level rise averaging just over 3 mm/yr over the same period. However, the rate of mass loss from Greenland has continued to accelerate since 2001, and it is thought that the Greenland Ice Sheet alone now contributes over 0.7 mm/yr to global sea-level rise. The total ice sheet contribution is almost 1 mm/yr, accounting for about one-third of the whole rise.

The remainder of the observed contemporary sea-level rise of 3.4 mm/yr is contributed from two sources. The first is from the melting of glaciers and ice caps elsewhere in the Arctic outside Greenland and from high-mountain areas of the world such as the Andes and Himalayas. The second is the thermal expansion of the oceans. As the world ocean continues to warm, under the strong influence of increasing levels of 'greenhouse' gases that include both carbon dioxide and methane, it expands. This is a process that occurs with all liquids, which take up more space as they are heated, as a simple home experiment can demonstrate. It is thought that ocean expansion contributes about 1.5 mm/yr to global sea-level rise, leaving the ice caps and mountain glaciers outside Antarctica and Greenland contributing a little under 1 mm/yr.

In comparison, average global sea-level rise over the 20th century was about 1.8 mm/yr, a rate that has almost doubled before the end of the second decade of the 21st century. Given that global mean temperature has shown a marked rising trend since the 1980s (Chapter 4), this shift towards greater rates of glacier and ice-sheet melting and, therefore, more rapid sea-level rise is not surprising.

Past ice-sheet form and flow

Approximately 20,000 years ago, at the height of the much colder last-glacial period, often referred to as the Last Glacial Maximum, global sea-level was about 120 m (394 ft) lower than today. At that time, the Antarctic Ice Sheet expanded and thickened, leading to its advance by as much as several hundred kilometres, in some places as far as edge of the continental shelf around Antarctica.

Evidence for these ice-sheet fluctuations comes from marine sediment cores, the radiocarbon dating of the carbonate shells of micro-organisms in these cores, and the shape of the sea floor. As ice expanded across the Antarctic continental shelf it deformed the sediments immediately beneath it to produce streamlined subglacial landforms. As the climate warmed, the ice margin retreated back towards its present position to reveal these landforms on the exposed sea floor. Marine-geophysical instruments allow these landforms to be imaged, with their maximum distribution and orientation on the continental shelf providing a record of past-ice sheet extent and flow direction (Chapter 7).

At the Last Glacial Maximum, mid-latitude ice sheets also built up over North America and Eurasia, with the former growing to about the same size as today's Antarctic Ice Sheet; for example, ice covered the Great Lakes and New York, and much of Britain and Scandinavia, at that time. This much larger total volume of glaciers and ice sheets produced a global sea-level fall of about 120 m (394 ft) relative to today, because the source of precipitation building the ice sheets was the global ocean. In addition, when the bulk of this ice, including almost all of the mid-latitude North American and Eurasian ice sheets, melted as the Earth passed from a full-glacial to its present interglacial climate, sea-level was rising at a maximum of 40-60 mm/yr about 14,000 years ago, much higher than today's rate.

At longer timescales, the inception of ice-cover on Antarctica took place at least 34 million years ago, when it is known to have reached the coast, probably linked in part to the

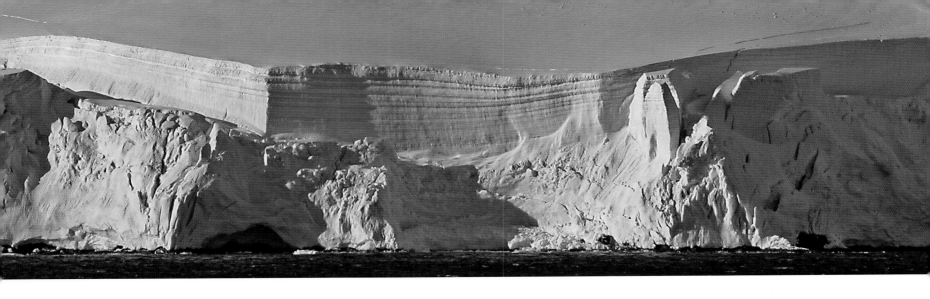

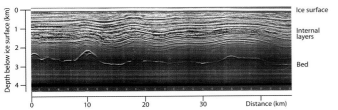

increasing isolation of Antarctica from lower-latitudes with the opening of the Drake Passage between South America and the Antarctic Peninsula, as discussed further in Chapter 3. There is also evidence from the bedrock landscape buried deep beneath the present Antarctic Ice Sheet that conditions may in the past have been more conducive to meltwater flow than they are today, indicating substantial climate change even since the ice sheet first formed. This is discussed in more detail in Chapter 6.

Past environmental change recorded in Antarctic ice cores

It is because snow builds up on the surface of ice sheets regularly each year that the layer-cake structure or stratigraphy of the Antarctic Ice Sheet provides a continuous long-term record of past environmental change. A number of deep ice cores have been recovered by drilling through the ice sheet, providing evidence of change dating back almost a million years. The two longest cores, in terms of both length and timespan, are those at Dome C and Vostok Station, 560 km (348 miles) apart near the crest of central East Antarctica. The sites were chosen here because snow accumulation is very low and ice flow is limited and simple. The Dome C ice core is 3,270 m (10,728 ft) long and records about 800,000 years of environmental history; that from Vostok Station contains ice dating back 420,000 years. Ancient air can be extracted from trapped bubbles deep in the ice to provide a direct archive of atmospheric gases, including past levels of carbon dioxide, methane and nitrous oxide.

From the analysis of melted ice-core samples, isotopes of several elements, most notably oxygen, can also be analysed to yield records of past temperature fluctuations. Marker horizons within the ice sheet, sometimes related to past major volcanic eruptions, can also be used to infer past changes in accumulation rate, surface-elevation and flow direction. These horizons can be mapped over much of Antarctica using airborne ice-penetrating radar records, because some of the radar signal is reflected back to the surface from internal layers within the ice sheet as well as from the bed.

Top: Internal layering ('stratification') exposed at a marine glacier terminus on Lion Island near the northern entrance to Neumayer Channel west of the Antarctic Peninsula.

Above: Internal layers in a 3 km (almost 2 mile) thick area of the Antarctic Ice Sheet recorded using ice-penetrating radar. Each layer represents a past ice-sheet surface that has been buried by subsequent snowfall, with such particularly reflective horizons sometimes due to past volcanic activity. (Source: Scott Polar Research Institute)

The Antarctic ice-core evidence on past temperatures and the changing nature of atmospheric gases over almost 800,000 years is crucial to the understanding of how Earth's climate has fluctuated. Seven periods known as glacial-interglacial cycles have been observed. In each cycle of about 100,000 years, the Earth's climate passes from a cold or glacial state to a warmer or interglacial state. The interglacial periods have temperatures similar to those of today and the past 10,000 years, whereas 80-90% of each cycle has colder temperatures than today by about 10° C (18° F), and ice sheets grew much larger than they are now. Thus, today, we live in a relatively warm interglacial period. Similarly, it can be shown from ice-core measurements that warmer interglacial periods were linked to higher carbon dioxide and methane levels, confirming their importance as 'greenhouse' gases. Finally, the ice-core records also show that carbon dioxide and methane levels today are much higher than at any time represented by the sampled ice – almost a million years. The significance of this increase in greenhouse gases for the future is discussed in Chapter 12.

Conventionally, ice-core drill sites are located at major domes on the ice sheets, because here distortions due to ice flow are minimized and the generation of a chronology or timescale is simplest. Cores recovered so far from these sites go back about 800,000 years. However, coring of old ice emerging at the surface in areas such as the Allan Hills, which are blue-ice zones constantly swept clear of new snow by wind, has sampled ice that may be much older.

Sensitivity of the Antarctic Ice Sheet to environmental change

Some parts of the Antarctic Ice Sheet are changing rapidly, and there are fears that such changes may accelerate over the coming decades as the atmosphere and oceans warm in response to climate change, a high proportion of which is induced by humanity's continuing use of fossil fuels and the production of greenhouse gases. Over much of the Antarctic Peninsula, and in several huge drainage basins of the West Antarctic Ice Sheet, changes are already being recorded and monitored using repeat satellite coverage.

An area of particular concern is the 350,000 km² (135,100 miles²) of the West Antarctic Ice Sheet that is drained by Pine Island and Thwaites glaciers; an area similar in size to that of Germany. These outlet glaciers have floating terminus regions, and satellite radar altimeter data show that the ice here is thinning. In addition, the grounding-line of the glaciers, where the ice looses contact with the bed and begins to float, is retreating. Further, because the ice is retreating into deeper water, this is seen as a place where the potential for stabilization of such retreat is limited. The combination of ice thinning and deepening water makes for a buoyant margin, with further iceberg calving and retreat likely into the interior of the ice sheet whose bed lies hundreds of metres below sea level. One important cause of the recent thinning is the incursion of relatively warm water from the Amundsen Sea across the Antarctic

Above: Ice cores contain a detailed record of past environmental change. Here, part of a 364 m (1,194 ft) long core from the summit of the ice cap on James Ross Island, at the northeastern tip of the Antarctic Peninsula, is being retrieved. The core contains a record of past temperature that may extend back several tens of thousands of years. (Courtesy Robert Mulvaney)

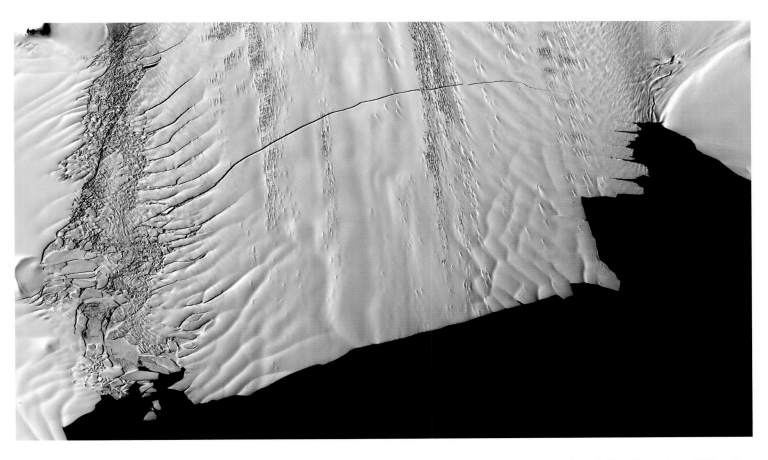

Above: The terminus of Pine Island Glacier (imaged on 13 November 2011), which drains into Pine Island Bay in the Amundsen Sea sector of West Antarctica. The ice is flowing from top to bottom and a prominent crack marks the likely point at which future icebergs may separate from the parent glacier. The image is about 52 km (27 miles) across. (Courtesy of NASA/GSFC/METI/ERSDAC/JAROS & US/Japan ASTER Science Team)

continental shelf to reach beneath the floating margin of Pine Island and Thwaites glaciers. This is a good illustration of the way in which relatively warm water and floating ice shelves produce particularly vulnerability to future losses of ice via basal melting that can reach a number of metres per year.

Major international scientific programmes are at work in the Pine Island-Thwaites area of West Antarctica, monitoring any changes in the rate of thinning and of potential increases in ice velocity, which might indicate increasingly rapid loss of ice from this drainage basin to the ocean. If the entire basin were to collapse, perhaps on the timescale of a century or two, our existing estimates of global sea-level rise, currently about a metre by 2100, would have to be revised upwards by at least half a metre. The strong influence of ice sheets and glaciers on global sea-level, and the changes scientists are observing today using sophisticated satellite instruments, mean that continuing monitoring of change and the enhancement in understanding of the processes affecting ice-sheet stability, are high-priority areas for continuing investigation. Changes in Antarctica, Greenland and in other Arctic and mountain glacier systems, are very relevant to people living in all parts of the globe particularly on low-lying coastlines and in the port cities of the world.

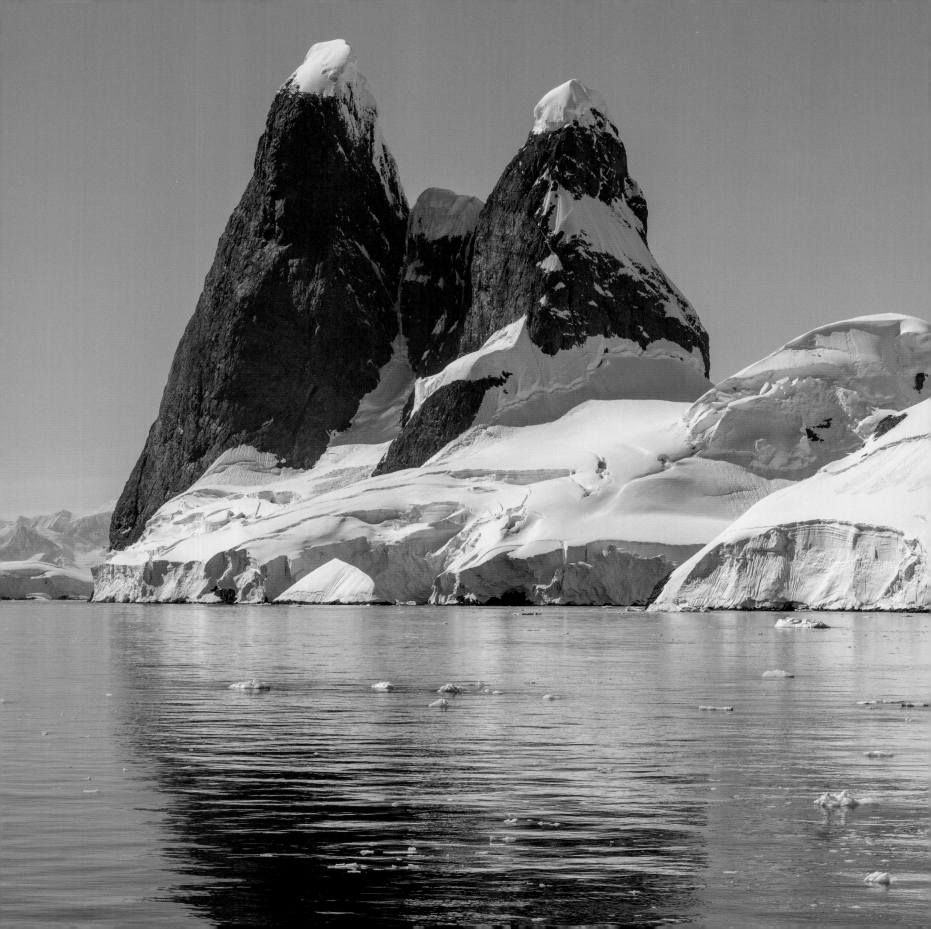

CHAPTER 6

The Emerging Landscape

Camping on a nunatak named Fisher Massif in the Prince Charles Mountains, overlooking the vast ice stream of the Lambert Glacier – Amery Ice Shelf system, my colleague Barrie McKelvey and I set out to unravel the ancient landscape history of this remote corner of Antarctica. Our project was one of several operated by the Australian National Antarctic Expedition of 1994/95, involving a 500 km (300 mile) transfer of our field camp from Davis Station on the coast. Our camp was organized by mountaineering-trained field assistant, Heather, and with polar pyramid tents to sleep in, and a small "Apple" fiberglass cabin for cooking and work, proved to be comfortable even in bad weather. We each had quad-bikes (colloquially known as "quikes") for getting around the ice-free stony terrain. A pair of Sikorsky long-range helicopters delivered the vehicles as under-slung loads, along with the cabin and camping equipment. Our nunatak, discovered as recently as 1957, rises nearly 2,000 m (6,400 ft) above the surrounding ice, and carries its own small glaciers, as well as broad open valleys dissecting a plateau-like massif measuring 30 by 9 km (18.6 x 5.6 miles). We found glacial troughs filled with glacier-influenced marine sediment at two distinct levels above the modern ice stream, which, following investigation of the fossil content back at home, dated back some 30 million years. The sediments that once accumulated below sea level in a huge fjord had been uplifted high above the modern glacier, giving us a sense of many million years of landscape evolution. The bare weathered rock surfaces and heaps of gravel, with well-developed patterned ground, also demonstrated to us the longevity of this landscape, and at high levels it appeared that shallow valleys were not carved by glaciers at all, but represented a pre-glacial river-fashioned landscape.

MJH

A continent buried by ice

The vast ice sheet covering the Antarctic continent, averaging almost 2 km (1¼ miles) in thickness, currently leaves only about 45,000 km² (17,000 miles²) or less than 1% free of ice. It is to this small area that most humans gravitate and establish their scientific bases, and where most onshore wildlife is to be found. Thus, scientists have learned a considerable amount about the processes operating in these ice-free areas, which are unique on the planet for their cold and arid nature, and devoid of vegetation except for

Opposite: Landscape of glacial erosion. A pair of peaks known as 'horns', at Cape Renard, form striking sentinels on the approach to Lemaire Channel from the north, western Antarctic Peninsula.

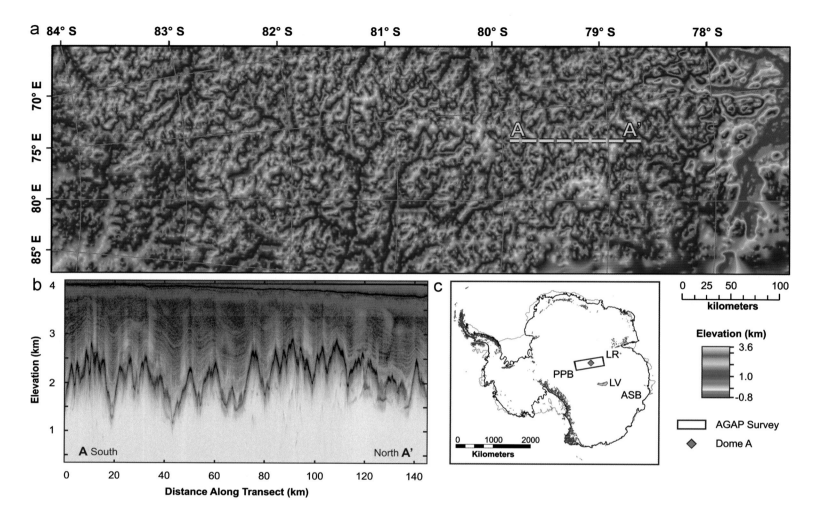

a 84° S 83° S 82° S 81° S 80° S 79° S 78° S

70° E 75° E 80° E 85° E

A ———————— A'

b 4 3 2 1

Elevation (km)

A South North **A'**

0 20 40 60 80 100 120 140

Distance Along Transect (km)

c

0 25 50 100
kilometers

Elevation (km)
3.6
1.0
-0.8

☐ AGAP Survey
◆ Dome A

LR
PPB
LV
ASB

0 1000 2000
Kilometers

algae and moss. These ice-free zones are commonly referred to as 'oases', and may be dotted with small lakes and carry small streams in summer.

The Antarctic Ice Sheet hides a subglacial landscape of remarkable complexity buried under several kilometres of ice that is slowly being revealed by ice-penetrating radar (Chapter 5). Nowadays, scientists have the technology to not only define the precise morphology of the bed, but can also find subglacial lakes and determine the internal structure of the ice sheet. It is from the resulting ice-thickness data that the crucial information about ice-sheet volume has been determined.

The Antarctic continent consists of three unequal parts: East Antarctica, West Antarctica and the Antarctic Peninsula (Chapter 2). The truly continental, and largest part is East Antarctica, where the ice sheet overlies an uneven bedrock surface that is mainly above sea level. However, there are several major troughs that extend well below sea level, one of which, the Astrolabe Subglacial Basin, underlies the thickest ice in the whole of Antarctica, amounting to 4,776 m (15,669 ft). Slicing through the

Above: A window on the hidden Gamburtsev Mountains, buried beneath the East Antarctic Ice Sheet. This area was surveyed by radio-echo sounding and other instruments fitted to a Twin Otter aircraft by an international team of scientists in 2008. The topographic map (a) covers an area of 182,000 km² (70,271 miles²), and shows deep valleys (green), fjords (blue) and mountains (orange, red, white). The cross section, A-A' (b), shows typical alpine topography, with the layering in the ice sheet draped over the top. The black box shows the surveyed area within Antarctica (c). The abbreviations are as follows: ASB–Aurora Subglacial Basin; LV–Lake Vostok; Lr–Lambert rift; PPB–Pensacola Pole Basin. The red diamond indicates the summit of Dome A, the highest part of the East Antarctic Ice Sheet. (From Rose et al., 2013, reproduced under Elsevier's Creative Commons Attribution License)

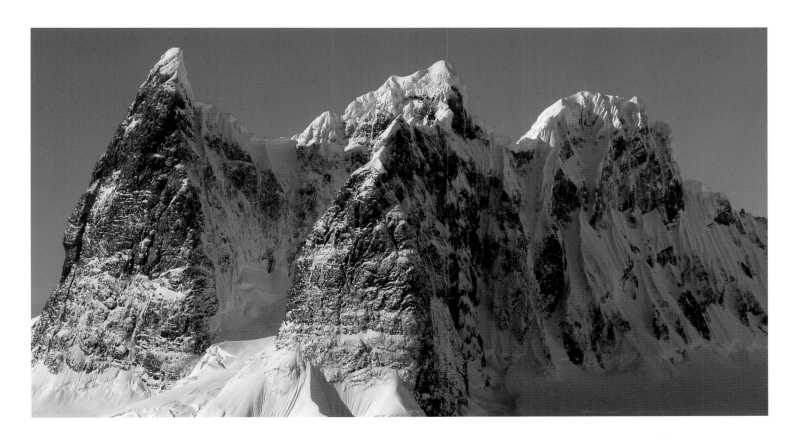

Above: Narrow ridge, known as an arête, formed as a result glacial erosion on both sides of Humphries Heights, near north end of Lemaire Channel, Antarctic Peninsula.

Transantarctic Mountains are many glacial troughs, occupied by famous glaciers such as the Amundsen, Beardmore, Byrd, Scott and Shackleton. These are also over-deepened below sea level, and are the product of excavation of bedrock by glaciers. Without glaciers and the buttressing Ross Ice Shelf, these troughs would be enormous fjords.

Even more remarkable is the presence of a mountain range of alpine proportions that is totally buried by ice – the Gamburtsev Subglacial Mountains. Detailed airborne radar surveys have recently been undertaken by an international team, the results revealing outstanding examples of buried glacial troughs, cirques and arêtes. The mountains are about 3,000 m (nearly 10,000 ft) high, but here the ice sheet reaches an elevation of nearly 4,000 m (13,000 ft) in elevation, and there is little surface expression of the complex topography beneath. Glaciologists regard these mountains as particularly significant, because it is here that the earliest East Antarctic Ice Sheet could well have started growing.

Similar landforms occur high in the arid parts of the Transantarctic Mountains, but have long been devoid of any ice. Alpine-style peaks and cirques in regions closer to the coast are nearly, but not quite buried by ice, indicating that these landscapes represent the first stages of glacier-growth in Antarctica, before the developing glaciers

coalesced to form the ice sheet. Furthermore, analysis of the subglacial bedrock topography reveals an even older history – a branching network of former river valleys converging into the huge Lambert Glacier, only some of which have been excavated subsequently by glaciers. Otherwise, these valleys have lain below cold parts of the ice sheet, which has protected them from subsequent erosion.

If the ice sheet were to melt, the Earth's crust would respond to the removal of ice by rising sometimes to elevations above sea level, a process called 'isostatic rebound'. The process is slow, and can take thousands of years, but it has been calculated that the interior of Antarctica could rise as much as 900 m (3,000 ft).

West Antarctica is not strictly continental as the ice sheet fills a complex series of basins that are below sea level (Chapter 5). Even after isostatic uplift, most of these basins would remain below sea level. Although the West Antarctic Ice Sheet is mainly marine-based, there is a range of mountains in the middle, the Ellsworths, which are in fact the highest in Antarctica. In Mt Vinson, they reach a height of 4,897 m (16,066 ft). These are also alpine peaks, and, like their counterparts in East Antarctica, the peaks were probably carved out by mountain glaciers prior to the growth of the ice sheet. The Ellsworth Mountains serve as a 'dip-stick' for estimating previous levels of the ice-sheet surface. New techniques, referred to as surface-exposure dating, now allow geologists to determine the time a particular surface has been exposed. The most prominent ice level in the Ellsworth Mountains, indicated by a 'trimline', dates from the Last Glacial Maximum, around 20,000 years ago. Since then, the ice sheet in this area has thinned by 230-480 m (760-1,580 ft).

The final piece in the Antarctic jig-saw is the Antarctic Peninsula, a mountain range that reaches heights typically of 1,500–2,000 m (4,900-6,500 ft), much of it capped by the long and narrow Antarctic Peninsula Ice Sheet. Although the ice volume is relatively small by Antarctic standards, it drapes the Peninsula from top to toe. Glaciers have eroded into a central elongate plateau, producing cirques and glacial troughs, features typical of alpine-style glaciation, and most of the coastline is fringed by glacier ice. To the west of the Peninsula are numerous mountainous islands, the largest of which (from north to south) are Brabant, Anvers, Adelaide and Alexander islands. Here, several peaks reach heights of 2,500-3,000 m (8,000-10,000 ft).

Glacial processes

The scars of glacial erosion and deposition are evident in many parts of the world given that, during the last full glacial period (or Ice Age) about 15-20,000 years ago, as much as 30% of the Earth's land surface was covered by glaciers and ice sheets. Antarctica can, therefore, provide insights concerning Ice-Age processes. However, as we have seen, the amount of ice-free ground is very limited, and therefore most of Antarctica's ice interacts directly with the ocean, as explained in Chapters 5 and 7. Another limiting

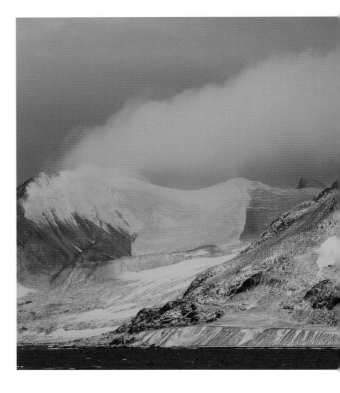

Above: Jenny Island, off the southeast coast of Adelaide Island, west of the Antarctic Peninsula, displays well-preserved raised beaches, indicating post-glacial uplift of this small island.

Opposite top: Granite bedrock, smoothed by glacial erosion, provides a site for a Gentoo penguin rookery on Pléneau Island near the southern entrance to Lemaire Channel, Antarctic Peninsula.

Opposite right: Aerial view of glacially eroded terrain of small hills and lakes, known as knock-and-lochan topography, Vestfold Hills, East Antarctica. The gneiss bedrock is dissected by prominent black igneous intrusions (dykes).

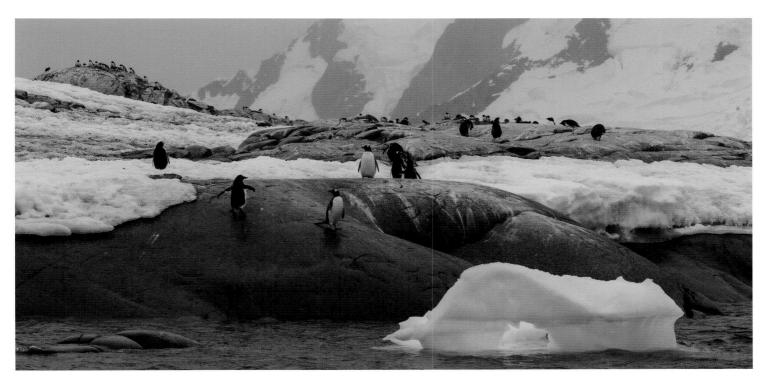

factor is that, even where ground is exposed, the former ice masses in many places were frozen to the bed, and tended to protect the landscape rather than erode it.

Glacial erosion in the distant past has produced the major troughs that are seen today, and this process continues, albeit largely hidden from view. The legacy on exposed land is best expressed in the Dry Valleys of Victoria Land, where valleys such as the Wright and Taylor have broad, straight flat-bottomed forms, with remnant glaciers still present. The most impressive glacial erosional scenery, however, is provided by the fjords, straits, channels and bays of the Antarctic Peninsula, which are expanding rapidly as the ice recedes. Many of these landforms are viewed by passengers on cruise ships, which ply the waters west of the Peninsula in the relatively sea-ice free summer period.

Less dramatic glacial erosional landscapes are found in some areas of low relief in the coastal oases of Antarctica. In East Antarctica, near the Australian stations of Casey and Davis, low rocky hills and lakes are present that can be described as 'knock-and-lochan' topography, after the glacially eroded landscape of northwest Scotland. There, on a smaller scale, glacially abraded and plucked surfaces form much of the low ground around the periphery of the ice sheet. Whaleback-shaped forms, known as *roches moutonnées*, several to tens of metres in length and height, are commonly carved with striations and chattermarks, which give an indication that glaciers were wet-based and sliding on their beds. To find extensive striated pavements that are so characteristic of glaciers in temperate and sub-polar regions, we need to turn to the

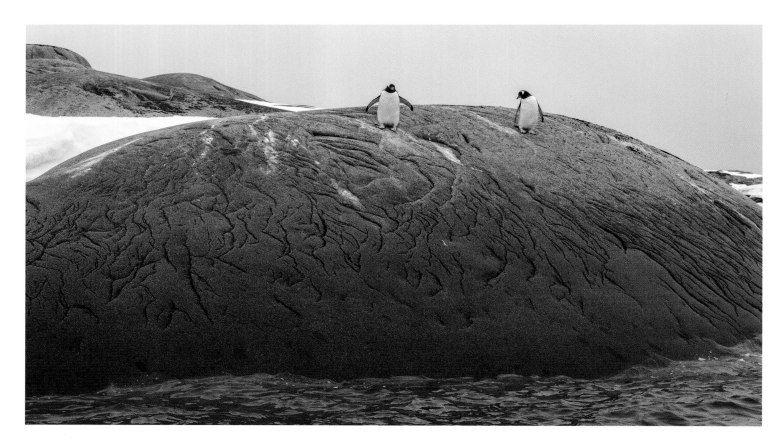

geological record, such as the bedrock that underlies the multi-million-year-old Sirius Group, described in Chapter 3.

An unusual landscape of erosion is the so-called Labyrinth at the head of Wright Valley in Victoria Land, where a 50 km (30 mile) long network of channels is cut into dolerite bedrock. The now-dry channels are up to 600 m (2,000 ft) wide and 250 m (800 ft) deep. They extend from the modern East Antarctic Ice Sheet, splitting and rejoining across the overall gently inclined terrain. Scientists think that the channels were formed during several subglacial outburst floods, when meltwater under high pressure escaped from beneath a much thicker East Antarctic Ice Sheet, some 14 million years ago. Similar subglacial meltwater channels and networks are also present elsewhere in Antarctica, some of them dating back several million years, but preserved by burial under younger glacial deposits. Off the Antarctic coast, on now deglaciated continental shelves, extensive channel networks have also been mapped.

The characteristics of glacial deposits generally reflect the climatic and topographic regimes under which they form, so there are differences between those in the Dry Valleys, and those in the milder northern part of the Antarctic Peninsula, well north of the Antarctic Circle. Most glacial geologists have accepted the long-held

Above: Small-scale features of glacial erosion are these curved fractures, known as crescentic gouges, on granite bedrock, formed by the juddering effect of boulders embedded in a glacier moving from left to right; Pléneau Island, Antarctic Peninsula.

Overleaf: The heavily 'glacierised' Anvers Island, dominated by Mt Français (2,825 m / 9,268 ft), one of the highest mountains in the Antarctic Peninsula. View across Gerlache Strait from Neko Harbour on the mainland.

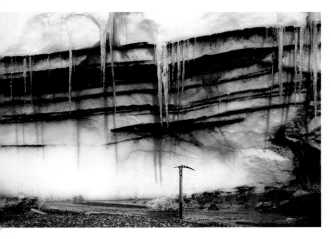

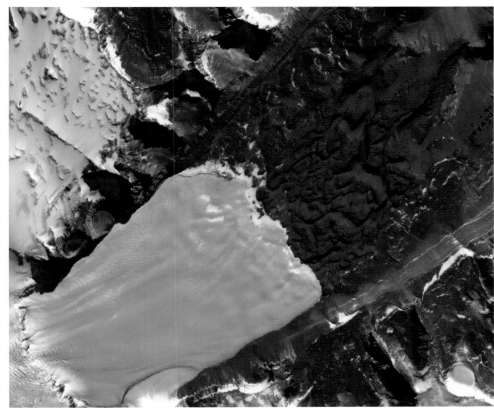

Top left: Debris close to the base of Taylor Glacier in the Dry Valleys. It has been entrained by freeze-on to the bed of the glacier and uplifted by deformation processes, including folding.

Above left: Aerial view of wind-blown sand piled up against the snout of Wright Lower Glacier, Dry Valleys. The sand covers a wedge of glacially deformed sediment. Small streams flow off the glaciers, and join the dried up stream bed flowing from left to right. This is the Onyx River, the longest exposed water-course in Antarctica. The cliff face is about 10 m (30 ft) high.

Above right: Satellite image of Victoria Upper Glacier, an outlet from the East Antarctic Ice Sheet in the Dry Valleys of Victoria Land. In front of the glacier is an extensive area of huge subglacial meltwater channels, known as the Labyrinth, formed during massive floods spanning a few million years. (Courtesy of NASA)

view that cold glaciers (those that are frozen to the bed) do not erode their beds or produce landforms such as moraines, but this is not always the case. In our work in the Dry Valleys, particularly at Wright Lower Glacier, where the temperature at the base is -17° C (1.4° F), we have documented how frozen debris is entrained into the base of cold glaciers and then undergoes internal deformation. The forward movement of the ice also deforms the frozen sediment in front of it, producing ramps up to 10 m (32 ft) high. Wind-blown (aeolian) sand commonly drapes these features, giving the appearance of sand dunes built up against the glacier margin. In areas of exposed bedrock in the far south, including some of the southernmost outcrops on the planet at 85° S, extremely arid conditions prevail, but the ice sheet has left dozens of closely spaced moraines, simply comprising angular boulders. These are formed by slight readvances of cold-based ice across the land, formed over thousands to perhaps millions of years.

Isolated boulders, commonly of different composition to the underlying bedrock, called erratics, are found throughout the ice-free areas of Antarctica, even at high levels in the mountains. They testify to periods when the ice sheets were thicker than those of today, indicating that during Ice Ages many of the now-exposed high mountains on the continent were mantled with ice.

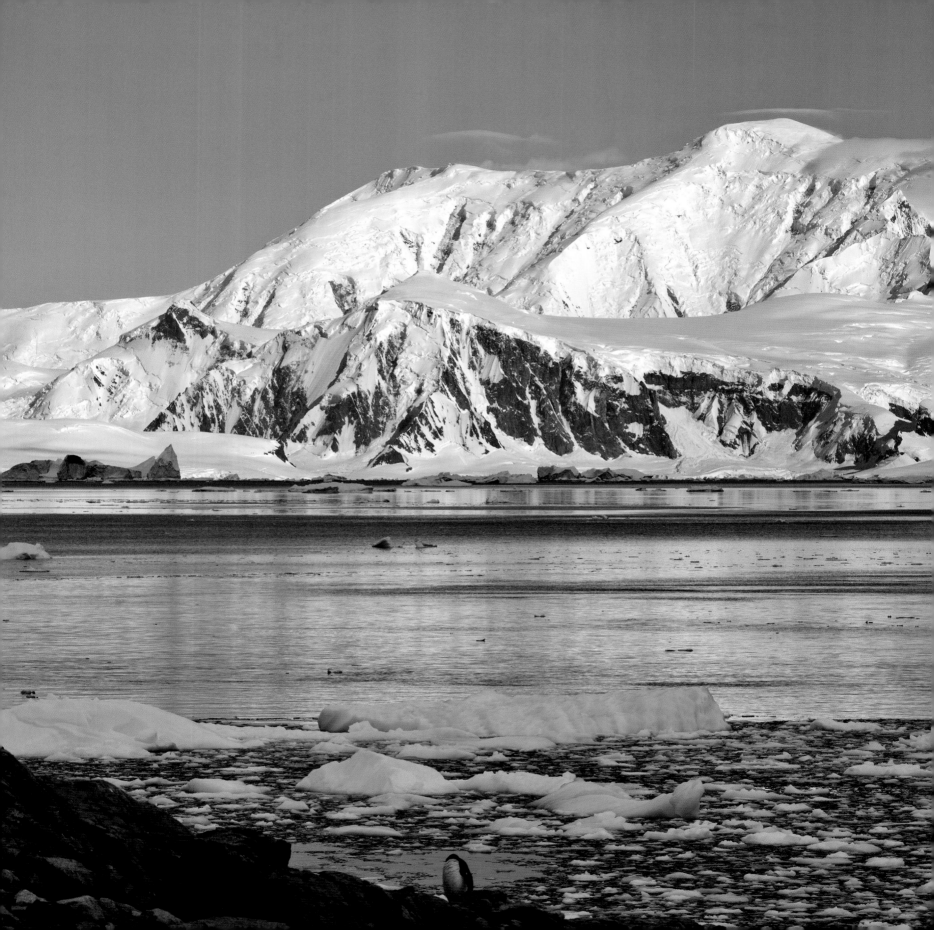

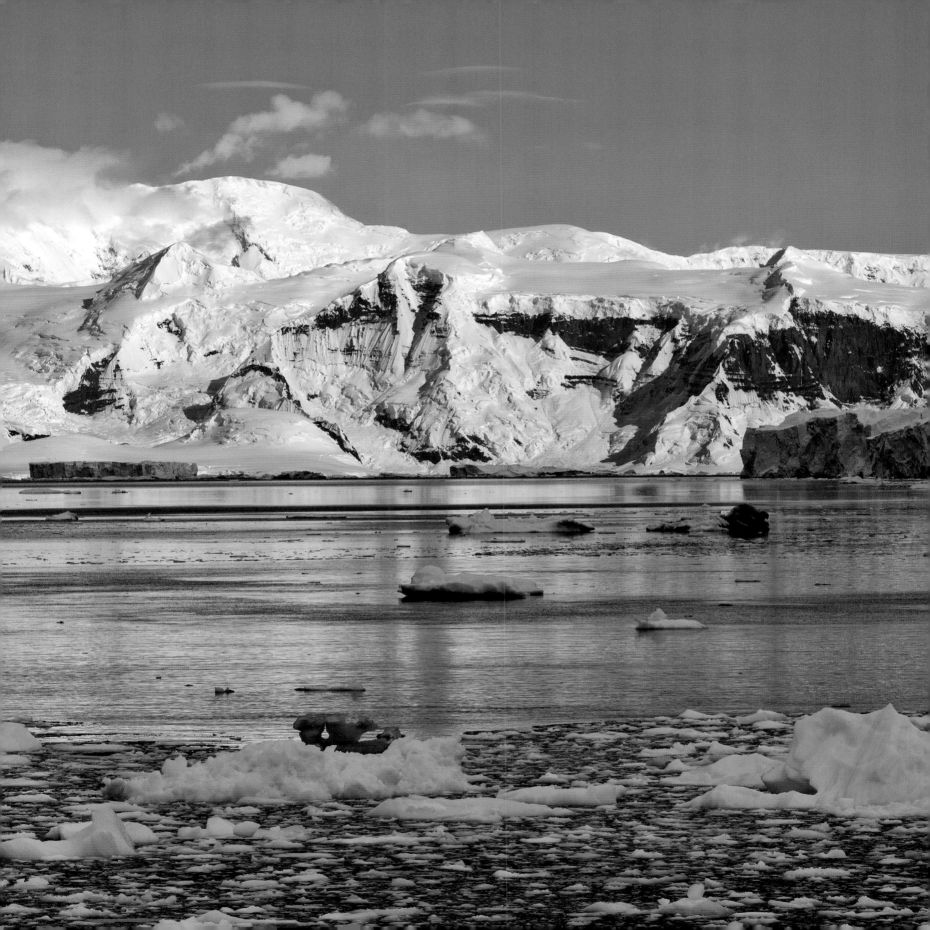

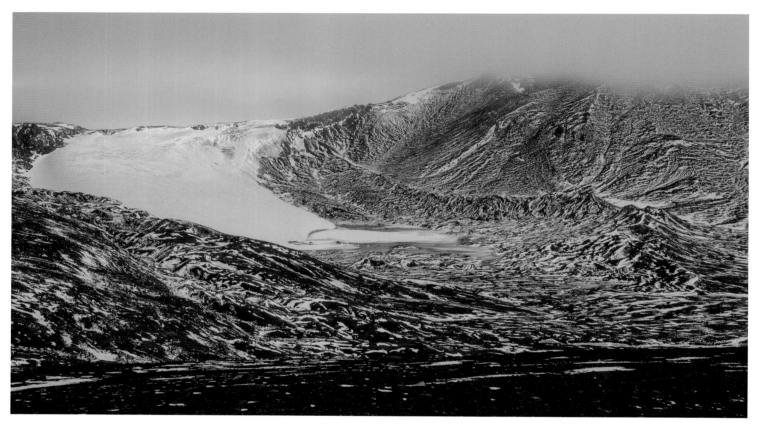

Above: A disconnected remnant of an outlet glacier from the James Ross Island Ice Cap, near Terrapin Hill. The prominent ridges on either side and below the snout are ice-cored lateral moraines, marking a former advanced position of the ice.

Right: The stagnating ice cap of Rotch Dome on Livingston Island, South Shetland Islands. In the foreground is an area of ponds known as kettle holes, and ice-cored moraines. In summer, an area like this is very soft and the glacial sediment is prone to debris flowage.

In the northern Antarctic Peninsula region, the climate is similar to that in high-Arctic areas, such as Svalbard, and the depositional characteristics are similar. Here, glacier recession has been taking place rapidly, over the past half-century or so, in one of the fastest warming regions on Earth (Chapter 4). Glacial landforms include prominent moraines, many of which are ice-cored, and water-generated features are not unusual. Furthermore, the sediments are more varied than those in cold, arid Antarctica, so mud, sand and gravel, and mixtures of each of these, are found. Glacial and meltwater deposits are abundant in areas inside the most recent moraines, which are thought to date from the Little Ice Age of the 19th century.

Mass movements

A variety of mass-movement processes occurs in Antarctica that are induced in one form or other by water. The largest features are landslips, but they are not common, and require special geological conditions. On James Ross Island, south of the tip of the Antarctic Peninsula, these conditions exist, where hard volcanic rocks rest on weak Cretaceous sand and mud, which in places are dipping gently seawards. Large detached blocks up to a kilometre long (about 0.6 miles) and over 100 m (328 ft) thick are slowly sliding downslope towards the sea, giving rise to a

Above: A large Precambrian gneiss erratic resting on a much younger surface of glacial sediments, several million years old, Amery Oasis, Prince Charles Mountains. It indicates a thicker, more expanded East Antarctic Ice Sheet in the past.

Right: A scattering of granite erratics, amongst glacial debris at Minna Bluff, at the edge of the southern McMurdo Ice Shelf, Ross Sea region. The young basalt volcano of Mt Discovery (2,681 m / 8,796 ft) is in the background.

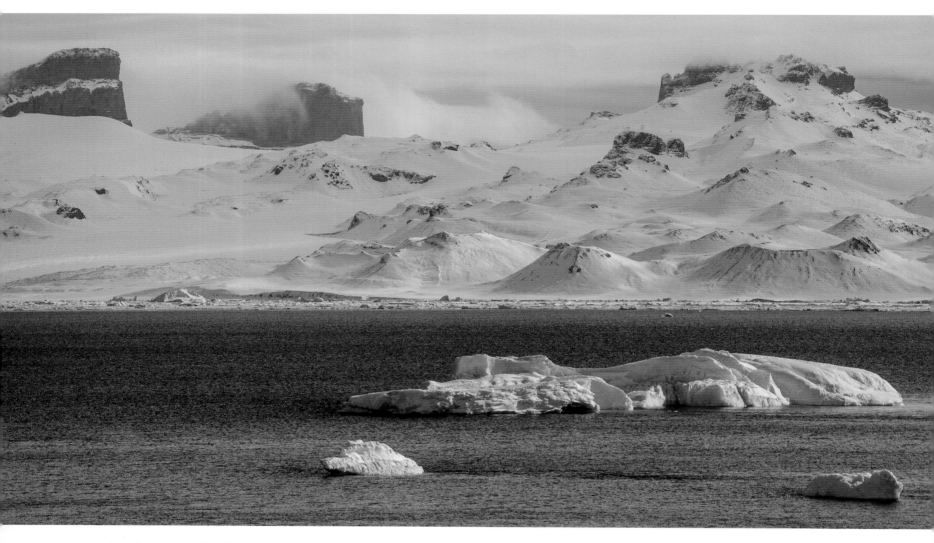

chaotic topography. It is not clear how active this process is today, and it is possible that some of these features could be a few million years old. Other large-scale mass movements are rock glaciers, with clear examples occurring on James Ross Island and in the South Shetland Islands. Here snow melts in summer and refreezes in a mass of loose rock to produce 'interstitial ice'. This ice can undergo deformation, allowing the material to creep downhill slowly, probably at less than 1 m (3 ft) a year, if comparisons with similar features in the Arctic are valid. Rockfalls seem to increase in incidence further north in Antarctica, as the glaciers here have a considerable amount of surface debris, whereas those at higher latitudes do not. Similarly, well-developed scree slopes are found mainly in the north where freeze-thaw processes are more prevalent. In the south, debris-strewn slopes are common, but the ground

Above: Ulu Peninsula, viewed from Croft Bay on James Ross Island, reveals large-scale landslips. The peaks are formed of hard basaltic volcanic rock and are underlain by soft sandstone and mudstone. Slippage and downslope movement occurs slowly over time, resulting in a complex topography of tilted basalt blocks.

just beneath the surface is generally frozen. For fieldworkers used to dealing with scree slopes in the Northern Hemisphere, where the stones give way beneath their feet, the frozen screes of Antarctica seem much more treacherous.

Gully-formation is a common product of erosion, both in bedrock, where freeze-thaw is the dominant process, and in unconsolidated sediment or soft bedrock, where the process is dominated by water from melting snow.

Another form of mass movement that becomes active when the temperature rises above freezing and the permafrost thaws out is debris-flowage. The lack of vegetation to bind loose material and soil together means that saturated ground on a slope is prone to failure. Either the sediment then creeps downslope, or it fails catastrophically and produces a fast-flowing body of sediment. The mass may leave a channel bounded by levees (ridges of sediment), before stopping as a lobate mass.

Mass movements in the form of slumping and debris flows are common in areas where glaciers have receded or stagnated, a common feature in more northern regions, such as the South Shetland Islands. Large amounts of glacial debris, comprising particles ranging from mud to boulders, are deposited in such regions, but commonly this sediment overlies stagnant or dead ice. As the ice melts in summertime, the sediment becomes saturated and flows downslope, sometimes temporarily exposing the stagnant ice beneath.

Bottom left: Rock glaciers are a feature of the northern Antarctic Peninsula region. They are formed from rockfall debris in which ice, from snow melt, has accumulated in the pore spaces between the boulders, enabling the whole mass to creep downslope. This example is on the flanks of Admiralty Bay, King George Island, South Shetland Islands.

Bottom right: Freeze-thaw processes in the more maritime regions of Antarctica produce fan-shaped lobes of scree, also known as talus cones. Here, scree is falling onto a glacier at the foot of a rock cliff in Neumayer Channel, Antarctic Peninsula.

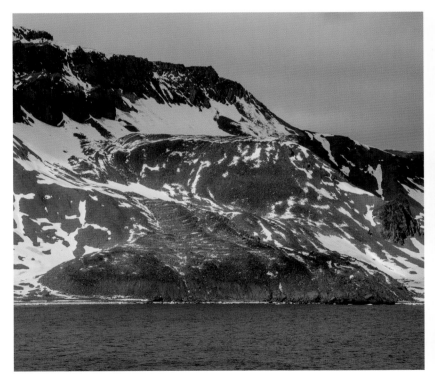
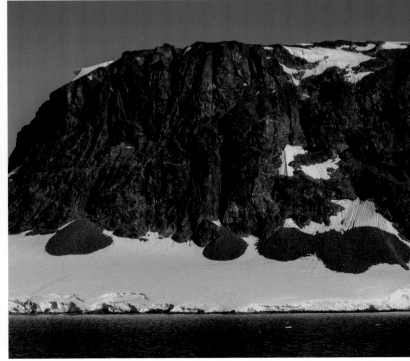

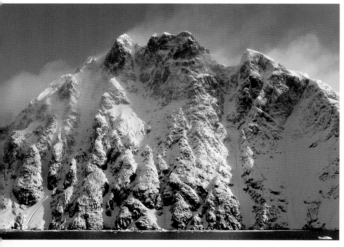

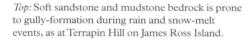

Top: Soft sandstone and mudstone bedrock is prone to gully-formation during rain and snow-melt events, as at Terrapin Hill on James Ross Island.

Above: Deep gullies in hard bedrock (metamorphosed volcanic rocks) in Humphries Heights, Lemaire Channel. Freeze-thaw processes selectively weather bedrock along faults or other weakness.

Right: Snow melt above Whalers Bay, Deception Island, has triggered flows of volcanic ash downslope, forming streaks on the snowbank below.

Opposite left: Example of stone polygons, a type of patterned ground formed by sorting of stones by freezing and thawing of glacial sediments over thousands or even a few million years. Regular polygons formed on the floor of Beacon Valley, Victoria Land, measuring several metres in diameter.

Opposite right: A fractured granite boulder about 3 m (10 ft) tall, surrounded by wind-blown sand, lower Taylor Valley, Victoria Land. Fracturing is caused by thermal stresses induced by solar radiation resulting in large temperature gradients within the rock, aided by biological-chemical weathering from algae in cracks.

Periglacial processes and weathering

'Periglacial' refers to geomorphological (landscape-forming) processes that occur in response to seasonal thawing of frozen ground, typically in terrestrial zones beyond the glacier ice margin. Periglacial processes are normally associated with permafrost (permanently frozen ground), but also with other areas where freezing and thawing of ground takes place. Permafrost forms where the mean annual temperature is below freezing, so the whole of Antarctica lies within this zone. The depth of permafrost is unknown, but probably amounts to several hundred metres in areas bordering the ice sheet. In most parts of the continent, and especially in the northern Antarctic Peninsula region, the surface only thaws out on north-facing slopes. Periglacial geomorphologists describe permafrost as "continuous" or "discontinuous", the latter occurring where conditions are marginal for its formation. As such, Antarctica offers a broad spectrum of periglacial processes, and these are classified into three zones: Maritime Sub-Antarctic (beyond the scope of this book), Maritime Antarctica

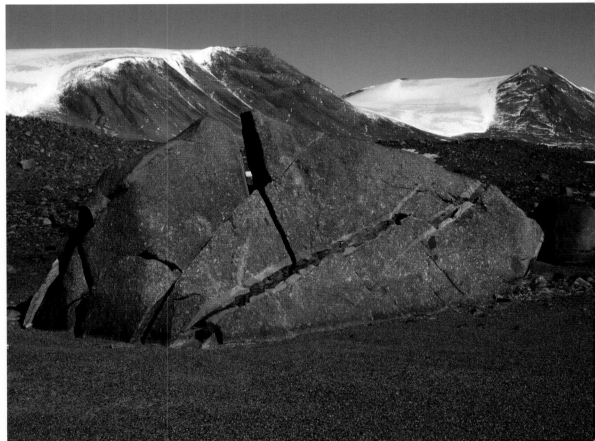

and the Antarctic Peninsula, and Continental Antarctica. Periglacial processes are not only dependent on temperature, but also on the availability of water, which decreases southwards, as does the impact of frost action.

'Maritime Antarctica and the Antarctic Peninsula' is the zone most closely resembling the Arctic, and so offers insight into condition that prevailed during the Ice Ages of the Northern Hemisphere. The northern parts of this climatically diverse zone embrace areas of discontinuous permafrost in the South Shetland Islands, which are relatively mild and wet. Here, the active layer (the surface which thaws out in summer) is quite deep, typically a metre (3 ft) or so. The growth of vegetation, such as mosses and lichens, produces thermal conditions that promote development of the active layer. In contrast, continuous permafrost extends throughout most of the Antarctic Peninsula, but as the climate becomes progressively drier southwards, the availability of water declines.

Within the northern parts of this zone, a range of striking periglacial phenomena can be viewed. In the South Shetland Islands, lobes of mobile sediment moving downslope ("solifluction lobes") are common, as are non-sorted stone circles and rock glaciers. Weathering of bedrock is achieved by freeze-thaw cycles, as well as by chemical degradation.

The 'Continental Antarctica' zone is represented by exposed nunataks, mountain ranges, coastal exposures and ice-free oases, mainly in East Antarctica, and in the Transantarctic and Prince Charles mountains. Areas such as the McMurdo Dry Valleys and Schirmacher Oasis are especially well-studied with regard to periglacial processes. These areas are characterised by extremes of low temperature, dryness and wind.

A striking visual indicator of periglacial processes in this zone is patterned ground, notably non-sorted polygons, which are the result of thermal contraction cracking in permafrost. Both ice-wedge and sand-wedge polygons form in unconsolidated sediment such as glacial deposits. Some have fine material in the centre and coarse gravel around the edges, and form micro-niches for vegetation and pioneer micro-organism colonisers such as cyanobacteria. Some patterned ground could be millions of years old, such as in the higher parts of the Prince Charles Mountains and the Dry Valleys, since the frost-sorting process required to separate the coarse material from the fines needs moisture, and this is lacking in much of today's environment. Interestingly, American geologists have identified patterned ground on Mars using remote-sensing imagery, and have used the Dry Valleys as an analogue for processes that occurred on the Red Planet millions of years ago.

Bedrock weathering in the Continental Antarctica zone is a major process that conveys a rusty, rotten look to much of the landscape. Traditionally, the freeze-thaw process was thought to be the main agent of weathering, but the absence of water makes this unlikely. Instead, geologists now think that thermal shock or expansion,

Top: Tors are towers of bedrock, left after a long period of weathering and lowering of the land surface. They are best developed above ice-sheet level, but sometimes are preserved if buried by non-erosive cold ice. This tor of metamorphic rock lies above a trough that contains Battye Glacier in the Amery Oasis, Prince Charles Mountains.

Bottom: Bedrock breaks down ultimately into boulder fields such as this one of gneiss on Fisher Massif, Prince Charles Mountains. Long-exposure to wind results in scalloped boulders and eventual degradation to sand.

biotic influences and salt-weathering are more important mechanisms in bedrock disintegration. Firstly, differences in rock temperature at the micro-scale lead to mineral-controlled disintegration. Some experiments have shown that the temperature between the sunny side of a rock and the shaded side, when the air temperatures are well below zero, is many degrees. This contrast sets up thermal stresses in the rock so that it can split apart. Thermal stresses at the mineral scale can exploit bedrock weaknesses such as joints, cleavage and foliation, which, in combination with wind erosion, give rise to pitted bedrock surfaces called 'tafoni', described below.

Secondly, biotic influences also play a role in the weathering process. Fracturing by algae has been recognised, where filaments of this primitive organism have sometimes been found deep inside what appear to be sound boulders, their presence indicating a source of weakness in the integrity of the rock.

Thirdly, from the Dry Valleys to the deep south, on the last rock islands before the Polar Plateau, another form of weathering causes rocks to disintegrate, and that is by salt. Veins in rock and stones embedded in the typical inorganic soil become sites for salt mineral growth. As many as 30 different salt phases have been reported from the Dry Valleys, including gypsum, halite and calcite. The once solid rock, following long periods of exposure (possibly millions of years), becomes friable and disintegrates.

Bedrock surfaces that have been exposed to frost action for hundreds of thousands of years become heavily degraded. *In situ* mounds of bedrock are referred to as tors, whilst total disintegration produces fields of boulders called felsenmeer, a German word, which translates literally as a stone sea.

Soils

Many ice-free parts of Antarctica are draped with loose debris, dust and fractured bedrock, which on first appearance look lifeless. Nevertheless, these are soils, and are the product of processes comparable to those operating in other parts of the world. Climate is regarded as the most important factor in determining the properties of soil in Antarctica, as it controls the rate of soil-forming processes. As noted above, Antarctic climates range from moist, relatively mild conditions in the northern Antarctic Peninsula and South Shetland Islands, to the cold, arid conditions of the southern limits of the Transantarctic Mountains. Soil development is influenced by geology, landscape and aspect. The best-developed soils occur in the more northern areas of Antarctica, aided particularly in the coastal zone by the fertilising effect of seabirds.

Soil formation is a slow process, largely because there is an absence of free water (except in the north), and permafrost is commonly less than a metre below the surface. Some soils are intimately associated with patterned ground. The source of soil is weathered bedrock, or, in coastal areas, penguin guano. Newly formed soils are grey, and are not oxidised. In contrast, old soils are characteristically orange or brown, a feature of oxidation of the material, and are rich in salts, sometimes with discrete horizons. Well-developed old soils attain ages of a few million years in areas that have not been over-ridden by ice, such as in parts of the Dry Valleys or high on interior nunataks in the Transantarctic Mountains, such as Roberts Massif where detailed studies have been made by New Zealand soil scientists.

Like soils everywhere, those in Antarctica have active ecosystems, aided by the fact that they have their own microclimate, with temperatures commonly several degrees above those of the air above. Antarctic soils contain micro-organisms, particularly bacteria, and they also support small populations of invertebrate grazers. Mosses and lichens are commonly associated with soil-forming processes.

Sadly, not all soils are pristine. Being fragile and slow-forming, they are particularly susceptible to human impact. Around many bases, even those dating back to the 'Heroic Era' of exploration, soils are contaminated by imported micro-organisms, waste of many types and subsequent run-off. Physical damage has been caused by vehicles and even human footprints. Recovery from such damage is likely to take hundreds of years. Fortunately, the poor waste management of the past has been replaced by a high level of environmental care, and many bases have been cleared of waste, as discussed in Chapter 11.

Wind

Antarctica is the windiest continent on Earth (Chapter 4). Not only does wind constrain human activity, it controls areas of snow accumulation in the lee of obstacles and has a severe impact on ice-free areas. Glaciers leave behind deposits of sand and gravel. High winds carry sand and even pebbles that have an extremely abrasive effect on bedrock and boulders. Although thermal stresses, referred to above, may trigger cavernous weathering and formation of 'tafoni', transport of sand by wind may enhance the process, especially if the rock type is sedimentary and relatively soft. Boulders are similarly affected, and even hard rocks such as dolerite become heavily pitted on faces exposed to wind, giving the appearance of abstract sculptures. The removal and movement of sand by the wind may leave a lag deposit of gravel, a typical armoured surface or "desert pavement".

The main product of wind abrasion is sand. High winds redistribute this material, commonly allowing concentrations to build up in the lee of boulders or other obstacles. Features typical of sandy deserts in the tropics are, however, mostly absent, although there is one area where sand dunes and sheets of sand occur, and that is Victoria Valley in the Dry Valleys of Victoria Land. Here, wind-blown sand accumulates in the lee of obstacles, or is even banked up against the glaciers.

Water – streams and lakes

It may be a surprise to many, but running water is not uncommon in the ice-free areas of Antarctica. Although the volumes are rarely substantial, solar radiation may be strong enough in mid-summer to induce melting of snow and ice, especially that which is in contact with the darker, radiation-absorbing debris. Melting takes place even when the air temperature is below freezing. Small trickles of meltwater may be seen as far south as 85° S on a still sunny day in early January.

Several sizeable lakes that are in contact with a glacier occur in the Dry Valleys, the largest ice-free area in Antarctica at 79° S. None of these lakes has an outflow into the sea, and as such they become saline through evaporation, whilst their levels fluctuate substantially over decades. A typical lake has a thick lid of ice, from which salts precipitate on the surface and accumulate at the bed. The salt chemistry of these lakes is complex and varied. For example, Lake Bonney may contain residual sea water, from which calcium carbonate, sodium chloride and sodium sulphate have been deposited. In addition, there are also the products of rock weathering, including magnesium and potassium salts, and sodium sulphate.

Other lakes in the Dry Valleys are connected seasonally to the glaciers by streams. In the Dry Valleys, runoff from glaciers produces streams that flow inland. The longest stream in Antarctica, the Onyx River, is fed by runoff from Wright Lower Glacier, and flows inland into Lake Brownworth first and finally into Lake Vanda after a journey

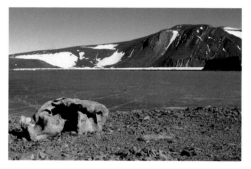

Examples of weathering of bedrock and boulders by wind-scouring:

Top: Intricately scoured sandstone bedrock on the flanks of Pagodroma Gorge, Prince Charles Mountains. These cavities provide an ideal sheltered home for the nesting snow petrel (*Pagodroma nivea*).

Centre. A heavily wind-scoured sandstone boulder on the shore of Radok Lake, Prince Charles Mountains, the largest exposed lake in Antarctica.

Bottom: 'Tafoni' – a wind-scoured boulder of dolerite near Australia's Davis Station, Vestfold Hills, East Antarctica.

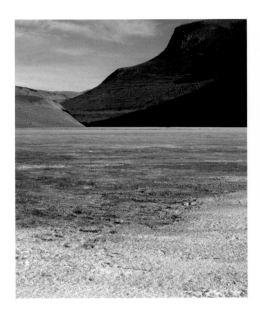

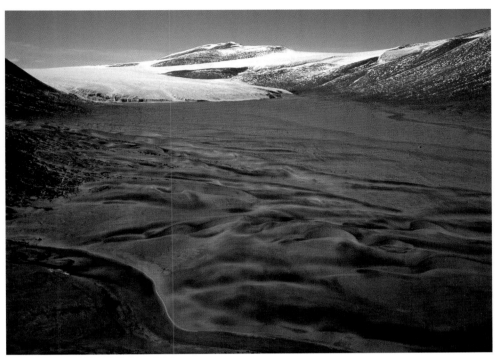

Top left: The frozen surface of Lake Bonney in Taylor Valley, Dry Valleys. Salt crystals have precipitated out on the ice surface. The lake is so salty it does not freeze until the temperature drops to -12° C (10° F).

Top right: Sand dunes of the 'barchan' type formed in the polar desert area of Victoria Valley, Victoria Land, viewed from the air. Beyond the dunes, a sand plain extends to the Victoria Lower Glacier.

Right: The frozen Lake Brownworth is an ice-contact lake adjacent to Wright Lower Glacier, Victoria Land. The lake is frozen with small icebergs trapped in the lake ice. Extensive wind-blown sand drapes the margin of the glacier, resulting in differential ablation and the formation of ice towers and pinnacles.

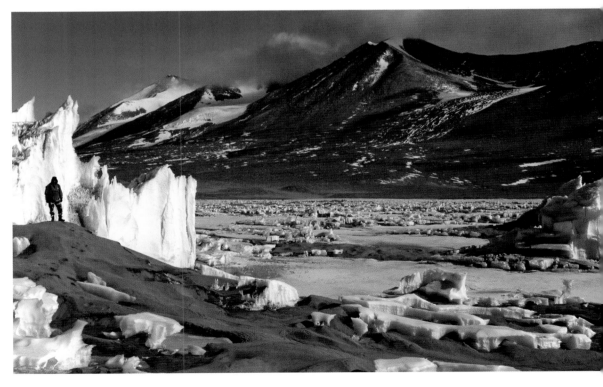

of about 30 km (19 miles). This lake is one of the most saline in the world. A similar situation prevails in Victoria Valley, where flow from Victoria Lower Glacier travels 8 km (5 miles) inland to Lake Vida. Most of the material carried by these streams is sand, and small deltas develop where the streams enter lakes.

Around the edges of these lakes in the Dry Valleys, a moat develops in summer, especially as the water is so saline that it can remain unfrozen down to -12° C (10° F) or so. The strangest thing about these lakes is the temperature of the water at depth – it can reach +10° C (50° F). Lack of circulation means that strong thermal stratification of the water column is achieved; warming is the result of solar radiation penetrating the ice lid. These saline lakes also promote the growth of algae, resulting in mats on the lake floor, especially in shallow water. However, more striking algal growths are 'stromatolites', which are vertically growing mounds with interbedded sand, a few tens of centimetres high. These modern stromatolites have a texture similar to soggy cardboard. The combination of cold-based glaciers, ice-contact saline lakes and stromatolites is the closest modern analogue that scientists have found for the extreme event known as 'Snowball Earth', when it has been envisaged that almost the entire planet was covered by ice around 600-700 million years ago.

The deepest exposed lake in Antarctica is Radok Lake in the Prince Charles Mountains. Located at a latitude of 71° S, it is 6 km (4 miles) long, and up to 362 m (1,188 ft) deep. The lake was carved out by an expanded Battye Glacier, which currently enters the lake as a narrow floating ice tongue. Although the lake surface is permanently frozen to a depth of 2 m (6.5 ft), a ferocious katabatic wind rushes down the glacier, keeping one corner of the lake ice-free. The outflow from the lake reaches the sea via an ancient subglacially formed gorge and the seawater-dominated Beaver Lake, which has a connection to the open sea under the Amery Ice Shelf.

All these areas are deep in continental Antarctica, but at the northern extremities of the Antarctic Peninsula the longer summer season delivers positive temperatures and much more meltwater, as well as occasional rainfall. The islands of James Ross and the South Shetlands have the second most extensive ice-free areas of Antarctica, after the Dry Valleys, so summertime streams and small lakes are abundant. Many glaciers here have typical ablation areas, and the snouts of those terminating on land are subject to melting, forming small proglacial braided streams. The volcanic topography of James Ross and Vega islands is conducive to the development of ice caps above steep cliffs; where this ice is receding away from the edge, waterfalls are to be found.

The ice-free coastal zone

Of the entire coastline of Antarctica, only 5% is free of glacier ice. These shores are mostly steep and rocky, reaching their most spectacular form on the west side of the Antarctic Peninsula. Rocky shores also form a fringe to low-relief coastal oases such as

Opposite top: Isostatic rebound, the process of uplift when an ice sheet is removed from the Earth's crust, is evident in the snow-covered raised beaches along the shore of Croft Bay, James Ross Island.

Opposite bottom: A storm beach of pebbles and cobbles at Fort Point on Greenwich Island, South Shetland Islands. Substantial numbers of chinstrap and gentoo penguins, and fur seals occupy the beach and adjacent sea stacks.

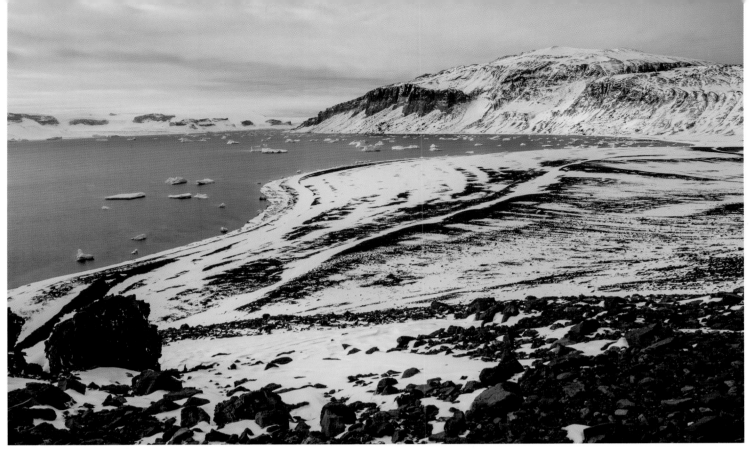

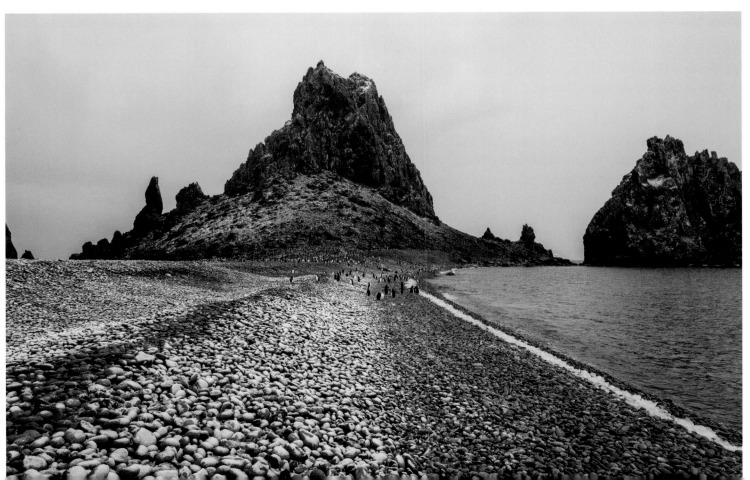

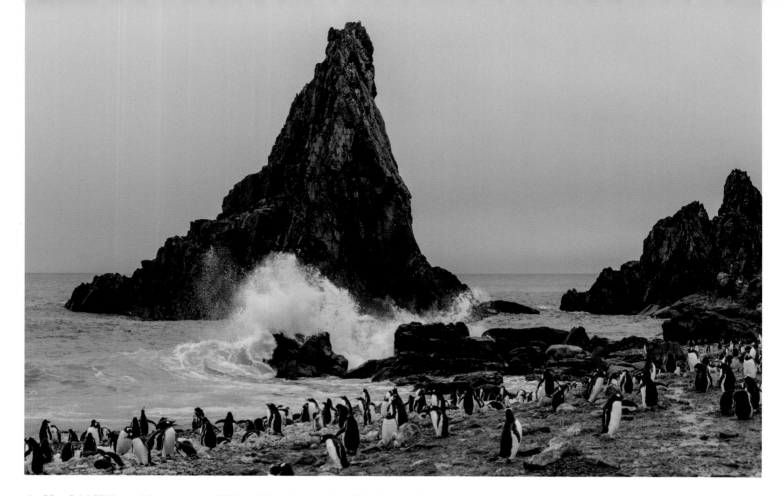

the Vestfold Hills and Larsemann Hills in East Antarctica. The low rocky hills, scraped by ice, have emerged from the sea as the land has recovered from ice-sheet loading of Earth's crust by isostatic rebound. This process is strikingly evident in the Vestfold Hills, where uplifted marine sediments contain well-preserved fish and dolphins.

Emerging coastlines are also found in the islands off the northern Antarctic Peninsula, including James Ross Island and the South Shetland Islands. These modern northern coastlines have many of the usual features of high-latitude regions, including sand beaches, gravel storm beaches with rounded cobbles and boulders, spits indicative of shore-parallel currents, lagoons and sea stacks. Isostatic rebound has resulted in the elevation of a range of coastal features. Excellent examples of raised beaches may be found on James Ross Island, in parts of the Antarctic Peninsula and adjacent islands, and in the Ross Sea. In the South Shetland Islands, it has been documented that up to 20 m (66 ft) of uplift has taken place since the ice receded about 7,000 years ago.

These low-lying coasts attract a wide variety of wildlife, such as seals and penguins (Chapter 8). In contrast, coastal cliffs several hundred metres high dominate the western side of the Antarctic Peninsula and the northern shores of the South Shetland Islands, although ice drapes much of them. Despite their inhospitable nature, these cliffs also offer a precarious foothold on land for several species of penguin and seal.

Above: Sea stack and powerful waves, with gentoo and chinstrap penguins milling around, Fort Point, Greenwich Island.

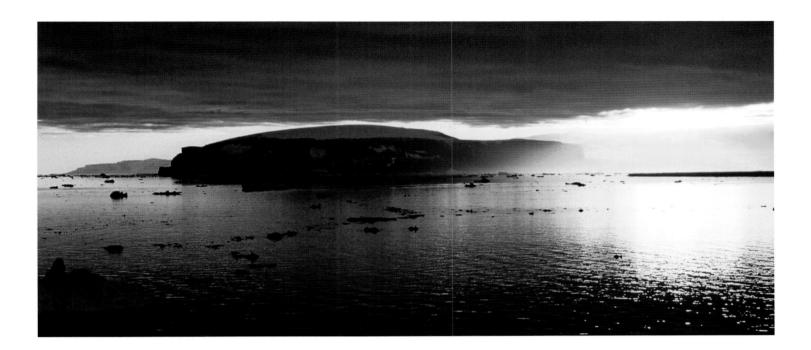

Volcanoes

Antarctica is well-endowed with volcanoes, but many remain hidden beneath the ice sheet. The best-known volcanoes are found around the periphery of the continent, mostly on offshore islands. The main active volcanic provinces are in the South Shetland Islands off the Antarctic Peninsula, notably Deception Island, and along the western margin of the Ross Sea as represented by Mt Erebus. Other volcanic provinces that may simply be dormant comprise subglacial volcanoes around James Ross Island, all with ice caps sitting on them, and in Marie Byrd Land lying mostly beneath the huge rift valleys occupied by the West Antarctic Ice Sheet.

Deception Island is an isolated active volcano in Bransfield Strait, 15 km (9 miles) in diameter, with a collapsed caldera flooded by the sea to a depth of around 150 m (500ft). This bay is well protected from the weather, and is reached via a narrow channel called Neptunes Bellows, and so is popular with cruise ships. The bay is ringed by low hills of lava and tephra, some of which are covered with small, ash-draped glaciers. The loose material on the slopes is heavily dissected by gullies, and alluvial fans and spits occur where this debris is discharged into the sea. The most recent eruption period was 1967-70 when three bases had to be evacuated. Near the entrance to the cove, the British base and an abandoned 18th century whaling station were damaged by falls of tephra, whilst a flood emanating from a melting glacier did further damage. Fortunately, the occupants were rescued.

On an altogether larger scale is the 3,794 m (12,448 ft) high Mt Erebus on Ross Island in the western Ross Sea. With a diameter at sea level of approximately 35

Above: Sunset behind the mound-shaped profile of a subglacial basaltic volcano, an outlier of the large shield volcano of Mt Haddington on James Ross Island, northeastern Antarctic Peninsula region.

km (22 miles), this is the world's southernmost active volcano, and holds a lava lake in its deep summit crater. Although heavily ice-covered, the lower slopes of the mountain and its subsidiary cones and craters are covered with tephra and scoria but, unlike Deception Island, little reworking of material by water is apparent.

Mt Erebus is part of the extensive McMurdo volcanic province, dominated by basalt, extruded as a result of crustal stretching. The province also includes inactive volcanoes such as Mt Terror, Mt Bird, Mt Discovery and Mt Melbourne. Other inactive volcanoes dating back several million years are found east of the northern tip of the Antarctic Peninsula, notably on James Ross Island. These were erupted subglacially, and consequently have flat tops. Where exposed, they typically have steep cliffs of hyaloclastite (a basaltic breccia that has interacted with water), capped by lava flows. The eruption periodicity of these volcanoes is measured in hundreds of thousands of years, so it is conceivable that this volcanic province is still 'live'.

Relationships between landscape and geology

Many aspects of the landscape of Antarctica reflect the type of bedrock and deep geological structures such as faults. On the largest scale, the entire continent is shaped by tectonic processes, notably the splitting of the supercontinent of Gondwana, and the separation of Antarctica from the other Southern Hemisphere continents, as outlined in Chapter 3. The huge rift system stretching from the Weddell Sea to the Ross Sea is marked by fault-bounded sedimentary basins and volcanoes, with the Transantarctic Mountains defining the western limit. The mountains represent the 'curled up' edge of the rift system, resulting in a topographic change from marine basins several hundred metres deep to peaks over 4,000 m (13,000ft).

Another major rift is the Lambert Graben, a down-faulted block of continental crust through which the world's largest glacier system, the Lambert Glacier-Amery Ice Shelf System, flows. These rift systems stretch for several hundred kilometres.

On the scale of several kilometres, fjords and channels commonly follow faults. The shattered rock is more readily gouged out by glaciers than the surrounding rocks, and good examples are the Lemaire and Neumayer channels on the west side of the Antarctic Peninsula.

Lastly, on a scale of hundreds of metres, bedrock structures, such as small faults, joints and foliation, have been exploited by glaciers, giving straight grooves or small valleys. This is especially true in the ancient gneisses of East Antarctica, such as can be found around the Australian stations of Davis and Casey.

Landscape quality

Scientists have been uniquely privileged to visit many parts of the icy continent. For more than a century, geologists have explored the interior mountains, as well as coastal ranges and oases, whilst biologists have focused mainly on coastal wildlife. Glaciologists have investigated the dynamics of ice masses and physicists have studied the atmosphere and space.

Nowadays, steadily rising numbers of tourists come to Antarctica on expedition cruise ships to learn more and appreciate the pristine environment. Television documentary programmes portraying the continent and its wildlife have played a significant part in encouraging this trend. In learning about the landscape and the wildlife, such visitors become ambassadors for protecting Antarctica from untoward developments.

For many visitors, it is the heavily ice-covered mountains, icebergs and sea ice that are major attractions, along with wildlife. There is nowhere better than the west side of the Antarctic Peninsula to see these attributes, and it is here that the majority of cruise ships visit. Indeed, few places on Earth match the beauty of the landscapes of this region.

Other parts of Antarctica contrast with the ice-dominated Peninsula, and are more the preserve of the scientist. In particular, Antarctica's frigid ice-free environments are unique on Earth. Superimposed on ancient glacial landscapes are the severe actions of wind, frost and weathering. There are strong latitudinal differences: in the deep south, in the McMurdo Dry Valleys and beyond, meltwater has limited impact, whereas in the far north, in the northern Antarctic Peninsula region, it is much more obvious. The lack of vegetation enhances the 'other-wordly' character of this landscape, so it is no wonder that areas like the Dry Valleys have been used to test instruments for use on the Moon and on Mars.

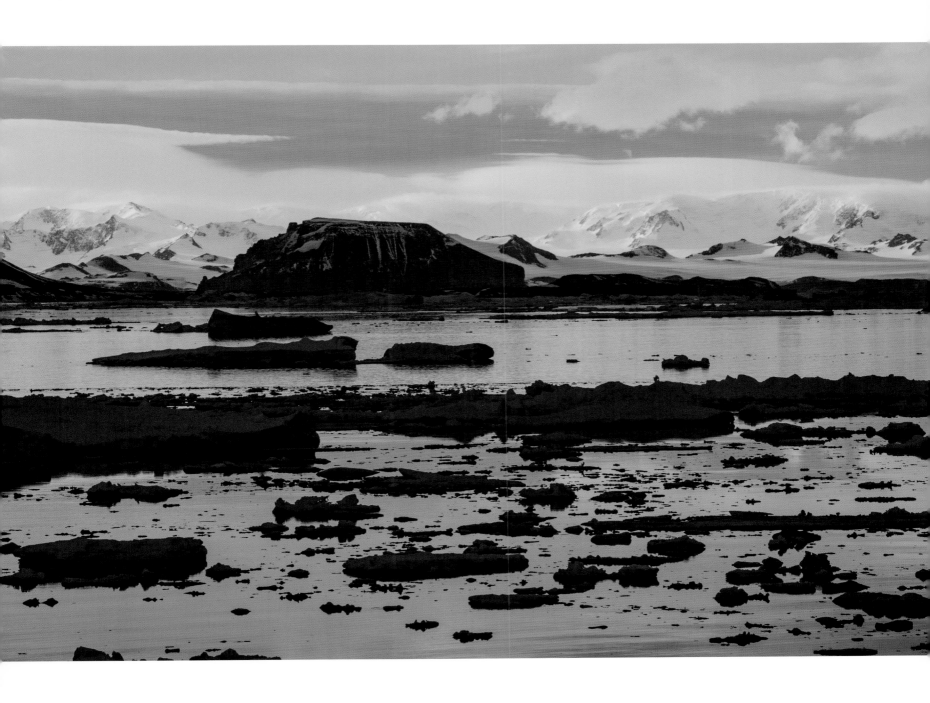

Above: Storm clouds gather over the glacially eroded landscape at the northern end of the Antarctic Peninsula, viewed from Croft Bay on James Ross Island.

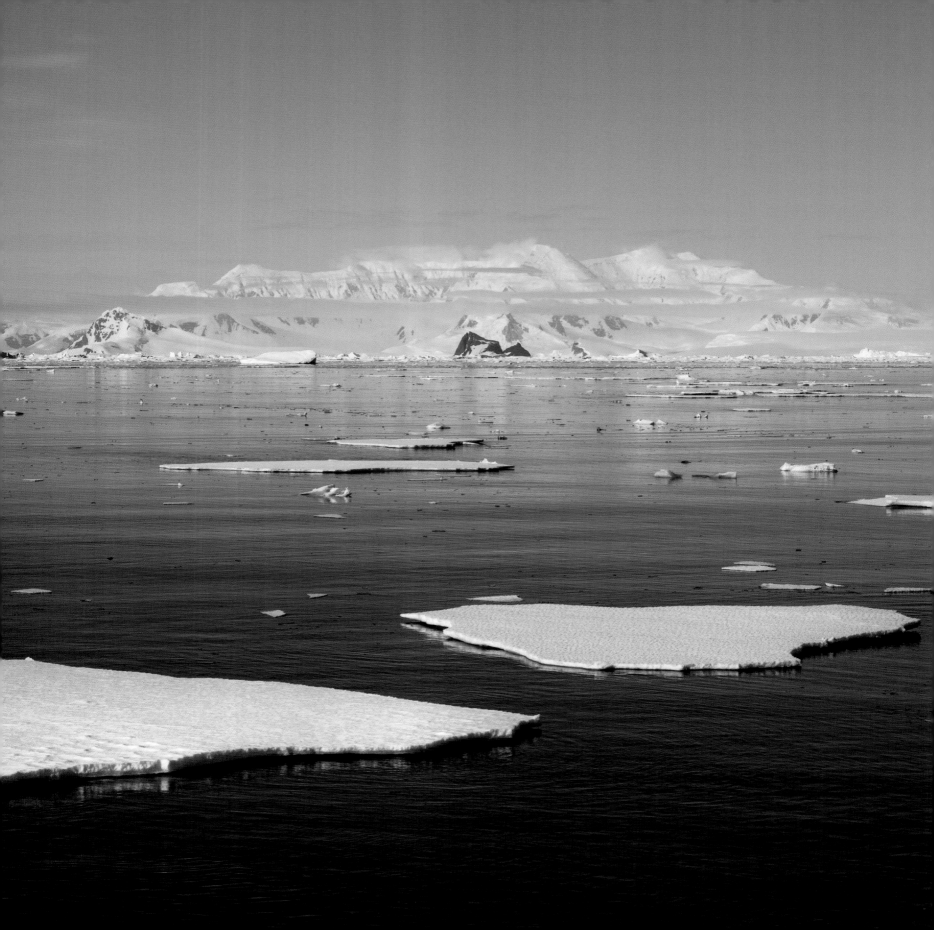

CHAPTER 7

The Southern Ocean, its Sea Ice and Icebergs

Ships navigating the Pacific section of the Southern Ocean, offshore of West Antarctica, are in particularly isolated waters even by Antarctic standards. A vessel in the Amundsen Sea is approximately equidistant between the British Rothera base on the Antarctic Peninsula and the American McMurdo station in the western Ross Sea. There are no bases between and almost a week of sailing in either direction. The journey outbound from Rothera to our scientific study area in the Amundsen Sea on the research vessel James Clark Ross was largely calm and uneventful, with the sighting of Peter I Island breaking the ship's daily routine. The journey back was less so. In rising seas we passed several huge flat-topped tabular icebergs, kilometres in length and with underwater keels several hundred metres below the surface. Waves were breaking over the ice cliffs of the bergs. We were late in the season and there were hours of darkness between shortening days as a deep Antarctic low-pressure area raised winds to severe gale force. The seas rose, with competing swells from adjacent storms producing huge and confused wave sets. Luckily, I don't get seasick, but most of the scientists were in their bunks, or trying to remain there as the ship bucked and rolled in unpredictable directions in the dark. In the dim of the ship's bridge the searchlights ahead showed a wild sea with green water coming onto the foredeck and the bows rising slowly to heave off the weight of water. But everything looked better in the early morning light – the sea was still running high but the waves were more organized and the wind was dropping.

JAD

Bathymetry of the Southern Ocean

The continent of Antarctica is completely surrounded by the Southern Ocean. The Drake Passage between Cape Horn at the Southern tip of South America and the South Shetland Islands is about 800 km (500 miles) wide. This represents the shortest distance to any of the Southern Hemisphere continents, and emphasizes the isolation of Antarctica. A first glance at the bathymetry of the Southern Ocean shows three major ocean basins, which comprise the southernmost parts of the Pacific, Atlantic and Indian oceans. The formal geographical boundary of the Southern Ocean is usually taken as 60° S, some distance south of the southern tips of South America (56° S) and New Zealand (47° S), and of relatively large sub-Antarctic islands such as the Falklands, South Georgia and Kerguelen. Below 60° S the Southern Ocean is just over 20 million km² (7.7 million miles²) in area with a mean depth of approximately 4,500 m (14,750 ft).

Opposite: Sea ice floes and a few scattered icebergs in the calm waters of Crystal Sound on the western side of the Antarctic Peninsula, just south of the Antarctic Circle.

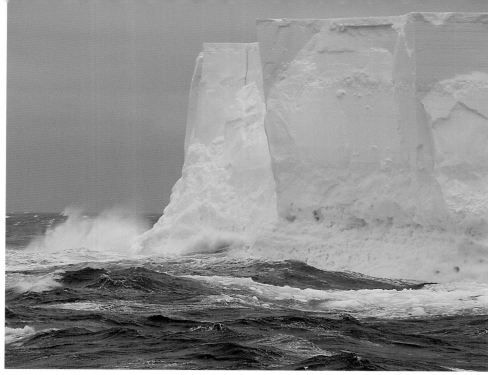

Left: Waves breaking on the 40 m (130 ft)-high cliffs of a tabular iceberg in the Amundsen Sea.

Below: A kilometre (0.6 mile)-long tabular or table-like iceberg drifting in the waters of the Amundsen Sea, offshore of West Antarctica.

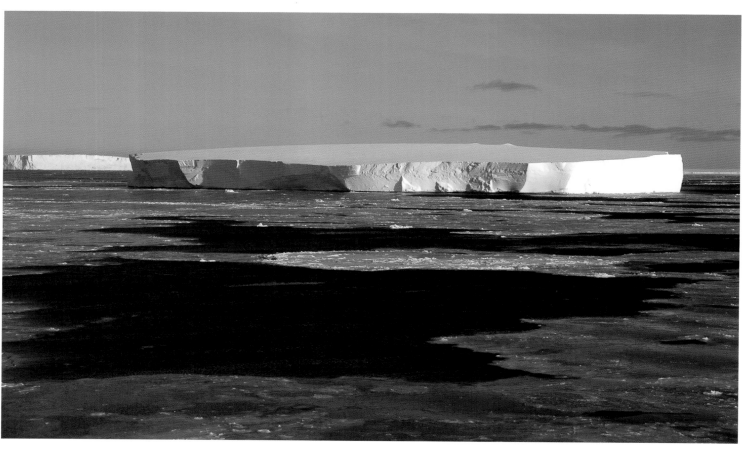

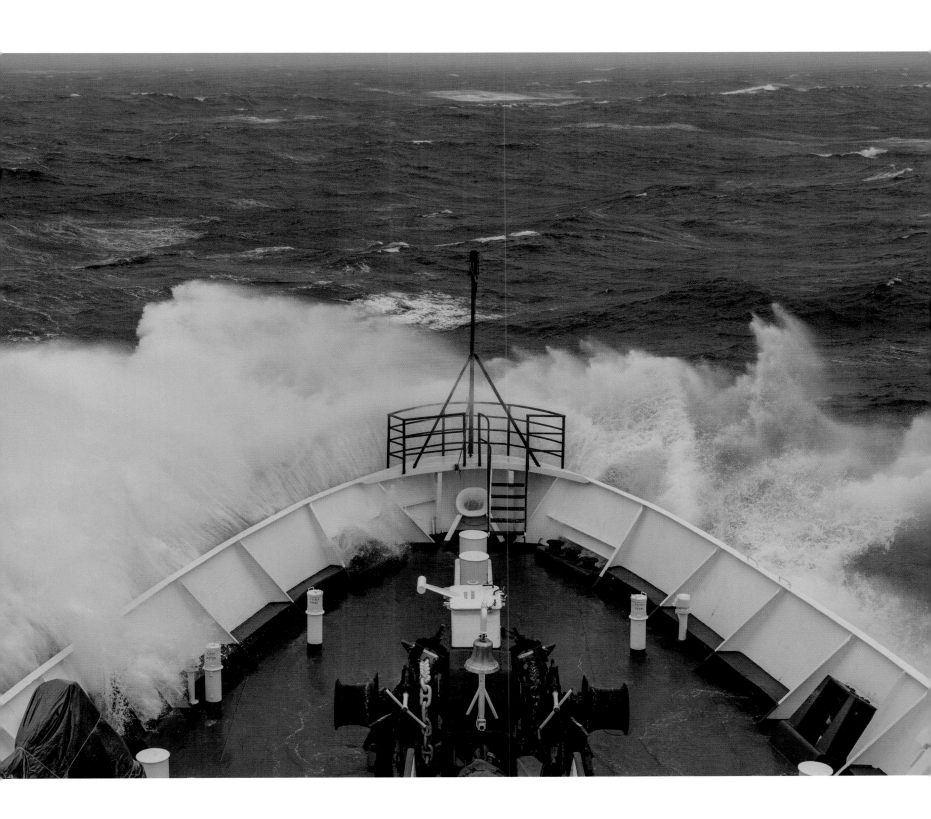

layers within the ocean-water column and with the sea floor. Centred at about 55° S, the dominant current around the Antarctic continent is the Antarctic Circumpolar Current. At up to 2,000 km (1,240 miles) wide and about 4,000 m (13,000 ft) deep, with current speeds averaging about 0.5 m/s, it transports huge volumes of water eastwards around the continent and is the largest current in the global ocean. Its more detailed dimensions are influenced by the adjacent landmasses and the shape of the sea floor. The Current is constricted laterally, for example through Drake Passage, between the tips of the Antarctic Peninsula and South America, and is deflected south by the large Kerguelen and Campbell submarine plateaus in the southern Indian Ocean and south of New Zealand, respectively.

Inshore of the Antarctic Circumpolar Current, within about 200 km (124 miles) of the Antarctic coast, the Antarctic Coastal Current flows in the opposite direction, from east to west. Large clockwise gyres of circulating ocean currents dominate water flow in the huge Ross and Weddell Sea embayments. In addition, very cold and dense water is generated by salt-rejection during sea-ice production on the continental shelf and beyond. Known as Antarctic Bottom Water, it sinks and flows north through the deepest parts of the sea floor into the abyssal basins of the Atlantic, Indian and Pacific oceans. The flow of this very dense deep water northwards is a major driver of the overall

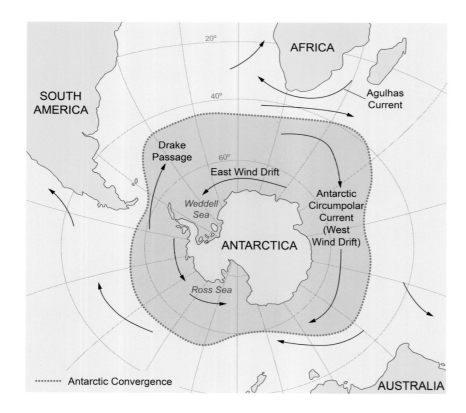

Left: Ocean circulation around Antarctica showing major current directions and the locations of ocean fronts between colder and warmer water.

Top and above: Oceanographic instrumentation has changed considerably over the past century, but the principle of collecting water at depth remains important. Modern instrument sensors measure ocean temperature and salinity, and bottles are used for acquiring water samples at multiple depths. Scientists on Captain Scott's ship *Terra Nova* about 100 years ago also collected water samples from the Ross Sea. (© Scott Polar Research Institute)

circulation of the oceans, and is responsible for transporting heat, nutrients and dissolved gases around the globe. The Ross and Weddell seas are particularly important locations of dense bottom-water formation, with 60% produced in the Weddell Sea alone. Indeed, dense bottom-water generated in the Weddell Sea flows northwards across the equator through deep-ocean basins to affect currents in the North Atlantic. This demonstrates the complex vertical structure of the oceans, where water masses of varying density sit one above the other and may flow in differing directions.

Oceanographic eddies at the northern margin of the Antarctic Circumpolar Current are important for heat exchange between warmer and colder waters. An example of a cold eddy breaking off and moving northwards occurred in 2006 when several large icebergs were observed within sight of New Zealand's South Island – before this, icebergs had not been spotted off the coast since 1931. Northward iceberg drift to this latitude, about 45° S, was enabled by the cold Southern Ocean water in which the icebergs were embedded.

The Southern Ocean and the global environment

Changes in the temperature, salinity and chemistry of the waters of the Southern Ocean affect the global climate system. Vertical circulation transfers parcels of water between the surface and deep ocean. In a warming world, heat can thus be transferred from atmosphere to ocean. Indeed, ocean warming is one of the two major contributors to observed contemporary sea-level rise of 3.4 mm/yr, the other being ice-sheet melting. This is because, as the oceans warm, they also expand to take up a greater volume given that warmer water is less dense than cold water.

Gases are also exchanged with the atmosphere at the ocean surface, and between water masses in the upper and deep ocean. Cold water at the surface of the Southern Ocean enables atmospheric carbon dioxide to dissolve relatively readily, and vertical circulation allows the transport of carbon dioxide into deep ocean waters. In addition, photosynthesis and plankton production in the ocean lock carbon up as calcareous shells, which are deposited on the sea floor or reabsorbed into the water column as individuals die. The global ocean as a whole is a modern sink for carbon dioxide, and about one-third of the CO_2 produced by fossil-fuel burning is thought to have been stored in ocean waters, slowing the growth in atmospheric carbon dioxide concentrations.

Scientists have shown recently that the Southern Ocean has very low concentrations of iron, which at lower latitudes is introduced to the ocean via wind-blown dust – this source is largely absent around Antarctica, since almost the whole continent is ice-covered. Recent iron-fertilization experiments have demonstrated that low iron concentrations are a limitation on plankton growth, and that biological productivity increases as iron is introduced. Artificially introduced iron is potentially an important, but controversial, 'geo-engineering' solution, given that any increased

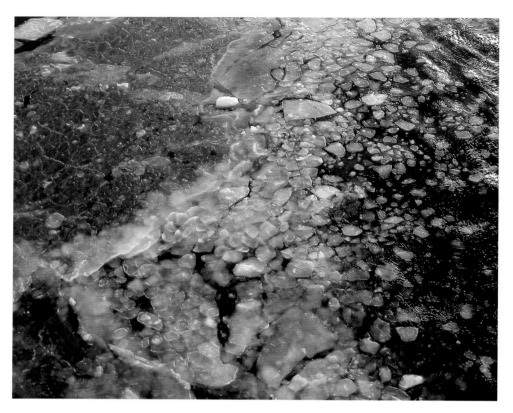

productivity from iron fertilization would allow more carbon to be sequestered in plankton shells and, hence, removed from the global atmospheric system. There are problems, however, with increasing carbon dioxide uptake from the atmosphere to the Southern Ocean, and to the world's oceans more generally, through enhanced acidity. Growing water acidity increases the solubility of the calcium carbonate making up plankton shells. This could negatively affect plankton populations and, in turn, the food chain of the Southern Ocean, of which plankton are a major component.

Sea ice formation and morphology

Sea ice is simply the frozen sea surface and is usually no more than a few metres thick. As the sea freezes, ice forms first as small plates and needles, which are termed frazil ice. When frazil ice builds up the sea often has a greasy appearance – this is called grease ice. Continuing thickening produces recognizable floes, small versions of which are known as pancake ice. Once formed, sea ice can grow further through water freezing onto its submerged base and by snow falling on its exposed upper surface.

Sea ice in the Southern Ocean is usually present in the form of pack ice, which is the accumulation of many individual floes that can be anything from a few

Above left and right: The water surface appears greasy as new sea ice forms in the Amundsen Sea. As freezing proceeds, individual pancakes of ice are produced, often a few tens of centimetres across.

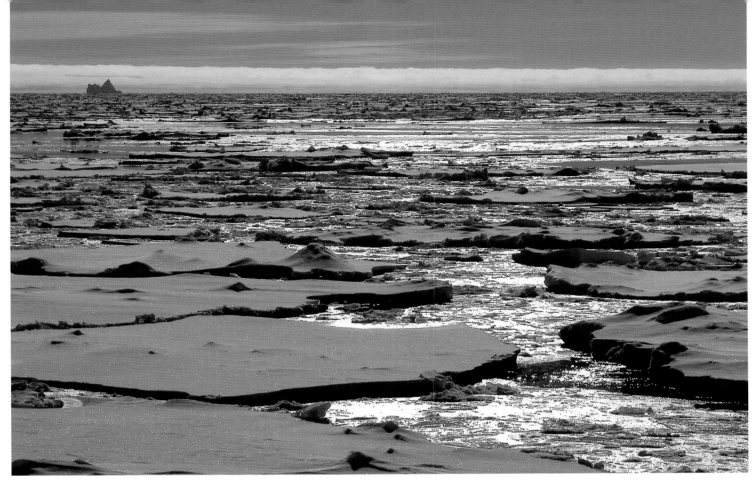

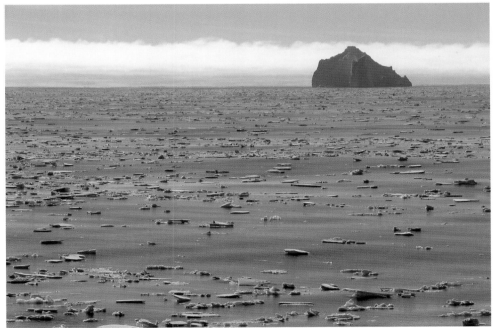

Top and right: Pack ice in the Amundsen Sea with cathedral-like icebergs in the background. The amount of sea ice varies from relatively open pack with limited amounts open water to ice floes only tens of centimetres in diameter located in largely open water.

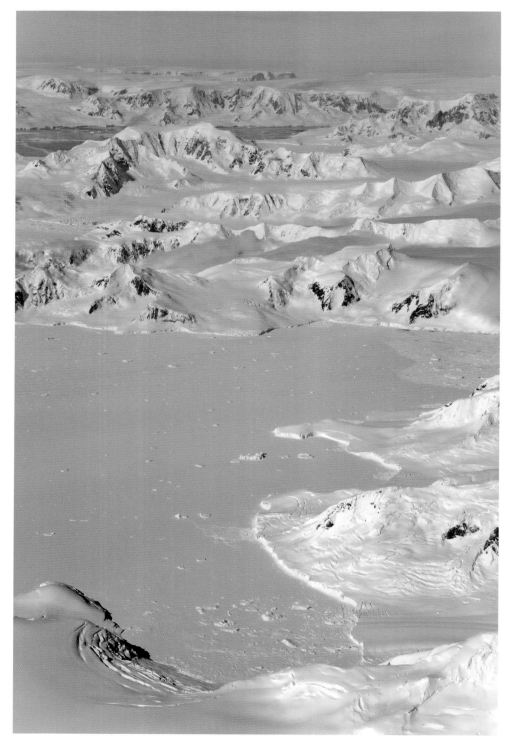

Left: Shorefast sea ice covers the whole sea surface north of Adelaide Island, western Antarctic Peninsula, trapping icebergs produced from several tidewater glaciers.

Top: Light penetrates through a thin sliver of multi-year sea ice in McMurdo Sound that has been formed into a ridge by ice pressure.

Above: Smooth shorefast sea ice covers the sea surface between Scott's hut at Cape Evans and the ice cliffs of Barne Glacier in McMurdo Sound.

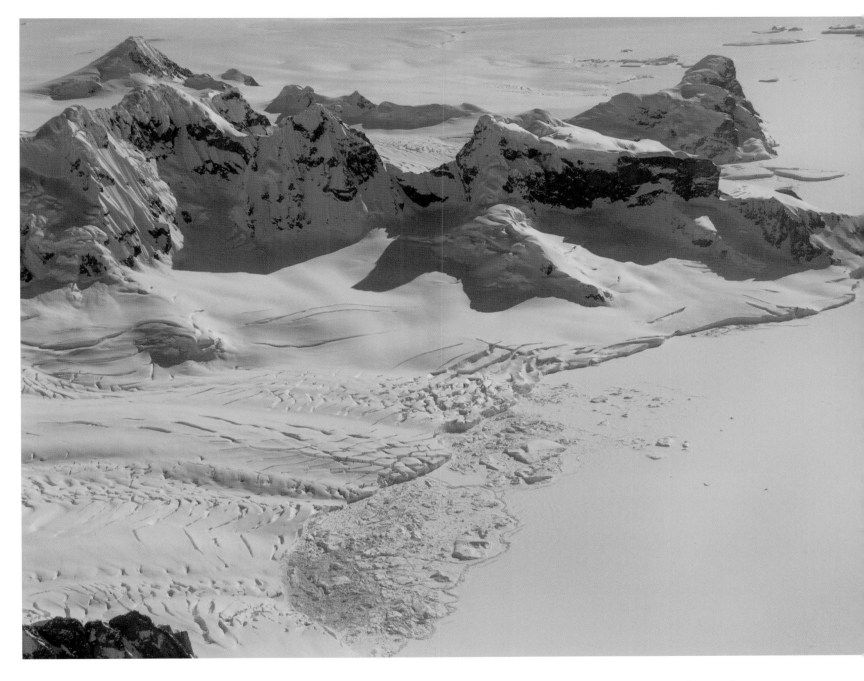

Above: Icebergs trapped in a smooth cover of shorefast sea ice at a glacier terminus in George VI Sound, Antarctic Peninsula. The icebergs are produced at the margins of low-level cirque glaciers terminating in Marguerite Bay.

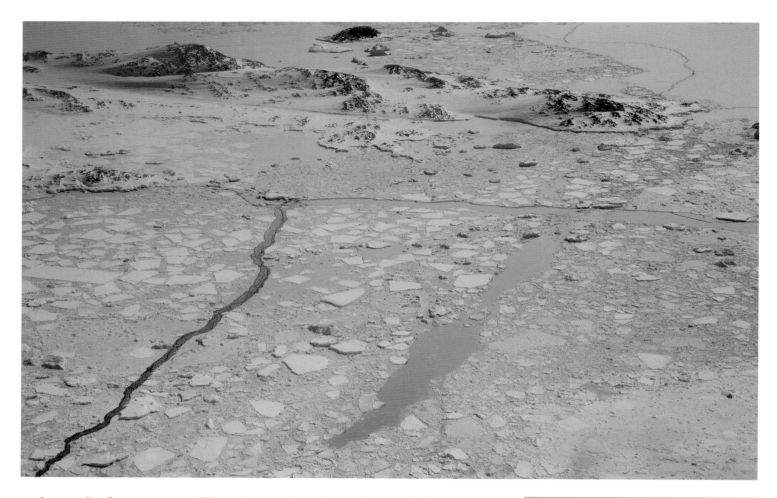

to thousands of metres across. When floes are forced together by winds or currents, ridges may form as floes are pushed over or under one another and sometimes buckle under pressure. Exposed sea-ice pressure ridges are often a few metres in height and similar structures are also present below water as protruding keels. Pressure ridges are a major obstacle to travel, in part because the ice is fractured and unstable, but they provide wonderful photographic opportunities. From the ice surface the ridges may appear as an impenetrable barrier. From the air, they form a mosaic of intersecting ridges with the smooth floes between. Modern icebreakers can generally cut through ice floes up to 2 m (6.6 ft) thick without difficulty. The ship's bow rides up onto the ice and the weight causes the ice to fracture. This is an impressive sight as the broken floes are up-ended as they rush alongside the vessel. Large pressure ridges are more of a problem for icebreakers, and are best avoided. Vessels also have difficulty with ice floes that are laden with snow, and separated by rather elastic grease ice. Shackleton experienced this type of ice prior to the crushing of *Endurance*, and likened it to

Top: Leads of open water within a field of pack ice in Marguerite Bay near the British base at Rothera on the west side of the Antarctic Peninsula. Leads are used by ships for navigation and by marine mammals for breathing.

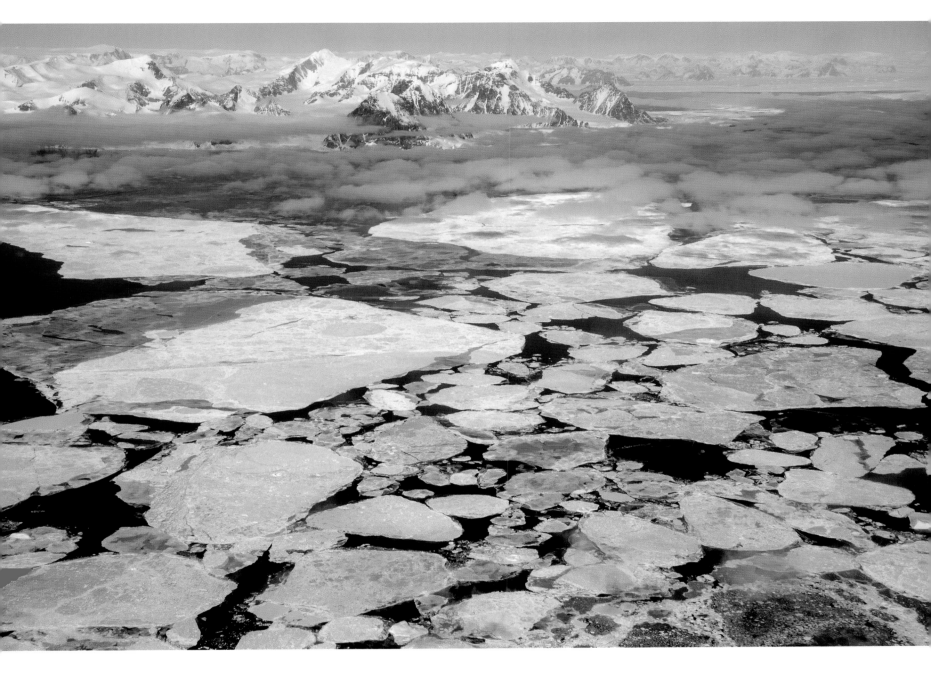

Above: Sea-ice breakup produces floes of varied size and shape. As breakup proceeds, larger floes predominate, as off Pourquoi Pas Island on the Antarctic Peninsula in early summer.

Opposite left: A four-engined C-17 Globemaster aircraft, with a 52 m (170 ft) wingspan and loaded weight of about 200 tonnes, lands on the sea ice runway near McMurdo Station, which is used early in each summer fieldwork season.

porridge. Even a powerful icebreaker, such as the German research vessel *Polarstern*, can get stuck in this sort of ice.

Where there are open water areas within Antarctic pack ice, these are called leads if they are narrow and relatively linear, and polynyas (from a Russian word meaning hole in the ice) if they are more extensive bodies of open water. Open water areas close to the coast, called shore leads, are usually produced by strong offshore winds, and polynyas are often formed in areas of ocean upwelling.

Most Antarctic sea ice melts during summer and the term multi-year ice is used for sea ice that has survived for more than one year; the converse is first-year ice. Multi-year ice is typically thicker and more ridged than first-year ice because it has had longer to build up and to experience pressure ridging. In addition, some sea ice forms at the Antarctic coast itself. This is called shorefast sea ice – sometimes shortened to fast ice, which is a potentially confusing name given that this type of sea ice does not drift with the wind.

Shorefast sea ice tends to form preferentially in embayments and fjords where it is protected, in part at least, from ocean swell whose long-period waves are an important cause of breakup together with strong offshore winds. The presence of shorefast sea ice in front of an ice-sheet or ice-shelf margin can also inhibit the production of icebergs and may trap any that are calved so that they cannot drift away until the sea ice breaks up.

The shorefast ice moves up and down with the tide, but is also largely attached to the shore and so it cannot drift away unless it breaks up. Tidecracks form close to land as a result of the rising and lowering of the tide during the winter sea ice season. These gaps, much narrower than they are deep, are nevertheless an obstacle to travel if they exceed a metre or two in width. The differential vertical movement may be a metre or more. When sea ice breaks out, it is the tidecrack that forms a boundary between drifting ice and ice that remains adhering to the land. Once the sea ice has floated away, a vertical ice cliff up to a few metres in height is left, called an ice foot. During the summer months, this slowly degrades until it reforms the following autumn from frozen sea spray and brash ice that is flung ashore by waves.

The early summer break-up of sea ice can be a spectacular and rapid event that has caused loss of life to sledging parties using sea ice for travel ever since the early days of exploration. The shorefast ice may break up into small angular pieces, or into large rounded or irregularly shaped floes, which melt as they drift into the open sea.

Unbroken expanses of shorefast sea ice over about 2 m (6.6 ft) thick are also capable of supporting considerable weight. This has been used to advantage near the American McMurdo Station, where C-17 Globemaster and C-130 Hercules aircraft regularly land on the sea-ice runway a few kilometers away. For aircraft landing on skis rather than wheels, the sea ice can be about 20% thinner since the load is distributed more widely across the ice; in either case a prepared and relatively smooth ice runway is usually used.

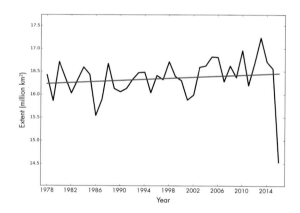

Above: Satellite-derived measurements of the November sea-ice extent around Antarctica since records began in 1978 (Source: National Snow and Ice Data Center). Note the remarkably low level of sea ice cover in 2016, superimposed on a slightly upward trend over the past four decades.

Opposite: Matusevich Glacier, a relatively small outlet glacier of the East Antarctic Ice Sheet, producing 0.5 km (0.3 mile)-long tabular icebergs as it enters the Lazarev Sea. Some of the icebergs are embedded in a smooth cover of shorefast sea ice. (Courtesy of NASA/GSFC/METI/ERSDAC/ JAROS & US/Japan ASTER Science Team)

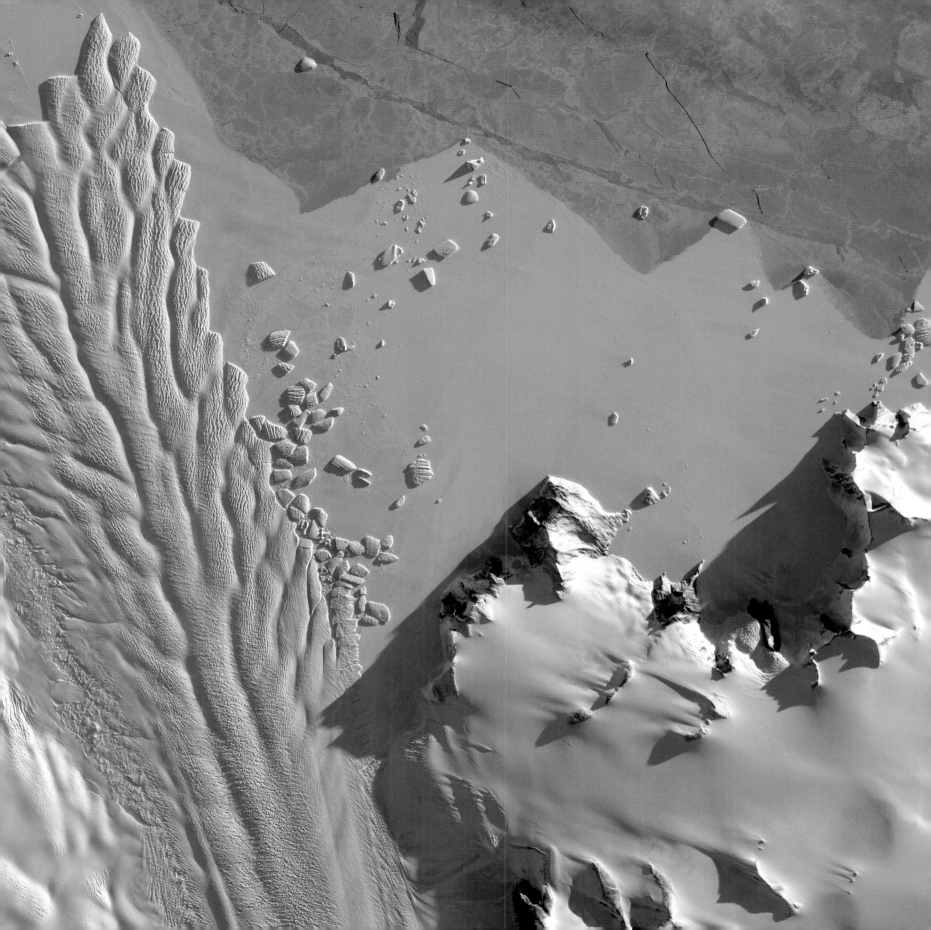

Sea ice distribution around Antarctica

In wintertime, sea ice extends up to about 1,000 km (620 miles) beyond the coast of Antarctica. This is about the length of Britain or a little less than the distance from Chicago to New York. The sea ice covers an area around the Antarctic continent that varies between a winter maximum of about 18 to 20 million km^2 (6.9 to 7.7 million miles2) in a given year. By the end of summer a minimum sea-ice cover of about 3 million km^2 (1.2 million miles2) is usually reached in late February or early March; this is an area of comparable size to India.

By contrast with Arctic sea ice, whose summer extent has declined sharply since the beginning of comprehensive satellite measurements in 1978, the area of summer sea ice around Antarctica has expanded slightly in recent years. However, there is much variability from year to year, and 2016 saw a major downturn in sea ice coverage and recorded the lowest value since satellite measurements began. Arctic sea-ice decline has been widely attributed to human-induced warming over the past few decades. In Antarctica, however, sea ice expansion has been ascribed to several possible causes. Enhanced offshore winds may, for example, drive pack ice further from the coast. It has also been suggested that increasing fresh water produced from Antarctica's ice shelves, linked to Southern Hemisphere warming, is counteracted by greater sea ice production in the cold and fresher surface water – a negative feedback process that offsets any atmospheric warming.

It is so-called katabatic winds (Chapter 4), caused as high-pressure air sinks over the Antarctic Ice Sheet and flows downwards to the coast, whose strength and consistency drives newly formed sea ice offshore. An open-water area known as a shore lead or, if larger, a coastal polynya, is often produced and maintained at the coast. The open water then freezes over again to produce more sea ice, and so on. This mechanism produces large volumes of sea ice and accompanying highly saline dense water, and is sometimes referred to as a 'sea-ice factory'. It is this dense water production from sea-ice formation that sinks to form Antarctic Bottom Water.

Sea ice, circulation and environmental change

Sea ice is an important driver of the production of Antarctic Bottom Water, which is a significant part of the circulation of the world's oceans. This is because the freezing of ocean water to form sea ice is accompanied by the rejection of salts. Consequently, sea ice often has only about 15% of the salt contained in the water it is derived from, and further salt is lost as brine drains through the crystals forming the sea ice. This fact has enabled mariners in the past acquire drinkable water supplies. Conversely, when sea ice melts in summer, relative fresh water is released that helps stabilize the water column and inhibits downward convection until new sea ice begins to form the following autumn.

The changing distribution of sea ice offshore of Antarctica also affects energy exchange with the water beneath. The amount of radiation reflected from the sea-ice cover of the Southern Ocean during winter contrasts dramatically the radiation absorbed by the much darker seawater in summer. The extent of sea ice therefore affects the reflectance or albedo of the ocean surface with the observed slight increase in ice cover in sharp contrast to continuing sea-ice decline in the Arctic Ocean. A sea-ice covered ocean also prevents the evaporation of moisture to the atmosphere, a factor important in making Antarctica such a dry continent, particularly during winter. Conversely, open-water areas within sea ice allow the penetration of light into the water, stimulating biological production.

Antarctic icebergs – size and shape

Antarctic icebergs are amongst the most stunning and photogenic natural phenomena in Antarctica, coming in many shapes, sizes and colours. Unlike sea ice, icebergs are derived from glaciers and ice sheets which, in turn, are formed from the year-on-year buildup of snow and its densification into ice as it is buried progressively more deeply. Given that snow is composed of fresh water, so too are icebergs. Icebergs are produced, or calved, when ice breaks off from the marine margins of the Antarctic Ice Sheet. The thickness of the parent ice mass at its margin governs the initial size of the underwater part of an iceberg (known as its submarine keel), which makes up about 80-90% of the total mass of a given iceberg. The keels of large Antarctic icebergs can reach up to about

Right: The variety of iceberg shapes is almost infinite, including a berg in the shape of a boot, with a 50 m (160 ft)-high 'leg', photographed against the sunset in the Amundsen Sea.

Below: As icebergs break up and overturn, they become more irregular in shape, and can include multiple pinnacles.

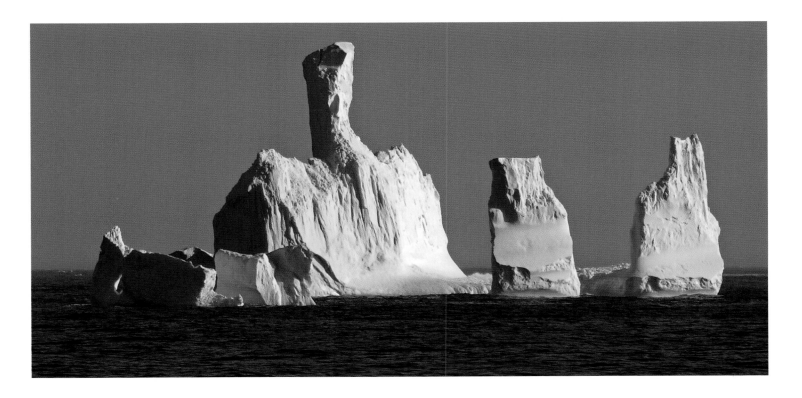

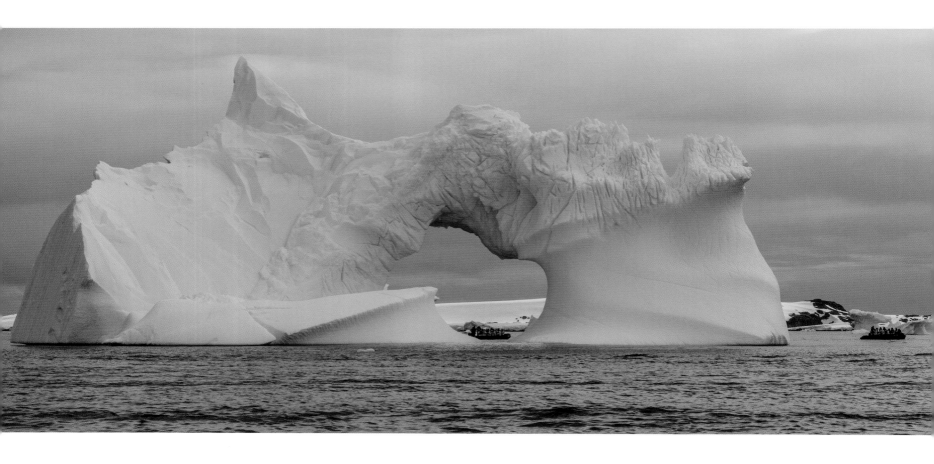

500 m (1,640 ft) below the water surface, but are more typically around 200-300 m (650-980 ft) in depth.

The shapes of icebergs are dependent initially on the form and flow of the marine-terminating ice margin from which they are derived. Large calving events from the parent ice sheet tend to produce flat-topped icebergs, known as tabular icebergs, which are often derived from the low-gradient surfaces of floating ice shelves or narrower floating glacier tongues. Large tabular icebergs can be tens of kilometres in length and thousands of square kilometres in area. The largest icebergs are often code-named and tracked in successive satellite images from their point of calving, in part for scientific study and also as an aid to navigation in Antarctic waters. As they break up and fragment, melting and overturn events affect iceberg shapes, and many small remnants of initially tabular icebergs are highly irregular in shape, sometimes with multiple towers and embayments known as docks, caves and arches. As melting and fragmentation proceed, an icebergs's centre of gravity shifts and a symmetrical series of wave-cut features may be produced as the waterline changes position.

Above: A rotated iceberg with arch and former waterline dwarfs the Zodiac boat passengers during a cruise amongst icebergs near Petermann Island, western Antarctic Peninsula.

Once icebergs have reduced in size to around 10 m (30 ft) across, they are referred to as 'bergy bits'. Particularly dense icebergs, often dark in colour and hard to see from ships, are known as 'growlers'. The smallest fragments of ice, a few centimetres or decimeters across, when gathered into a substantial areal distribution, are referred to as 'brash ice'. People travelling in small boats often collect pieces of brash ice to add to their evening drinks. The pressurized air bubble in contact with whisky, for example, produce a popping sound and a fine mist around one's face, sometimes known as 'bergy selzer'.

Much of the visual attraction of an iceberg is down to its internal structure, the manner in which it weathers and melts, and the way it fractures during calving events. Tabular icebergs commonly show horizontal layering; this is the annual layering of snow that has been transformed into ice, without significant internal deformation, as is the case in ice shelves. Another form of layering is foliation, which forms in glaciers that are deforming internally. It consists of distinctive bubbly and non-bubbly ice layers, which weather at different rates, forming a furrowed surface. Most icebergs have air bubbles, trapped when the original snow was buried. As the iceberg melts below water, streams of bubbles are release upwards, creating 'bubble rills' – vertical grooves worn out by the rising air. Icebergs, like their source glaciers, are also prone to calving. Small pieces break off the vertical faces, creating a chiselled appearance.

Recent iceberg calving

There are spectacular examples of recent calving events around Antarctica. The rapid breakup of the Larsen A Ice Shelf in 1995, and of Larsen B in 2002, each delivered thousands of icebergs to the western Weddell Sea. In 2017 part of the more southerly and larger Larsen C Ice Shelf broke off, producing an iceberg code-named A68 of 5,800 km^2 (2,240 miles2) in area.

One of the biggest calving events ever recorded was from the much larger Ross Ice Shelf in 2000. The huge iceberg B-15 was initially 295 km (183 miles) long and 37 km (23 miles) wide; its 11,000 km^2 (4,250 miles2) area was about the size

Below: Satellite imagery recorded the rapid breakup of the Larsen B Ice Shelf on the eastern side of the Antarctic Peninsula between January and March 2002 (courtesy of NASA). About 3,250 km^2 (1,255 miles2) of ice about 220 m (720 ft) thick was broken off and drifted away as icebergs. Individual images are from (A) 31 January, (B) 17 February, (C) 23 February and (D) 5 March 2002. Each image is about 215 km (133 miles) across.

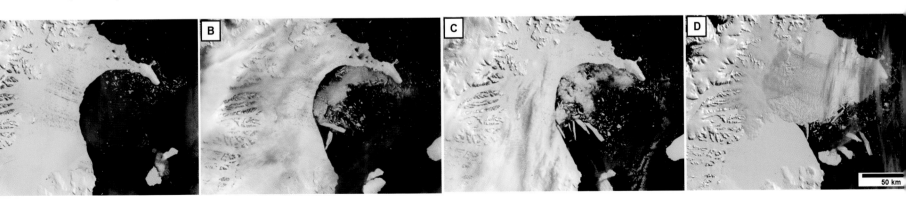

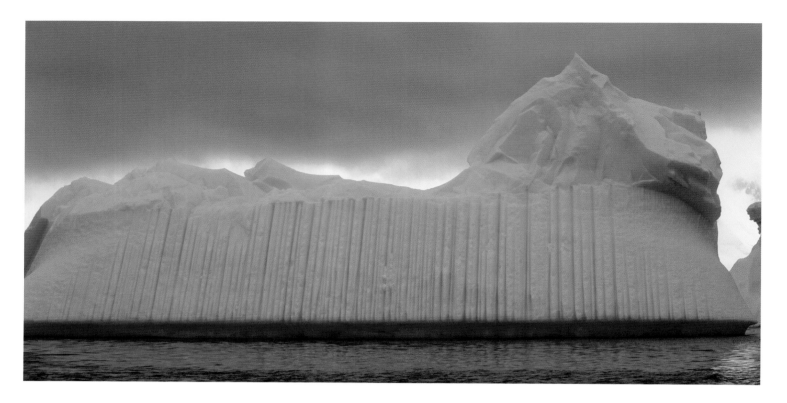

of Massachusetts or Jamaica. Within two years it had fragmented into a number of smaller pieces, and its final remnants were tracked to the east side of New Zealand in 2006. The calving of relatively large icebergs from Antarctic ice shelves is a fairly regular occurrence and is a normal mechanism of mass loss from the Antarctic Ice Sheet. Ice shelves typically grow slowly seawards until they become unstable, resulting in a large calving event. However, the rapid collapse of the fringing ice shelves of the Antarctic Peninsula, such as those in the Larsen area on the west side of the Weddell Sea, may be linked to climate warming since the mechanism for breakup involves the penetration of increasing quantities of surface meltwater into crevasses which then propagate through the entire ice-shelf thickness to cause collapse.

The calving of such very large icebergs has consequences for both wildlife and humans in Antarctica. Penguins may have to travel much further to reach their feeding grounds in the open sea if tabular icebergs block their way. It is estimated that about 150,000 Adélie penguins have died since 2010 when the 2,900 km² (1,120 miles) iceberg code-named B09B effectively landlocked their colony at Cape Denison in Commonwealth Bay, offshore of East Antarctica.

As they drift, huge icebergs also cool and freshen the seawater, and seed the ocean with iron by delivering dust particles as they melt. This, in turn, means more algae and plankton at the base of the Southern Ocean food chain in areas traversed by large

Above: Bubble rills are often found on icebergs that have overturned to reveal their previously submerged keels. The rills are strongly aligned and represent differential submarine melting linked to previously trapped air in bubbles within the ice migrating to the former sea surface on release.

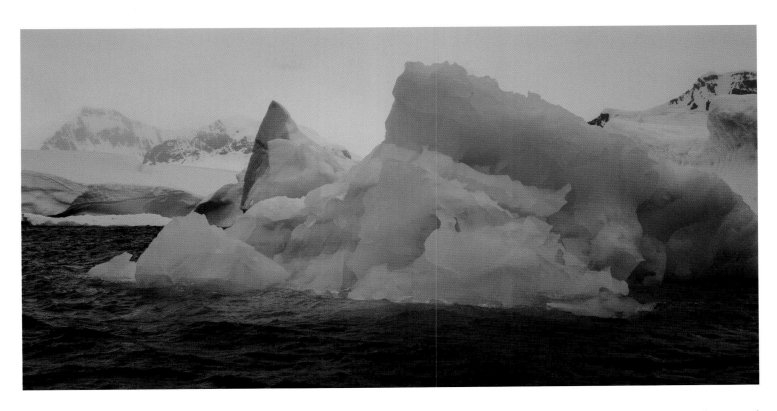

numbers of icebergs. Large calving events from the Ross Ice Shelf have also threatened ship access to the major American base at McMurdo Sound, while the development of cracks in the Brunt Ice Shelf in 2016-2017 led to the removal of overwintering personal from Britain's base at Halley and the relocation of base, using tractors, to the inland side of the cracks. If a calving event had occurred before transfer of the station, the base would have drifted away on the resulting tabular iceberg.

Iceberg drift and grounding

Opposite left: The drift tracks of a number of icebergs around Antarctica as simulated by a computer model (Courtesy of the Alfred Wegener Institute and Rackow et al. (2017) Journal of Geophysical Research). Icebergs appear to escape from inner-shelf waters to lower latitudes in only three parts of Antarctica. The five classes represent iceberg sizes, with Class 5 the largest.

Above: Many icebergs contain zones which appear to be a rich blue colour rather than a shade of white. This is an optical effect related to the presence of bubble- and particle-free ice. This example is from the Gerlache Strait, Antarctic Peninsula.

Once calving has taken place, icebergs float freely and drift with ocean currents and the wind. Unlike largely wind-driven sea ice, currents are the more important influence on iceberg drift direction. This is because of their deep keels, which are acted on by the upper few hundred metres of the water column. Thus, icebergs and sea ice, which is shallow-keeled and driven mainly by wind shear, tend to follow different drift tracks even in the same area of the ocean. Such a situation is of concern to mariners if their ship is trapped in sea ice, as an iceberg could gouge a track through the sea ice towards them, placing them in a highly vulnerable situation.

The Antarctic Coastal Current propels most icebergs westwards within about 200 km (125 miles) of the coast. When icebergs break out from this current into

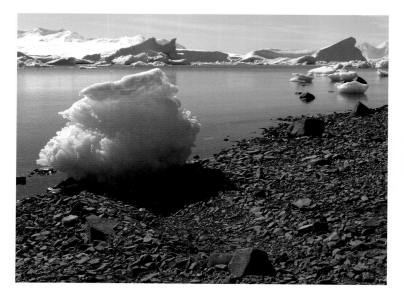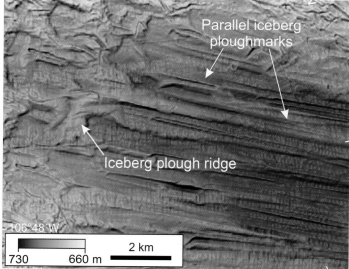

the Antarctic Circumpolar Current, their drift reverses to become predominantly eastwards. There are several areas around Antarctica where icebergs preferentially break out northward from Antarctic coastal waters; east of the Antarctic Peninsula, beyond Victoria Land in the eastern Ross Sea, and south of the Kerguelen Plateau sector of the Southern Ocean below India.

As they drift, icebergs gradually melt and fragment in the seas around Antarctica – water temperature is a key control on their longevity, which can be several years. As icebergs melt, any sediment held within the ice rains out into the sea, providing a simple but effective mechanism for delivering glacially eroded debris onto the ocean floor at distances up to hundreds and, sometimes, several thousands of kilometres from their ice-sheet source. Icebergs undergo little melting in the frigid waters offshore of much of East Antarctica, where ocean temperatures can be below zero, but beyond the cold Antarctic Circumpolar Current they melt rapidly.

If the deep keels of icebergs touch the sea floor during their drift, the keels are able to plough through soft submarine sediments. This action produces furrows that are referred to as iceberg ploughmarks. The furrows are typically tens to a few hundred metres wide and several metres deep. Much of the continental shelf of Antarctica that is shallower than 400 to 500 m (1,300 to 1,640 ft) has been affected by the ploughing action of iceberg keels, and the geological record of past sedimentation is reworked by this process. Iceberg grounding also has a severe impact in terms of disturbance to ecosystems on the sea floor. Ploughmarks produced by Antarctic icebergs have been observed as far north as the Argentine Shelf and the Chatham Rise east of New Zealand. These features were probably not formed today, but instead when the Antarctic Ice Sheet last expanded to the continental shelf edge about 20,000 years ago.

Above left and above right: Where the underwater keels of drifting icebergs come into contact with the sea floor, ploughmarks are formed as the ice keels push aside sedimentary material to leave curving grooves with ridges ('berms') at their margins. Such features can occasionally be seen forming at the coast as small icebergs move with the tide, but are more frequently imaged on the sea floor using multibeam echo-sounders. The sea floor image is from a water depth of about 700 m (2,300 ft) in Pine Island Bay, West Antarctica. (Right image courtesy of Martin Jakobsson)

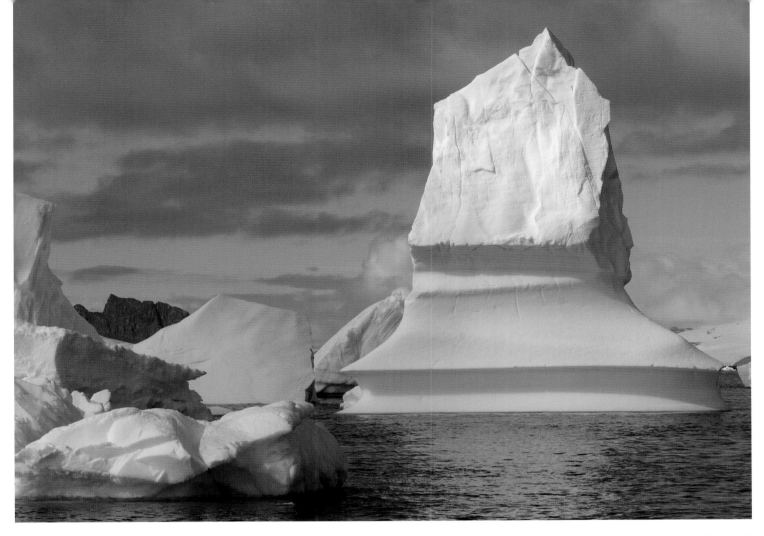

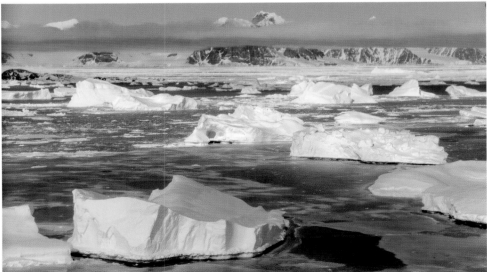

Above: When icebergs rotate in the water, often as a result of fragmentation and melting, waterlines form if a berg stabilizes in one position for a relatively long period of time.

Right: A 'graveyard' of grounded and decaying icebergs near the British base at Rothera – a series of former waterlines can be see.

Why are some icebergs blue (or occasionally green or black)?

Icebergs are an impressive sight in the seas around Antarctica, not only for their varied shapes but also for their colour, which is sometimes a strikingly clear blue, especially on cloudy days, when there is no reflected sunlight. This is an optical effect, produced by absorption of red light and the continued transmission of blue light. It takes a considerable thickness of pure ice in order to absorb enough red light to make an iceberg look blue or even turquoise, and for the light to travel far through an iceberg there must be few air bubbles or debris particles. However, the bulk of glacier ice is rich in air bubbles (Chapter 5). Air bubbles in the ice scatter incoming light and reflect much of it back after only a short internal travel path. As a result, little absorption of red light occurs, and the ice appears white rather than blue – hence, white icebergs are far more common than blue ones. Blue icebergs, or blue stripes within icebergs, are therefore those where the ice is particularly pure and free of internal scatterers such as bubbles or debris. This ice is likely to be derived from meltwater that has frozen onto the glacier bed or in crevasses.

Very occasionally, some icebergs contain ice that appears green or black. Such ice is thought to derive from the freezing on of ice platelets beneath floating ice shelves. The platelets accumulate and become compacted into bubble-free, desalinated ice. The green or black colour is due to the presence of marine-derived organic or particulate matter incorporated during the freezing process at the base of the ice shelf. Only when this ice is calved off as icebergs, which subsequently overturn to reveal their strangely coloured base, is the green or black ice exposed at the sea surface. Such icebergs are rare and have been sighted mainly offshore of the Ronne and Amery ice shelves, which are known to have extensive areas where sea water freezes onto the base.

Below left: An iceberg in the Bellingshausen Sea showing both white and blue ice components.

Below right: A rounded and overturned iceberg in the Bellingshausen Sea showing a layer of ice that appears to be green. This colour is thought to derive from the freezing on of ice platelets and small marine organisms or particulate matter at the base of ice shelves and is exposed only when calved icebergs overturn during their subsequent drift.

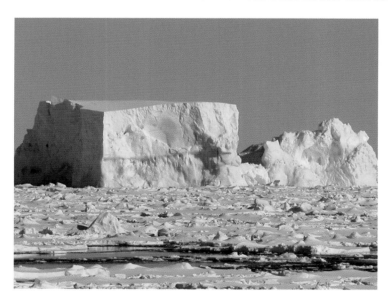

Iceberg harvesting: a potential solution to water shortages?

The idea of using Antarctic icebergs for refrigeration or as a water supply is not new. Back in the 1850s, Chilean breweries used ice from Antarctica to chill their beer. The crucial need today, however, is to resolve global water shortages. It has been estimated that by 2040 the demand for water globally will exceed supply by 30%. In the past, Antarctic icebergs have been seen as a potential resource that could help mitigate this problem. However, the focus for harvesting has been wealthy hot, arid countries. Some Middle Eastern nations have occasionally proposed towing large icebergs from the Indian Ocean sector of the Southern Ocean to the Arabian Peninsula. In the late 1970s the Saudi royal family explored through an international conference the feasibility of sourcing icebergs in Antarctica, but costs at that time were prohibitive. In 2017, a company proposed harvesting icebergs in this manner, by towing them to the United Arab Emirates, a distance of over 8,000 km (5,000 miles). It was said that each iceberg could contain 20 billion gallons of water that, if delivered successfully, would reduce the need for expensive desalination plants. Another potential source of icebergs could be the Ross Sea, which might potentially benefit Australia.

There are, however, innumerable problems, which include: the potential rolling, break-up and melting of icebergs *en route*; the stability of icebergs under tow; the frictional resistance of dragging an iceberg; the problem of berthing icebergs some hundreds of metres thick on a shallow continental shelf; and the huge cost of developing an infrastructure to capture, store and melt icebergs. Furthermore, there would be environmental consequences, and it is not clear under the Antarctic Treaty System (Chapter 11) whether removal of icebergs from the Southern Ocean is indeed permissible. On the other hand, if these issues can be resolved, it has been argued that a 'cold rush' could ensue.

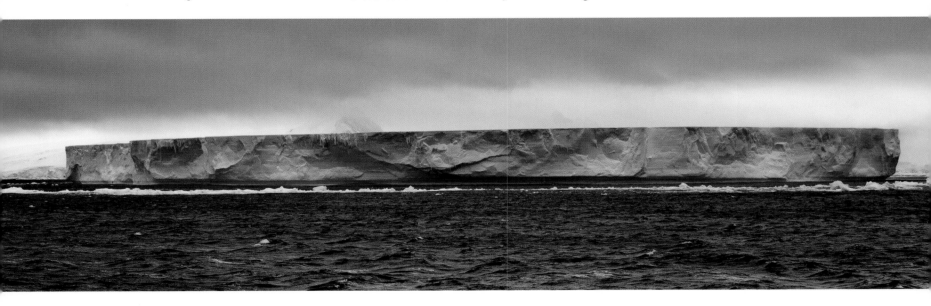

Below: A large tabular iceberg, about a kilometre long, with the northeast tip of the Antarctic Peninsula in the background.

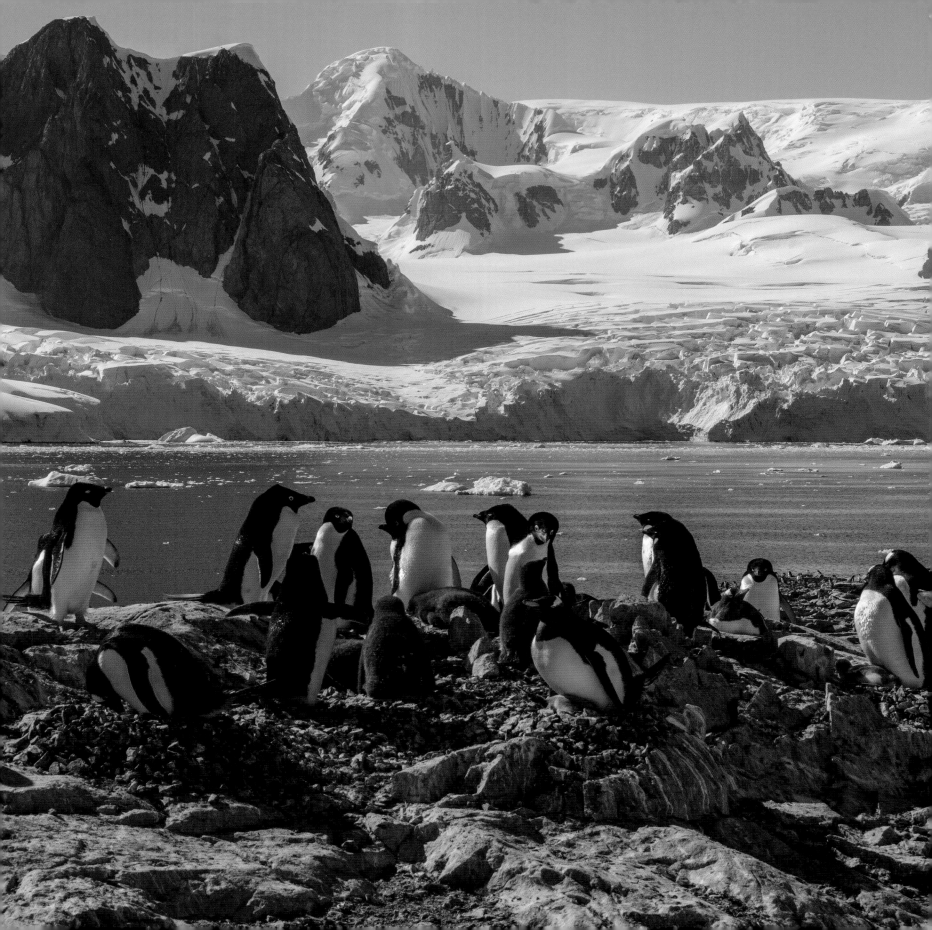

CHAPTER 8

Life in a Frigid Environment

A visit to an emperor penguin rookery

During a long-distance transfer by helicopter between the Australian stations of Casey and Davis in East Antarctica in early 1995, bad weather forced our party to land at the Russian station of Mirny. This was the coastal base for establishing an ice-core drilling project in the heart of the East Antarctic Ice Sheet, resulting in the extraction of the famous Vostok ice core (Chapter 5). Our enforced overnight stay yielded a wonderful opportunity to visit an emperor penguin rookery with resident Swiss photographer, Bruno Zehnder. Late in the evening, Bruno led us on foot across creaking sea ice, jumping newly opened leads and meeting occasional Adélie penguins en route. The air was still and the temperature just a few degrees below freezing, as we meandered between magnificent grounded icebergs, with their vertical ice faces glowing gently in the twilight. Despite being overcast, the sky had a range of warm colours that contrasted with the deep blues of shadowed ice. After an hour or so we reached a small island where Bruno had a hut at the edge of the emperor penguin rookery. The noise from the rookery commanded our attention, as the haunting cries of the emperors rose and fell in a gentle breeze. As we stood watching, the penguins mingled with us. Standing waist-height, and with their black and white plumage and orange-yellow necks, the adults possessed a very stately appearance. A number of large chicks were present, some moulting, some drying out and being fed, but, strikingly, many dead chicks were scattered around. Bruno had watched these birds all through the previous winter, which reminded me of Edward Wilson's mid-winter journey to Cape Crozier in 1911 to collect embryos of emperor penguin eggs, a story that is so vividly portrayed in the 'Worst Journey in the World' by Apsley Cherry-Garrard. After our extended midnight encounter with these magnificent birds, we made our way back in improving light, treasuring the memorable experience we had just had.

MJH

Opposite: Adélie and Gentoo penguins breeding together on Petermann Island, western Antarctic Peninsula, with Mt Scott on mainland in the background.

The Antarctic Ecosystem

Animal and plant life in Antarctica is focused on the coastal areas and seas beyond, and is determined by climate and oceanographic conditions. The area covered in this book is the Antarctic continent itself, the continental shelf, and the area that is affected by sea ice in winter. However, many species extend their range beyond this limit, while the sub-Antarctic islands are home to many additional species.

As a place for living organisms, the harshness of Antarctica will be apparent from the preceding chapters. Well under one percent of the continental land area is free of snow and ice, and most of this comprises either soaring mountains or polar desert. Temperatures only reach above freezing in summer in coastal areas or in sheltered inland valleys, whilst fierce winds scour the land all year round. Nevertheless, inland areas do support some well-adapted and often microscopic organisms, and even a few species of bird, such as the Antarctic skua, snow petrel and Antarctic petrel, venture some way inland to nest.

In contrast, the seas surrounding the continent are richly productive. The combination of turbulent winds and upwelling ocean currents provides nutrients for plankton, which in turn sustain fish, millions of sea birds (including the iconic penguin), whales and seals. All these Antarctic species form part of the marine ecosystem and only come ashore to breed or moult. Beaches, rocky shorelines, cliffs and shorefast sea ice provide space for breeding in the short summer season, close to the ready oceanic source of food.

Species such as the great whales and fur seals were treated as an economic resource until the mid-20th century, and stocks were decimated as a result. 'Scientific whaling' continues to this day, but whales are otherwise protected. In recent years, a potential new threat is the large-scale extraction of the shrimp-like krill on which so many higher species depend (Chapter 11).

Despite their past exploitation, many marine birds and mammals are not frightened of humans. There are few places on Earth where truly wild animals, such as penguins and seals, will come right up to humans if they remain still for a while. It is this aspect of wildlife which more than anything else draws so many visitors to Antarctica. For lovers of wildlife, there is no more special experience than sitting down on a rock or on the ice and having emperor or Adélie penguins walk up to you, simply out of curiosity.

The science of ecology, a branch of biology, considers the relationships between organisms, and with their physical surroundings. It involves the study of biodiversity, species distribution, biomass, populations, and interactions within and between species. Thus, ecosystems are represented by a dynamic interaction between organisms and their response to their environment.

The Antarctic ecosystems, divided into marine and terrestrial, are unique, because evolution has taken place in isolation from the rest of the world. Formerly part of the Gondwana supercontinent, Antarctica remained centred on the South Pole while the other continents drifted northwards one-by-one. The last to drift away was

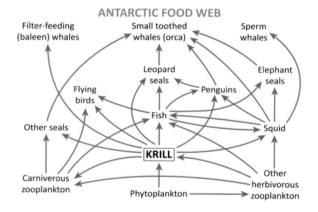

Above: The Antarctic food web, showing the interconnectedness of all species from micro-organisms at the base, via the keystone species, krill, to marine mammals at the top.

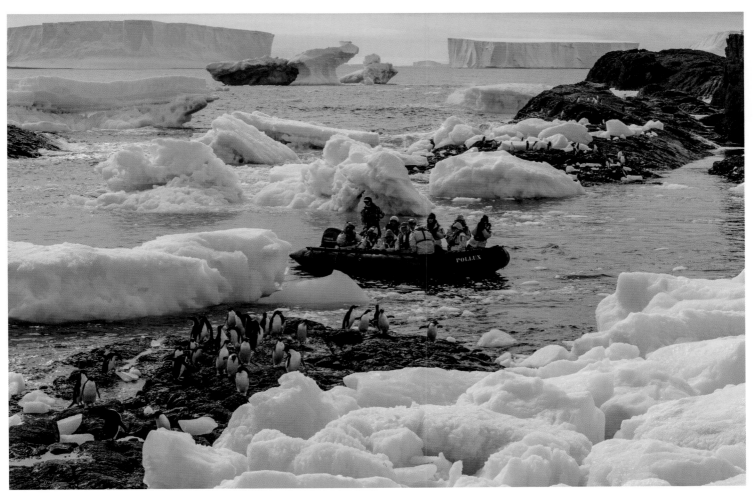

Above: Visitors from an expedition ship pass a group of Adélie penguins at Gourdin Island, at the northern tip of the Antarctic Peninsula.

South America around 34 to 30 million years ago, when the Drake Passage opened and thermally isolated Antarctica. Also around 34 million years ago the first ice sheets reached the coast, and since then the Antarctic ecosystem has evolved in a freezing climate, albeit one that switched from glacial to interglacial conditions, driven by changes in Earth's orbit around the sun. Despite conditions which seem to us humans as extreme, Antarctic organisms have managed to survive and indeed flourish.

In the Antarctic marine ecosystem, the food web is a key component which links together all species from micro-organisms to whales. The base of the food web is represented by plankton, followed upwards by fish and squid, and lastly birds, seals and whales. In contrast, on land, the food web is simple, as it lacks higher-level vertebrates such as fish and mammals. The inter-connectivity of species means that if any one component is disrupted, such as through climate change or over-exploitation, the whole food web may be adversely affected.

In order to better understand how the Antarctic ecosystem functions, scientists are increasingly turning to genomics (the study of species at the genetic level) and ecosystem modelling. These approaches are vital if we are to understand, not only how the ecosystem itself works, but also the impacts of climate change and over-exploitation on the health of the ecosystem. Such investigations involve the study of species at all scales, from micro-organisms to the largest animals, and on a range of spatial scales from individual bays or valleys to the entire Southern Ocean. Ecology in Antarctica connects with other scientific disciplines, such as geology, physical geography, glaciology, oceanography and climatology, and also considers the impact of humans since their first arrival on the continent.

The Antarctic marine ecosystem benefits from great stability of temperature, albeit very low by human standards. However, the ecosystem has to respond to extreme seasonal changes. Two-thirds of the Southern Ocean freezes over during the winter, effectively doubling the surface area, including the continent, covered by ice. This expansion and shrinking of the Antarctic pack ice is the greatest seasonal process in the world's oceans, and is crucial to the life cycles of organisms that live in the region. In addition, there is strong seasonality of input of solar energy (Chapter 4), and this leads to short periods of intense primary productivity during the summer. Indeed, some estimates suggest that the Southern Ocean is responsible for around half of all ocean carbon fixation in photosynthesis. It is also estimated that half of that productivity is actually through algae linked to sea ice. Thus, seasonal variations in food supply are important challenges experienced by the higher animals. Not only that, but organisms are faced with unpredictable large-scale changes to their physical environment, such as glacier calving, ice-shelf collapse and iceberg-grounding. The highest productivity is confined mainly to the edge of the sea ice, rather than extending over the whole Southern Ocean, and this is clearly in evidence when a ship enters the pack-ice zone.

The marine ecosystem has been influenced by exploitation of its living resources for over 200 years. Whales, seals, fish, and most recently krill, have all suffered in this way. Indeed, a system that was once dominated by the large whales may have changed to one that is dominated by fur seals and squid, invoking the possibility that the ecosystem will not return to its former state. Furthermore, the consequences of climate change on the marine ecosystem are poorly understood, and it is not known how resilient it will be to forthcoming changes – changes that have not been experienced in the last few million years. For life that is physiologically adapted to chronically cold and stable conditions, the atmospheric and oceanographic warming already experienced in the Antarctic Peninsula may have a profound impact on the survival of key species. For instance, when sea ice area shrinks or duration reduces, species that rely on this environment will become more vulnerable, leading to reductions in productivity.

The Antarctic terrestrial ecosystem, to a large extent benefits from having many birds and seals bringing nutrients from the marine environment to the terrestrial

A selection of animals living on the sea floor of Marguerite Bay, west of the Antarctic Peninsula, photographed from a remotely operated vehicle moving a few metres above the bed. For scale, there are two red dots in each photograph representing a distance of 10 cm (3.9 in).

Top row, from left to right:
A range of fauna including gorgonians, basket stars, sea cucumbers and brittle stars.

Seastars, brittle stars and gorgonians.

One of the many species of *Cnidaria*.

Bottom row, from left to right:
A group of brittle stars.

Feather stars belonging to the class of animals named *Crinoidea*.

The seapen *Umbellula*.

ecosystem. However, the terrestrial ecosystem has much lower diversity of species than the surrounding Southern Ocean, but does show wide variation in space and time. The Antarctic continent is divided into two biogeographical zones: the Maritime Antarctic Zone forming the west coast of the Antarctic Peninsula, which is relatively mild and wet; and the Continental Antarctic Zone, which covers the rest of the continent and is a polar desert. In addition to the cold and dryness, a major factor that influences the survival of terrestrial species south of the Antarctic Circle is the extreme seasonality, with 24-hour daylight in summer, and 24-hour darkness in winter. Life requires moisture, but for most of the year water remains frozen, and organisms have to adapt to the sub-zero conditions. Despite the severity of the Antarctic climate, near the ground the microclimate is more favourable to life, as the ground is warmed by the Sun, and in certain areas small-scale life forms can flourish.

The status of the Antarctic ecosystems is today being affected by climate change, especially in the Antarctic Peninsula where warming has been most pronounced. Both terrestrial and marine species are having to adapt to changes to the physical environment, such as when glaciers and ice shelves recede. What we are now seeing are irreversible changes to their habitats (Chapter 12).

Life beneath the ocean surface

Although the Antarctic is a land that is hostile to most life, it is surrounded by an ocean that proves to be one of the richest in the world. There we find a variety of life that is strange and colourful, sometimes claimed to equal tropical coral reefs in terms of biodiversity or biomass.

A poem written by Griffith Taylor on Scott's Last Expedition (1911), *Life's Round in the Antarctic*, engagingly summarises the interconnectedness of marine organisms in Antarctica. Here is the first verse:

Big floes have little floes all around about them
And all the yellow diatoms couldn't do without them
Forty million shrimplets feed upon the latter
And the shrimps make the penguins and the seals and
whales much fatter

Despite the rich diversity of species in the Southern Ocean, detailed studies have focused mainly on areas close to Antarctic bases or from scientific research vessels. As such, new species are being recorded frequently. The most common, and best-known, species or groups are described below, but this is by no means a complete list.

Micro-organisms. All life in the seas surrounding Antarctica, as indeed everywhere on the planet, depends on the micro-organisms that live there. Forming the base of the food web, they are highly sensitive to environmental changes. Micro-organisms, which can only be seen under the microscope, are represented by phytoplankton (microscopic plants or algae), zooplankton (microscopic animals, also known as protozoa), bacteria (the most abundant organisms on the planet), fungi (major players in decomposition and nutrient release) and viruses (which are biological agents that infect other organisms). Phytoplankton draw their energy for growth and reproduction from sunlight by the process of photosynthesis. Approximately 400 species live in the Southern Ocean, mostly close to the sea surface as they depend on light energy, and they provide the food and energy for the entire Antarctic marine food web.

Diatoms are a particularly important group of phytoplankton – single-cell plants that form the base of the Antarctic food web, representing three-quarters of the primary production in the Southern Ocean. Diatoms draw in some of the atmospheric carbon dioxide that is dissolved in the ocean, converting it into sugars to allow the cells to function and create reproductive capacity. Largely through diatoms, the Southern Ocean is the world's largest sink for atmospheric carbon dioxide into the deep ocean. With their robust siliceous skeletons, the diatoms sink to the sea floor, where they contribute substantially to the accumulation of sediment, unless ingested by predators. When a sediment consists of almost pure diatom remains, it is referred to as 'ooze'. Diatoms have evolved over tens of millions of years, and in the sedimentary record they tell a story of environmental change in Antarctica. Diatoms can also be transported inland by wind, so many parts of the continent have thinly dispersed deposits of this organism.

Zooplankton (protozoa) occur wherever there is moisture, not just in the sea, but in lakes, streams, wet sediment, soil and

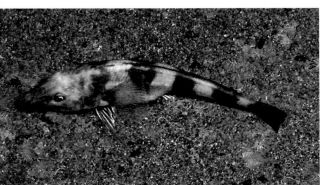

Top: The Antarctic krill *Euphausia superba*. (Courtesy of NOAA/US Dept. of Commerce and Valerie Loeb)

Bottom: An icefish close to the sea floor off the Antarctic Peninsula. The two red dots (at the top of the fish's body) provide a scale 10 cm (3.9 in) across in this photograph, which is derived from a remotely operated vehicle.

inside other organisms. They feed on phytoplankton, bacteria and each other; indeed, they have similar functions to those of higher animals, such as taking in food, excreting waste and reproducing.

Bacteria occur everywhere on Earth, ranging from the deepest oceans, across all land areas, in ice sheets and in the atmosphere. They are even hypothesised to occur on Mars and other planets. Bacteria are incredibly robust. For instance, in Antarctica, they have remained dormant in ice possibly for hundreds of thousands of years, but have recovered when exposed to air. We are all familiar with bacteria causing disease in other living beings, including ourselves, but these are a minority. Most bacteria feed on dead organisms or waste products, allowing the important process of decomposition to occur.

Viruses are the fourth group of organisms found in Antarctic waters. They infect the other three groups: phytoplankton, zooplankton and bacteria. With concentrations of 1 to 4 million particles per millilitre of water, they are important in controlling the composition and size of communities of microscopic organisms in Antarctica.

Krill. Krill are one of the world's most abundant animals. The term is of Norwegian origin, and krill embraces 85 species of free-swimming crustaceans called *euphausiids*. Red or orange in colour, individuals grow to 6 cm (2½ in) in length and may weigh over a gram (0.03 oz). Krill rely on the underside of sea ice as a nursery for their larvae, as algae growing there provide a source of food. With a biomass estimated by the International Union for Conservation of Nature (IUCN) at 200 million tonnes and much more by other estimates, krill make one of the largest contributions to global biomass of any multi-cellular animal species on Earth. Most higher-order life in Antarctica depends on krill for food, including fish, squid, seals, whales, penguins and other seabirds; for this reason, krill are regarded as 'keystone' species.

Krill can congregate into enormous schools that stretch for several kilometres (a few miles) across the ocean. The schools rise to the surface at night but tend to remain in deep water during the day. It is very common to see the brightly coloured krill on the underside of ice floes that have overturned.

Fish. Fish are a large group of animals with backbones (vertebrates). The rich supply of micro-organisms and krill support abundant fish inside the Antarctic Convergence, despite the cold waters. As many as 200 species have been recorded in this region, many of them occurring nowhere else on the planet, and being uniquely adapted to the cold conditions. Their uniqueness also stems from the fact that most fish species died out when Antarctica became thermally isolated around 34 million years ago, and those that remained evolved separately. A representative selection of fish is described here.

The largest fish in the region is the Antarctic cod (*Notothenia coriiceps*), which is found mainly on continental shelves and in the deeper waters of the Ross Sea; it is not, however, related to true cod. Antarctic cod grow typically to 1.5 m (5 ft) in length and weigh

on average 25 kg (55 lb), but some may be much bigger. Other deep-water fish, such as the crocodile dragon fish (*Parachaenichthys georgianus*) are half a metre (20 in) long. Some small fish lack scales, but carry spines, such as the Antarctic spiny plunder fish (*Harpagifer antarcticus*), which lives in shallow water around the tip of the Antarctic Peninsula. The Antarctic toothfish (*Dissostichus mawsoni*) is commonly regarded as a particularly important species, as it is suitable for fisheries, but significant exploitation is illegal. This fish is found close to the Antarctic continent, but lives near the sea bottom, at depths ranging from 110 m to 3,000 m (350 to 10,000 ft). Toothfish may grow up to 2 m (6 ½ ft) long and weigh 100 kg (220 lb) when fully grown and live to the remarkable age of 45 years. There is another group of fish that has no red blood cells, the so-called icefish (e.g. the black-finned icefish, *Chaenocephalus aceratus*).

Antarctic fish are uniquely adapted to the near-freezing water. They contain proteins in the blood and body tissue which act as an antifreeze. Some species are able to live under ice floes in water that may be below -1° C (30° F) because of this adaptation to cold.

Squid. Unlike fish, squid are invertebrates, meaning that they lack backbones. They belong to a group of molluscs called cephalopods, which includes octopus, an animal that is also common in Antarctica but little-studied. This diverse group of animals ranges in size from just a few centimetres (*Idiosepius* sp.) to nearly 20 m (65 ft) for the giant squid (*Architeuthis* sp.). There are some 20 species in the Southern Ocean, living mainly in deep water. They forage on krill, small fish and each other, and themselves are prey for whales, penguins and other large sea birds. Most squid complete their life cycle in just one year. Squid are heavily fished in the areas adjacent to Antarctica, and exploratory fishing has taken place inside the Convergence. If commercial squid fishing does develop, it will be managed by the Commission for the Conservation of Antarctic Marine Living Resources (CCAMLR), as described in Chapter 11.

Salps. Salps are small gelatinous marine invertebrates belonging to a group of animals called Tunicata, growing up to 10 cm (4 in) in length. They look like jellyfish, but are in no way related. The visitor to Antarctica is more likely to see salps than most other marine organisms, as they are often washed ashore and stranded at high tide. They are common in the world's oceans, but only two species occur in Antarctica: *Salpa thompsoni*, which is abundant in ice-free areas, and *Ihlea racovitzai* which occurs close to the edge of sea ice in high latitudes. The former becomes more abundant in years of low ice extent when there is a lesser abundance of krill. Salps have a pumping action, which filters food particles and doubles as a means of propulsion, so they feed and swim at the same time. Some fish eat salps, and they have also been found in the stomachs of albatrosses and seals. However, since they are 95% water, they are not sufficiently nutritious for larger species.

Life near the shore

The shoreline, intertidal zone and shallow seas of Antarctica are, unlike the deep ocean, inhospitable places for life. As much as 95% of the Antarctic coastline is fringed by glacier ice, and this is frequently calving large and small icebergs (Chapter 7). The sea floor is therefore constantly being scoured by the underwater keels of icebergs, as well as sea ice in shallow water. Some icebergs have submarine draughts of hundreds of metres, and wind and currents cause them to abrade the sea bed. Thus in most places no perennial seaweeds grow, except in protected crevices. Iceberg influence is less extreme in the northermost parts of Antarctica, such as the tip of the Peninsula and the South Shetland Islands, and it is here that beds of giant kelp can grow; this often litters the shores after a storm.

On rocky shores below the influence of tides and waves, and where iceberg influence is diminished, it is possible to find a colourful array of worms, crustaceans, sea slugs, sea spiders, sea urchins, starfish, anemones and sponges. The variety of species is immense: at least 300 species of Antarctic sponges alone have been identified, for example.

There is life to be found even beneath ice shelves. It might be expected that a layer of over a hundred metres of glacier ice on the surface of the ocean would be enough to discourage life from venturing underneath. However, it is known that quite rich animal communities exist beneath ice shelves. Unusual evidence for this comes from the surface of the McMurdo Ice Shelf in the Ross Sea. Here, the remains of gigantic fish (*Dissostichus mawsoni*), sea urchins, corals, sponges, shellfish and other sea-

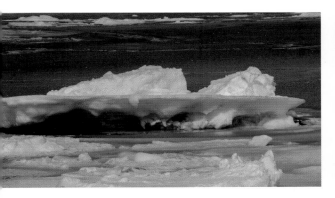

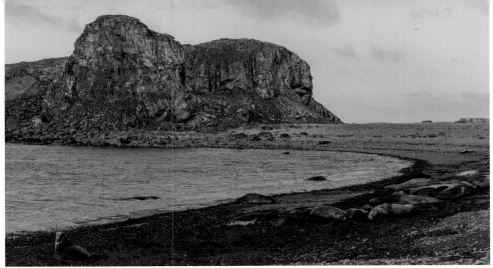

floor animals have been found, tens of kilometres from the open sea. How they reached this location is related to the way this part of the ice shelf, which is composed entirely of marine-derived ice, ablates and grows. Freeze-on to the base occurs, trapping the animals (along with sediment) in frazil ice. Net ablation at the surface means that the animals are drawn upwards until they are deposited on the surface. In the nearby Ross Ice Shelf, 450 km (280 miles) from open water, a borehole camera revealed various swimming animals, including copepods, crustaceans, amphipods and fish. Large-scale iceberg calving events also provide an opportunity to study the life-forms that existed beneath an ice shelf.

Marine mammals

Cetaceans

The order Cetacea embraces whales, dolphins and porpoises. There is a widespread perception that whales are intimately associated with Antarctica and the Southern Ocean, but in fact many only migrate there in early summer (October to November) to feed on krill and phytoplankton as the sea ice disintegrates. Antarctic whales are divided into those that feed on krill (blue, fin, humpback and minke whales), those that feed on small pelagic species such as copepods (southern right whale), those that eat fish and squid (sperm whales), those that predate on seals and penguins (orcas, also known as killer whales), and a variety of beaked whales.

Those species that are associated with sea ice, often swimming close to the edge of the pack ice, are minke, blue and humpback whales, as it is here that large concentrations of krill occur. Whale populations were decimated in the 19th and 20th centuries by commercial whaling (Chapter 9), but this activity was suspended by international agreement in 1984 (Chapter 11). Since then, some species have begun to recover, notably humpback and southern right whales, but others like the blue whale remain on the critically endangered list. Even so, controversially, 'scientific' whaling continues, by Japan, which harvests a few hundred minke whales in each year it occurs.

Top left: The orange staining on the underside of this ice floe, grounded on the sea bottom at Rothera Station (UK), represents a rich assemblage of algae, the source of food for krill and other organisms.

Bottom left: Salp, stranded by the outgoing tide on a volcanic sand beach, Deception Island, South Shetland Islands.

Top right: Kelp, thrown up from the sea floor during a storm, forms a ring around this gravel beach at Elephant Point, Livingston Island, South Shetland Islands. The kelp forms a bed for a group of elephant seals.

Whales play a vital role in the Southern Ocean ecosystem, and are therefore the focus of substantial research concerning their migrations, feeding strategies, and even identifying their language. In addition to formal research undertaken by international scientific programmes, this research is supported by Antarctic tour operators, with their vessels often in a position to spot and identify whales.

Southern right whale (Eubalaena australis). The name 'right' stems from the fact that these whales were the most suitable for hunting, being relatively slow and easy to harpoon. Right whales reach about 17 m (58 ft) in length and weigh up to 100 tonnes. They are found principally in sub-Antarctic and more northerly waters, but are currently increasingly likely to be seen around the South Shetland Islands and further south on the Peninsula. The right whale feeds on krill in shallow water, blowing frequently. In the Southern Hemisphere right whales were hunted from the early 17th century, but by the early 20th century they were almost extinct, with only about 300 left by the 1920s. Legal protection followed in 1935, but illegal hunting continued until the 1970s. Since then they have made a strong recovery, and it is believed that there are now several thousand. Consequently, they no longer regarded as an endangered species.

Blue whale (Balaenoptera musculus). The blue whale is so-called because of its bluish grey skin. It is the largest animal ever to have lived on the planet, measuring around 30 m (100 ft) in length and having a weight of 150 tonnes. The blue whale is found in small numbers in all the world's oceans. The Antarctic form, (*B. m. intermedia*) lives in the Southern Ocean as far south as the ice edge. It feeds almost entirely on krill, both at the surface and in deep water, taking an estimated 8 tonnes a day. It swims slowly, often in groups of several animals, blowing at the surface a vertical jet 10 m (30 ft) into the air before rolling over. In pre-whaling days the blue whale was extremely

Creatures from the sea floor beneath McMurdo Ice Shelf. They are attached to frazil ice and then adhere to the base of the ice shelf, and, as the surface ablates, the organisms move towards the ice surface where they can be found.

Left: A scallop shell of the species *Adamussium colbecki*.

Right: A bryozoan coral of the species *Reteporella*.

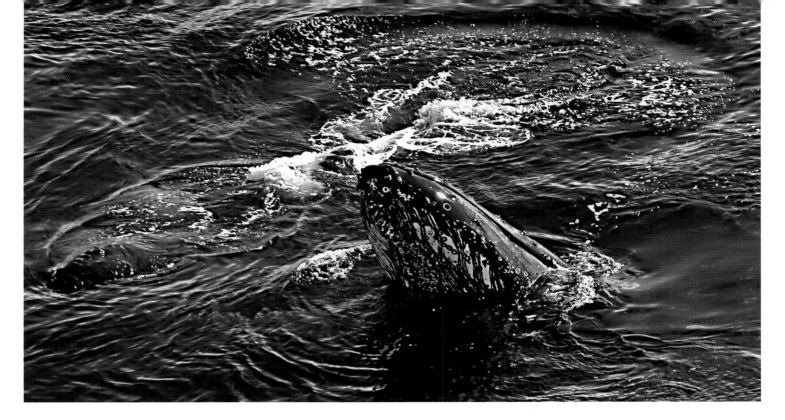

abundant, but catches in the 20th century alone amounted to over 340,000, and even after protection numbers have barely started to increase, leaving the species on the endangered list. A survey that ended in 2001 still only estimated a population of about 1,700 animals. Consequently, the blue whale is rarely seen in Antarctica.

Fin whale (Balaenoptera physalus). A sleek, fast-swimming whale, the fin is similar to the blue, but smaller. Its name derives from the prominent dorsal fin. It measure up to 27 m (88 ft) in length and weighs up to 90 tonnes. It is a regular summer visitor to Antarctic waters, but its distribution is global. Fin whales feed on plankton and krill near the surface, and dive to over 200 m (650 ft) to catch squid and fish. At the surface a fin whale blows several times, then rolls over, and may even breach the surface of the sea. In the Southern Hemisphere three-quarters of a million fin whales were caught by commercial whaling operations in the 20th century up until 1976, when catches were restricted. Only about 15,000 are estimated to be alive today, and there are no clear signs of a recovery; therefore, the fin whale is still regarded as an endangered species.

Antarctic minke whale (Balaenoptera bonaerensis). This streamlined species is a fast swimmer that spends much of the summer close inshore near to the edge of, and within, the pack-ice – often in groups. It was named after a Captain Meincke, a Norwegian whaler. In winter minkes range far into temperate and even equatorial latitudes. Minkes feed almost exclusively on krill. They average about 8 m (26 ft) in length and weigh 6-8 tonnes. The minke whale was not exploited so heavily as the larger

Above: Humpback whales inspecting a ship in Gerlache Strait, with the one lower middle 'breaching' the surface.

whales, but even so some 100,000 whales were taken in the 20th century. The catch is now much reduced but still continues under a scientific permit. It is thought that there are still 760,000 minke whales left, but there is a large uncertainty in this estimate, and there are insufficient data to assess their status in terms of population trends.

Humpback whale (Magaptera novaeangliae). The humpback whale is so named because of the small dorsal fin on a hump, which is prominent when it arches its back. It is a stocky looking whale with a length of about 15 m (50 ft) and weight approaching 50 tonnes. Humpbacks are found in all the world's oceans, with Antarctic individuals spending the summer cruising the pack-ice edge in groups. The humpback is the most likely whale to be seen by visitors, and it is possible to approach them quite closely in inflatable boats. They commonly swim alongside or dive beneath the boat, and are one of the biggest attractions of an Antarctic voyage. Humpbacks have large flippers, which are about 5 m (16 ft) long, making them a powerful, albeit slow swimmers with the ability to leap clear of the water – an impressive display of 'breaching'. Equally spectacular is their habit of 'fluking', which as a precursor to a dive, is their ability to twist their tail vertically, and the water to flow off in a manner similar to a waterfall. Humpbacks are noted for their vocal long-distance communication, through varied whistling and rumbling. When cruising at the surface they produce a bushy blow, especially before fluking. They often hunt in packs of several animals, feeding mainly on krill and plankton, by engulfing swarms with their open mouths. They also use the sophisticated technique of bubble-netting to surround their prey, whereby a group of whales will encircle a shoal of krill creating a wall of bubbles that prevents them from escaping. Commercial whaling in the 20th century and earlier decimated the humpback whale population, although this ceased in the Southern Hemisphere in 1963. Nevertheless, the humpback whale has recovered strongly, and the global population estimate is 60,000 animals. However, humpback whales occur in several distinct populations, between which there is little interaction. Classified as 'Endangered' as recently as 1988, they are now considered to be of 'Least Concern', a substantial improvement for this impressive creature.

Orca or killer whale (Orcinus orca). With a name like this, it is not surprising that the orca is one of the most feared marine mammals. It is actually one of the smaller whale species, in reality a dolphin, with the males measuring 9 m (30 ft) in length and weighing up to 7 tonnes, and the females half this weight. Globally, there are several types, and the Antarctic populations tend to travel in groups ('pods'). They can travel fast, with their large triangular dorsal fins giving them a distinctive appearance. Their fearsome reputation derives from the fact that they prey on seals, other whales (e.g. minke whales) and penguins, as well as fish. Orcas operate extensively in ice-filled coastal waters in summer, especially in the vicinity of penguin rookeries. Orcas are highly intelligent animals, and use a technique of 'wave-washing' seals off ice floes, usually doing so through team-work. They

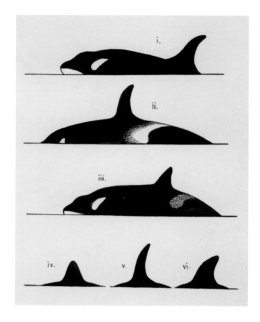

Above: A field sketch of *Orca gladiator* by Edward Wilson drawn during Scott's *Terra Nova* Expedition. The diagrammatic representation of markings are: 'i' and 'ii' adult, 'iii' young, with 'iv', 'v' and 'vi' showing varieties of dorsal fin. (© Scott Polar Research Institute)

also investigate potential prey by 'spy-hopping', whereby they rise vertically with their heads well above water. In the annals of polar literature, the story of Scott's photographer, Herbert Ponting, who narrowly escaped being tipped off an ice floe by orcas, is well known. Globally, orcas have been affected by hunting, pollution and fatal encounters with fisheries, but their conservation status is unknown because of insufficient data. In Antarctica, there is the long-term threat of a reduction in sea ice, which is where they obtain much of their prey.

Hourglass dolphin (Lagenorhynchus cruciger). With a black and white body, this sleek dolphin is a striking sight as it follows ships. Along with the orca, it is one of the few species of dolphin to venture into Antarctic waters, as most species prefer warmer conditions. Measuring 1.7 m (5½ ft) in length and weighing up to 100 kg (220 lb), it commonly forms pods of a few dozen. It ranges widely in the Southern Ocean, often following the ice edge, and also ventures well north of the Antarctic Convergence. The population of hourglass dolphins is estimated to be 144,000 south of the Convergence but, although the population trend is unknown, this species is not considered to be endangered.

Cetaceans beyond the continental shelf. There are a number of whale species outside the scope of this book, that are occasional visitors to the Southern Ocean, feeding in the deep ocean basins, but not generally venturing onto the Antarctic continental shelf. They include the sperm whale (*Physeter microcephalus*; 15 m (50 ft), 40 tonnes), the sei whale (*Balaenoptera borealis*; 20 m (67 ft), 20 tonnes), and the southern bottlenose whale (*Hyperoodon planifrons*; 9 m (30 ft), 3 tonnes). The first two of these species were slaughtered in vast numbers by commercial whalers, and have barely recovered since. The bottlenose whale, in contrast, was little-hunted, and populations are strong and stable.

Seals

Six species of seal inhabit the pack ice and seas around Antarctica, and the adjacent shores: the Weddell, crabeater, Ross, elephant, leopard and fur. They haul out frequently onto sea ice and onto rocky and sandy shorelines which have free access to the open sea. With their thick coat of fur and layer of blubber or fat, seals are well adapted to withstand the rigour of the Antarctic climate. On land, seals are ungainly creatures, but at sea they are superb divers and swimmers. They need to be, to catch their prey, which consists of fish and benthic organisms, and to escape from their principal predator, the orca.

Weddell seal (Leptonychotes weddellii). The southernmost breeding seal in the world is the Weddell, attaining a latitude of 78°S in McMurdo Sound in the Ross Sea. The species is named after Sir James Weddell who commanded the ship that first entered the sea that bears his name in the early 19th century. The Weddell is one of largest species of seal, the female measuring 3.3 m (nearly 10 ft) and weighing about 450 kg (990 lb), while the male is slightly smaller. With their 'smiley' faces and docile nature, the Weddell seal is a favourite of wildlife aficionados. Weddell seals are able to swim a considerable distance under shorefast sea ice, and with their sharp teeth they are able to gnaw holes in the ice. This allows them to climb onto shorefast ice in order to give birth to their pups, which are born in early spring (September and October). Weddell seals do not generally form groups, except aggregating in pupping areas. Their ability to create holes in the ice enables them to remain near the continent in winter. The Weddell seal's main source of food is the large Antarctic cod (*Notothenia coriiceps*), for which it dives to 750 m (2,500 ft), and it may stay underwater for an hour or more, but it also feeds on krill and squid. For some unknown reason, some Weddell seals venture inland and perish. For example, the Dry Valleys contain the scattered remains of many mummified Weddell seals. Some of these dead, desiccated animals are many kilometres inland and are thousands of years old. Weddell seals were not harvested, except on a small scale during the early years of Antarctic exploration, and for feeding sledge-dogs until the last were removed from the continent in the 1990s.

Crabeater seal (Lobodon carcinophaga). The crabeater seal is a slim and highly mobile animal, able to move rapidly across sea ice. This species is believed to be the most abundant seal on the planet, but estimates vary widely; the IUCN figure is around 4 million, but other surveys give twice this figure. A typical male crabeater seal measures 2.6 m in length (8 ½ ft) and weighs 225 kg (500 lb), with

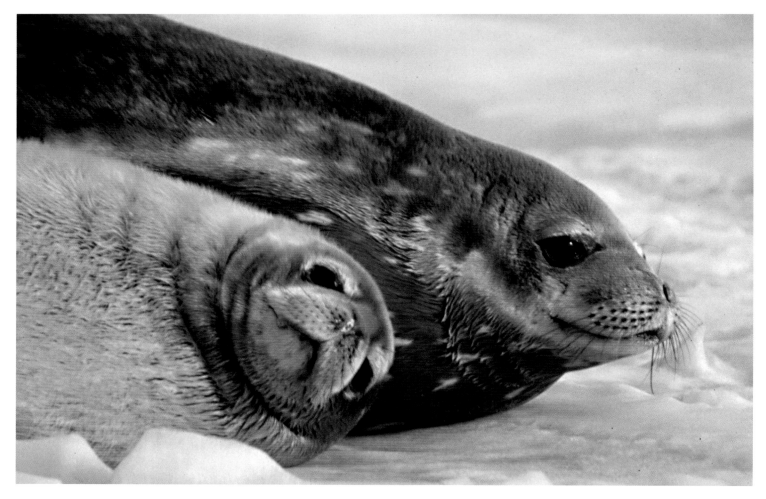

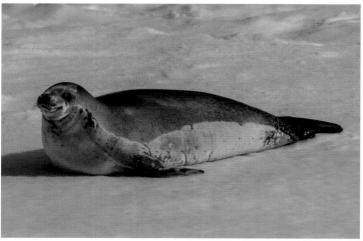

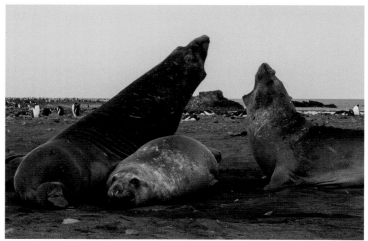

174 *The Continent of Antarctica*

the females being slightly larger. Pups are born in spring, from mid-September to early November. Crabeaters spend their whole lives in the pack ice, feeding on krill, fish and squid, but despite their name, they do not eat crabs (which do not occur on the Antarctic continental shelf). Crabeaters are especially common around the northern coasts of the Peninsula and in the Ross Sea, where they will often be spotted in small groups on ice floes or bergy bits. Along with Weddell seals, crabeaters share the unusual behaviour of wandering inland. Remarkably, one live animal was found 113 km (70 miles) from the open sea at an elevation of 920 m (3,000 ft) in the Dry Valleys; other carcases have been found as high as 1,100 m (3,600 ft), and one of the authors even spotted one entombed within a glacier.

Ross Seal (Ommatophoca rossii). The Ross seal, also colloquially known as the singing seal, spends much of its life in dense consolidated pack ice. Such locations are only reachable by powerful icebreakers, and the Ross seal is therefore not a well-studied species, although satellite tracking indicates that when not on the ice it ranges widely in the Southern Ocean. The species is named after Sir James Clark Ross, the British naval captain, whose Antarctic expedition of 1841 was the first to collect a specimen. This sleek animal averages about 2 m (6 ½ ft) in length and weighs around 200 kg (440 lb). It specialises in feeding on squid, but also catches krill and fish. The Ross seal is highly vocal, producing a distinctive siren-like sound. The population of Ross Seals is not known with certainty, but there could be around 40,000 around Antarctica. It is not thought they are vulnerable, but this could change if sea ice decreases with global warming.

Southern elephant seal (Mirounga leonine). Formerly called the sea elephant, this seal is the largest in the world. The males, at 4.5 m (14½ ft) to 5.8 m (19 ft) in length and weighing up to four tonnes, are much bigger than the females at 2.8 m (11 ft) and just under a tonne. The males have an inflatable proboscis, which gives the species its name. Their diet consists mainly of squid and fish, which they catch by diving deeply. In fact dives to a 1,000 m (3,300 ft) have been recorded. They build up large reserves of blubber in preparation for the breeding season, during which they fast. Males gather a harem of maybe 50 females for breeding, and challengers are met by a roar and a degree of violence – hence the extensive scarring around the neck. Pups are born in October, and are weaned after about 23 days. After mating, elephant seals spend a period of feeding at sea, and then return to their favoured sandy beaches in late summer, where they remain for around 40 days moulting. It is fascinating to watch these lugubrious creatures piled up in their smelly hollows, belching, breaking wind, scratching and occasionally arguing with each other or posturing. Elephant seals range widely throughout the south polar region, but breed mainly on the sub-Antarctic islands, with about half on South Georgia alone. Populations can also be found on the continent itself, and their lack of fear of humans leads them to scientific bases such as Davis (Australia) and Rothera (UK), where they

Opposite top: A Weddell seal with her pup on shorefast sea ice near Mackay Glacier, western Ross Sea.

Opposite bottom left: The crabeater is Antarctica's most abundant seal, and is commonly observed on ice floes, as in Gerlache Strait, northwestern Antarctic Peninsula.

Opposite bottom right: Elephant seals, such as these two young sparring males, have made a strong recovery from exploitation in the 19th century, and a large colony exists at so-called Elephant Point, Livingston Island.

can be quite disruptive. Southern elephants seals were harvested intensively in the early 19th century and this continued around South Georgia until 1964. Their blubber could be rendered into valuable oil, but no commercial sealing is undertaken today, and the population appears to have stabilised at around 325,000 mature individuals.

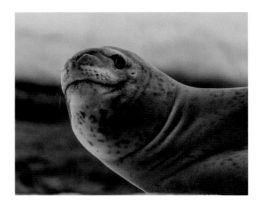

Leopard seal (Hydrurga leptonyx). Early explorers called this seal the *sea leopard* on account of its spotted coat, but its head is almost reptilian in character, embracing a set of vicious-looking teeth. It is found mainly at the edges of the pack ice, but some also occur in the sub-Antarctic islands. The average length of an adult male is 2.8 m (11 ft), with a weight of 325 kg (715 lb), the female being slightly larger. The leopard seal is a solitary animal, whose life-cycle is little known. However, individuals may be spotted occasionally on small ice floes in summer after giving birth in November or December. The seal's diet is varied, using their wide jaws to scoop up shoals of krill, squid, fish, penguin and even juvenile crabeater seals. Like the Weddell and crabeater seals, they sometimes venture inland, where their desiccated remains can be found. Population estimates show large variations; one estimate gives a range of 220,000 to 440,000 individuals. Because of their remote location, they were not subject to extreme commercial pressures in the peak years of sealing as were more northern species, but illegal catches did occur in the late 20th century, even though by then they were officially protected. Leopard seals are regarded as potentially dangerous to humans. They have drowned one diver, for example, and have attacked people walking over sea ice, presumably mistaking them for normal prey. They have also been known to puncture inflatable boats on occasion.

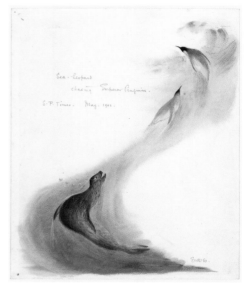

Antarctic fur seal (Arctocephalus gazella). Fur seals occur mainly in the northern parts of Antarctica, especially the western side of the Antarctic Peninsula and the adjacent islands, with some spotted even south of Alexander Island. It is notable that the fur seal has been extending its range southwards in this region. However, the highest populations occur on sub-Antarctic South Georgia. A typical male fur seal is 2 m (6½ ft) long, weighing around 100 kg (220 lb), with the females being smaller. Fur seals live mainly on krill, but also catch fish, squid and penguins, diving to around 50 m (165 ft). Pups are born from late November onwards. Fur seals belong to the 'sea lion' group, whereas all other Antarctic seals are blubber seals – the two groups have different characteristics, particularly relating to the flipper morphology and ears. They actually have rear flippers that can face both backwards and forwards, making them highly mobile on land, where they are often able to outrun a human on rough beach terrain. With an array of sharp teeth and a nasty bacteria-laden bite, they are best given a wide berth! Antarctic fur seals were slaughtered in vast numbers in the early 19th century, bringing the species close to extinction, but legislation now protects them, and their numbers have increased dramatically, possibly even exceeding pre-exploitation levels. Indeed, fur seals now occur in areas where no prior record of their presence exists, including the South Shetland Islands and the South Orkney Islands

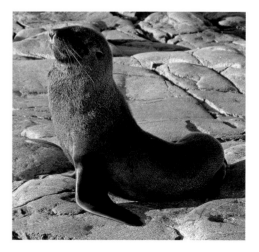

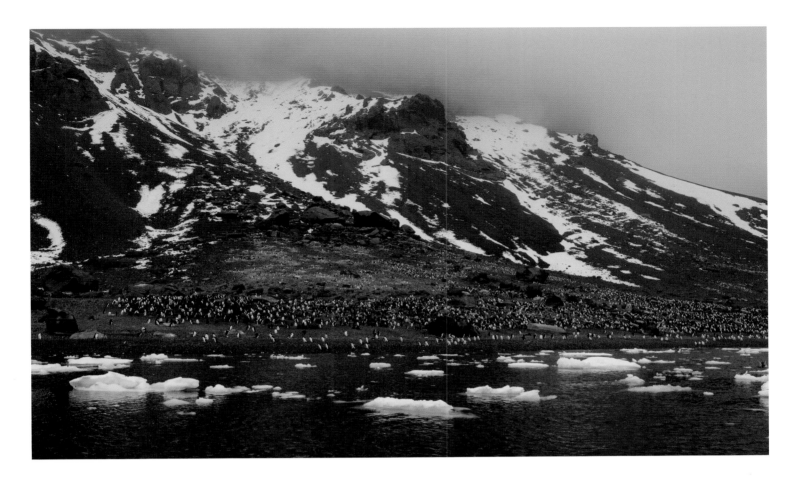

Penguins

Of all the birds in Antarctica, penguins are the most common, often living in huge colonies, numbering tens of thousands. Penguins are the best-studied of all Antarctic bird species. The origin of the term 'penguin' is not known with certainty. It may come from the Latin 'pinguis', which refers to the fat or blubber that penguins carries. Alternatively, it may come from the Welsh 'pen gwyn', or 'white head'. Being flightless and naturally inquisitive, penguins are relatively easy to study for monitoring purposes. Of the eighteen species of penguin, only five breed on and around the continent and adjoining islands – the emperor, Adélie, chinstrap, gentoo and macaroni, although other species may make an appearance in the northernmost parts of Antarctica from time-to-time. Each of these species is characterised by a black back and white front. There are many millions of these birds, and they are largely dependent on krill and other marine prey for food. Any shifts in the marine ecosystem, such as human-induced changes through climate warming and fishery activities, or natural changes such as large icebergs

Above: A large Adélie penguin rookery amongst the boulders fallen from the cliffs at Brown Bluff, northeastern Antarctic Peninsula.

Opposite top: Leopard seal on an ice floe in Mikkelsen Harbour. The name derives from the spotted nature of their fur.

Opposite centre: 'Sea Leopard [now known as Leopard Seal] chasing Emperor Penguins' – a 1902 painting by Edward Wilson that appeared in the *Discovery* expedition's winter newspaper the 'South Polar Times'. (© Scott Polar Research Institute)

Opposite bottom: A fur seal in the sunshine near Rothera Point.

altering local conditions, will have an impact on penguin populations, and for this reason many monitoring studies are being undertaken.

Ungainly though they may appear on land, penguins are superb swimmers. Their bodies are compact and streamlined, and they have powerful flippers (evolved from wings) which act as paddles. Their tolerance of cold arises from an insulating layer of feathers over a layer of skin and blubber. They can travel fast at the surface of the water by 'porpoising', and can also dive fast in search of fish, squid or krill. On land they waddle, jump or progress by 'tobogganing' on their bellies. When walking upright, humans find their human-like gait endearing, and they are a major attraction of a visit to Antarctica for many visitors. Penguins swim in large groups, and on land they form rookeries thousands of individuals strong. Safety in numbers gives individuals some defence against predators such as leopard seals and orcas. The five species of penguin are described according to their ranges from south to north. Other species of penguin, notably the king penguin, are found on the sub-Antarctic islands.

Penguins are believed to have evolved from flying birds, similar to the petrels, around 50 million years ago, as indicated by the fossil record in rocks. This record in Antarctica has revealed that much larger species existed around 40 million years ago, with one giant species standing 1.7 m (5½ ft) tall.

A visit to a penguin rookery is an amazing sensory encounter. Apart from the visual feast, the noise and all-pervasive smell gives the visitor an experience that he or she will never forget.

Emperor penguin (Aptenodytes forsteri).

The emperor is the largest of the extant penguin species, reaching over a metre in height, and weighing 20-40 kg (44-88 lb). The emperor breeds in the most extreme environment on Earth – on shorefast sea ice adjacent to the Antarctic coast in winter. A single egg is laid in May (early winter), and is incubated by the male by balancing it on its feet, and covering it with a flap of skin. During the incubation period of around 65 days and at the young chick stage, the adult males endure the rigours of the dark Antarctic winter by forming a close huddle, through which every bird moves. This dynamic process allows each bird to share in the protection necessary from the low winter temperatures that can fall below -50° C (-58° F), and blizzards with wind speeds of up to 200 km/hr (125 mph). During this time, for approximately eight weeks, the male is fasting. Meanwhile, the female leaves for a long walk to the sea ice edge, and spends two months feeding, before returning with a full stomach of food and taking over the job of nurturing the recently hatched chick. The male, having lost nearly half of his body weight, now walks off to the open sea to feed, and in due course returns to the adult female and chick.

The chick develops rapidly and acquires a grey downy coat, fed now by both parents. At about six weeks the chicks group together in 'crèches', fledging after about five months at the onset of spring. This coincides with the break-out of sea ice, and as

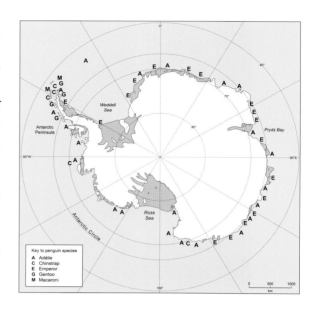

Above: Distribution of the principal penguin species around the Antarctic continent. (Compiled from maps in Soper, T., 2013. Antarctica – a Guide to Wildlife, Bradt Travel Guides Ltd.)

Opposite, clockwise from top left:

Adult Adélie penguin on sentry duty, with this season's young on the verge of fledging, near Esperanza Station (Argentina), northeastern Antarctic Peninsula.

The largest of the penguin species is the emperor. Their elegant heads and shoulders reveal yellow and orange colouring of neck and beak.

The agility of an Adélie penguin is demonstrated here, near Rothera Station (UK).

A group of emperor penguins on sea ice in McMurdo Sound. The group came up inquisitively to one of the authors (JAD) and his colleagues during scientific work.

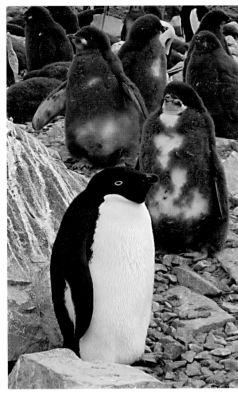

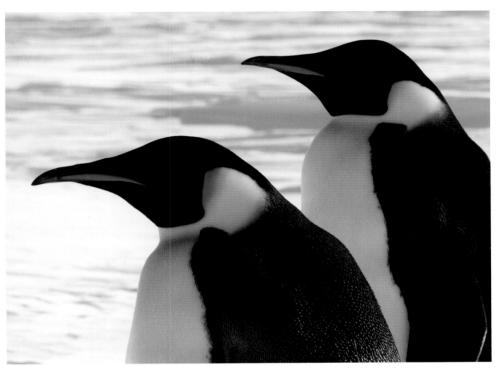

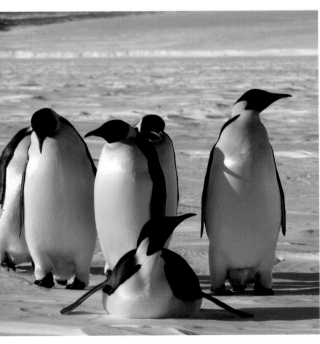

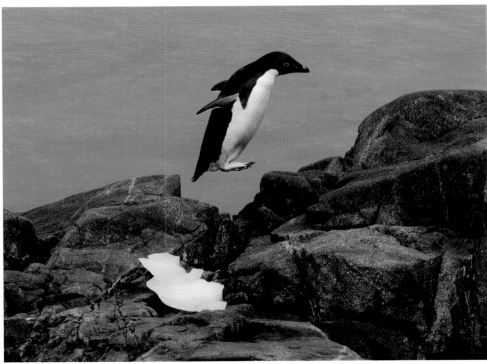

the chicks moult and acquire their swimming plumage they now are able to fish for themselves, becoming wholly independent. If the sea ice fails to break up, for example due to iceberg movement trapping ice, or a colder winter than normal, there may be extreme mortality amongst the young chicks, but generally they have a high (95%) survival rate. Conversely, an early break-out of sea ice can also be a threat to newly hatched chicks. Although earlier break-outs are to be expected in response to global warming, some scientists believe that emperor colonies are responsive to change, and may be less threatened than some researchers believe. Once the breeding season is over, the emperors moult and spend their time in the Southern Ocean, although only rarely do they venture beyond the Antarctic Convergence. In 2009 it was estimated that there were around 600,000 emperor penguins, spread among 47 colonies, but with the refinement of satellite tracking, a further seven colonies had been identified up to 2017, although as yet no new numerical estimate has been provided.

Adélie penguin (Pygoscelis adeliae). The Adélie penguin is another species of the deep south, breeding on rock outcrops at the southern limits of the Southern Ocean, as well as further north in the Antarctic Peninsula. The species was first described scientifically by the French explorer Dumont d'Urville, who not only named them after his wife, but also named the land surrounding a penguin colony Adélie Land, where he planted the French flag in 1837.

Adélies are much smaller than emperors, with a height typically of 75 cm (30 in) and a weight of 5 kg (11 lb). In the sea they swim well, cruising along at around 7 km/hr (4.3 mph), constantly porpoising in groups, and feeding largely on krill. However, they also dive after fish, reaching depths of over 100 m (330 ft). On land, they waddle comically along like little plump men in evening dress, jumping across gaps, and they also toboggan across snow on their bellies.

Adélies breed in large rookeries during the short few weeks of summer, when the sea ice disperses and food is abundant nearby. Rookeries are established on rocky coasts, headlands and islands, sometimes even well above sea-level where they exhibit remarkable climbing skills. Males and females pair up after crossing shorefast sea ice from the open sea, and typically produce two eggs in mid-November. Their nests consist of collections of pebbles, and these are defended with vigour, although some stealing from neighbours is common. Hatching occurs after just over a month, and the chicks join crèches a few weeks later. They are fledged after six to nine weeks, and then moult on land or on an ice floe, before feeding for themselves in the ocean. However, mortality is often high. They are subject to predation by Antarctic skuas when young and leopard seals when fledging, and they succumb readily to severe weather. After several years at sea, during which they may have covered thousands of kilometres (as recorded by satellite tracking devices), the young birds return to the rookery where they were hatched, and may live for a dozen years.

Opposite: With a grounded iceberg in the background, a chinstrap penguin is sitting out a snowstorm at Hydrurga Rocks in Gerlache Strait, western Antarctic Peninsula.

Overleaf right: Gentoo penguin feeding half-starved chick on Goudier Island near the historic base at Port Lockroy, western Antarctic Peninsula.

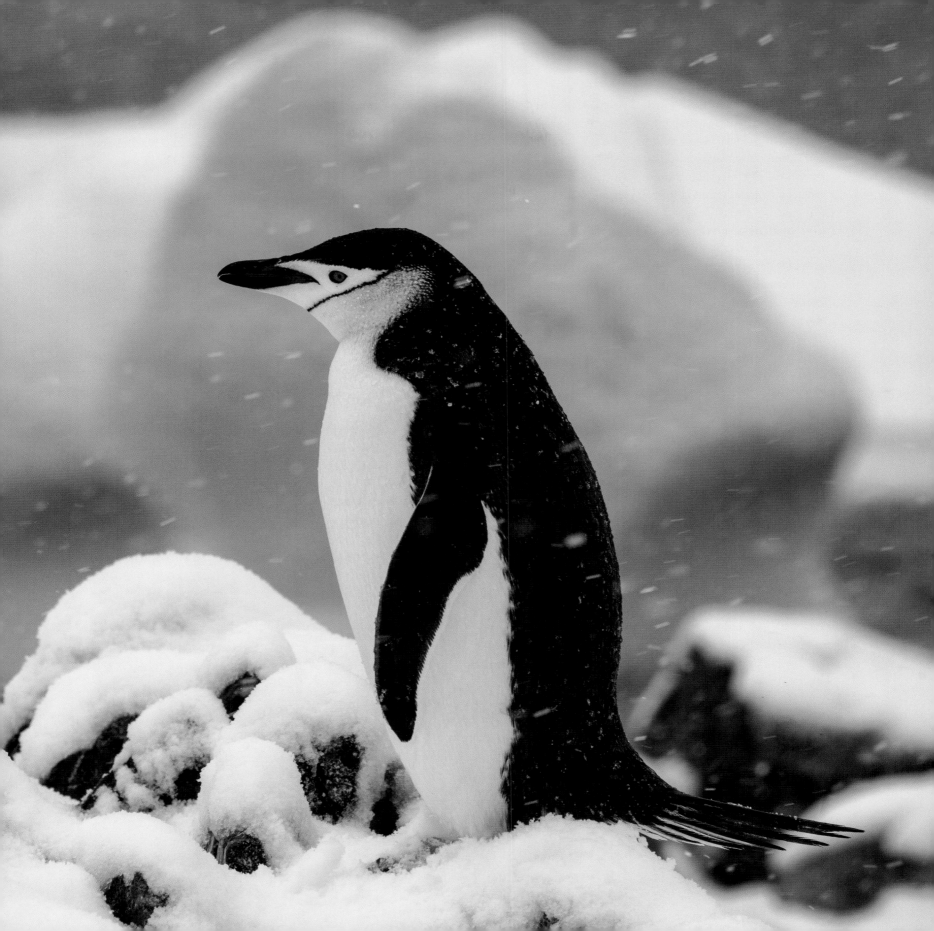

Adélie penguins are widely distributed around much of the coast of the Antarctic mainland, with a population estimated to be around 7½ million. However, with warming ocean temperatures and declining sea ice conditions, especially around the Antarctic Peninsula region, their range is shifting southwards, to be replaced by gentoo and chinstrap penguins.

Chinstrap penguin (Pygoscelis antarcticus). A more northerly species than Adélie and emperor penguins, adult chinstrap penguins are readily recognised by the distinctive black line across the otherwise white chin and front. They are slimmer and shorter than Adélies, with a height of 68-72 cm (27-29 in), and a weight of 4 kg (9 lb). They feed mainly on krill, which they obtain during short dives (to 10 m / 33ft). Occasionally, they will dive much deeper, and the record is 70 m (230 ft). Chinstrap rookeries are usually on rocky slopes, sometimes extending up to 100 m (330 ft) above sea level. Consequently, they are accomplished climbers. They commonly breed in close proximity to Adélie and gentoo penguins, colonies often numbering many thousands.

Chinstraps arrive at their breeding sites in late October, climbing their way up to their chosen site using their claws and sharp beak. Returning to the sea they jump, slide and (on snow) toboggan. The male-female bond is strong, and the male, who arrives first, will wait for his mate before breeding. The nest is a bowl of pebbles, with a few bones and feathers. Thieving of stones and even hijacking of nests is commonplace, and aggressive behaviour between neighbours is normal. Egg-laying is spread over about a month from late November onwards. Normally, there are two eggs, which are incubated for just over a month. The chicks are fed regurgitated krill and after a further month they join a crèche. They take nearly two months to fledge and they may go to sea while the adults are moulting. The last to fledge may not enter the water until May.

Occurring further north than the emperor or Adélie, the chinstrap penguin is broadly restricted to the northern Antarctic Peninsula and the chain of islands known as Scotia Arc that links Antarctica to South America. There are estimated to be 4 million breeding pairs of chinstraps (1999 figures), which makes them the second most abundant species; however, their numbers are in decline.

Gentoo penguin (Pygoscelis papua). Gentoo penguins are small, plump birds that are mainly a sub-Antarctic species, although also breeding in the northern Antarctica Peninsula. They measure around 80 cm (32 in) in height, and weigh 6 kg (13 lb). They carry a prominent red bill and a white patch behind their eyes. Their diet is varied, consisting of fish, crustaceans and krill, which they obtain in both shallow water and in dives down to 100 m (330 ft).

Gentoos form large rookeries on rocky shorelines of low relief, commonly ice-scoured bedrock or beaches, or occasionally low ridges and mounds. They sometimes share the same ground as Adélie and chinstrap penguins, as well as elephant seals. However, although the male and female form a strong permanent bond, they are less choosy about their nesting site, as usually they have plenty of possibilities. The nests are made up of pebbles arranged in a bowl shape, in which they lay two eggs, although usually only one chick survives.

Incubation takes place over a period of around 35 days, plus-or-minus a few days, during which the chicks are fed by regurgitation on krill or small fish. After about a month, like other penguin species, the chicks gather into crèches, and after a further two to three months they are fledged. The parents, unlike those of other species, continue to feed the chicks as they moult, so they remain together as late as March. Mortality is high, the adults being preyed on by leopard seals, and the chicks by skuas.

The range of Gentoo penguins in limited to the Antarctic Peninsula, the sub-Antarctic islands and the Falkland Islands. Estimates put the total gentoo population at 774,000 (in 2012), and this appears to be stable.

Macaroni penguin (Eudyptes chrysolophus) . The macaroni is a relatively plump, black-backed, white-fronted penguin with distinctive long orange tufts as eyebrows. They reach about 70 cm (27 in) in height and weigh 4 kg (9 lb), and cluster in massive rookeries of thousands of birds. They are primarily a sub-Antarctic species, but some breed in the South Orkney Islands and South Shetland Islands, and there is one known rookery on the Antarctic Peninsula itself. Typically, individuals may join with populations of other small penguin species. Macaroni penguins feed mainly on krill, and their breeding success is heavily dependent on the

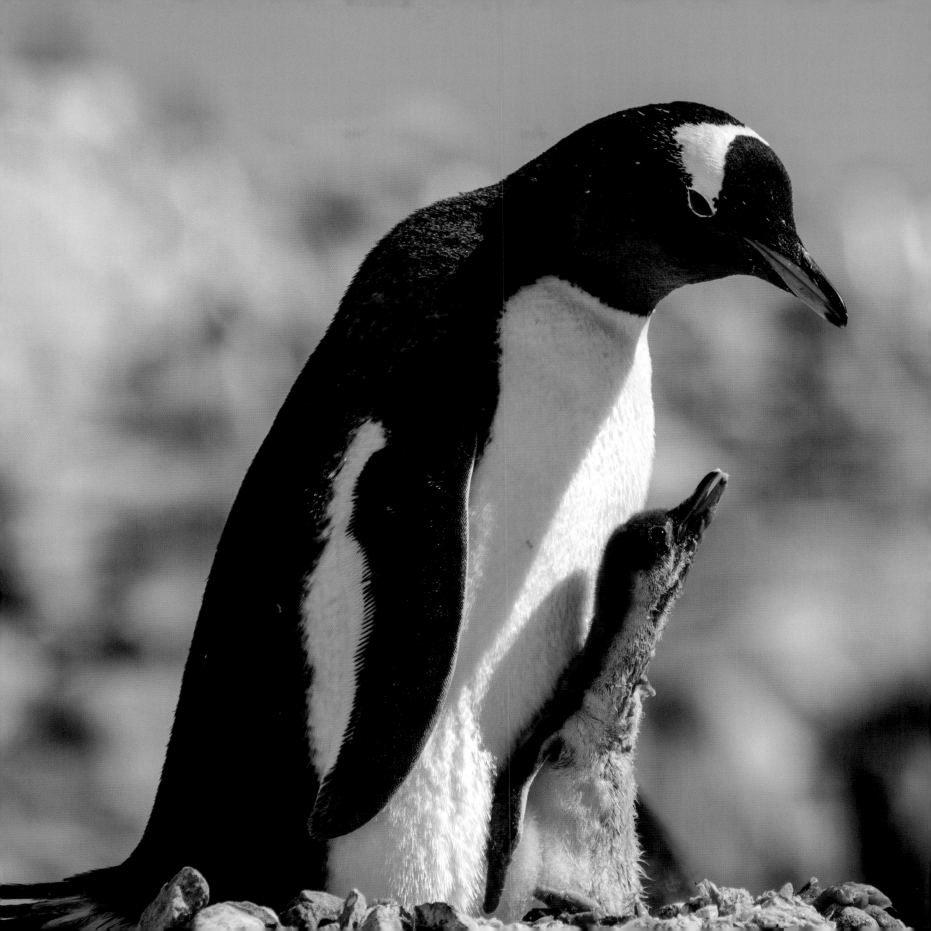

availability of this crustacean. The macaroni lays two eggs in early summer, but one is much smaller than the other and rarely hatches. Incubation is undertaken by both male and female, and takes just over a month. When the chick hatches, it is looked after by the male, while the female goes fishing, returning at intervals. Chicks form crèches soon after hatching and within two months they are fledged, usually in February or March. In March the adults moult, and by April they disperse to warmer waters to the north.

Sea birds on the wing

The Southern Ocean supports huge numbers of seabirds, its nutrient-rich waters providing the food on which birds, whales and seals thrive. As with penguins, flying sea birds provide a good indication of the state of health of the Southern Ocean ecosystem. Their populations have varied over time in response to changes in fishery activity, and overall environmental and climatic change. Most bird species have low rates of reproduction, and, if affected negatively by human activity, such as long-line fishing and krill-harvesting, populations only recover slowly, if at all. Of the many species of birds in the Southern Ocean, here we focus on those that have a link with the continent itself and the immediately adjacent islands at the tip of the Antarctic Peninsula.

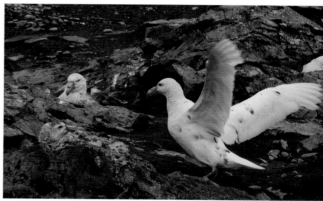

Albatrosses. The iconic bird of the Southern Ocean is the albatross. It does not breed on the Antarctic continent itself, but on sub-Antarctic islands such as South Georgia, Prince Edward, Marion, Crozet and Kerguelen. Albatrosses remain at sea for most of their lives, using the wind to soar with seemingly minimal effort, and feeding mainly on squid. Individual birds have been electronically tracked encircling the continent. Species which are known to fly as far as the Antarctic continent itself include the wandering albatross (*Diomedea exulans*), the black-browed albatross (*Thalassarche melanophrys*), the grey-headed albatross (*Thalassarche chrysostoma*) and the light-mantled sooty albatross (*Phoebetria palpebrate*). Sightings have been made in the western Antarctic Peninsula region and deep in the Weddell Sea. The wandering albatross is the largest flying bird on Earth, with a length of over a metre (3 ft) a wing-span up to 3½ m (12 ft), and weighing in at 9 kg (20 lb). Its plumage changes as it gets older from brown to almost black and white to almost pure white. Although mortality is high in the first year, those that do survive can live to 50 years or more. The other albatrosses are typically around 80 cm (32 in) in length and have a wing-span of approximately 2 m (6 ft). Most species of albatross in the Southern Ocean are in serious decline from an estimated figure previously of ¾ million breeding pairs. This decline is a consequence of being caught on the hooks of long-line fishing boats, drowning in nets and choking on floating plastic rubbish. International initiatives are underway to protect the albatross, including attempts to change fishery practices.

Opposite top: A wandering albatross, flying close to a ship crossing the Drake Passage. This species has seen massive population decline in recent years, as a result of the expansion of long-line fishing.

Opposite centre: A pair of southern giant petrels on their nest at Elephant Point, Livingston Island.

Opposite bottom: A more common brown example of the southern giant petrel, seen from the deck of a ship crossing the Drake Passage.

Above: A flock of Cape petrels over Ferguson Channel, Danco Coast, western Antarctic Peninsula

Petrels. There are many species of petrel, several of which breed on the Antarctic continent and adjacent islands, and others (outside the area covered by this book) in the sub-Antarctic islands. They are also known as 'tubenoses' on account of their long nostrils, which provide them with a strong sense of smell – a rare characteristic amongst birds. They generally have grooved and hooked bills through which they regurgitate fish-oil, stored in their stomachs, to feed the young – and as a defence measure to ward off intruders. Like the albatross, they are magnificent flyers, but all except the giant petrels are ungainly on land. Sea-going visitors to Antarctica find petrels a welcome companion to ships. They use uplift of air from bow waves, sweep back to the stern to catch small fish and plankton churned up by the propellers, and shelter on the lee-side of the ship in bad weather.

The largest petrel, with a length of 1 m (3 ft) and wingspan of 2 m (6 ft) is the southern giant petrel (*Macroconectes giganteus*), which breeds in the northern Antarctic Peninsula and adjacent islands. This petrel species is usually dark brown as a juvenile and becomes paler with age, but some adult individuals are nearly all white. They are scavengers, feeding off sea-mammal carcasses, for which they are sometimes known as the 'vultures of the Antarctic', as well as on krill and squid. Their main form of defence is to eject their oily, smelly stomach contents at the victim, a characteristic that has led to the informal name of 'stinker', given to them by whalers. The giant petrel lays a single

egg in November, incubates it for two months, with the chick becoming fully fledged by May. It is estimated that there are around 12,000 pairs in the Antarctic Peninsula, and many more in the sub-Antarctic.

The southern fulmar (*Fulmaris glacialoides*) is a smaller variety of petrel, with a length of half a metre and wingspan just over a metre (3 ft). Fulmars eat small fish, squid and plankton, but in whaling days they were noted for foraging on whale carcasses and discarded waste. They are superb fliers, especially adept at gliding and soaring. They breed on exposed sea cliffs in the Antarctic Peninsula and on islands surrounding Antarctica, mainly in the western sector.

The Antarctic petrel (*Thalassoica antarctica*) is slightly smaller than the southern fulmar, and has the same ability to glide for long distances with an occasional wing-beat. Its plumage is dark brown and white. Its main source of food is krill, small fish and amphipods, which it takes by hovering, then plunging into the sea. This petrel is a solely Antarctic species, nesting on cliffs around the edge of the continent, especially in the Ross Sea and Prydz Bay regions, and also on inland nunataks. Adult birds spend the winter close to the pack-ice edge, although juveniles may be spotted as far north as New Zealand or South Africa.

Another bird that flies like a typical fulmar is the Cape petrel, also known as the Cape pigeon (*Daption capense*). It attains a length of around 40 cm (16 in) and has a wing span of up to 90 cm (36 in). Its plumage is dark brown and white. It feeds on squid, fish and krill, which it pecks at in pigeon-like fashion, hence its alternative name. Cape petrels breed in the northern Antarctic Peninsula and sub-Antarctic islands on exposed cliffs and amongst boulders. They range widely over the Southern Ocean and beyond, and frequently accompany ships in large flocks, especially fishery vessels.

The snow petrel (*Pagodroma nivea*), as its name suggests, is almost pure white, with striking black eyes and beak. It is considered by many people to be the most beautiful bird in Antarctica. Its length is 40 cm (16 in) and it has a wingspan of 90 cm (36 in). Snow petrels feed on krill, small fish and carrion. They breed in small colonies in the Antarctic Peninsula, all around the coast of Antarctica, and on inland mountains, especially in hollows and crevices in weathered rocks. These petrels do not fly far from their nesting sites, and generally remain within the limits of the pack-ice.

The broad-billed prion (*Pachyptila vittata*) is a short stocky blue-grey bird, with a length of up to 30 cm (12 ft) and wingspan of around 60 cm (24 ft). Prions feed by flying slowly in large flocks over the water and dipping their heads to catch plankton as they skate across the water with their feet. Although it breeds mainly on the sub-Antarctic islands, the prion is also found in the northernmost Antarctic Peninsula.

There are two species of storm petrel in and around the Southern Ocean that have Antarctic continental connections. Wilson's storm petrel (*Oceanites oceanicus*), the smallest bird species in Antarctica, is the most widespread, breeding along much of the Antarctic coastline except the western side of the Weddell Sea. It is a small sooty-

Above: A pair of south polar skuas feeding on a gentoo penguin chick on Petermann Island, western Antarctic Peninsula. The skua is the principal predator of penguins nesting on land.

Opposite, clockwise from top left:

A blue eyed cormorant in flight at Rothera Point, Adelaide Island, western Antarctic Peninsula.

A breeding pair of blue-eyed cormorants in falling snow at Hydrurga Rocks, Gerlache Strait.

The large wing-span of the kelp gull is evident in this scene from Rothera Point, with Pourquoi Pas Island in the background.

Kelp gull on a stranded ice floe, near Rothera Station (UK) on Adelaide Island, western Antarctic Peninsula.

Life in a Frigid Environment 187

brown bird, with a white rump, measuring 18 cm (7 in) in length, with a wingspan of 40 cm (16 in). It feeds mainly on krill by skipping or walking on water. The latter trait has led to the name 'Jesus-bird', reflecting the 'walking-on-the-water' event described in the Bible. They are commonly seen singly, but also in large flocks, especially when following fishing vessels. It is thought that this storm petrel is the most abundant of all sea birds, with a population of many millions. They nest on rocky islands, cliffs, between boulders and in burrows. The petrel lays a single egg around the end of the year, and hatching takes place between late January and late February. Fledglings are left to their own devices by the parents in early April, and the birds migrate thousands of kilometres north in winter, some as far as mid-northern latitudes. The black-bellied storm petrel (*Fregetta tropica*) is a slightly larger black and white bird, whose link to Antarctica is its occasional visits to breed to the South Shetland Islands and the northernmost part of the Peninsula.

Skuas. Skuas represent those birds that are noted for preying on other species, especially penguins. Two species are found in Antarctica, which superficially resemble large aggressive juvenile gulls. The south polar skua (*Catharacta maccormicki*), whose Latin name derives from Robert McCormick who sailed with James Clark Ross into the Ross Sea in 1841, has the distinction of being the most southerly bird species on Earth. This species often ventures far into the interior of the continent and has even been sighted at the South Pole. These brown birds, with their dark upper and light underparts, are half a metre (20 in) in length and have

Above: Antarctic terns using the wreck of the Norwegian whaling ship, the *Guvenoren*, in Føyn Harbour, Wilhelmina Bay, western Antarctic Peninsula, as a place to breed.

a wingspan of 125 cm (4 ft). Their diet is varied, feeding on fish and krill at sea, and preying on the nests of penguin and other species on land. These skuas breed around the entire edge of the continent, often close to penguin rookeries and bird cliffs, and nesting on open ground or on elevated look-outs. With a permanent mate, skuas return to the same nesting site each year and typically lay two eggs between late November and mid-February, according to the availability of food. Fledging takes place after about 8 weeks. During this time skuas will aggressively defend their nest, and physical attacks on humans are not uncommon if they venture too close.

The brown skua (*Catharacta antarctica*) looks very similar to the south polar skua, but is heavier and larger, with a length of up to 66 cm (26 in) and a wingspan of 1½ m (5 ft). The two species sometimes inter-breed. The brown colouring is similar to that of the south polar skua, although generally perhaps somewhat darker and almost black on top. It has distinctive white patches on its wings. The brown skua is an aggressive bird, attacking shags and terns in flight, forcing them to disgorge their own catch. It also preys on penguin eggs chicks and carrion, often in conjunction with other skuas. Brown skuas are more typically a sub-Antarctic species, but they do breed around the northern parts of the Antarctic Peninsula and the Scotia Arc archipelagos. Nesting behaviour is similar to that of the south polar skua.

Cormorants and shags. Shags and cormorants belong to a large group of sea birds spanning the whole globe. However, only one species, the blue-eyed cormorant (*Phalacrocorax atriceps*) inhabits continental Antarctica, albeit going under several names, including blue-eyed shag, Antarctic shag/cormorant and imperial shag. There are closely related and similar species in South Georgia and southern South America. The name blue-eyed cormorant stems from the blue rings that surrounds the eyes. The adults have a black back and a white front, whereas the chicks and juveniles are brown. Adult birds measure about 70 cm (27 in) in length, and have a wingspan up to 124 cm (49 in). They feed on fish, squid, krill and sea-bottom invertebrates, caught mainly following a dive. At a distance, a stationary cormorant may be mistaken for a penguin, that is until it flies off! The cormorants are often seen singly, but also move in flocks. Breeding colonies are mainly found in the northern and central Antarctic Peninsula and the sub-Antarctic islands, where they nest on sea cliffs, scree slopes, small islands and flat ground. Some colonies are several thousand strong, but others have only a few pairs, and smaller colonies move location quite frequently. Two or three chicks are reared by both parents, and the chicks fledge in about seven weeks, after which the young birds congregate in flocks

Gulls. The only gull that breeds in Antarctica, and then only in the northern and central Antarctic Peninsula and the Scotia Arc archipelagos, is the kelp gull (*Larus dominicanus*), but its range extends almost to the equator. The adults are similar in appearance to the

Above: A sheathbill poses on rocks at Gourdin Island, northern Antarctic Peninsula, where it finds offal from a large colony of penguins.

black-backed gulls of the Northern Hemisphere, having a yellow bill, a white head and underparts, and a black back. It measures 58 cm (23 in) in length and has a wingspan of up to 140 cm (55 in). Its feeding areas are the coastal fringes of Antarctica, where it obtains limpets (*Nacella concinna*) and also krill and small fish offshore. Limpets are swallowed whole, the shells being regurgitated into neat piles near the nest, which often accumulate over many years. Two or three eggs are laid in late November, and hatching takes place after about a month. The chicks are fed by both parents, mainly on Antarctic herring (*Pleurogramma antarcticum*). Chicks fledge from mid-January onwards, but remain with their parents for many weeks afterwards. The population of adult kelp gulls remains within Antarctic waters in winter, fishing amongst loose sea ice floes, but young birds migrate to South America for their first winter.

Terns. Two species of tern are found in Antarctica in summer, the Antarctic and Arctic terns. The Antarctic tern (*Sterna vittata*) is a small white and pale grey bird with a black head, and red legs and bill. It has a distinctive forked tail. It is typically 40 cm (16 in) long and has a wingspan of 79 cm (31 in). Its main range is the northern and central Antarctic Peninsula, with approximately 35,000 pairs in the South Shetland Islands alone, and more widely in the Scotia Arc an other sub-Antarctic islands. Their diet consists of krill and small herring, catching them by hovering, then diving. Terns nest in their scores near to the shoreline, especially on sandy and gravelly beaches. The nest, which changes from year-to-year is little more than a scrape in the ground, in which they lay one or two very well-camouflaged eggs in mid-November. They also nest amongst human debris. Chicks hatch around 23 days later, and in under a week leave the nest to hide from predators. After a further 25 days, they are fledged, but remain with their parents for a time.

The Arctic tern (*Sterna paradisaea*) is perhaps the most remarkable visitor to Antarctica, since this small bird holds the record distance travelled by any animal. It breeds in the Arctic and sub-Arctic during the Northern Hemisphere summer, and spends its 'winter' in the south. It is similar in size to the Antarctic tern, and each year it migrates some 18,000 km (11,000 miles) to the Antarctic pack ice, and back again. The striking red bill of the Arctic summer, changes to black as it flies south, making it difficult to distinguish from its cousin.

Sheathbill. The sheathbill is the only bird in Antarctica with webbed feet, and is thought to be related to waders, gulls and skuas. One species of sheathbill occurs in Antarctica, the pale-faced sheathbill (*Chionis alba*), which is confined to the Antarctic Peninsula, Scotia Arc and the sub-Antarctic (notably South Georgia). It resembles a pigeon but has white plumage, and measures 40 cm (16 in) in length, with a wingspan of 79 cm (31 in). Sheathbills are commonly found strutting around amongst penguin rookeries, feeding on the food that penguins bring their chicks. Sheathbills also feed on penguin eggs and small chicks, as well as carrion, and the faeces of other birds and seals. They are generally fairly solitary, and nest in crevices in cliffs, in scree slopes and amongst the debris associated with scientific stations or abandoned whaling stations. Between two and four eggs are laid in December or January, which are incubated for about a month, the chicks becoming fledged in late February. However, usually only one or two chicks survive. In winter they migrate to southern South America and the Falkland Islands.

Terrestrial and freshwater organisms

With less than one percent of the land area of Antarctica free of permanent snow and ice, the available habitats for plants and animals is severely limited. Thus, in the light of such harsh environments, it is unsurprising that, unlike all the other continents, there are few higher forms of life on Antarctica. Nonetheless, the fossil record demonstrates that Antarctica had a much richer and more diverse flora and fauna many millions of years ago than that of today. Currently, there are no trees, shrubs or woody plants on the continent, although over ten million years ago there was well established mixed woodland, with southern beech and other plant species widely distributed. Similarly there was a range of animals, including reptiles, dinosaurs and birds from around 65 million years ago, which found their home in the ancient woodlands.

Plants. The vegetation of continental Antarctica is nowhere abundant, being limited to ice-free coastal sites, inland valleys

and nunataks. Although these areas lack precipitation, being classified as a polar desert, areas with winter snow accumulation and melting glacier ice can in summer provide sufficient moisture for plants to grow. Some micro-organisms even grow on the snow and ice-covered areas themselves.

The greatest diversity of plant life is found in the western side of the Antarctic Peninsula as far south as about 69° S on northern Alexander Island, the South Shetland Islands and the South Orkney Islands. In this region, the climate is warmer and wetter than the rest of Antarctica, and the region is referred to, biogeographically, as the Maritime Antarctic Zone. Summer temperatures may reach several degrees above freezing, and rainfall events occur in summer with increasing frequency. In Antarctica as a whole, there are only two species of native flowering plant, and these are both found in this zone: Antarctic hair grass (*Deschampsia antarctica*) and Antarctic pearlwort (*Colobanthus quitensis*). However, here, as well as in the Continental Antarctic Zone, most vegetation consists mainly of lower plant groups (mosses – 100 species, liverworts – 25 species, and algae, in addition to lichens – 400 species, macro-fungi – 20 species). These species are particularly well-adapted for living in harsh environments, where temperatures are below zero for most of the year, and desiccation is a common process. Mosses may form extensive mats or carpets in wetter, low-lying areas, becoming bright green in high summer. Certain species of moss can accumulate banks over 2 m (6 ft) deep in suitable

Above: Brown moss near Ablation Lake, Alexander Island, before it has turned green, as happens in summer.

locations, dating back over 5,000 years, and containing a record of past climate. They are soft and extremely vulnerable to trampling, and visitor guidelines discourage people from walking on these mats. The most striking lichens are red and green, and often form colourful displays on rocks that have been used as bird perches. The most prominent lichen genera are *Buellia*, *Caloplaca*, *Rhizocarpon* and *Xanthoria*, which are able to colonise most types of bedrock and bouldery ground. Algae, often green and orange in colour, commonly bloom in stagnant pools and on damp ground near penguin colonies.

In the hyper-arid frigid Dry Valleys of Victoria Land, and the remotest nunataks of the Transantarctic Mountains, it seems remarkable that algae, fungi and lichens are able to survive – in the most extreme cold conditions on the planet. They exist in cavities inside rocks, and in fact are instrumental in facilitating the breakdown of boulders and the bedrock itself, thereby representing a major contributor to weathering (Chapter 6).

Algae and bacteria also colonise snow and ice surfaces. Snow may turn pink, red, yellow or green from algae in summer, especially when fertilised by bird droppings. On the surface of glaciers, sediment aids melting of ponds and small holes called cryoconite, and in these algae, fungi and bacteria can live in high concentrations. These micro-organisms can even survive beneath glaciers and the ice sheet. The well-known Blood Falls at the terminus of Taylor Glacier in the Dry Valleys is an example of where hyper-saline water reaches the glacier surface from the bed, its orange colour indicating iron-enrichment triggered by microbial life.

Other areas in which microbes flourish are where volcanoes are occasionally active, since in such locations hot springs and heated ground are often found. Fumaroles emit steam and gas, sometimes at temperatures approaching or even exceeding the boiling point. In otherwise extreme environments, such as at over 3,000 m on Mt Erebus, soil microbes are present. The frequently visited volcano of Deception Island in the South Shetland Islands supports a number of mosses not otherwise found in Antarctica, including the European and Southern African species, *Campylopus pyriformis*.

With climatic and other environmental change processes having an impact on the Antarctic Peninsula region in particular, rainfall is becoming more common, the ground wetter, and the ice-free ground area increasing as snow and ice melt, and these potentially could encourage the influx of invasive species (Chapter 12). Thus all human visitors should be subject to strict biosecurity controls when setting foot on Antarctica.

Animals. Apart from nesting birds and stray seals and penguins, animal life on land is limited to a few species of invertebrates, notably springtails, mites and a flightless midge, together with water bears (Tardigrades), worms (nematodes) and rotifers. Of these, the largest is the midge, which at most is only 0.5 cm ($^1/_4$ in) long and weighs less than a milligramme (fraction of an ounce). Among the mites is the hardiest and southernmost-living animal in the world, *Nanorchestes antarcticus*, which is found on nunataks in the

Below: Hair grass grows in cavities and in open areas in the warmer parts of the Antarctic Peninsula region, as here on Livingston Island.

Transantarctic Mountains, the nearest exposed rocks to the South Pole at 85° S. They live in poorly developed soil and cavities in rocks where there is some moisture, and also in biological habitats such as moss, algal mats and microbial crusts. They survive because stress-tolerant compounds exist in their bodies. The polar desert soils of Antarctica represent the most impoverished ice-free environment on Earth. Yet although species diversity is low, population densities in favourable circumstances may be high, perhaps reaching tens of millions of individuals per square metre (or yard).

While these ecosystems and communities might appear insignificant and small, it is increasingly realised that they represent a complex and ancient biodiversity. Antarctica is currently divided into sixteen distinct biogeographical regions, known as Antarctic Conservation Biogeographic Regions. Recent research has demonstrated that much of the terrestrial diversity within Antarctica is unique to this continent, and to different areas within it. The life we see today has had an evolutionary history that has taken place in isolation from the rest of the world. This life has survived the multiple glaciations that have covered most of the continent several times since it became geographically isolated over 30 million years ago.

Life in Antarctic lakes. Antarctica is host to a large number of lakes that display a wide range of physical and chemical conditions. They range from freshwater to hyper-saline, and many high-latitude ones have a continuous lid of ice. Saline lakes occur where streams flow in, but there is little or no outflow, thereby concentrating the dissolved salts. Over time, evaporation results in salinity increasing. Most exposed lakes are located in polar desert areas, such as the Dry Valleys of Victoria Land, and in coastal oases. The most visible plants in such lakes are algal growths, in the form of mats or columns, known as 'stromatolites'. These have been compared with some of the earliest life forms on Earth; rocks of Precambrian age (older than 540 million years) are richly endowed with stromatolites.

Yet other lakes occur in large numbers beneath the Antarctic Ice Sheet, as described in Chapter 5, as well as on its surface, albeit only seasonally. Some 'lakes', called epishelf lakes are connected to the open sea beneath an ice shelf, such as Beaver Lake in the Prince Charles Mountains or Ablation Lake on Alexander Island. These lakes have a lid of fresh water which gives them the biology of true lakes, although the upper surface is frozen, while marine waters exists at depth.

As in Antarctic soils, lakes are dominated by micro-organisms, notably plankton, algae, fungi, bacteria and viruses. A few crustaceans are present in epishelf and near-coastal lakes. These lakes have a much higher microbial diversity than recently thought, and one that is unique to Antarctica, and indeed to individual regions within the continent. In fact, on the South Shetland Islands, some lakes have yielded very high microbial diversity and possibly the highest diversity of viruses on Earth. This biodiversity, which has evolved separately from the rest of the world, provides scientists with unique opportunities to study evolutionary biology at the molecular level, and take ecosystem modelling to a high level.

Although most lakes have escaped direct human interference, the organisms within them are vulnerable to climatic warming, to changes in ultraviolet radiation, induced by the formation of the ozone hole (Chapter 4), changes in seasonal duration of ice cover, changes in nutrient input associated with bird and mammal populations, and to changes in meltwater input from snow and ice.

Exploitation and conservation of marine living resources

More than two centuries of commercial exploitation in the 19th and 20th centuries drew many marine mammal species close to extinction. As a consequence, the Southern Ocean ecosystem changed dramatically. However, we do not know its pre-exploitation state. Fur seals were first hunted almost to extinction, followed by decimation of stocks of elephant seals, and then large whales (Chapter 9). Their bones litter the beaches of the northern Antarctic Peninsula and neighbouring islands, as well as throughout the sub-Antarctic. Exploitation of fish followed, and although there were few commercially viable species, these were also reduced to low levels by the 1970s.

The turn-around for wildlife protection came in 1959 with the signing of the Antarctic Treaty, which was designed to

keep the continent for peaceful purposes and science, and to protect the environment (Chapter 11). Protection of Antarctica under the Treaty was further strengthened in 1991 with the signing of the Protocol on Environmental Protection (commonly known as the Madrid Protocol), which subsequently came into force in 1998). Meanwhile, the Southern Ocean was less well-protected, but seals south of latitude 60° S became protected in 1972 under the Convention for the Conservation of Antarctic Seals, even though sealing had long-since ceased. By the early 1970s, the most recent target for fisheries had become krill, and within a decade there was a real prospect of serious over-fishing of this keystone species. In response to growing concerns about unsustainable krill-harvesting and its impact on animals higher up the food web, the Commission for the Conservation of Antarctic Marine Living Resources (CCAMLR) came into force as part of the Antarctic Treaty in 1982. CCAMLR takes a complete ecosystem approach, and does not explicitly ban all harvesting of marine living resources. Rather, it aims to see that it is sustainably managed; for this to succeed, however, requires considerable investment in scientific research. Even so, stocks of most of the species that CCAMLR now regulates had already been decimated before regulation was introduced, and few species have recovered significantly since then.

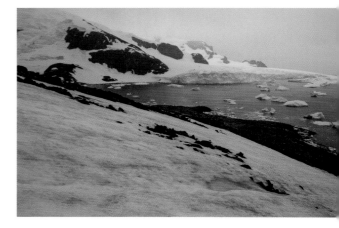

Another important body, concerned with examining the status of individual species and with a global remit, is the International Union for Conservation of Nature (IUCN). This organisation estimated in 2017 that 300,000 tonnes of krill were being caught annually, although this was down from a peak of over 500,000 tonnes in the early 1980s. Amongst the uses of krill are for 'Omega 3' oil supplements for human consumption and for feeding farmed salmon. Although the abundance of krill varies enormously through the year and from season to season, IUCN believes that overall stocks are stable. These various measures for the conservation of Antarctic species are described in more detail in Chapter 11.

Within IUCN's 'Red List' are many Antarctic species. Examples of the status of several iconic Antarctic species are listed in the table opposite. IUCN uses several terms to describe the status of many species, which in order are: *Critically Endangered, Endangered, Vulnerable, Near-threatened, Least Concern, Data Deficient* and *Not Evaluated*. For many species in Antarctica, there are insufficient data to establish whether they are vulnerable or otherwise.

Therefore, increasing monitoring is an important challenge faced by policy-makers, funders and scientists. There are many changes taking place to Antarctic ecosystems, whether due to direct exploitation by humans, or climate change. These issues are explored further in Chapter 12.

Above: Algae grow on melting snow in summertime, colouring extensive areas with a reddish tinge, as on Cuverville Island, northwestern Antarctic Peninsula. Red and green algae are particularly common where snowbanks are fertilised by passing penguins.

Top: During the relative warmth of summer, algae commonly grow in stagnant ponds as here amongst ice-cored moraines on Livingston Island, South Shetland Islands.

Table: Conservation status of selected Antarctic species as determined by the International Union for Conservation of Nature (IUCN). ★ The fur seal according to some recent estimates has increased to 4 million, possibly exceeding pre-exploitation levels.

Species	Status	Population Estimate	Trend	Notes

Penguins

Species	Status	Population Estimate	Trend	Notes
Emperor *Aptenodytes forsteri*	Near-threatened	595,000 (2009) in 46 colonies	Unknown	A further 7 colonies found since (no pop. est.)
Adélie *Pygoscelis adeliae*	Least concern	7,580,000	Increasing	Formerly Near-threatened (2012)
Gentoo *Pygoscelis papua*	Least concern	774,000	Stable	Formerly Near-threatened (2012)
Chinstrap *Pygoscelis antarcticus*	Least concern	Uncertain; 4 million breeding pairs (1999)	Decreasing	

Other sea birds

Species	Status	Population Estimate	Trend	Notes
Antarctic petrel *Thalassoica antarctica*	Least concern	10-20 million (2004)	Stable	
Snow petrel *Pagodroma nivea*	Least concern	>4 million (2004)	Stable	
Wandering albatross *Diomedea exulans*	Vulnerable	20,100	Decreasing	Long-line fishing principal cause of decline

Whales

Species	Status	Population Estimate	Trend	Notes
Blue *Balaenoptera musculus* intermedia	Critically Endangered	1,700 (global)	Increasing	Commercial whaling may have reduced population by up to 90%
Humpback *Megaptera novaeangliae*	Least Concern	36,600 (all Southern Hemisphere)	Increasing	Previously Vulnerable (1996) and Endangered (1988)

Seals

Species	Status	Population Estimate	Trend	Notes
Weddell *Leptonychotes weddellii*	Least Concern	300,000	Unknown	Large uncertainty concerning population
Crabeater *Lobodon carcinophaga*	Least Concern	4 million	Unknown	Believed to be the world's most abundant seal species
Leopard *Hydrurga leptonyx*	Least Concern	18,000	Unknown	Status not well known
Antarctic Fur *Arctocephalus gazelle* ★	Least Concern	700,000 to 1 million	Decreasing	Nearly extinct by late 19th century, but recovered well since

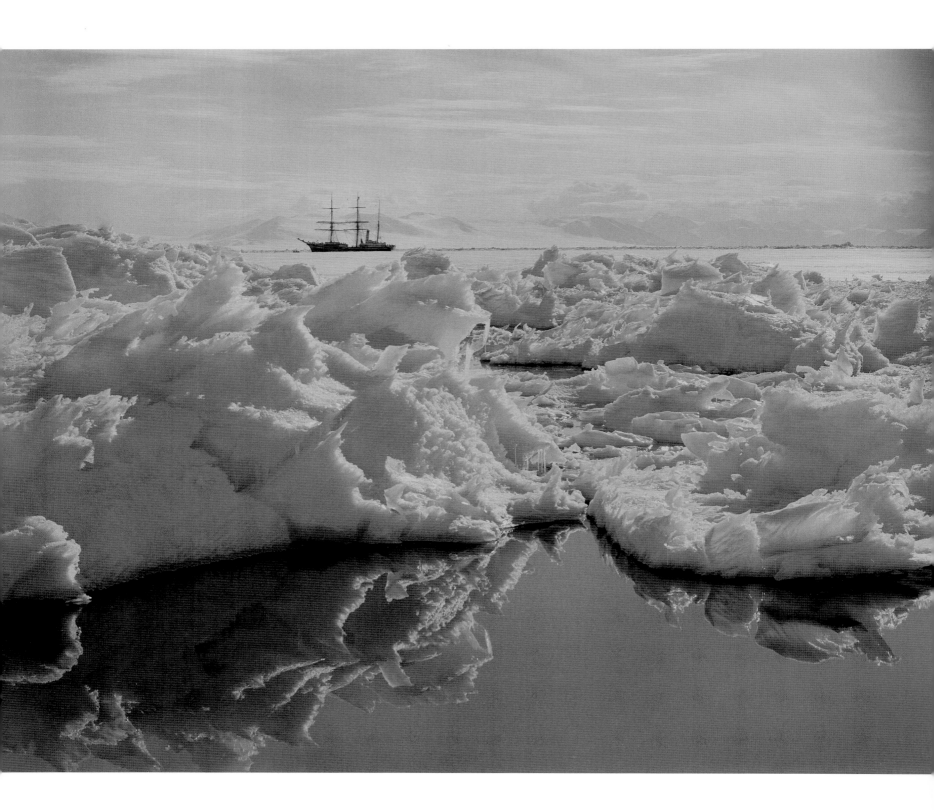

CHAPTER 9

The Last Frontier of Exploration

Having worked at the Scott Polar Research Institute in Cambridge for many years, I am very familiar with many of the artefacts, documents, photographs and paintings from Captain Scott's two Antarctic expeditions. An aspiration had always been to visit the Cape Evans hut in McMurdo Sound, which, although restored, was still reputed to retain its original Edwardian expedition atmosphere. And here I was, at McMurdo, waiting for the oversnow vehicle to drive the eleven miles over the sea ice to the hut from the American McMurdo Station (referred to by its residents as MacTown). Anticipation was high, and I was flying out of Antarctica two days later at the end of scientific fieldwork measuring the thickness of the huge Byrd Glacier basin in East Antarctica. This was my last chance in that year. We started out in the vehicle, getting bogged down in the soft snow-cover several times, but also seeing six emperor penguins who came inquisitively up to us once we stopped the engine. Then we rounded the cape and saw the hut – with its superb backdrop of the ice cliffs of Barne Glacier and Mt Erebus. First, I walked round the hut and up to the meteorological station, thinking back to Herbert Ponting's photograph of Edward Wilson taking readings there a hundred years earlier. Then into the hut – kindly, the others with me had already looked round and gave me some time in the hut alone. This was certainly one of the most special and atmospheric places I have ever been – the kitchen, crockery and old cocoa tins apparently unchanged, and Ponting's darkroom, Atkinson's laboratory and the emperor penguin on Wilson's table seemingly just as they had been on the Terra Nova expedition. I looked at 'the tenements', the bunks where Bowers, Oates and Cherry-Garrard had been – one of Cherry's socks was still there with his name sown onto it … so personal and so powerful.

JAD

Early discoveries

Antarctica was the last continent to be discovered, in the early 19th century. The South Pole was not reached until 1911, and even the outline of the coast of Antarctica was not defined in full until the era of satellites. Today, there remain many places in the vast Antarctic continent that have never been visited. Indeed, a century ago the exploration of Antarctica was viewed much as we might consider astronauts leaving Earth for Mars.

Long before this, some two millennia ago, the early Greeks imagined a world in which Northern Hemisphere landmasses were balanced against the inferred presence of a southern continent; '*Antarktikos*',

Opposite: Herbert Ponting's photograph of *Terra Nova* in the sea ice of McMurdo Sound, taken during Captain Scott's second Antarctic expedition of 1910-13. (© Scott Polar Research Institute)

meaning the opposite of the Arctic. Ptolemy wrote of a '*Terra Australis incognita*' or unknown southern land, which he speculated might be fertile and inhabited. Such ideas persisted in medieval and early modern maps of the world up to about the 17ᵗʰ century, even though they were entirely speculative.

Although several sub-Antarctic islands, including the Kerguelen and Crozet archipelagos at 49° S and 48° S in the southern Indian Ocean, respectively, and the largely glacier-covered South Georgia (55° S) in the South Atlantic sector, were discovered in the preceding century, Captain James Cook was the first to circumnavigate Antarctica. On the *Resolution* between 1772 and 1775, Cook deliberately penetrated beyond the Antarctic Circle at several longitudes in search of a southern continent. He did not find land even though his farthest south, offshore of what we now know as the deep indentation of Pine Island Bay at 71° S 107° W, would have intersected the Antarctic coast at many longitudes. Cook concluded that a southern continent might exist '*near the pole, and out of reach of navigation … If any one should have resolution and perseverance to clear up this point by proceeding farther than I have done, I shall not envy him the honour of the discovery; but I will be bold to say, that the world will not be benefited by it.*'

It was not until the early 19ᵗʰ century that the South Shetland and South Orkney Islands were discovered, in 1819 and 1821, respectively. These discoveries were related

Below: Whaling water boats with bows at both ends to move easily in either direction, long abandoned but still preserved on Deception Island, west of the Antarctic Peninsula. The island was a major focus for early whaling activity.

The Continent of Antarctica

to the extension of commercial activity in the form of sealing into southern waters, beginning in the 1770s. Oil from the blubber of seals became a sought-after commodity, but the skins were only of limited value. Growth in the number of ships, and declining catches, drove hunting to increasingly high southern latitudes. Although the commercial nature of these activities restricted reporting, it was William Smith, captain of the British brig *William*, who appears to have first brought back formal knowledge of Livingston Island, now known as part of the South Shetland Islands at 62°40' S 80° W, in 1819. The neighbouring active volcano of Deception Island, with its sheltered anchorage inside its flooded caldera was charted in 1820 by the American sealing captain, Nathaniel Palmer. Also during 1820, Edward Bransfield, together with Smith, led a naval expedition to chart the region, and later that year apparently made the first landing on the mainland of the Antarctic Peninsula. Palmer, after whom the modern Palmer Station on Anvers Island and the southern part of the Antarctic Peninsula are named, also located the South Orkney Islands in 1821. These and other discoveries led to a huge growth in fur-sealing in the South Shetlands and South Orkneys, and other islands offshore of the western Antarctic Peninsula. The anchorage on Deception Island became a base for massive harvesting of seals in the South Shetland Islands. Exploitation was so extreme that the industry had more-or-less collapsed by 1825, although it was partly resurrected when elephant seals became the next species to be devastated. It has taken over a century for seal stocks to have recovered to former levels, and both fur and elephant seals are once again plentiful on many of the islands around the Antarctic Peninsula.

Below: A primitive sealers' hut and whale bones on Elephant Point, Livingston Island, recording the 19th century exploitation of marine animal life in the waters around Antarctica.

The British sealing captain James Weddell, aboard the *Jane*, penetrated deep into what is now named after him as the Weddell Sea, reaching 74° 15' S in a very light sea-ice year in this usually treacherous embayment. A man with scientific interests, he collected seal specimens during his 1822-24 expedition, including a species that bears his name - *Leptonychotes weddelli*, the Weddell seal (Chapter 8). By contrast, a Russian expedition led by Fabian von Bellingshausen in 1819 was sent out by the Tsar with the intention of projecting Russia as an important nation at a time of international dominance by the British navy following the Napoleonic wars. The expedition discovered the isolated Peter I Island, the first to be reported from within the Antarctic Circle, and the South Sandwich Islands. One of the most successful voyages of this period was that of the Briton James Clark Ross, who had acquired considerable experience of Arctic exploration before going south with the ships *Erebus* and *Terror* in 1839. Ross pushed through the sea ice that often blocked the outer part of the Ross Sea to discover and sail along much of the length of what he named the '*Great Ice Barrier*' – the ice cliffs that mark the edge of the huge Ross Ice Shelf, subsequently named after him. He also entered McMurdo Sound, charting as he went, and discovered the volcanoes Mt Erebus and Mt Terror on Ross Island, which was to be the starting point for several later British expeditions to the South Pole. By contrast with Ross's successes, the first International Polar Year in 1882, which was an early exercise in internationally collaborative science instigated by the Austrian Karl Weyprecht, yielded only a single expedition to the south, a German venture to South Georgia.

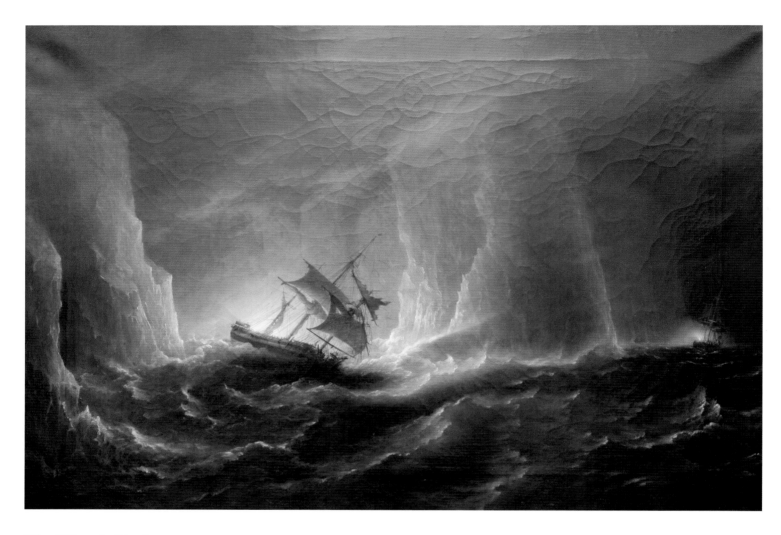

The 'Heroic Era'

An important stimulus to the exploration of Antarctica came with the 6th International Geographical Congress held in London in 1895. The conference concluded with an address by the German geographer Georg von Neumayer on the wide-ranging importance of exploring the still largely unknown continent of Antarctica. At the time, much of the continent's coastline remained completely unmapped and none had ever ventured into its ice-covered interior, let alone reached either the geographical or magnetic South Poles. In the twenty years or so that followed, expeditions were organised by explorers and scientists from several nations. These expeditions took forward the mapping of Antarctica's coastline and the pioneering of routes to the South Pole itself – a period known as the 'Heroic Era' of Antarctic exploration. In

Above: R.B. Beechey's oil painting of HMS *Erebus* and HMS *Terror* is named 'Escape from the bergs, 1842'. It provides a dramatic depiction of the encounter of James Clark Ross's ships with icebergs in rough waters during his exploration of the Ross Sea. (© Scott Polar Research Institute)

Paintings and photographs record the site of Scott's first expedition base at Hut Point on Ross Island in McMurdo Sound.

Above: Edward Wilson's watercolour of *Discovery* embedded in the shorefast sea ice of McMurdo Sound. Hut Point and Scott's *Discovery* hut are in the background. (© Scott Polar Research Institute)

Right: The two relief ships, *Morning* and *Terra Nova*, in McMurdo Sound during January 1904, just prior to *Discovery* breaking out from the shorefast sea ice at the end of the expedition. The modern McMurdo Station is now located on land behind the three ships. (© Scott Polar Research Institute)

common with the varying amounts of governmental and learned society support received, the expeditions had a mix of exploration, scientific and geopolitical motives. Even at this early stage, part of the motivation for Antarctic exploration was to establish claims of sovereignty.

Expeditions led by Adrien de Gerlache on the *Belgica* and Carsten Borchgrevink aboard the *Southern Cross* began the exploration of the Bellingshausen Sea and the tip of the northern Victoria Land coast of Antarctica, respectively. Borchgrevink's *Southern Cross* expedition was the first to overwinter on the Antarctic continent, at Cape Adare in 1899. The first men to enter the interior of Antarctica, however, were Captain Robert Falcon Scott and his colleagues Edward Wilson and Ernest Shackleton on Scott's 1901-04 *Discovery* expedition. Arriving at Ross Island in McMurdo Sound, discovered by James Clark Ross over 50 years earlier, the expedition had the dual aims of science and geographical exploration. Scientists specializing in geology, biology, oceanography, meteorology and glaciology compiled twenty-two volumes of research as a result of the expedition. Much of the research was undertaken on the Antarctic mainland, opposite Hut Point. Here in the Transantarctic Mountains (then known as the Western Mountains), Cambridge-trained geologist Hartley Ferrar made the stunning discovery of fossil plants that suggested Antarctica had once been a much warmer place – a precursor to the theory of polar wandering and plate tectonics. In addition, Scott, Wilson and Shackleton travelled for 93 days covering a total distance of 1,550 km (963 miles) to a record furthest south position on the Ross Ice Shelf of 82° 17' S, mapping a long section of the Transantarctic Mountains as they went. This expedition established a hut on a rocky spur that was named 'Hut Point', close to the edge of the McMurdo Ice Shelf, which was a convenient starting point for inland journeys towards the South Pole.

Above: The volcano Mt Erebus on Ross Island in the McMurdo Sound area of Antarctica was discovered by James Clark Ross in 1841. Mt Erebus is 3,794 m (12,448 ft) high and is the world's southernmost active volcano. Its crater contains an active lava lake and smoke is frequently observed emanating from the summit. The photograph is taken from a field camp in Windless Bight.

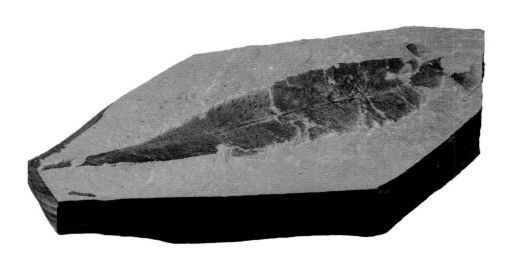

Above: Hartley Ferrar, geologist on Scott's *Discovery* expedition, collected rock samples that contained fossil plants, *Glossopteris indica*, during a sledging journey to the Western Mountains of Victoria Land in 1903. The length of the fossil is about 15 cm (6 inches). (© Scott Polar Research Institute)

Top right: Discovery was constructed in Dundee in 1901 specifically for Captain Scott's first Antarctic expedition, the British National Antarctic Expedition. The ship was later used by the Hudson's Bay Company and for further research expeditions. For many years it was alongside The Embankment in London before being transported back to Dundee in 1986 where it has pride of place at the Discovery Point museum.

Opposite bottom: The *Discovery* hut was the first to be erected in the McMurdo Sound area, on Scott's first Antarctica expedition of 1901-04 aboard the *Discovery*. The hut, which was not purpose built and was originally designed for Australian sheep stations, was poorly insulated. The *Discovery* itself, frozen into a nearby bay by sea ice, remained a warmer venue for expedition members.

Left: The hut from McMurdo Station with the memorial cross to George Vince (an expedition member lost and presumed drowned) on Hut Point and the sea-ice covered McMurdo Sound beyond.

Right: The *Discovery* hut today, looking towards the American McMurdo Station.

The hut survives to this day, on the edge of the site occupied by America's McMurdo Station, as does the *Discovery* itself, in the city of Dundee in eastern Scotland, where it was built.

Expeditions to other parts of Antarctica from Germany, Sweden, Scotland and France soon followed, varying in their aims and locations. Jean Baptiste Charcot, in the French vessels *Français* (1903-05) and, later, *Pourquoi-pas?* (1908-10), undertook scientific investigations and mapping in fjords of the western Antarctic Peninsula, whereas William Spears Bruce led the *Scotia* expedition to the more easterly South Orkney Islands (1902-04), in part to assess their mineral potential. Bruce established a meteorological station here, which he passed to the government of Argentina at the end of his expedition – the station has the longest running weather records in Antarctica. The Swedish explorer Otto Nordenskiöld, having already gained experience through expeditions to Svalbard and Greenland in the Arctic, led an Antarctic expedition between 1901 and 1904, conducting geological work around Snow Hill Island on the eastern side of the Antarctic Peninsula. The expedition ship, *Antarctic*, was crushed by pack ice before it could pick up Nordenskiöld and another shore party, also leaving her 20-man crew drifting on the sea ice. An epic rescue followed. The men from the ship underwent a 16-day march across the sea ice to Paulet Island. Both groups were forced to overwinter, and were eventually rescued in the austral spring of 1903 by the Argentine gunboat, the *Uruguay*.

Ernest Shackleton returned to McMurdo Sound on the *Nimrod* expedition of 1907-09. After an aborted attempt to land on the Ross Ice Shelf, east of McMurdo Sound, Shackleton established a base at Cape Royds on Ross Island, about 20 km (12 miles) north of Scott's *Discovery* hut. With a back-drop of the volcano of Mt Erebus,

Shackleton's hut remains, complete with its original contents. Supported by teams of ponies, Shackleton and three companions retraced Scott's and his own previous route across the Ross Ice Shelf and extended it, discovering and pioneering the difficult ascent of the highly crevassed Beardmore Glacier onto the high Antarctic Plateau. Reaching a position of 88° 23' S, 162° E, his team had come within 180 km (111 miles) of the South Pole. Here Shackleton halted, planting the Union Flag, and writing in his diary '*we have shot our bolt … better a live donkey than a dead lion*'. He realized that the party had insufficient time and resources to attain the Pole and return safely before the onset of winter; undoubtedly, he could have reached the South Pole, but was almost certainly correct in viewing the risk of death on the return journey too great to continue. Pioneering geological work took place on the expedition through British-born Australians T.W. Edgeworth David and Douglas Mawson. Among

Above: Dr Jean Baptiste Charcot was one of the early explorers of the western Antarctic Peninsula on two expeditions between 1903 and 1905 and again between 1908 and 1910. A number of place names in the area, including the 50 km (30 mile)-long Bourgeois Fjord, reflect the presence of Charcot, who was a distinguished French explorer of both the Antarctic and Arctic.

Right: For his 1907-09 Antarctic expedition, Shackleton selected the former whaling and sealing vessel *Nimrod*. The *Nimrod*, at 334 tonnes, was less than half the size of the *Discovery* and *Terra Nova* used on Scott's two Antarctic expeditions. Here, *Nimrod* is photographed leaving Lyttelton Harbour in New Zealand for Antarctica (© Scott Polar Research Institute).

Below: The page of Shackleton's *Nimrod* expedition diary that records his decision to turn round 180 km (111 statute miles or 97 nautical miles) short of the South Pole. The text, written in pencil to avoid possible water damage, reads:

'*9.1.09*
The last day out we have shot our bolt and the Lat is 88 23 S. 162 E. The wind eased down at 1 am. At 2 am we were up had breakfast and shortly after 4 am started South with the Union Jacks and the brass cylinders of stamps. At 9 am hard quick marching we were in 88.23 and there hoisted HMs flag took possession of the Plateau in the name of H.M. and called it K.E. Plat. Rushed back over a surface hardened somewhat by the recent wind and …..'

(© Scott Polar Research Institute)

their accomplishments was reaching the South Magnetic Pole, together with Alistair Mackay, high on the East Antarctic Ice Sheet in Victoria Land, on 16 January 1909. Located at 72°25' S, 155°16' E at the time, the migrating pole was attained on an arduous man-hauled sledging journey of over 450 km (280 miles) from their base at Cape Royds. These men, with several companions, were also the first to ascend the high volcano of Mt Erebus.

The challenge of the South Pole remained, and Scott's 1910-13 *Terra Nova* expedition was planned as the next attempt at this prize, combining geographical exploration with a comprehensive inter-disciplinary science programme. Meanwhile, the Norwegian Roald Amundsen had succeeded in borrowing Fridtjov Nansen's ship *Fram* for what was envisaged as an attempt on the North Pole. Once at sea, however, and having heard of Robert Peary's subsequently challenged claim to have reached the North Pole, Amundsen announced his intention to head for Antarctica instead, beginning what has been referred to by some as '*The Race for the Pole*'. In part this is a misnomer, given that Scott, on receiving Amundsen's telegram, told a relieved group of scientists on the *Terra Nova* that he had no intention of modifying his ambitious scientific plans for a simple dash to the Pole. His plans, drawn up before the expedition sailed south, remained unaltered. Both expeditions reached the Ross Sea and set up bases for the winter of 1910-11, Scott on land at Cape Evans about 24 km (15 miles) from the *Discovery* hut built a decade earlier, and Amundsen at the Bay of Whales on the edge of the floating Ross Ice Shelf.

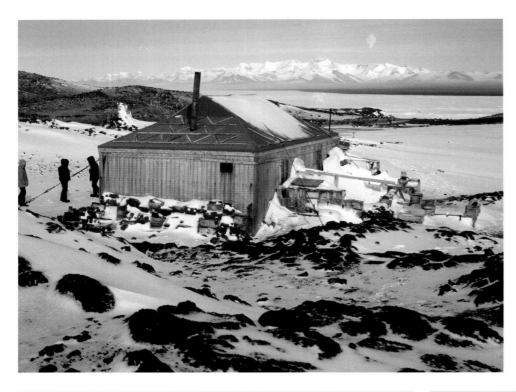

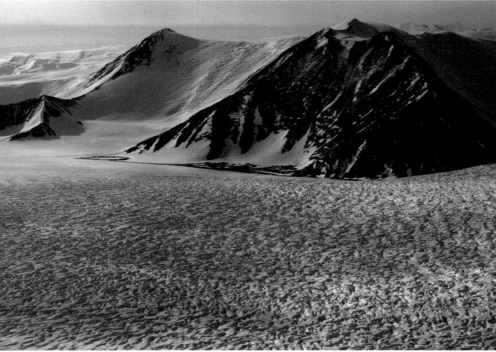

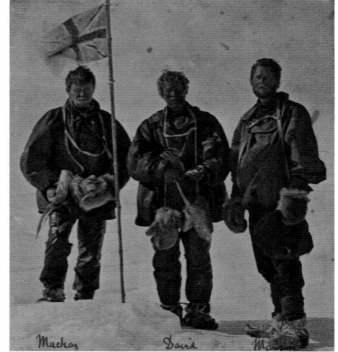

Mackay David Mawson

During that winter, Scott's expedition prepared equipment for the attempt on the Pole the following summer, and set up laboratories for the scientific staff. A winter journey in total darkness to search of emperor penguin eggs at Cape Crozier, some 120 km (75 miles) from the Cape Evans hut, was even undertaken by Edward Wilson, Henry 'Birdie' Bowers and Apsley Cherry-Garrard. Wilson, as a biologist, was interested in the embryology of the penguin and hoped it might offer clues on the origin of birds. Cherry-Garrard was to name his book, on the *Terra Nova* expedition and the fate of Scott and his four companions, *The Worst Journey in the World* – not after the demise of the Polar Party, but after the winter journey to Cape Crozier in darkness and blizzard conditions. The book, first published in 1922, remains a much-read classic on the 'Heroic Era' of Antarctic exploration.

Amundsen, after having to return to base due to very cold early-season conditions, headed south over completely unknown territory. The Transantarctic Mountains barred his way, but the Axel Heiberg Glacier proved a suitable, but heavily crevassed, route to the Antarctic Plateau and the Pole itself. After a journey of 56 days, Amundsen and his four-man party reached the South Pole on 14 December 1911, arriving back at the Bay of Whales on 25 January 1912, after a remarkably quick return journey of only 42 days. His success was due to remarkably thorough planning, considerable previous experience of travel on ski and sledge, and the use of 52 dogs. A small tent, '*Polheim*', was left at the Pole with letters for the King of Norway and for Scott – a wise precaution since the hazardous Axel Heiberg Glacier still had to be negotiated on the return journey.

Meanwhile, Scott and his team left Cape Evans two weeks after Amundsen had departed, using ponies and man-hauling of sledges. Following Shackleton's route, the Beardmore Glacier was ascended after a wearying trudge through soft snow on the Ross Ice Shelf. Scott's party of five reached the South Pole on 17 January 1912, over a month after Amundsen. Ski tracks and black flags from the Norwegians had been spotted before the *Polheim* tent was reached. After this disappointment, the British group at first made good progress back across the Plateau; this did not last, however. Edgar Evans cut his hand while repairing a sledge – the wound failed to heal and he also suffered frostbite and serious concussion from a fall. He was buried at the base of the Beardmore Glacier a month after the Pole had been reached. In the gathering autumn, temperatures across the Ross Ice Shelf plummeted and Scott, Wilson, Bowers and Oates struggled from one food and fuel depot to the next, suffering increasingly from frostbite – indeed, comparisons with modern meteorological records suggest that this was one of the coldest autumns of the 20th century. Oates, the worst affected, knowing he was dying and holding back his companions, uttered the unforgettable words '*I am just going outside and may be some time*', before walking into the blizzard, never to be seen again. The other three pushed on until pinned down eleven miles from the major One Ton Depot of food and fuel. Here they died, their bodies, diaries and letters recording the circumstances of their fate being found the next year after their colleagues from the Cape Evans base located their last camp with its

Opposite top left: During the *Nimrod* expedition, Shackleton established a base at Cape Royds on Ross Island, about 70 km (44 miles) north of Scott's *Discovery* hut. The location has a backdrop of the Royal Society Range across McMurdo Sound (pictured here) and the volcano Mt Erebus (behind the photographer).

Opposite top right: Shackleton's hut remains today and has been recently restored, complete with many of its original contents.

Opposite bottom left: The Beardmore Glacier, first ascended by Shackleton on his *Nimrod* expedition and named after an expedition sponsor, was Scott's hazardous route through the Transantarctic Mountain to the Polar Plateau in 1911-12. This huge glacier drains an area of about 90,000 km² (35,000 miles²) of the ice sheet interior; it is heavily crevassed and fast-flowing at about 350 m/yr (1,100 ft/yr) where it enters the Ross Ice Shelf.

Opposite bottom right: Alistair Mackay, T.W. Edgeworth David and Douglas Mawson at the South Magnetic Pole, which was located on the Antarctic Plateau in Victoria Land in 1909. The magnetic pole is not a fixed point, and it is now several hundred kilometres off the coast of East Antarctica. It has drifted about 1,300 km (800 miles) at an average of just over 8 km/yr (5 miles/year) since the first observations made by James Clark Ross in 1841. (© Scott Polar Research Institute)

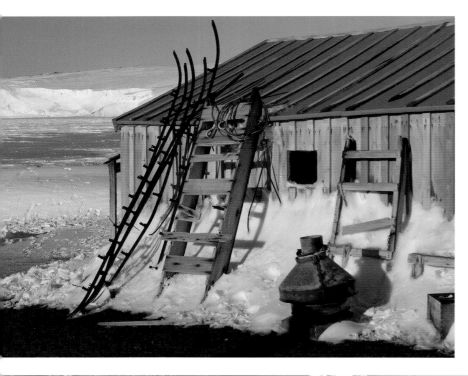

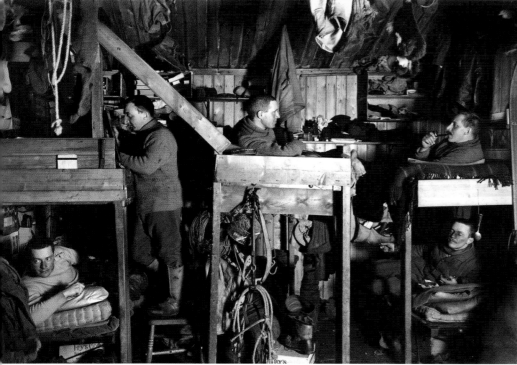

Opposite top left: An external view of Captain Scott's Cape Evans hut, purpose built and erected in 1911, about 24 km (15 miles) north of the earlier *Discovery* hut.

Opposite top right: Inside the hut, food from several expedition suppliers is well preserved in the chill of Antarctica, including Colman's mustard and Huntley and Palmers biscuits.

Opposite bottom left: Expedition photographer Herbert Ponting's beautifully composed image of 'The Tenements' – one of several sets of bunks in the Cape Evans hut. Two of those pictured, Bowers (standing) and Oates (on the central bunk bed), were to die on the return journey from the South Pole in March 1912. (© Scott Polar Research Institute)

Opposite bottom right: Today, an emperor penguin lies on the table between the sleeping areas once occupied by Scott and Wilson. Wilson drew and painted here.

Below: Captain Scott took a series of photographs on the march to the South Pole in 1911-12. For many years, these photographs were thought to have been lost, but are now held at the Scott Polar Research Institute in Cambridge. Here, ponies and men trudge wearily through soft snow on the Ross Ice Shelf. (© Scott Polar Research Institute)

drifted-over tent. A burial service was read and a snow cairn was raised over the site – their bodies remain on the Ross Ice Shelf, buried deeper and deeper under the accumulating snow. Before they left Antarctica, the departing group left a large wooden cross in memory of the polar party on the top of Observation Hill, a volcanic summit between the modern McMurdo Station and New Zealand's Scott Base. The cross is inscribed with the immortal words of Tennyson: *to strive, to seek, to find, and not to yield.*

Others had also been in peril on the expedition. A further group of six men led by Victor Campbell, known as Scott's Northern Party, had been set down in early 1911 by the *Terra Nova* for what had been intended as a six-week geological exploration of part of Victoria Land about 320 km (200 miles) north of Cape Evans. Poor sea-ice conditions prevented the ship returning to pick them up and they were forced to overwinter in a tiny snow cave on the aptly named Inexpressible Island. They survived, despite lack of food and illness, and eventually reached Cape Evans on foot in late 1912.

While the attention of the world and its media was focused firmly on the success of Amundsen and the tragedy of Scott, the Japanese *Kainan-maru* (usually known as the Shirase expedition, after its leader) and German *Deutschland* expeditions were active on the other side of Antarctica, while the Australian Douglas Mawson's *Aurora* expedition, 1911-14, was exploring part of the interior of the East Antarctic Ice Sheet from a base in Commonwealth Bay. Mawson's privations, after the deaths of his sledging companions Belgrave Ninnis and Xavier Mertz, are described graphically in his book '*The Home of the Blizzard*' – a recent scientific paper has confirmed that Commonwealth Bay is indeed the windiest place on Earth.

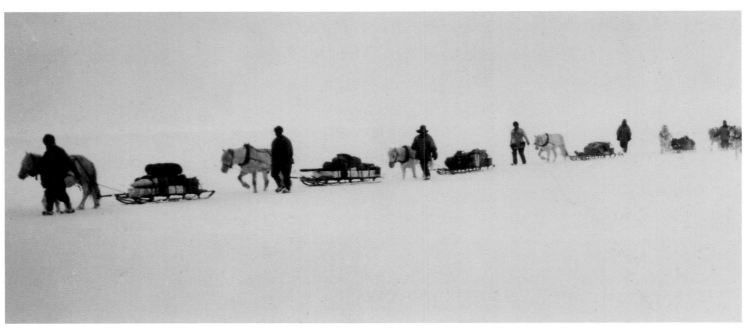

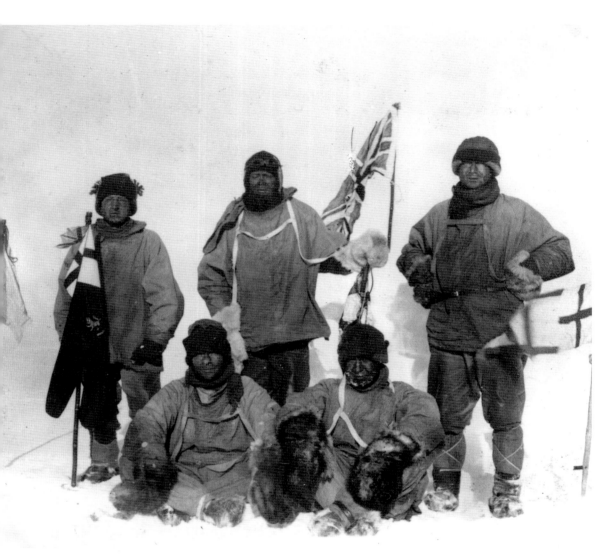

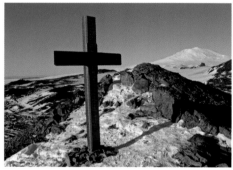

Above left: Captain Scott, together with Wilson, Bowers, Oates and Evans, at the South Pole on 17 January 1912. Several sledging flags, often made by loved ones and carried South from home, can be see along with a Union Jack. (© Scott Polar Research Institute)

Top right: Edward Wilson sketched one of the black flags left by Amundsen's expedition a few kilometres from the South Pole. The flags were set out to demonstrate that the Norwegians had traversed a relatively wide area around Amundsen's actual reckoning of the position of the Pole. (© Scott Polar Research Institute)

Centre right: The snow cairn and cross (made from the skis of Tryggve Gran) erected above the tent on the Ross Ice Shelf in which Scott, Wilson and Bowers died by the party that found their frozen bodies the next spring. The site is now buried by tens of metres of snow. (© Scott Polar Research Institute)

Bottom right: The large wooden memorial to Scott and his four companions, who died on the return journey from the South Pole in March 1912. The cross was erected on the summit of the volcanic rocks of Observation Hill, between the modern McMurdo Station and New Zealand's Scott Base, by the remaining members of the *Terra Nova* expedition. It is inscribed with the immortal words of Tennyson: *to strive, to seek, to find, and not to yield.*

Opposite: Shackleton's *Endurance* became trapped in the dense pack ice of the Weddell Sea before she could reach the Antarctic coast at Vahsel Bay, where the crossing of Antarctica had been intended to begin. The ship drifted for ten months and over 2,000 km (1,250 miles) while beset in the sea ice before being crushed by ice pressure and sinking in about 3,000 m (10,000 ft) of water, leaving Shackleton's party of 28 men stranded on the ice. (© Scott Polar Research Institute)

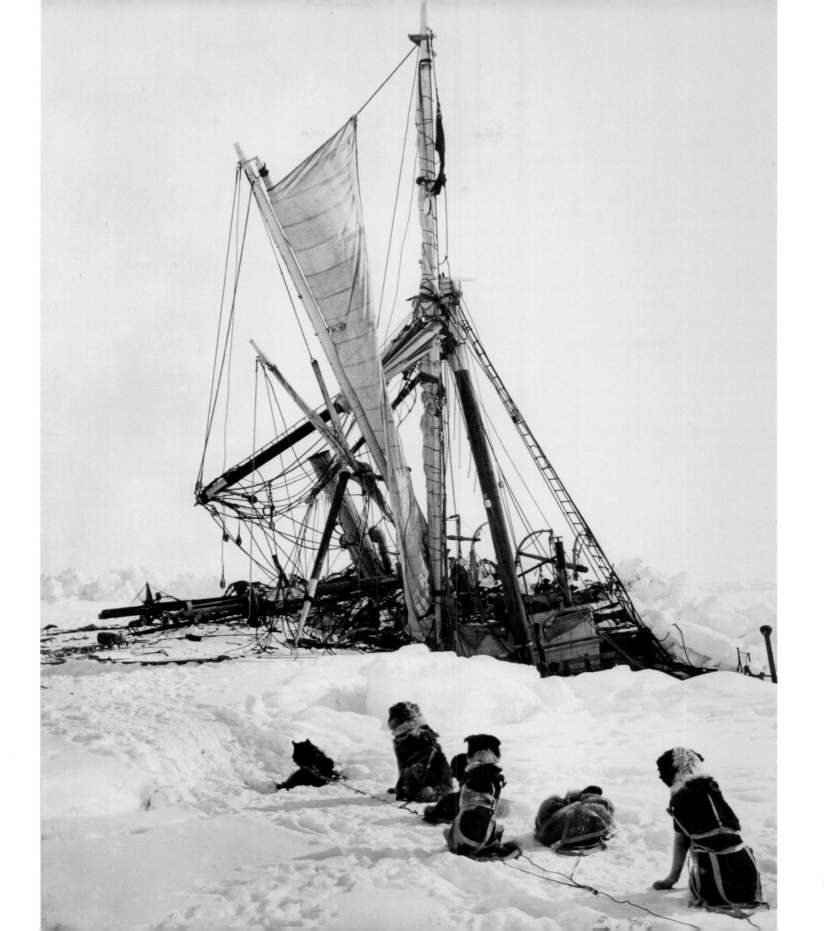

Shackleton still hankered after a return to the Antarctic and, in order to raise the support to do so, began planning for an Imperial Trans-Antarctic Expedition – the first crossing of the Antarctic continent. The *Endurance* left Britain in August 1914. The aim was for *Endurance* to deliver Shackleton and his team to the Weddell Sea coast, while a second vessel, *Aurora*, would place another party on the Ross Sea side to lay a series of food and fuel depots for Shackleton to pick up after reaching the Pole. The *Aurora* party, at great personal cost and the loss of three lives, laid the depots under the harshest of conditions, but Shackleton was never able to use them, having failed even to reach the Antarctic coast. On 19 January 2015, *Endurance* was first trapped in sea ice and finally crushed and sank after a ten-month drift through the ice-infested Weddell Sea. The group of 28 men abandoned the stricken vessel and first tried to haul the ship's three small lifeboats across the rough sea ice. This task was beyond their strength, and they set up camp on the thin floating sea ice, taking to the boats again only when the ice broke up on 19 April 2016. They sailed north towards the islands at the tip of the Antarctic Peninsula, where whalers were sometimes to be found. After an arduous 5-day journey in freezing conditions they landed on a rocky promontory (now known as Point Wild after Shackleton's second-in-command) on the north coast of Elephant Island, eventually setting up a camp using upturned boats, but with an abundant supply of penguin and seal for much-needed food and fuel. A more inhospitable location is hard to imagine. Exposed to the raging storms of the Southern Ocean, one side of the promontory was bounded by a steep and heavily crevassed glacier, and elsewhere by a precipitous cliff rising to nearly 1,000 m (3,300 ft).

Shackleton realized that rescue was unlikely and that the party would probably not survive a winter sheltering beneath the upturned boats. After the sides of the 7-metre (23 ft)-long *James Caird* had been built up and an awning added, the little boat with six men aboard set off on 24 April on the 1,300 km (800 mile) journey across the open ocean, surviving huge seas to reach the west coast of South Georgia after 15

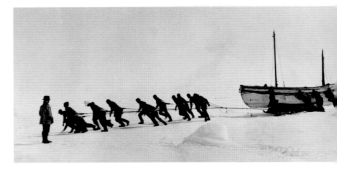

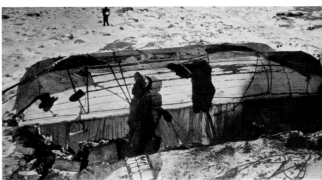

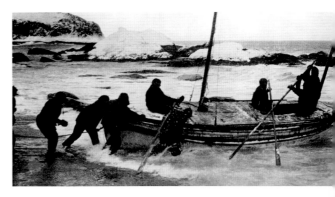

From top to bottom:
Once *Endurance* had sunk, Shackelton and his men first tried to haul the ship's three small lifeboats (*James Caird*, 7 m (23 ft) long; and *Stancomb Wills* and *Dudley Docker*, each 6.4 m (21 ft) long – each named after an expedition sponsor) across the rough sea ice. This proved too difficult a task, and the party then camped on the sea ice until it broke up enough for the boats to be launched and then sailed to Elephant Island.

During their stay on Elephant Island, 22 men of the *Endurance* expedition, led by Frank Wild, sheltering beneath two upturned boats – *Stancomb Wills* and *Dudley Docker* – while they awaited possible rescue, hoping Shackleton's boat journey to South Georgia was successful.

The *James Caird* setting out from Elephant Island towards South Georgia on its journey across the huge seas of the Southern Ocean – one of the most notable small-boat voyages ever made.

Photographer Frank Hurley captures the moment when the *Yelcho* (in the distance) finally reached Elephant Island to rescue the *Endurance* expedition's marooned party on 30 August 1916.
(All images © Scott Polar Research Institute)

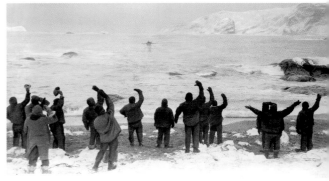

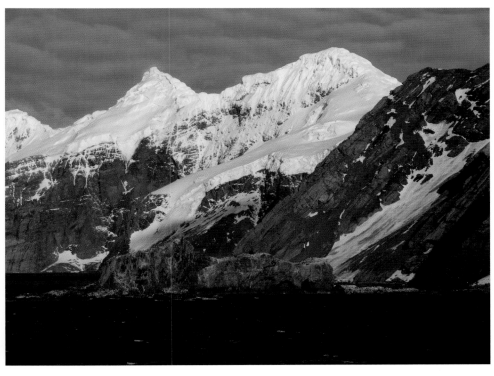

Top left: A monument at Cape Wild on Elephant Island records the rescue of Shackleton's 22 men on 30 August 1916 by the Chilean vessel *Yelcho*, captained by Luis Pardo, after four and a half months on the island through the Antarctic winter. (Courtesy of Vicky Dowdeswell)

Top right: The exposed Cape Wild and storm beach on Elephant Island, which Shackleton's party reached after an arduous passage, once their three lifeboats had been launched from the breaking-up sea ice. Nothing now remains of the two boats that were abandoned on the beach once Shackleton's men had been rescued.

days – a major feat of leadership by Shackleton, and of seamanship and exemplary navigation by Frank Worsley. However, the whaling station where potential rescuers awaited was on the east side of the island beyond unmapped mountains and glaciers. Shackleton, Worsley and Tom Crean found a route through this unknown terrain to raise the alarm. On approaching the whaling station on 20 May the morning hooter went off. Shackleton wrote later, '*This was the first human sound we had heard for three years beyond that of our own voices*'. On arriving at the whaling station, the bedraggled party learned for the first time of the unimaginable carnage of the First World War.

Rescue of the twenty-two men remaining on Elephant Island was not straightforward given the hazards of sea ice and the difficulties of acquiring suitable vessels. Three attempts were made before the Chilean vessel *Yelcho*, captained by Luis Pardo, finally reached the island to rescue the entire party on 30 August 1916. The escape from the icy Weddell Sea, and the open-boat journey to South Georgia, had been remarkable.

Shackleton returned to Antarctica once more, on the *Quest* expedition in 1921-22, and the so-called 'Heroic Era' of Antarctic exploration is widely considered to have ended with his death from a heart attack on South Georgia in January 1922. The First World War had curtailed much scientific exploration, the Great Depression was approaching and funds for further expeditions to the south were in short supply, especially since the geographical challenge of the South Pole had been met.

20th Century whaling

Coinciding with the 'Heroic Era', whaling became the dominant commercial activity in Antarctica during the early 20th century. Interest in exploitation of whales began in response to the decline of Northern Hemisphere stocks in the 1890s. An exploratory voyage from Scotland to the Weddell Sea and the Antarctic Peninsula was undertaken by the Dundee Whaling Expedition from 1892 to 1893, whilst the Norwegian Sandefjord Whaling Expedition under the captaincy of C.A. Larsen visited the western Weddell Sea, the South Orkney Islands, as well as the sub-Antarctic island of South Georgia, from 1892 to 1894. On the opposite side of Antarctica, the Norwegian (Tønsberg) Whaling Expedition under H.J. Bull, explored the Ross Sea.

None of these expeditions were commercially successful, but they provided the groundwork for early 20th century exploitation. Following establishment of whale-processing operations on South Georgia, the Norwegian whaler Ch. Christensen turned his attention to the South Shetland Islands in 1905-06 on the factory ship

Below: The sub-Antarctic island of South Georgia was a major centre for whaling in the Southern Ocean. Frank Hurley's 1914 photograph captures the whaling settlement and ships in the adjacent harbour at Grytviken. (© Scott Polar Research Institute)

Opposite top: The church (left), houses and remnants of the whaling industry in modern Grytviken. The harbour is visited regularly by cruise ships, which represent a major modern commercial activity in and around Antarctica. (Courtesy of Jennifer Hirsh)

Opposite centre: Wreck of the Norwegian whaling factory ship *Guvernøren* in Føyn Harbour, Wilhelmina Bay, western Antarctic Peninsula. The ship ran aground and burned out in 1915.

Opposite bottom: Whale bones remain exposed near Port Lockroy, providing clear evidence of past whaling activity around the Antarctic Peninsula.

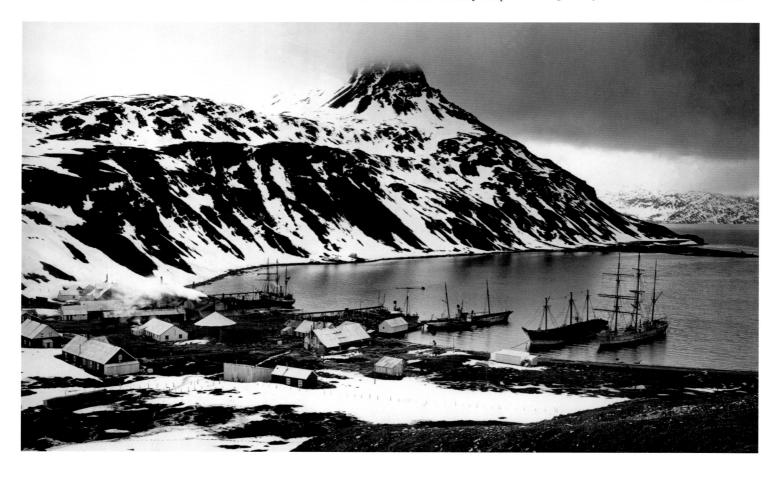

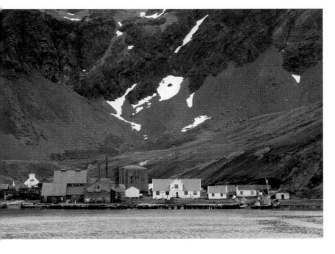

Admiralen. In the same season a Chilean-Norwegian enterprise sent the factory ship *Gobernador Bories* to the former focus of sealing, Deception Island. Later operations moved south to the sheltered harbours of the western Antarctic Peninsula. Deception Island became the main land-based whale processing station in Antarctica, operated by the Chilean-Norwegian Hektor Whaling Company from 1912-31. A small whaling station was also established on Signy Island in the South Orkney Islands in 1920. However, much of the whale processing was undertaken on factory ships, especially in the Peninsula region itself. As the British introduced land taxes and other regulations in the Antarctic Peninsula and South Georgia, Norwegian whalers sought other whaling opportunities, and in 1923-24 the factory ship *Sir James Clark Ross*, commanded by Larsen, successfully began exploiting whales in the Ross Sea.

The demand for whale oil increased dramatically in the 1920s, leading to further expansion of whaling in the Southern Ocean. Over-production caused the market to collapse, and in 1931 the *Convention for the Regulation of Whaling* was agreed internationally to protect the industry from over-extraction. Among the whale species under pressure were right, grey, humpback, blue and fin whales. Whaling continued in the Southern Ocean throughout World War II, after which the International Whaling Commission was established in 1946 to provide further controls on the industry. This agreement was designed specifically to introduce annual quotas, but catches increased, reaching 41,000 whales taken by 1960-61. The Whaling Commission was unable to prevent the dramatic decline in whale stocks under the existing commercial pressures and competition, and increasingly companies withdrew from whaling activities as they became unviable. Nevertheless, limited so-called 'scientific whaling' has continued to this day, even after a ban in 1994 by the International Whaling Commission on commercial whaling.

The Antarctic Peninsula and the adjacent islands today preserve a remarkable legacy of the whaling industry, with whale bones and wooden water boats littering ice-free coastal sites.

Inter-war years of exploration

From 1934-37, the British Graham Land Expedition (BGLE) mapped a large section of the Antarctic Peninsula during dog-sledge journeys, demonstrating that it was indeed part of the Antarctic continent rather than an island archipelago. A small aircraft formed part of the mapping programme of BGLE. More ambitious flying from 1928 had begun with the American Hubert Wilkins, and was followed up with a series of flights by Richard Byrd, which initiated the opening up of the interior of Antarctica using this new means of transport. Byrd flew over the South Pole from the 'Little America' base at the edge of the Ross Ice Shelf in November 1929 – the journey took less than 16 hours compared with three months for Amundsen's over-

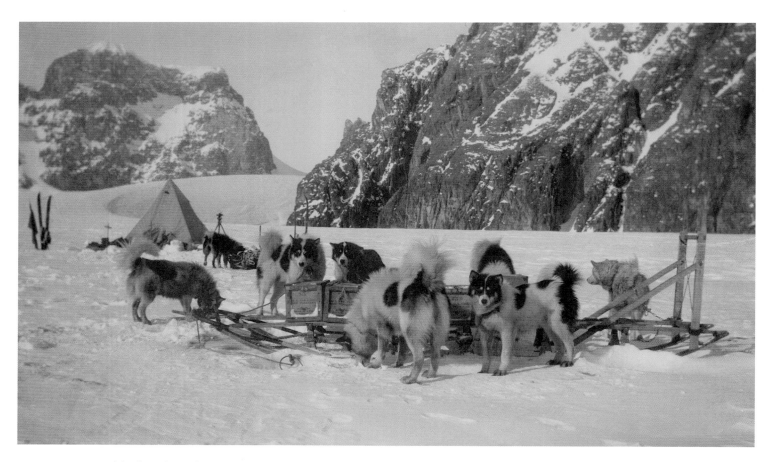

snow traverse with dogs less than 20 years earlier. Importantly, the United States government supported Byrd's subsequent expeditions to Antarctica, including those in 1933-35 and 1939-41, the latter establishing Little America III station in West Antarctica and East Base at Stonington Island off the Antarctic Peninsula. It was also Byrd who pioneered the routine use of aircraft in Antarctica for the deployment and resupply of scientists undertaking research there.

National interests were never far from the surface at this time. Mawson's 1929-31 British, Australian, New Zealand Antarctic Research Expedition (BANZARE) to the Pacific coast of East Antarctica was designed to pave the way for an Australian territorial claim. Norwegian expeditions led by Hjalmar Riiser-Larsen and the German *Schwabenland* expedition of 1939 were aimed at mapping and establishing claims along the East Antarctic coast south of southern Africa. The German expedition, under Alfred Ritscher, used an aircraft to photograph large tracts of mountainous terrain which he named Neu Schwabenland. Unknown to the Germans, Norway, having heard of the forthcoming expedition, had already lodged a territorial claim for the area, which they termed Dronning (Queen) Maud Land.

Above: The 1934-37 British Graham Land Expedition (BGLE) used dog-sledging to travel widely around the western Antarctic Peninsula and its adjacent islands, in the first systematic attempt to map the area using surveying by sledging parties combined with a programme of aerial photography. (© Scott Polar Research Institute)

World War II and post-war years

During the Second World War, Antarctic exploration slowed once more as nations were occupied elsewhere. Britain, however, launched a secret expedition under the code-name Operation Tabarin, ironically named after a Paris nightclub. The official line on Tabarin was that several bases would be established to counter any German threat in the South Atlantic, but the covert aim was the establishment of stations with the objective of strengthening the British claim to sovereignty over the Antarctic Peninsula in opposition to those of Argentina and Chile. The first of these bases was built in February 1944 and known simply as Base A. It is located on Goudier Island (64°49' S, 63°30' W) on the west side of the Antarctic Peninsula, at a site known from whaling days as Port Lockroy. Following the Second World War, Base A was operated for science by the Falkland Islands Dependencies Survey, the forerunner of the British Antarctic Survey. It remained open until 1962 when it closed permanently as scientific activities moved to more modern bases elsewhere. In 1994, the base was designated as an Historic Site and Monument under the Antarctic Treaty, soon after which it was restored, ultimately being taken over by the UK Antarctic Heritage Trust in 2006. Today, the Trust operates the base as a museum that evokes the spirit of a remote Antarctic base as it was in the 1950s. A post office and shop adds to the interest of passengers on the numerous tourist vessels that visit the area.

The American, Richard Byrd, having risen to the rank of Rear-Admiral, led further Antarctic expeditions after the Second World War: in 1946-47 (Operation Highjump) and 1955-56 (Operation Deep Freeze). Operation Highjump was by some distance the largest ever operation on and around the Antarctic continent. It involved about 4,700 personnel, over 20 aircraft and was supported by 13 ships, with the explicit aim of testing logistics in the coldest continent. Implicitly, it was a statement of American power extended to the most inaccessible part of the world. The huge American station at McMurdo Sound, and the logistical infrastructure of aircraft and ice runways that went with it, was established from this time. Today, McMurdo station is by far the largest in Antarctica, comprising a harbour, landing strips on sea ice and the McMurdo Ice Shelf, along with about 100 buildings for catering, accommodation, a chapel, workshops, power and water-distillation plants, and science laboratories. The station houses over 200 people during winter, swelling to more than 1,000 logistics and scientific staff during summer.

The military-led approach of the Americans contrasted with the Norwegian-British-Swedish or 'Maudheim' expedition of 1949-52, which was an explicitly international scientific expedition to Antarctica. Its research foci were the meteorology, glaciology and geology of the Dronning Maud Land region of East Antarctica, in combination with airborne surveying. New scientific methods, including the testing of seismic techniques for measuring the thickness of the ice sheet, were pioneered on this expedition, which in many ways was a precursor to the wide-ranging scientific projects that formed part of the International Geophysical Year of 1957-58.

Top: The buildings now used as a post office, shop and museum at Port Lockroy, on the western side of the Antarctic Peninsula, were first established as 'Base A' during Britain's wartime clandestine Antarctic operation, code-named 'Tabarin'.

Above: Measurement of atmospheric conditions from an instrumented air balloon during the Norwegian-British-Swedish or 'Maudheim' expedition to Donning Maud Land in 1949-52. (© Scott Polar Research Institute)

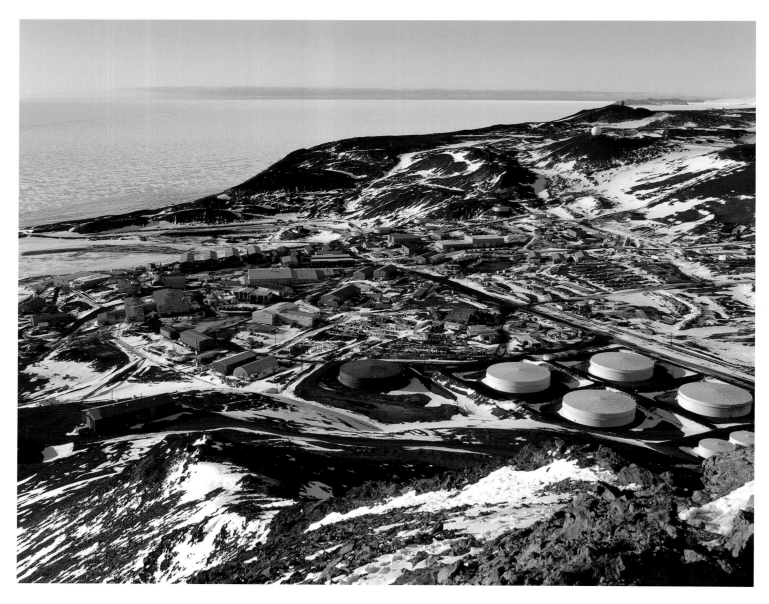

Coming full-circle from Shackleton's original idea of an Antarctic crossing, but more modern in its scientific aims and mode of transport, the Commonwealth Trans-Antarctic Expedition of 1955-58 had the objective of traversing the whole continent for the first time. It succeeded, whereas Shackleton's Imperial Trans-Antarctic Expedition had failed forty year earlier. Led by Vivian Fuchs from the Weddell Sea side of Antarctica, and supported by Edmund Hillary from McMurdo Sound, the motorized snow-cats took 99 days to complete a traverse of almost 3,500 km (2,200 miles) from the Weddell Sea coast to McMurdo Sound via the South Pole.

Above: McMurdo Station, or 'Mac Town', is operated as part of the United States' Antarctic Program. The station is by some way the largest in Antarctica. It has about 100 buildings and houses over 1000 people during a busy summer field season. The base, adjacent to Scott's original hut at Hut Point, was opened in 1956. All personnel and cargo heading for America's Amundsen-Scott Station at the South Pole pass through McMurdo Station.

The International Geophysical Year and Antarctic Treaty years

In many ways, the Maudheim and Commonwealth Trans-Antarctic expeditions were symbolic of a changing approach to Antarctica in terms of both geopolitics and science. The International Geophysical Year (IGY) saw researchers from twelve countries joining together to promote an ambitious interdisciplinary scientific programme in Antarctica utilizing both existing and new bases around the continent. The establishment of these bases, including an American station at the South Pole, was a very major logistical and financial commitment. The continuation of scientific work from these bases, and the international collaboration it involved, was a significant stimulus to the development of a formal international agreement relating to the Antarctic that became the Antarctic Treaty in 1959.

The current status of Antarctica is one of peaceful co-existence and collaboration between nations, with a strong emphasis on environmental protection. Thus, geopolitics and science were combined in taking the exploration and understanding of Antarctica in an important new direction; subsequent developments, discussed further in Chapter 11 of this book, concern the modern governance and management of Antarctica by regulated international consensus.

Above: One of the four snow-cats used for the first crossing of Antarctica on the Commonwealth Trans-Antarctic expedition of 1955-58. The expedition made a series of scientific measurements during the crossing, as part of the International Geophysical Year. The snow-cat is preserved in Canterbury Museum, Christchurch, New Zealand.

Right: The Trans-Antarctic Expedition (TAE) Hut, was erected in 1957 at what is now New Zealand's Scott Base in McMurdo Sound. The hut was designed to house the part of the TAE led by Edmund Hillary, which rendezvoused with and resupplied Vivian Fuchs' part of the expedition once the South Pole had been reached from the Weddell Sea. It was used for many years as the Mess Hut for Scott Base.

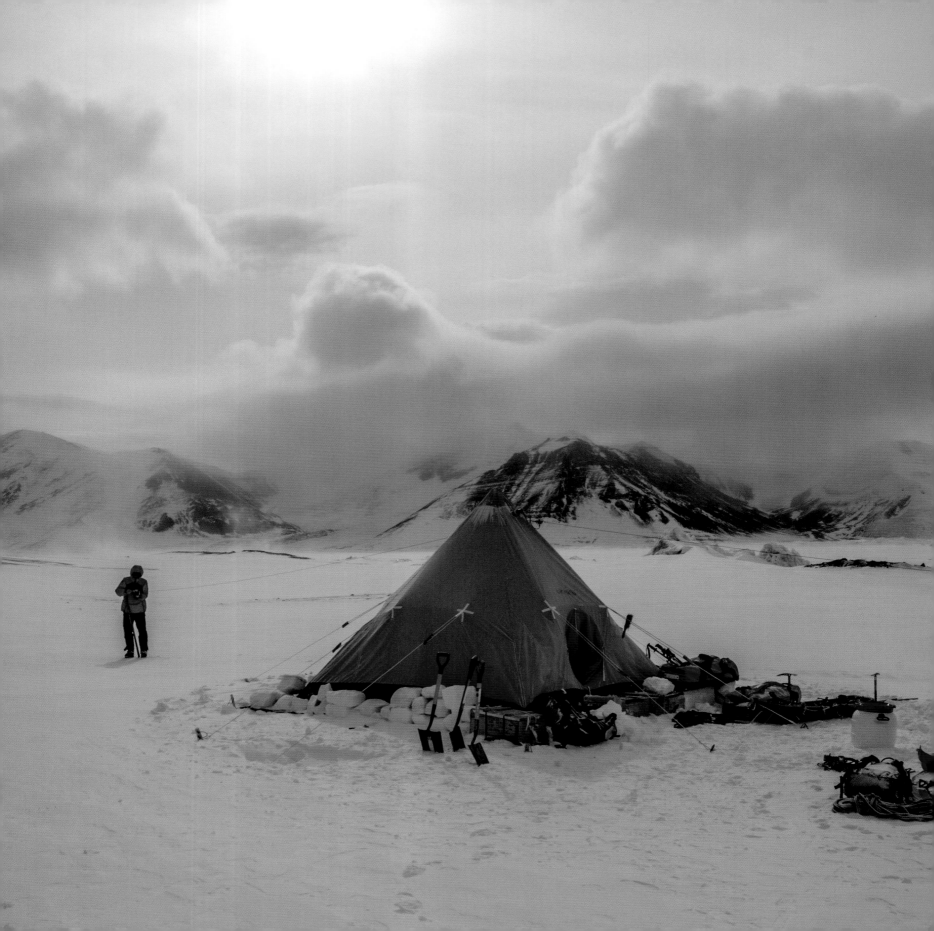

CHAPTER 10

Living and Working in Antarctica

As part of a programme to investigate the response of the Antarctic Peninsula Ice Sheet to climate change, we had arranged to undertake fieldwork with the support of the British Antarctic Survey from their research station at Rothera. Our destination was Ablation Lake at 71° S on the Alexander Island side of the massive George VI Ice Shelf. After a few days of field training at Rothera, our geological party of three headed south in a Twin Otter aircraft. We passed over the wonderful icy mountains of Palmer Land, and then across the ice shelf to Alexander Island. After circling the area of anticipated fieldwork, the landing place for our ski-equipped aircraft was on the adjacent ice shelf, but rough ice, comprising a series of ridges and frozen ponds, separated us from our pre-planned campsite on Alexander Island. After being dropped off with the intention of staying for a month, we had the task of conveying a tonne of kit to shore using plastic boat-shaped sledges. In the absence of purpose-made sledging harnesses, Ian, our field general assistant, improvised by using climbing harnesses with waist and leg loops, carabiners and slings. Fellow geologist, Bethan, really got stuck in to the sledge-hauling, while Ian piled a huge load onto his sledge. I found my lesser load (a concession to age perhaps?) hard, back-straining work. We only had about 4 km (2½ miles) to cover but had to weave in and out of what seemed endless ridges and well-frozen ponds as we went. We were soon overheating, despite the cold wind and sub-zero temperature. It took us over three hours to cover this short distance, but eventually we made landfall, finding a good smooth snowfield to set up camp. Ian directed operations, and we soon had our 3-person pyramid pitched to withstand whatever the Antarctic chose to throw at us. After melting snow, we enjoyed a brew and simple meal. The temperature dropped to -21° C (-6° F) that night, proving the effectiveness of the camping set-up and double-down sleeping bags. My respect for those early man-hauling parties rose immeasurably after our own small encounter with this mode of transport.

MJH

Opposite: Geologists' camp at the edge of the George VI Ice Shelf, Alexander Island, under stormy skies.

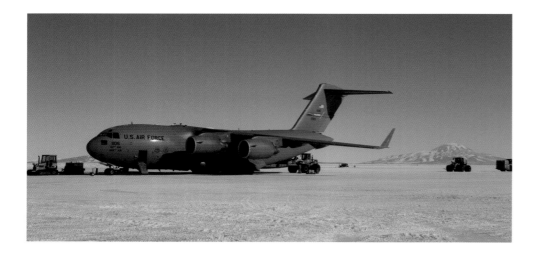

Travelling to Antarctica

Although still a remote continent, Antarctica today has many links from other Southern Hemisphere land masses by both sea and air. Scientists and support staff today generally fly to the continent in order to maximise their time – gone are the days when they would join a ship in the Northern Hemisphere and spend months sailing to the Antarctic. Almost invariably, scientists are supported by the logistics of government operators, and privately organised scientific programmes are unusual.

By far the busiest air route is from Christchurch, New Zealand to McMurdo Sound, which serves both McMurdo Station (USA) and Scott Base (New Zealand) on the shores of the Ross Sea. Before departure, the logistical operators provide passengers with full Antarctic kit, and explain the rigours of Antarctic climate and safety issues. Security checks are rigorous, including the use of sniffer dogs to catch possible drug-users. Preparations can take some days, and then there is the waiting for appropriate weather conditions *en route*. Flights are often postponed and, even when in the air, returns before reaching the half-way point are not uncommon – such flights are known as boomerangs.

The aircraft are dual-purpose, for cargo and people-carrying, and their cramped webbing seats often preclude easy movement to reach the limited facilities. Furthermore, passengers are required to put on their cold-weather gear at the outset in preparation for landing, but commonly the air crew do not turn the heating down to compensate – the flights are far from comfortable.

Landing early in the season takes place on the sea ice just offshore from McMurdo Station. The ice may be 2 m (6 ft) thick, but its elasticity prevents it from cracking during landing. When the sea ice becomes unsound, the landing is transferred to an air strip called Williams Field, on the nearby McMurdo Ice Shelf. Americans are transferred by bus to McMurdo Station, and Kiwis to Scott Base. McMurdo Station is

Above: Boeing Globemaster (C-17) aircraft of the U.S. Air Force after transferring scientists and support staff from Christchurch, New Zealand to a sea ice landing strip at McMurdo Station, Antarctica. The inactive volcano of Mt Discovery is in the right background.

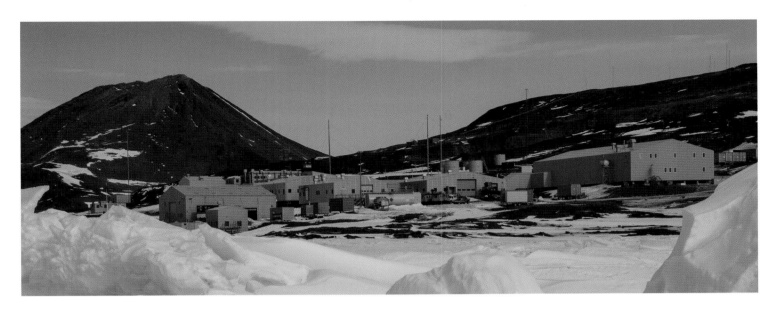

located near Scott's old *Discovery* hut (Chapter 9), and with numerous buildings, heavy traffic and an overpowering smell of diesel fumes and the canteen, it has the appearance of an unattractive mining town. In contrast, Scott Base, a tenth of the size, is located 3 km (2 miles) away on the other side of Observation Hill, a look-out point on Scott's expeditions. A road connects the two bases, but Scott Base has glorious views of the ice shelf and the steaming volcano of Mt Erebus – and much cleaner air! McMurdo is a hub for air operations throughout this sector of Antarctica, including frequent C-130 flights to the South Pole Station (USA) and to large distant temporary camps on the ice sheet. A range of smaller aircraft, including helicopters, are used on shorter trips, especially to the nearby Dry Valleys in the Transantarctic Mountains.

Another well-used air route is from either the Falkland Islands or Punta Arenas in Chile to the British base of Rothera, which has a hard gravel runway, also used by other nations. From here, the real Antarctic workhorse, the De Havilland Twin Otter, fitted with skis, transports scientific teams into the 'deep field'. The Australian Antarctic Division also uses an air-bridge from its base in Hobart, Tasmania, to Wilkins Aerodrome near Casey Station in East Antarctica. From here helicopters and ski-equipped fixed-wing aircraft deploy scientific teams into the deep field. Elsewhere, scientists involved in one-off field programmes have flown from Cape Town to bases in Dronning Maud Land, East Antarctica, including landing in the interior on blue-ice runways, rather than on snow.

Private companies also operate air services to Antarctica for tourists, adventurers and mountaineers. Providing full logistical support and accommodation and transport in the field, one company flies out of Punta Arenas in Chile to Union Glacier near the Ellsworth Mountains in West Antarctica. From there are guided tours to Mt Vinson, the highest mountain in Antarctica, and the South Pole, amongst other destinations.

Above: New Zealand's Scott Base nestles in a delightful position beneath Observation Hill (left background), close to a series of tall pressure ridges.

Tourist overflights of the Ross Sea sector of Antarctica were initiated in 1977 from New Zealand to offer passengers a unique sight-seeing experience, but these flights came to a premature end on 28 November 1979 when an aircraft crashed into Mt Erebus, killing all 257 people on board. This disaster remains by far the worst to have befallen the Antarctic continent. Similar sight-seeing flight operated out of Australia were also suspended soon after this disaster, but these flights resumed in 1994, and continue to this day.

In recent years, a new airlink for tourists has been established between Punta Arenas and an airstrip at the Chilean Frei and Russian Bellingshausen bases on King George Island in the South Shetland Islands. An expedition ship then picks up or drops off passengers for a voyage to the Antarctic Peninsula. This arrangement is aimed at passengers who are short of time, or for those who want to avoid the Southern Ocean and a potentially stormy crossing of the Drake Passage. The flight time is around two hours, but bad weather on King George Island has been known to delay passengers by up to three days.

Shipping is required for the bulk transport of equipment and supplies to the continent, and many nations have icebreakers or ice-strengthened vessels for this purpose. An example is the passage from Hobart to the Australian stations of Davis and Mawson, where journey times can last over a week. Many other countries combine logistics transfer by ship with the carrying of scientists to the continent.

Even so, the numbers of scientists and associated staff in Antarctica are small (4,000 in summer and about 1,000 in winter) in comparison with those now visiting on cruise ships (or 'expedition ships' as they are commonly known) (44,000 in 2016-17). Tourists remain largely ship-based, although some companies offer a one-night camping trip on the mainland if conditions allow.

Few attempts have been made to colonise Antarctica, and to date only an estimated eleven people have been born on the continent – eight from Argentina and three from Chile. These events have been used to reinforce the overlapping claims of these two countries to the Antarctic Peninsula sector of the continent.

Both scientific investigations and tourism require careful management, a topic that is addressed in Chapter 11.

Preparing for Antarctic conditions

Preparations for Antarctic fieldwork begin many months before departure, starting with a full-scale medical examination that is more rigorous than for airline pilots or oil-rig divers. Wide-ranging blood tests are taken, as certain conditions such as HIV are normally a bar on deployment in Antarctica, as each person is regarded as a potential blood bank. Body-mass index that falls into the overweight or higher categories may also be a prohibitive condition. For the over 50s, even more rigorous testing is required, including tests for heart conditions.

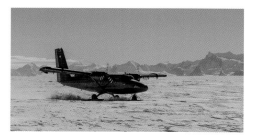

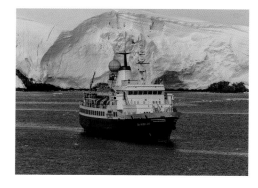

Top: A De Havilland Dash 7 aircraft provides an 'air bridge' from Punta Arenas in Chile or the Falkland Islands to Britain's Rothera Station on Adelaide Island, western Antarctic Peninsula.

Centre: The De Havilland Twin Otter is the 'workhorse' aircraft of the Antarctic continent, shown here landing on skis on George VI Ice Shelf. The mountains of Palmer Land are in the background.

Bottom: Ice-strengthened passenger ships provide tourists with a unique opportunity to view glaciers, icebergs and wildlife at close quarters. Ships with fewer than 200 passengers, such as *Sea Adventurer* illustrated here, are permitted to make shore landings.

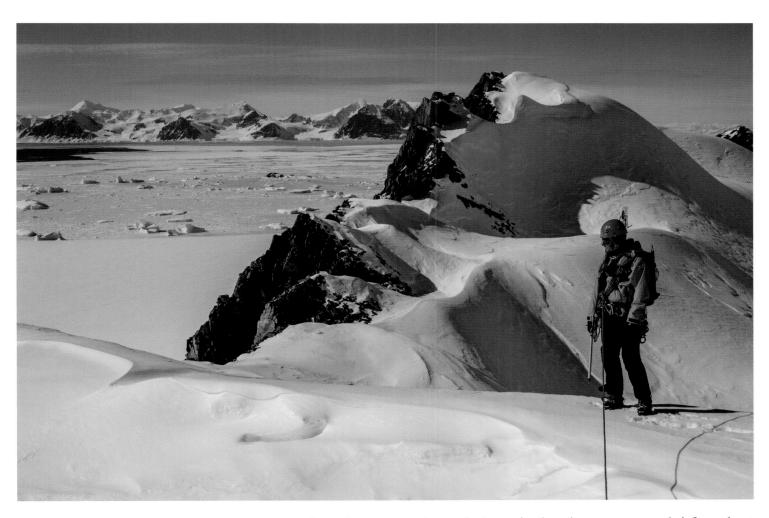

Above: Training with the British Antarctic Survey hones mountaineering skills, by traversing the rock-snow arête of Reptile Ridge near Rothera Station.

Assuming you pass the medical examination, the next steps are briefings about Antarctica and how to live and operate there safely. Environmental issues are covered, and several days of first-aid training are provided.

Field training includes practise in the art of camping, including pitching a polar pyramid tent, lighting stoves and lamps, and using HF radios. Travelling methods and self-rescue techniques from crevasses are also learned, particularly the use of a GPS and compass for navigation, as well as rope-management on cliffs to simulate crevasse rescue. Participants also rope up as though moving together in alpine terrain, and practice search and rescue techniques. These activities may take place either in Antarctica, or at home before departure. Additional days of training are provided for those people intending to handle boats and other machinery, where fuel spills are a potential environmental issue. This training provides good opportunities to meet potential team members, especially fellow scientists and field assistants. The latter

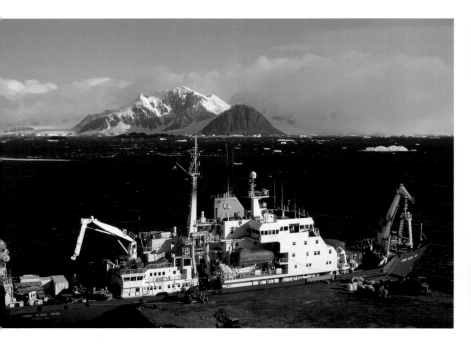

are usually mountaineers and they are responsible for managing camp and travel arrangements, as well as keeping the scientists safe in the field.

Personnel are fitted out with a full set of specialist Antarctic clothing. Many nations have standard kits for different tasks and parts of Antarctica to be visited, whether remaining on base, or camping in the 'deep field'. Clothing is usually based on the layering principle: typically a thermal base layer of leggings and long-sleeved vest, fleece salopettes, fleece shirt, heavy-duty wind-proof trousers, synthetic windproof jacket, headover (which is a fleece round-neck, with cotton to protect the face), and a close-woven wind-proof over-jacket with large hood. For the head, a balaclava, hat with earmuffs, or beano is provided. Feet are protected with thick woollen socks, and a choice of footwear, ranging from plastic climbing boots with inners, leather mountaineering boots, RBLTs (which stands for 'rubber bottom, leather tops'), mukluks (a soft snow boot of Inuit origin), and hard-toe trainers for work on base. Ski goggles, mountain sun glasses and a variety of gloves are also provided. Thus, the only clothing that personnel need to take themselves is civilian kit for travel, a supply of underwear and any favourite items. Once in Antarctica, additionally specialist kit is provided, including a down duvet for conditions well below freezing, crampons, rucksack and ice axe.

Field training generally resumes on arrival in the Antarctic, as practice is important prior to travelling to a remote field camp. A mountaineer gives the scientific team a refresher course on camping and safe travel over crevassed terrain and mountain ridges. For personnel new to Antarctica, this will be their first experience of operating in this hostile environment, while for old hands the renewal of skills is equally valuable.

Top left: The UK's RRS *James Clark Ross* is an icebreaking research vessel fitted with state-of-the-art scientific equipment. Here it is docked at Rothera Station, where it has offloaded supplies and equipment.

Top right: Crossing the Southern Ocean to reach Antarctica is often stormy, as viewed here from the bridge of RRS *James Clark Ross*.

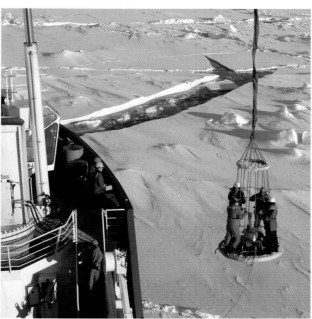

Working at sea

Many nations have well-equipped research vessels with ice-breaking capability for research in marine biology and geology, oceanography and geophysics around Antarctica and the Southern Ocean. The ship's company is usually housed in comfortable cabins of single or shared occupancy, and they benefit from good on-board catering. Work schedules are commonly unpredictable because of the vagaries of weather and sea-ice conditions, but if all is going well, round-the-clock sampling, monitoring and measurement takes place in either two 12-hour or three 8-hour shifts, or watches. At such times, the work is intense but exciting, as marine-scientific cruises frequently throw up new scientific findings in the often previously uncharted waters around the continent. However, no matter how well-planned a marine cruise is, the Antarctic can disrupt those plans completely. The seasoned scientist knows this, and always has a contingency plan that may be very different from the original, or she or he may need to adapt to completely new research opportunities.

An example from personal experience (MJH) of having to change research plans dramatically was during a cruise with the German research vessel, RV *Polarstern*, to the Weddell Sea in early 1991. The cruise plans involved investigation of the geology, biology and oceanography of the southernmost Weddell Sea. The ship was initially able to break its way through solid sea ice, the bow throwing up broken sea ice in spectacular fashion. Near the coast of Coats Land, in the eastern Weddell Sea we encountered what was dubbed 'porridge ice' – a mixture of old ice floes with thick snow on top, and newly formed elastic

Top left: The Autosub autonomous underwater vehicle (AUV) ready for deployment into the waters off the Antarctic Peninsula. The AUV is programmed to take a prescribed underwater course and to return to the parent ship with scientific information on, for example, water temperature and salinity.

Centre: Scientists being deployed onto a large sea-ice floe by crane from an icebreaking research vessel.

Top right: MV *Polarstern* battles difficult sea-ice conditions off the coast of Coats Land (background) in the southeastern Weddell Sea. The ice cover is a mix of old ice floes, pressure ridges, new elastic ice and thick snow cover, with the texture of porridge.

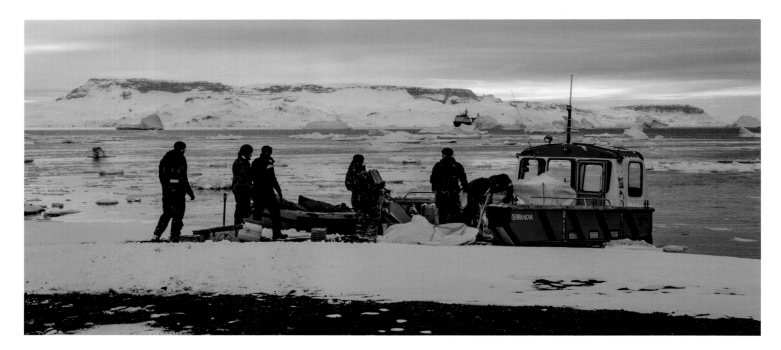

ice between. Soon we were held fast in this glue-like mix. Interestingly, this was within a few nautical miles of where Shackleton became beset in *Endurance* in January 1915 (Chapter 9) – and in the same type of ice. For twelve days we were encased in this ice, but our on-board helicopters eventually spotted an open-water lead. After a day of edging through the ice pack, we eventually escaped from its grip. Clearly, our designated research area was unreachable that season, so we turned our attention further east, to the Lazarev Sea. The biologists on board were now able to sample the sea bed using dredges. In addition to the abundant organisms that interested the biologists, the geologists were enthused by the many ice-rafted dropstones that were mixed with the organic material. Finally, sediment coring of the sea bed enabled the geologists to formulate a history of ice-sheet change for this part of Antarctica, although not for the area that was originally planned.

Sometimes research vessels, and even navy ships, are used to deploy scientists into coastal field areas. Helicopters are the preferred means of ship-to-shore transport, but not all ships have them, and in those cases, boats or landing craft are utilised.

Antarctic bases

Around 30 nations operate 38 year-round bases in Antarctica, plus over twenty more which are open in summer only. The International Geophysical Year of 1957-58 provided a considerable stimulus for major expansion of scientific activity and international collaboration, a process that has continued to this day (Chapter 11). Most bases are distributed around the coast to allow the entry of ship-borne supplies, and many do not have

Above: A landing craft deploys a geological party at Croft Bay on James Ross Island. A group of Royal Marines provide much-welcomed help in transferring the kit ashore. The craft is named *Terra Nova* in recognition of the ship used during Scott's Last Expedition. The host ship, HMS *Protector*, is in the background.

Opposite top: Some of the buildings and Helipad at the large American base of McMurdo Station.

Opposite bottom left: Sign giving the geographical coordinates of New Zealand's Scott Base.

Opposite bottom right: The lounge and library at Scott Base, with telescope for spotting wildlife on the nearby sea ice.

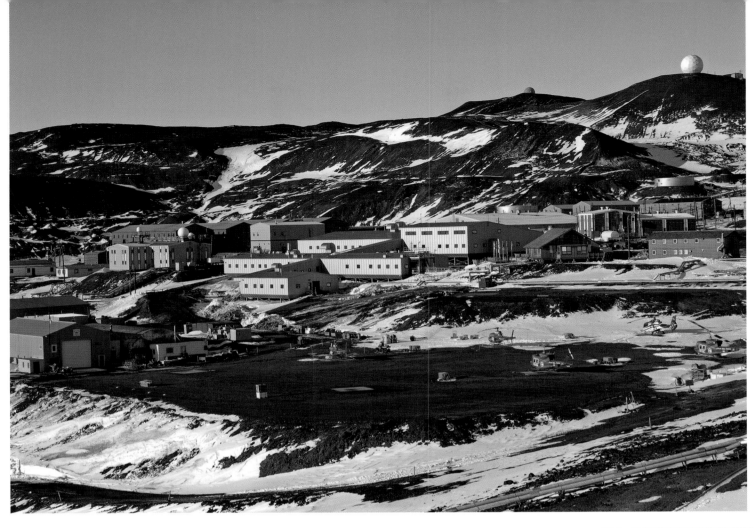

landing facilities for aircraft. Of the year-round bases, most only have a small skeleton staff in winter, but numbers expand considerably in summer, as the Table opposite illustrates.

By far the largest base is the USA's McMurdo Station in the western Ross Sea, which hosts about 1,000 personnel in summer and 200 in winter. McMurdo is a major hub for aircraft operations, including flights to the USA's Amundsen-Scott Station at the South Pole (250 personnel in summer), for limited-duration glaciological and geological projects in the Antarctic interior, and helicopter flights to the Dry Valleys on the other side of McMurdo Sound, where there is a focus on biological and other interdisciplinary investigations. The nearby Scott Base, operated by New Zealand, is more typical in size for an Antarctic base, with some 100 personnel in summer. West of the Ross Sea, along the East Antarctic coastline as far as the Weddell Sea, several countries have year-round bases, including France, Australia, Russia, China, Germany, and the UK. Of these, most are on solid ground but a few are on ice shelves, and the stability of these is uncertain. Indeed, the British Halley Station on the Brunt Ice Shelf has been looking so vulnerable that it had to be evacuated in 2016-17. A series of new and unpredictable crevasses formed, threatening the creation of an enormous iceberg on which the station could float away.

On the Antarctic Peninsula, there are numerous bases, for example those belonging to Argentina and Chile, most of which are located in the northeast and west of the Peninsula and its adjacent islands. Britain's presence in the Antarctic Peninsula is now consolidated on one year-round station, Rothera, which has become an important hub for aircraft operations. The setting of many of these bases is spectacular, surrounded as they are by jagged, heavily glacier-covered mountains.

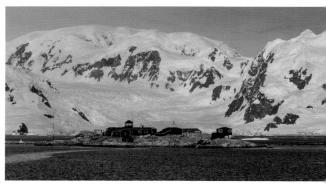

The largest cluster of bases is in the South Shetland Islands, where there are fifteen since, for many countries new to operating in Antarctica, this region is the most accessible in the whole of the Antarctic. Chile's Frei Station on King George Island is alongside the Russian Bellingshausen Station, and has the advantage of a gravel runway that services flights from southern South America. In contrast to the Peninsula, the more southerly coastal areas of the Weddell and Amundsen seas are inhospitable and devoid of permanent bases, and most onshore work is undertaken from icebreaking research vessels or from aircraft.

Modern Antarctic bases are constructed to a high standard of thermal efficiency and comfort. Because of the danger of fire in the very dry air and frequently windy conditions, up-to-date bases comprise multiple buildings, which are constructed of non-flammable material, either linked by fire-proof corridors or standing alone. Serious fires are therefore unusual, but two recent examples serve as a salutary reminder that fire is the biggest hazard on an Antarctic base. In 2001, a fire completely destroyed a biological laboratory at Rothera Station (UK); it was caused by an electrical fault and spread rapidly in the high wind. More recently, in March 2012, Brazil's Comandante Ferrez Station on King George Island was destroyed by a fire owing to a generator fault, sadly resulting in the deaths of two staff. The proximity of other bases meant that the survivors could be evacuated safely, while personnel from the British ice-patrol vessel, HMS *Protector*, which was in the vicinity, took charge of putting out the fire out.

Above: Russia's Mirny Station in East Antarctica, the base for supplying the famous ice-core drilling site of Vostok. The tank-like vehicle in front was used to transfer personnel to Vostok.

Opposite top: The red buildings of Argentina's Esperanza Station provide a splash of cover amongst the mountains and glaciers of the northern Antarctic Peninsula.

Opposite centre top: The stunningly located Chilean Gabriel Gonzalez Videla Station in the Aguirre Passage, western Antarctic Peninsula.

Opposite centre bottom: The main administrative and mess building, Bransfield House, at Rothera Station, is overlooked by Mt Gaudry and its glaciers.

Opposite bottom: The aftermath of a fatal fire which destroyed most of Brazil's Commandante Ferraz Station on King George Island, South Shetland Islands, in March 2012. The Royal Navy's HMS *Protector*, from which this photograph was taken, provided a fire-fighting crew to douse the fire, after the station personnel had been evacuated by crews from neighbouring Chilean, Argentinian and Polish bases.

Examples of Antarctic bases operating year-round with approximate numbers of personnel involved. Listed westwards from the Ross Sea.

Base/station	Nationality	Number of Summer staff	Number of Winter staff	Location
McMurdo	USA	1000	200	Western Ross Sea
Amundson-Scott	USA	200	50	South Pole
Scott Base	New Zealand	100	10	Western Ross Sea
Dumont d'Urville	France	100	25	East Antarctica
Casey, Davis and Mawson	Australia	c. 60-70 at each station	c. 20 at each station	East Antarctica
Mirny	Russia	170	60	East Antarctica
Zhongshan	China	60	25	East Antarctica
Neumayer	Germany	50	9	East Antarctica
Halley	UK	70	14	East Antarctica / E. Weddell Sea
Marambio	Argentina	150	55	W. Weddell Sea
Esperanza	Argentina	90	55	NE Antarctic Peninsula
General Bernado O'Higgins Riquelme	Chile	44	16	W. Antarctic Peninsula
Palmer	USA	40	15-20	W. Antarctic Peninsula
Rothera	UK	100	20	W. Antarctic Peninsula
Comandante Ferrez	Brazil	40	12	South Shetland Islands
Bellingshausen	Russia	40	13	South Shetland Islands

An interesting example of a traditional small base is the UK's Fossil Bluff Station, which is operational only during summer. It has figured prominently in the exploration of the southern Antarctic Peninsula, but is still used as a summer transit base and refuelling stop for aircraft heading to more southerly destinations. It is also used occasionally by geological parties working in the local area. Usually occupied by only a few staff, it is essentially a self-catering cabin with bunks and a kitchen area, with separate food and fuel stores.

Large temporary field camps are a form of deep-field science infrastructure that are maintained in operation for just one or a few summer field seasons. They are particularly favoured by the US and multi-national programmes, and involve the establishment of portable cabins (e.g. tunnel-shaped Jamesway huts) for a cook-serviced canteen, full

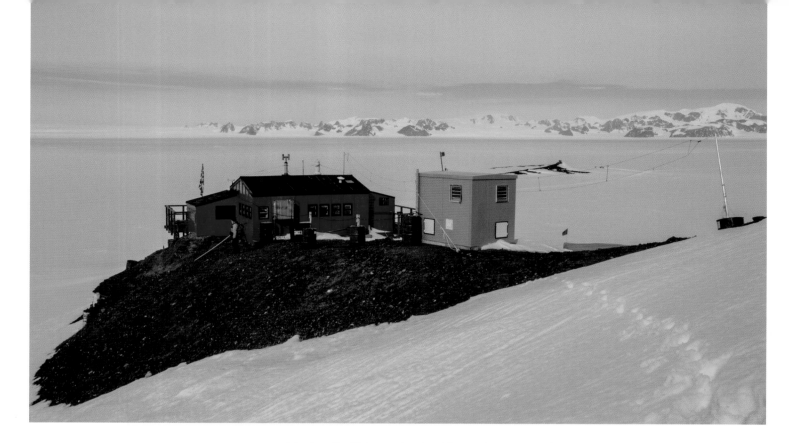

Above: A traditional 1960s base: the UK's Fossil Bluff Station on Alexander Island. It is occupied intermittently in summer and serves as a transit point and refuelling facility for aircraft venturing further south to a blue ice runway and distant field station named Sky-Blu. The station occupies an elevated position on bedrock overlooking George VI Ice Shelf and the mountains of Palmer Land beyond. It was so-named on account of the abundance of marine and terrestrial fossils found in the vicinity.

ablution facilities and scientific equipment, whilst many staff sleep in pyramid tents. Typical projects include geological investigations in the remoter parts of the Transantarctic Mountains and ice-core drilling projects on the East Antarctic Ice Sheet. Scores of personnel are involved, and the whole camp is serviced by large ski-equipped aircraft, such as the Hercules, with day-to-day operations by small helicopters or ski-equipped aircraft.

Deep-field camping

Living in tents for an extending period is an essential activity for the field geologist or glaciologist. Although the days of several-month-long independent journeys by snowmobile are now relatively rare, it is still vital that careful preparations according to tried and tested methods are followed. As an example of 'deep field' geological research, we describe from first-hand experience (MJH) the planning that goes into having a relatively comfortable and successful field season, lasting about a month, in an area far removed from base. In this case, we were a British Antarctic Survey (BAS)-supported party of two geologists and one Field General Assistant (FGA), deployed out of Rothera Station to a camp at the edge of the George VI Ice Shelf. Travel to the site involved a journey in a Twin Otter aircraft of two hours and a ski-landing on the ice shelf; our arrival is described at the start of this chapter.

The camping set-up is organised by the FGA. The job title underestimates the range of skills required. She or he is a highly experienced mountaineer, whose job is to co-

Top left: A large-scale but temporary field camp of the US Antarctic Program in 1995-96, supporting dozens of scientists on one of the major outlets of the East Antarctic Ice Sheet, the Shackleton Glacier. Communal huts are on the right and sleeping tents are on the left, with toilet in the middle. At lower left is a fuel bladder, which supplies the Squirrel helicopter and Twin Otter in the lower middle. The operation lasted several months and all equipment and personnel were emplaced by Hercules aircraft.

Top right: A three-person geological party established this deep-field camp in magnificent surroundings near the frozen Ablation Lake on Alexander Island. The three-person pyramid tent is supplement by a ridge tent that serves as a toilet and store. Emergency equipment is on the mound to the right, separate from the main camp area.

ordinate logistics, guide the scientists over challenging terrain, keep the party safe, service equipment, ensure camp is secure enough to withstand the worst of weather, attend to mechanical breakdowns of snowmobiles (if used) and operate the daily scheduled radio contact with base. The FGA therefore has to have special personal qualities, because fieldwork often avoids the more challenging terrain that they might otherwise relish, but instead may be called upon to help with sampling and other scientific activities.

The standard tent for Antarctic use by several nations is the pyramid, little changed in basic design from the tents used by Scott, Amundsen, and others over a century ago. Indeed, the US Antarctic programme refers to them as 'Scott tents'. A range of other mountain tents may be used in areas where abundant air or overland support is available. The principal features of the pyramid tent are its heavy-duty cloth and weight (typically 40 kg / 88 lbs with pegs for the New Zealand version), essentially making these tents capable of withstanding violent blizzards with sharp ice crystals and blown sand and gravel. Both two-person and three-person tents are available. The tent has a tunnel entrance, with tapes to seal the tunnel, and a wide valence on which food boxes, fuel cans, first-aid kit and snow blocks are stashed to hold it down in stormy weather. Drifting snow will further secure the tent, by providing a seal with the ground, so camping on snow is preferred to stony ground. Inside the tent are an assortment of tapes in the apex to allow small items of clothing to dry, and numerous pockets for storage. Also in the apex is a rubber tube, called a dongle, for ventilation, since carbon monoxide poisoning from stoves is a real hazard. When pitched in snow, boxes are provided on which to kneel and knock boots clear of snow before entering.

The layout inside a pyramid tent has been tried and tested over several decades, and few parties deviate from this arrangement. From the back of the tent to the entrance there is an HF radio; an aerial cable which passes through the dongle to an antenna outside; a carbon monoxide monitor; a stove box and kitchen box with a traditional Primus stove anchored between; water bottles; and a 'goodies' box. In a two-person tent,

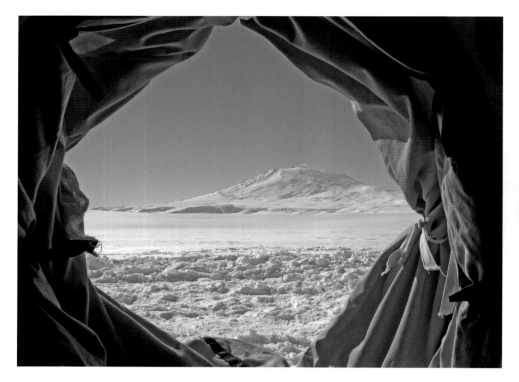

this set-up runs down the middle, and provides each occupant with their own personal space on either side, thus giving a limited amount of privacy. In a three-person tent two of the occupants have to share one side of the catering boxes, and may choose to sleep head-to-toe to avoid breathing or snoring into each other's faces. Getting up cannot be done simultaneously and each has to use the other's 'territory' to put away sleeping kit each day. A degree of tolerance is needed in such circumstances!

Camping on ice in the deep field demands protection from the underlying snow and a reasonable level of comfort. A wooden board, self-inflatable mattress, sheepskin, a double down sleeping bag, a fleece liner for really cold conditions or a cotton liner, camp booties and a 1-litre plastic pee-bottle are all provided. There is also a heavy-duty canvas sleeping bag cover and a bivouac sack, if the worst-comes-to-worst and the tent is destroyed. These items are provided on base and placed in a P(personal)-bag, with the individuals' tags on them, so there is no danger of critical kit being forgotten.

Cooking, especially providing an adequate water supply in sub-zero conditions, requires careful management. Despite the numerous sophisticated camping stoves now available, the Primus is still widely used as a reliable, robust, simple paraffin stove, easy to repair, and based on a cooker designed by famous Norwegian explorer Nansen at the end of the 19th century. In the absence of running water, several steps are required even to make a simple cup of tea (and do the other cooking): cut some snow blocks, prime the Primus with methylated spirit and light jet when hot and pumped up, place cut snow

Top left: Outlook from an Antarctica New Zealand 2-person pyramid tent, looking across McMurdo Ice Shelf to Mt Erebus.

Top right: Helicopter arriving to supply a remote US geological field camp at Bennett Platform, upper Shackleton Glacier, at 85° S.

blocks into a pan and keep adding to fill the pan, and then boil. The process is then repeated for a meal and a second brew, using some hot water to start the melting process.

Starting with cold low-density snow, the whole process for both breakfast and evening meal can take at least 2 hours for a three-person team. Melting snow continues through the evening and water is placed in durable plastic bottles and Thermos flasks. These could freeze overnight if left out on the cooking box, so they are taken into sleeping bags for the night.

The layout of the camp around the main tent requires as much care as inside. The main tent is best pitched with the tunnel entrance away from the prevailing wind, as denoted by the orientation of sastrugi (snow dunes – Chapter 5). The radio antenna (of wire) is aligned at right-angles to the direction of base. For a toilet, a simple dug-out trench or sometimes a 'pup' tent is used (usually more than 10 m / 30 ft away, and offset to the prevailing wind to prevent drifting up of main tent). In this tent, a hole is dug in the snow floor for a bucket, and convenient snow-shelves are excavated. The pup tent also serves as depot for rubbish and fuel. A few metres behind the tent a pee flag is driven into the snow, to limit the area affected by contamination.

Finding a clean source of water is a vital consideration, and usually a snow-block 'quarry' is created in a deep snow drift, well away from the tents. However, as a field season progresses and temperatures rise, the luxury of melt-pools in certain areas makes the task of acquiring water much easier. During blizzards, it is necessary to set up a climbing rope between tents as a hand-rail, to avoid getting lost in a white-out, which could be fatal.

The above camping set-up, used in British field work, is designed to be independent of the need for supporting logistics when deployed in the field. More flexible arrangements are possible when frequent helicopter support or overland transport is available. The American's one-off Shackleton Glacier Project in 1995-96 at 85° S is an example of regular support by Hercules aircraft from McMurdo to a large central camp, and as-required helicopter support for outlying field parties. In contrast, the New Zealand programme is able to transport considerable quantities of kit over the McMurdo Ice Shelf for field parties. In both of these arrangements, the field party members may be permitted the luxury of a tent each, and in the case of the latter, a converted container to work and cook in.

Food

There is nothing like food to raise or undermine morale. The typical British field menu is built around standard 20 person-day wooden boxes (referred to as 'manfood' to distinguish it from dog food from the old days). These boxes are designed to maximise calorie intake (3,500 calories per person per day) with regard to weight, and they include predominantly dehydrated foods. Typical main meals simply require boiling water to be added to a foil bag, left some minutes, and then eaten with a spoon direct from the bag. Lunches are usually hard biscuits, some form of spread, energy and chocolate bars. Breakfast is normally porridge or muesli. This menu is perfectly adequate on its own, but morale is much improved by the addition of 'goodies'. Sometimes sealed frozen stews, chicken fillets, bacon and cake can be obtained. The meat, of course, needs to be kept frozen. This is not a problem in Antarctica, and a hole in the snow nearby serves as a freezer.

Where a field camp is within easy reach of a base, meals are a mixture of dehydrated and fresh food (which can be kept frozen in the snow). With the US programme, field operations commonly involve a large multi-programme central camp with a cook and canteen meals in a Jamesway or similar hut. If individual field parties need to camp away from the central camp, they collect their own food from a store at McMurdo Station, which is a bit like a supermarket back home. The emphasis here is on fresh (or frozen) foods, but they obviously weigh a lot more, and there is a tendency for more waste. However, the US uses larger aircraft (C-130s) and is generous with helicopter time, so weight is less of an issue than with other national programmes.

Medical and hygiene

Each national programme has detailed guidelines for dealing with health issues in Antarctica. Most bases have a doctor in residence, with satellite communication to hospitals back home. Once in the deep field, there is no ready access to a doctor, other than *via* the radio. Therefore, the emphasis in preparing for fieldwork is on medical tests and first-aid training back home, and hygiene and safety in the field.

The deep-field situation (except in peripheral areas of Antarctica where it is close to freezing in summer) is characterised typically by temperatures well below zero. Snow just for cooking, as explained, takes hours. There is little opportunity to have a daily wash of body or clothes. Modern inventions like 'wetwipes' and antibacterial gels are now regarded as essential for keeping the body superficially clean; but the former need to be taken into a sleeping bag for the same reason as water – to prevent freezing. On a camp day or 'lie-up' day one might heat up a pan of water each for an all-over wash. We have done this outside when the weather has been calm and sunny, but the slightest air movement has a rapidly chilling effect.

Medical kits are comprehensive as rescue in an emergency could be delayed by weather for several days. Day-to-day ailments include: cuts and bruises; frost-nip; sunburn, which is especially problematic as the ozone hole allows strong ultra-violet rays to affect exposed skin (Chapter 4); chapped lips and dry cracking skin on hands; and back-ache from bending in the confined space of tents. Care is taken to avoid hypothermia and frostbite, but even a moderate wind can make being outside very uncomfortable. After a strenuous day's fieldwork in such a dry climate, the body loses a lot of fluid, so it is important to rehydrate properly. The recommended daily fluid intake is three to four litres, compared with an average of two at home. Medics tell us that we are dehydrated when the colour of our urine is dark, a situation avoided by drinking a lot and foregoing alcohol.

Environmental and waste management

Keeping the environment clean is the duty of all nations operating in Antarctica. The Antarctic Treaty System has several protocols that must be followed (Chapter 11). However, there remains an historical legacy of disposing of waste that needs to be rectified. Waste was often dumped offshore (sometimes on sea ice which ultimately floated away) or down crevasses. Expeditions from the 'Heroic Era' and later often dumped their waste just outside their huts, although many of the discarded items are now regarded as historical artefacts.

Toilet arrangements away from bases need careful management. Often a tent or other shelter into which is placed a toilet bucket, lined with a sealable plastic bag. All solid (including human) waste has to be removed from the field. Waste generated today is commonly sorted into a dozen or more categories and shipped out of Antarctica, or is otherwise incinerated. Grey water, which includes washing-up water and in some cases urine, is disposed of in holes in the ground, down tide-cracks or on a beach. In some parts of Antarctica, notably in the vicinity of McMurdo Station and Scott Base, where relatively large numbers of people are deployed in ecologically sensitive areas, urine generated in the field also has to be returned to camp for disposal in grey-water containers for removal to base.

Top: A trench shelter with a cooking bench on a windy day, with the occupants plastered with snow. The stylish uniform is standard clothing for Antarctica New Zealand scientists , worn here by Evelyn Dowdeswell (right).

Above: Frostbite is a medical hazard that must be guarded against. This photograph of a seriously blistered hand was taken on Scott's last expedition by Herbert Ponting. (© Scott Polar Research Institute)

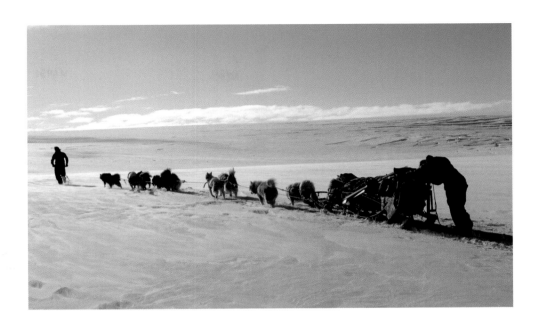

Getting around in the field: traditional travel

Until reliable motorised vehicles were invented, many Antarctic nations used animal power, notably dogs, and for several decades these animals were the preferred means of transport for self-contained sledging parties. Then, in the early 1990s, an environmental protocol of the Antarctic Treaty System decreed that no introduced animals (except humans) could be retained in Antarctica, and that all sledge dogs should be removed by 1 April 1994. The fear was that canine distemper could be transmitted to other species, notably seals.

The history of dog-sledging goes back to the British-backed Norwegian explorer Borchgrevink, who in 1899-1900 led the first expedition to over-winter in Antarctica at Cape Adare. Subsequently, all early 20th century 'Heroic Era' expeditions used dogs, including those led by Drygalski (1902, Germany), Nordenskjöld (1902, Sweden), Scott (1901, 1910, Great Britain), Shackleton (1907, Great Britain), Amundsen (1911, Norway), Filchner (1911, Germany), Shirase (1911, Japan) and Mawson (1912, Australia). These expeditions all used dogs, and proved that dog-sledging was the best form of transport in Antarctica, although the British expeditions relied more heavily on ponies for sledge-hauling. Dog teams remained the mainstay of travel for expeditions between World Wars I and II, and they were still heavily used even with the successful introduction of mechanised transport from the end of World War II and even during the International Geophysical Year of 1957-58 when there was a massive increase in scientific activity in Antarctica (Chapter 11). During the 1960s and 1970s, Argentina, Australia, New Zealand and the United Kingdom still used dogs, and

Above: For almost a century, up to the 1990s, dog-sledging was the mainstay of transport for the field parties of several nations. Dogs were then withdrawn completely from Antarctica under new environmental regulations, and replaced by mechanised transport. This photograph shows a British Antarctic Survey team with their Antarctic-bred Greenland huskies on Shambles Glacier, Adelaide Island. (Courtesy of Nick Cox)

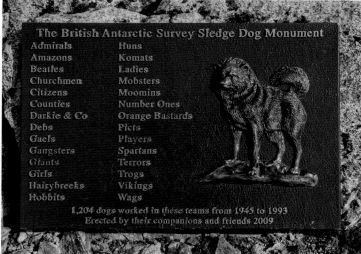

The British Antarctic Survey Sledge Dog Monument

Admirals — Huns
Amazons — Komats
Beatles — Ladies
Churchmen — Mobsters
Citizens — Moomins
Counties — Number Ones
Darkie & Co — Orange Bastards
Debs — Picts
Gaels — Players
Gangsters — Spartans
Giants — Terrors
Girls — Trogs
Hairybreeks — Vikings
Hobbits — Wags

1,204 dogs worked in these teams from 1945 to 1993
Erected by their companions and friends 2009

breeding programmes became well-established, to the extent that huskies became almost indigenous to the continent.

An example of the most recent use of dog teams were those operated by the geological and survey teams of the Falkland Islands Dependencies Survey (FIDS), later renamed the British Antarctic Survey (BAS). This organisation used dogs continuously from several bases between 1945 and 1994, epitomising dog-sledging in Antarctica. Aircraft deployed a whole team of dogs and men to their designated field area, and the team travelled around independently for as much as three months before being picked up, covering distances approaching 2,000 km (1,250 miles). The breed of dog was derived from Greenland and Labrador huskies, as used by the Inuit. They were very hardy animals, able to withstand blizzard conditions by curling up in the snow. They were exuberant and worked hard, but tended to fight each other at times. They enjoyed human company, a feeling that was reciprocated; they were certainly good for morale, especially in winter, or when new pups arrived. Records of each dog were kept by FIDS/BAS throughout, which documented pedigree, pups, illnesses, traits and journeys undertaken. Dog teams were given names, and the Rothera teams are commemorated on a plaque near the base and a similar one, with a statue, in Cambridge. Each team, comprising up to 14 dogs, pulled a highly flexible Nansen sledge, made of ash held together with twine. Typically 4 m (13 ft) long, the Nansen sledge (named after the Norwegian explorer who developed them for Arctic use) had a travelling platform at the back for the driver, as an enthusiastic dog team could shoot off at a phenomenal pace. The Nansen sledge, without the platform, is still used today, and is hauled by snow scooters.

Although snow scooters and other forms of motorised transport had taken over much of the exploratory role of dog-teams by the 1980s, dogs were still valued for recreational purposes, especially by wintering personnel. Thus, many people were

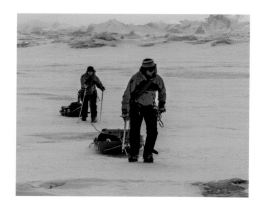

Top left: A sculpture of a Greenland husky outside the Scott Polar Research Institute in Cambridge commemorates the decades of service provided by the dogs of the British Antarctic Survey and its forerunner, the Falkland Islands Dependencies Survey.

Top right: The dog-team commemoration plaque at Rothera Point, near to the base from whence many teams ventured to explore the territory beyond between 1945 and 1993.

Above: Moving stores and geological specimens over snow-covered ground, where no mechanised transport is permitted, using lightweight plastic sledges. Using a climbing harness, substantial loads can be 'man-hauled' over level ground, but relaying may be necessary on inclined terrain.

saddened when the dogs had to be removed from the continent for environmental reasons, as they had served science and exploration with distinction for nearly a century. The last to be removed were the Australian dogs at Mawson and the British dogs at Rothera in 1994.

Man-hauling is one of the most arduous activities devised by man, yet it figures prominently throughout polar history. Scott regarded this activity as the purest form of travel, yet his party's demise may have been prevented if he had mastered dog-teams. His party, like many before and since, used a version of the Nansen sledge, which was pulled along using chest harnesses. Today, most national operators do not rely heavily on man-hauling as a means of long-distance travel, but synthetic sledges are still used by adventurers on long journeys, and by scientists on day trips.

Getting around in the field: mechanised transport

Motorised transport has long been regarded as the most effective means of travelling in Antarctica. The early expeditions of Scott and Shackleton experimented with vehicles that were forerunners of the World War I tanks, but they were unreliable in the cold, and essentially had to be abandoned after limited use. In later expeditions, a variety of car-sized vehicles were developed and used successfully as reliability improved. The International Geophysical Year of 1957-58 saw a big expansion in the used of vehicles, epitomised most dramatically by the Commonwealth Trans-antarctic Expedition of the same years, which successfully crossed the continent for the first time, a distance of nearly 3,500 km (2,200 miles) (Chapter 9). The Expedition started in the southern Weddell Sea under the leadership of Vivian Fuchs of the UK. He took several vehicles with him, including four Tucker Snow-cats that measured approximately 6 m in length and 3 m in height (20 x 10 ft). Powered by a Chrysler motor and fitted with four

Above left: A pair of snow scooters or snowmobiles, in this case the modern version of the original 'Ski-doo', crossing the icy surface of McMurdo Ice Shelf, with White Island in the background.

Above right: Standard excavation vehicles, such as this CAT bulldozer can be turned to other transport uses. In this case, a sledge-mounted Wannigan is being towed across McMurdo Ice Shelf for use by a glaciological field party from the University of Otago. The Wannigan is actually a shipping container converted for use as an office and eating area.

caterpillar tracks, they hauled loads up to 2.7 tonnes at speeds up to 25 km/hr (16 miles/hr). The support party, led by New Zealander Edmund Hillary of Everest fame, was tasked with laying depots from the Ross Sea side of the continent. This party used adapted Ferguson farm tractors, and reached the pole ahead of Fuchs. Examples of both types of vehicle are displayed at Canterbury Museum in Christchurch, New Zealand. Whilst these larger vehicles had taken over much of the heavy-duty work, dog teams were still used efficiently for other travel.

A vehicle called the 'Snow-cat' was the forerunner of the large vehicles used today. Its successor is widely used by large operators, amongst a fleet of various-sized tracked and wheeled vehicles. A recent example is the PistenBulley, originally designed for grooming snow slopes at ski resorts, but capable of traverses of many hundreds of kilometres. Such machines can be fitted with ground-penetrating radar to detect hidden crevasses. A vehicle favoured by several national operators is the military-specified Hägglunds, an articulated unit with a front drive unit in which are passenger seats, and a rear carriage for more people and equipment. A special feature is its ability to float, making it particularly suitable for traverses across sea ice. If it breaks through, it can be winched out of the water. Other examples of machinery on base include a variety of tractors, excavators and bulldozers. Sometimes, tractors may be pressed into service to form equipment trains to establish field parties. They can even haul large cabins, such as converted shipping containers, nicknamed 'wannigans', as long as a smooth firm surface of snow is available. The latest innovation is the use of modified four-wheel drive vehicles, such as the Toyota Hilux, fitted with balloon tyres, which spread the load over the snow surface. Pioneered on the ice caps in Iceland, they have been used successfully in long traverses across the East Antarctic Ice Sheet. Again, radar equipment is fitted to detect crevasses.

The dominant machine used by smaller field parties is the snow scooter (or snowmobile). Many of the more powerful machines are highly tuned and can reach speeds in excess of 200 km/hr (125 mph), but these are inappropriate in Antarctica where wind chill, crevasses and sastrugi are ever-present hazards. More robust and slower machines, capable of hauling heavy sledges, are preferred. Unlike the dog teams that they replaced, these machines cannot sense hidden crevasses or other dangers. Consequently, safe travel in crevassed terrain requires pairs of snow scooters to be roped together, with full rescue equipment readily to hand, or routes marked out with bamboo canes and flags. All operators are trained to retrieve a snow scooter from a crevasse.

Although snow and ice predominate in Antarctica, there are areas of stony ground where other mechanised transport is required. We have used Honda Quad bikes (nicknamed 'Quikes') to get around the nunataks of the Prince Charles Mountains and on rough terrain on James Ross Island. Extreme care must be taken with these vehicles, however, as their imprint on soft or loose ground can be long-lasting.

Today, the range of suitable vehicles of all size is immense, and those described above are just a sample, from personal experience, of what is available. However, whatever the machine, the key to successful operation in the harsh conditions is having a skilled mechanic, able to perform tasks beyond those given in the manuals and to improvise when parts fail.

A day in the life of a geological field party

Geological fieldwork in Antarctica is often challenging with steep terrain, rockfall and poor weather to contend with, but on a good day with fine companions and wonderful scenery there is no better experience. This is an account of one such day, working out of the relative comfort of Fossil Bluff Station on Alexander Island after a month living in tents.

It is early summer (2 December 2012), and we have planned a longish walk to sample rocks around the 700-m (2,250 ft)-high peaks at the head of Khufu Corrie, an amphitheatre containing a small glacier bordering the huge George VI Ice Shelf. The purpose of the work is to determine the impact of the Antarctic Peninsula Ice Sheet on the island, and the history of the ice cap itself. We are a party of three, Bethan and myself (MJH) as geologists, and Ian our Field General Assistant, who already knew the area. We are looking for erratic boulders that can tell us how long they have been exposed since the withdrawal of ice, using the technique of cosmogenic nuclide dating (Chapter 3). Knowing the rate of thinning and retreat of the ice provides information about how the remaining ice sheets may behave in future.

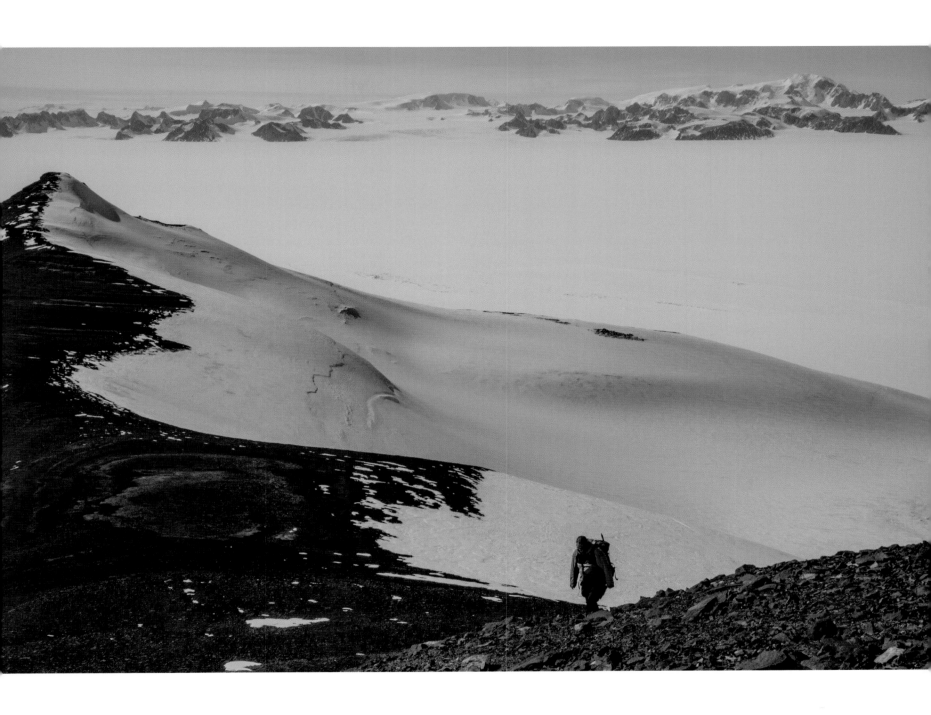

Above: Ascending a ridge, on 2 December 2012,
leading towards Pyramid Peak (750 m / 2460 ft),
with the George VI Ice Shelf and Palmer Land
mountains in the background.

The day is perfect – clear and sunny, with a light wind and a balmy temperature of -5° C. After clambering over bouldery moraine, we cross over the partly snow-covered surface of the small Khufu Glacier, weaving between 1 m (3 ft)-high pinnacles of ice to the foot of a prominent snow gully. We ascend the hard snow using ice axes and crampons, which proves to be hot work. With the ground easing off we cross over to the terminal moraine of a small snow-covered glacier that is clearly thinning, and then up to a col where we find the first of our boulders – erratics derived from the interior of Alexander Island.

After sampling one of the boulders by chipping away at its surface, which takes over an hour, we proceed up loose scree and a rocky rake to a ridge with a small summit. The inclined bedrock strata seen against a rolling icefield gives a strange sense of perspective, but the views of rock and ice are striking. We then scramble along the southeast ridge of the dominant mountain here, Pyramid Peak (745 m), to its summit. In almost still conditions, we take in the expansive vista, which includes much of the southern Antarctic Peninsula Ice Sheet beyond the George VI Ice Shelf at our feet, as well as the larger icy mountains of Alexander Island behind us. It all looks utterly devoid of life, but a solitary pure white snow petrel appears out of nowhere, circled above our heads and then disappears. Why was it here, the first creature we had seen for a month, over 200 km (125 miles) from the open sea? A special moment indeed.

From the summit, our walk continued down another ridge over mixed terrain of rock, scree and snow, sampling a few boulders *en route*, eventually to reach our last summit, Drune Hill (680 m / 2,230 ft high). Again, we paused to take in the view of the ice shelf and the mountains beyond, in which Mt Bagshawe at over 2,000 m (6,560 ft) stood out prominently. Finally, we dropped steeply off the summit over a mix of rock and scree, before finishing with a marvellous scree run within sight of the hut. This outing was the highlight of a wonderful field season. It gave us an experience of Antarctica's vastness, remoteness and stark beauty that base life cannot provide, and it felt a real privilege to have had that experience.

Embracing solitude

To many scientists, a major attraction of Antarctica, apart from the science, is to experience a part of the planet that has been largely untouched by humanity. The landscapes are unique and in many places stunningly beautiful, enhanced by the low sun and atmospheric effects (Chapter 4). To experience this alone is a rare and special experience. A human being is a mere pinprick in the Antarctic landscape, and she or he can feel small and vulnerable. It is actually unusual for the scientist to be alone in Antarctica, since for safety reasons working in parties of two or more is the usual practice, so we are constantly aware of each other's presence, but the feeling of solitude is shared. Antarctic bases commonly have flagged walking or skiing routes to give personnel an opportunity to see the wonderful surroundings. After signing out, it is possible to enjoy Antarctic solitude just a kilometre from base. Examples are a walk between pressure ridges of sea ice and onto the McMurdo Ice Shelf from Scott Base (New Zealand), a cross-country ski route onto a shoulder with volcanic outcrops near McMurdo Station (USA), or a circular walk around and over Rothera Point near the British base which delivers stunning mountain and sea views in all directions.

Solitude and remoteness from civilisation are not for everyone, so personnel selection tries to identify those who might suffer from feelings of isolation. This is especially true for those who overwinter, since they have to experience many days of darkness, base-confining weather and a restricted group of people.

Perceptions of Antarctica

From the early days of exploration, there has been an appreciation of the special landscape and wildlife value of Antarctica. In recent decades, with the production of stunning documentaries about the landscape, wildlife, and the continent's impact on the rest of the world through global warming, Antarctica is never far from public view.

Antarctica has had interesting connections with the arts, featuring occasionally in music and literature. The first significant composition featuring Antarctica was written in 1948, when British composer, Vaughan Williams, produced the score to accompany the film *Scott of the Antarctic*. He subsequently reworked this music as Symphony No. 7, *Sinfonia Antartica* (note the spelling). Despite never having been to the continent himself, Vaughan Williams's hauntingly beautiful music conveys the majesty and harshness

of the continent, as well as the tragic story of Scott's last, ill-fated expedition. More recently, Peter Maxwell Davis, wrote the Antarctic Symphony No. 8, to commemorate the 50th anniversary of Vaughan Williams' masterpiece. His work was based on a visit to Antarctica, and conveys a wide range of sounds, from the ice being shattered by an icebreaker, through the calls of whales and penguins, to the sounds of snowfall, blizzards and avalanches. Several contemporary musicians are also engaged in produced classical works with an Antarctic theme, while Antarctica has also occasionally featured in the genres of popular and folk music.

Antarctica has appeared in literature primarily in the form of expedition accounts and personal reminiscences. In science fiction, by contrast, perceptions and imagination have been allowed to develop more freely. Probably the first important work focusing on Antarctica was Edgar Allan Poe's 1838 novel *Narrative of Arthur Gordon Pym of Nantucket*, which involved a stowaway (Pym) on a ship sailing south through an ice barrier to fictional warm waters of the South Pole. Jules Verne, wrote the two-volume *An Antarctic Mystery* in 1897. Linked to Poe's characters, the novel describes a hazardous journey from the Kerguelen Isles in the Indian Ocean southwards into ice-infested waters. More recently, science fiction writers have used Antarctica as a backdrop for their plots. Of these, the well-researched novel *Antarctica* by Kim Stanley Robinson has a particularly strong environmental and political message, portraying the continent following the supposed collapse of the Antarctic Treaty – which we all hope will not happen.

In poetry, Antarctica has featured intermittently since Samuel Taylor Coleridge published the *Rime of the Ancient Mariner* in 1834, three verses of which are reproduced here:

And now there came both mist and snow,
And it grew wondrous cold:
And ice, mast-high, came floating by,
As green as emerald.

And through the drifts the snowy clifts
Did send a dismal sheen:
Nor shapes of men nor beasts we ken—
The ice was all between.

The ice was here, the ice was there,
The ice was all around:
It cracked and growled, and roared and howled,
Like noises in a swound!

Some early explorers were poetry enthusiasts. Shackleton took the works of Browning to Antarctica, while Scott enjoyed Tennyson. The epithet on the memorial cross to Scott and his companions erected on Observation Hill on Ross Island, bears an inscription from Tennyson's *Ulysses*: *To strive, to seek, to find and not to yield*. Pioneering explorers such as Edward Wilson, Frank Debenham, Griffith Taylor and Douglas Mawson could also turn a hand to poetry.

The visual arts are well-represented in Antarctica. In the days of early exploration, when photography was in its infancy, heavy reliance was placed on documenting natural phenomena, landscape and wildlife through sketches and paintings. Edward Wilson, a scientist of many talents, was arguably the most prolific, and several of his paintings and sketches are found in this book. During the 'Heroic Era', photographic equipment, despite its bulkiness and weight, allowed 'camera artists' such as Herbert Ponting with Scott and Frank Hurley with Shackleton to obtain some of the most evocative images ever taken during their journeys South. With an emphasis on snow and rock, Antarctica particularly lends itself to black-and-white photography, which these photographers pioneered, but colour photography is the norm these days, emphasising the subtle colours in ice and in the landscape, especially in low-light conditions.

Several national operators and universities accept writers, poets, painters, musicians and film-makers onto their Antarctic programmes, recognising that science alone is not the only valid approach to imagining Antarctica. Through these 'artists and writers programmes', pioneered by the US National Science Foundation in the 1970s, new audiences have been reached, enabling an 'environmental message' to be more widely promulgated. As we hope this book demonstrates, the connection between science and art is especially strong in Antarctica.

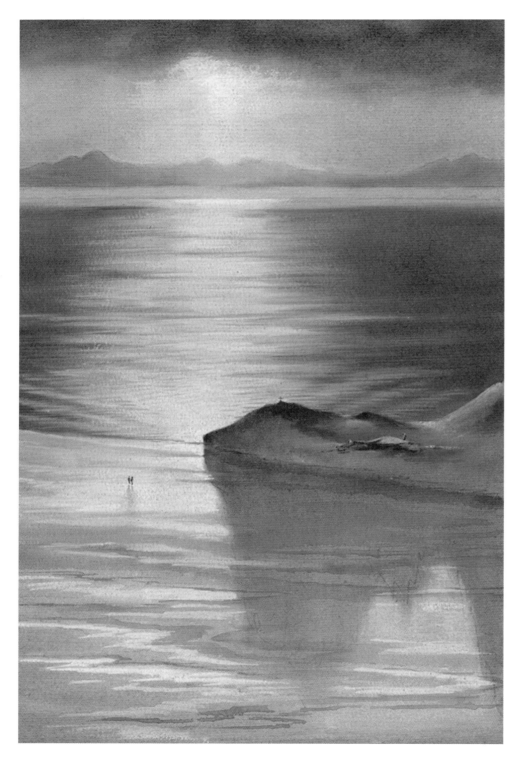

Left: Artists such as Edward Wilson, on Scott's expeditions, have provided evocative paintings of the Antarctic landscape and expedition activities, such as this watercolour of Hut Point near the modern McMurdo Station on Ross Island, in which the memorial cross to George Vince is shown together with two figures on the sea ice. (© Scott Polar Research Institute)

Opposite: One of the first photographers to document Antarctica was Scott's highly skilled 'camera artist', Herbert Ponting, who took this classic image of *Terra Nova*, anchored near Cape Evans on Ross Island. (© Scott Polar Research Institute)

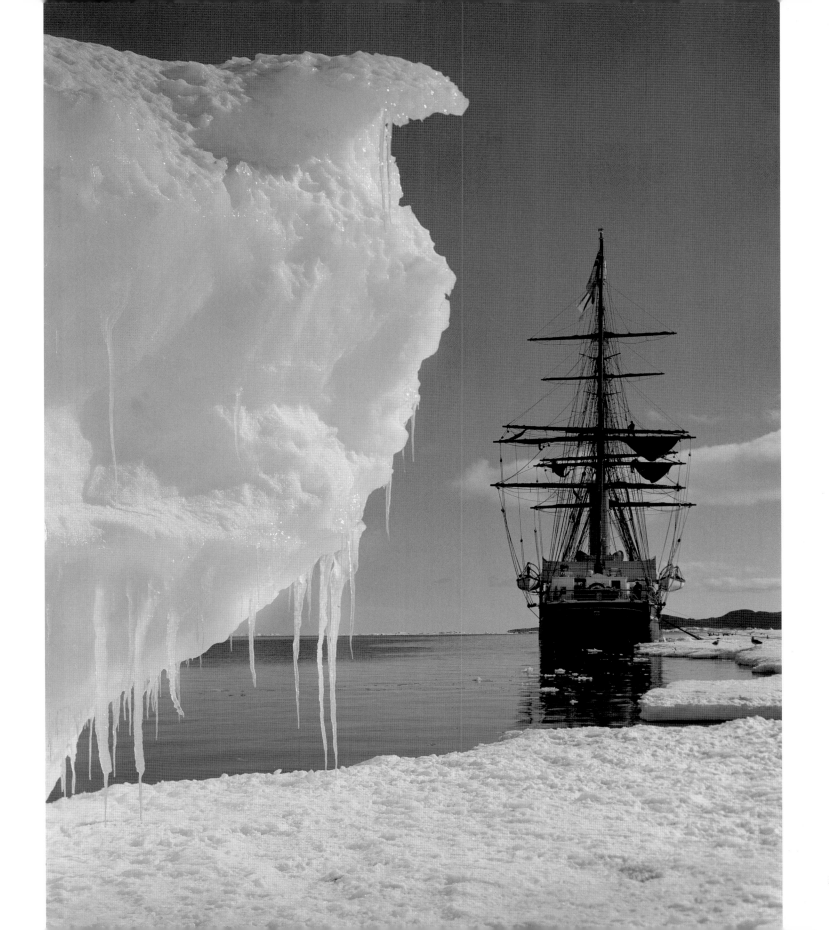

CHAPTER 11

Managing Antarctica

As an Antarctic scientist, it is important to be involved in the continent's principal scientific organisation, the Scientific Committee on Antarctic Research (SCAR). Each country with an active programme of research in Antarctica has a national committee, and it was through the UK National Antarctic Research Committee that I became involved in SCAR activities. SCAR has delegates from each country in each of its main subject areas, and I joined the GeoSciences Group. In due course, I was elected to serve as Secretary of this Group, and my task was to gather all relevant information about Antarctic research activity in the Earth Sciences from around the world, which included compiling and editing a publication called 'GeoReach', and contributing to SCAR's Annual Report. In addition, I became involved in policy-making, and contributed to the formulation of new geoscience initiatives, assessed nominations for SCAR Fellowships, evaluated student requests for financial support to attend conferences, and helped develop a web presence. In the middle of my four-year tenure as Secretary of the GeoSciences Group, the UK offered to host the XIth International Symposium on Antarctic Earth Sciences, which was held in Edinburgh in 2011. This was wonderful location for the symposium, as it was here that many of the fundamental principles of geology were formulated in the late 18th century. Our efforts were rewarded with attendance of over 500 delegates, of whom a fifth were students. We also held a mentoring session for early career scientists, with a panel of more senior people to take questions, such as 'how do I get into polar research?'

MJH

The years of unconstrained exploitation and exploration: a brief recap

Soon after the English seafarer, James Cook, circumnavigated Antarctica in 1775 and reported large numbers of seals and whales, the commercial sealing, and later the whaling, companies of the Northern Hemisphere began to exploit these resources, as documented in Chapter 9. The lack of regulation resulted in the decimation of the large marine animals, and several species were brought to the verge of extinction by the mid-20th century.

Scientific expeditions, on the other hand, had grander ideals, notably to promote geographical discovery and advance natural science, which was particularly true during the 'Heroic Era' of Antarctic exploration from 1895-1922. But even here, expedition leaders had territorial claims in mind, as through that approach funding from governments was more readily obtained. Until the 1950s, most expeditions

Opposite: Expedition ship voyages are an increasingly common activity in Antarctica, especially on the western side of the Antarctic Peninsula. Here the MS *Fram* is sailing past Cape Renard at the northern end of the Lemaire Channel.

originated from individual countries (sometimes including their colonial partners) and there was relatively little cross-fertilisation of scientific ideas between nations. Following World War II, however, it was recognised that international collaboration was the best way forward, and the International Geophysical Year of 1957-58 cemented these ideals, helping to inspire the Antarctic Treaty.

Territorial claims and counter-claims

Territorial claims in Antarctica were generally made by the first expedition leader to set foot on a particular piece of land, planting a national flag and a sign, and making a proclamation that the territory was now a possession of that country. Claims were backed up by describing, mapping and naming the territory concerned, and were adopted by national governments, hoping for international agreement.

Although many countries have undertaken exploration of Antarctica, only seven have made formal territorial claims: Argentina, Australia, Chile, France, New Zealand, Norway and the United Kingdom. By 1939, the whole of the continent was claimed apart from a large sector of West Antarctica (80° to 150° W). The UK's claim on the Antarctic Peninsula was countered by Chile and Argentina in the early 1940s; both established overlapping claims. As a consequence, serious tensions developed between the competing nations. In contrast, the United States and the former Soviet Union did not recognise any of these claims, but instead each reserved their right to claim the entire continent.

Even during World War II, Antarctica never became a battlefield, but small units were deployed in the Antarctic Peninsula by the British in part as a response to a perceived threat by Germany and Japan to establish maritime operations there, but also to bolster the UK's territorial claim (Chapter 9). In the immediate post-war years the three nations claiming the Antarctic Peninsula frequently exchanged formal protest notes, and even minor skirmishes took place around the various bases. The closest that military conflict has come to Antarctica was when Argentina invaded the sub-Antarctic island of South Georgia in 1982 at the start of the Falklands War. Even during these times of conflict, base staff and scientists from competing countries were generally quite civil towards each other. The harshness of the Antarctic environment meant that, to survive, a spirit of interdependence had to be developed, leading to cooperation rather than conflict.

Increasing post-war international interest in Antarctica

Following the end of World War II, various countries sought to assert their dominance and territorial claims in Antarctica. The USA hastily launched its 'Operation Highjump' in 1946. This was a massive operation, never exceeded in scale before or since. At the start of the Cold War, this was seen as a provocative act by other countries, not least by the Soviet Union. In contrast, the Norwegian-British-Swedish Antarctic Expedition of 1949-52 was

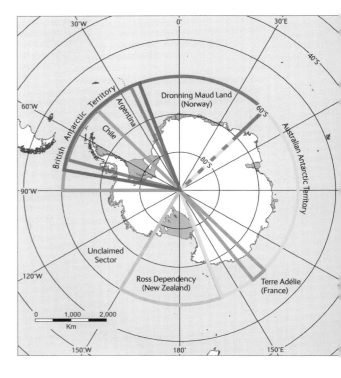

Above: Map of territorial claims in Antarctica. (Courtesy of the British Antarctic Survey and Natural History Museum)

Above: A Norwegian whalers' hut on Deception Island in the South Shetland Islands. This was part of a substantial industrial complex which, although derelict today, is a protected historical site.

the first truly international scientific expedition (Chapter 9). Through the late 1940s and early 1950s several other nations established bases on the Antarctic continent, partly to undertake science, but also to reinforce their territorial claims. They included the three protagonists in the Antarctic Peninsula, together with Australia, France and New Zealand.

The spirit of international collaboration engendered by Norwegian-British-Swedish Antarctic Expedition led several of its scientists to become instrumental in establishing an International Geophysical Year (IGY) programme for the Antarctic, and in founding the Scientific Committee on Antarctic Research (SCAR) in 1957. It had already been decided to hold an International Polar Year within the framework of the global International Geophysical Year, set to run from 1957 to 1958. Meanwhile, SCAR was already looking to a future of continuing long-term scientific activity on the continent. With high-level government support from several countries, including endorsement by President Eisenhower of the United States, scientists and logistics experts combined to establish new bases in Antarctica, and to co-ordinate their research internationally. The Antarctic component of the IGY was supported by the countries already with bases, to which were added Belgium, Japan, Norway, South Africa, the Soviet Union and the United States, who themselves also built stations. In

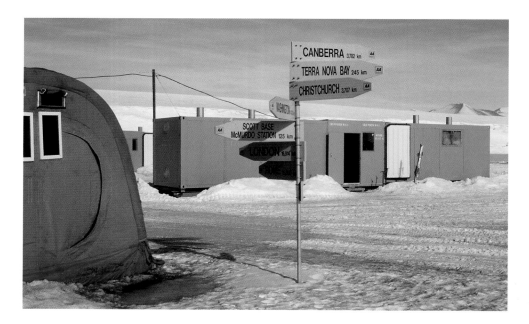

constructing bases at the South Pole (USA) and the Pole of Relative Inaccessibility (Soviet Union), logistical requirements reached a new level, requiring full military involvement to support the science.

The huge financial investment at this time was the trigger for participating countries to continue scientific research in Antarctica beyond the IGY, but also to try and resolve political issues of ownership and competing territorial claims. Eisenhower and others viewed the IGY as a preliminary solution, but began to search for a wider, longer-term international agreement to manage Antarctica. Thus, in June 1958, the twelve participating nations achieved a consensus to establish the Antarctic Treaty, which in due course was signed on 1 December 1959, and came into force on 23 June 1961. Agreement was achieved by setting aside territorial claims and permitting inspections of each other's operations. The treaty has underpinned all subsequent activity on the Antarctic continent. By 2018, fifty-three countries (referred to as 'parties') had acceded to the Treaty, representing two-thirds of the global population.

The Antarctic Treaty System

Today, the Antarctic Treaty System (ATS) comprises a complex set of arrangements that govern activities of all forms in Antarctica south of latitude 60° S, as well as regulating relations among the countries operating on the continent. At the ATS's heart is the original Antarctic Treaty (1959), supplemented by three subsequent international agreements: the Convention for the Conservation of Antarctic Seals (1972), the Convention on the Conservation of Antarctic Marine Living Resources (1980), and the Protocol on Environmental Protection

Above: International cooperation represented by the Cape Roberts Project in western McMurdo Sound, where, under the auspices of the Scientific Committee of Antarctic Research (SCAR) several nations came together in the late 1990s to determine climatic history by deep drilling into the sea floor. The different countries are represented by the names on the signpost.

Table of Signatories to the Antarctic Treaty (at 2018)

Country	Date of entry into force	Consultative status
Argentina	**23 June 1961**	**23 June 1961**
Australia	**23 June 1961**	**23 June 1961**
Austria	25 August 1987	
Belgium	**23 June 1961**	**23 June 1961**
Belarus	27 December 2006	
Brazil	16 May 1975	27 September 1983
Bulgaria	11 September 1978	5 June 1998
Canada	4 May 1988	
Chile	**23 June 1961**	**23 June 1961**
China	8 June 1983	7 October 1985
Colombia	31 January 1989	
Cuba	16 August 1984	
Czech Republic	1 September 1993	1 April 2014
Denmark	20 May 1965	
Ecuador	15 September 1987	19 November 1990
Estonia	17 May 2001	
Finland	15 May 1984	20 October 1989
France	**23 June 1961**	**23 June 1961**
Germany	5 February 1979	3 March 1981
Greece	8 January 1987	
Guatemala	31 July 1991	
Hungary	27 January 1984	
Iceland	13 October 2015	
Kazakhstan	27 January 2015	
India	19 August 1983	12 September 1983
Italy	18 March 1981	5 October 1987
Japan	**23 June 1961**	**23 June 1961**
Korea DPRK	21 January 1987	
Korea ROK	28 November 1986	9 October 1989
Malaysia	31 October 2011	
Monaco	30 May 2008	
Mongolia	23 March 2015	
Netherlands	30 March 1967	19 November 1990
New Zealand	**23 June 1961**	**23 June 1961**
Norway	**23 June 1961**	**23 June 1961**
Pakistan	1 March 2012	
Papua New Guinea	16 September 1975	
Peru	10 April 1981	9 October 1989
Poland	23 June 1961	29 July 1977
Portugal	29 January 2010	
Romania	15 September 1971	
Russian Federation	**23 June 1961**	**23 June 1961**
Slovak Republic	1 January 1993	
South Africa	**23 June 1961**	**23 June 1961**
Spain	31 March 1982	21 September 1988
Sweden	24 April 1984	21 September 1988
Switzerland	15 November 1990	
Turkey	24 January 1996	
Ukraine	28 October 1982	4 June 2004
United Kingdom	**23 June 1961**	**23 June 1961**
United States	**23 June 1961**	**23 June 1961**
Uruguay	11 January 1980	7 October 1985
Venezuela	24 March 1999	

Twenty-eight nations have Consultative status.
The original twelve nations are indicated in **bold**.

to the Antarctic Treaty (1991). As a consequence, the environmental regime, resulting from the cooperation and commitment of Treaty nations, means that the entire continent is to remain protected and subject to minimal disturbance.

In simple terms, the Treaty parties regard Antarctica as '…a natural reserve, devoted to peace and science'. Having been built on the spirit of warm cooperation that characterised the IGY, the Treaty represents a truly unique way of advancing international relations, and it has proved to have been one of the most successful treaties in recent history, setting an example to the rest of the world in living and working together harmoniously. This remarkably simple Treaty consists of just fourteen Articles, which are summarised below.

Summary of Antarctic Treaty Articles https://www.bas.ac.uk/about/antarctica/the-antarctic-treaty/the-antarctic-treaty-explained/: the Treaty

- stipulates that Antarctica should be used exclusively for peaceful purposes, military activities, such as the establishment of military bases or weapons testing, are specifically prohibited;
- guarantees continued freedom to conduct scientific research, as enjoyed during the IGY;
- promotes international scientific cooperation including the exchange of research plans and personnel, and requires that results of research be made freely available;
- sets aside the potential for sovereignty disputes between Treaty parties by providing that no activities will enhance or diminish previously asserted positions with respect to territorial claims, provides that no new or enlarged claims can be made, and makes rules relating to jurisdiction;
- prohibits nuclear explosions and the disposal of radioactive waste;
- provides for inspection by observers, designated by any party, of ships, stations and equipment in Antarctica to ensure the observance of, and compliance with, the Treaty;
- requires parties to give advance notice of their expeditions; provides for the parties to meet periodically to discuss measures to further the objectives of the Treaty; and
- puts in place a dispute settlement procedure and a mechanism by which the Treaty can be modified.

Antarctic Treaty Consultative Meetings (ATCMs), held biennially, became the forum for managing Antarctica. Consultative Parties are those with an active and continuing scientific programme on the continent. These include the original twelve nations who operated there during the IGY, and the many who have joined since. To make decisions regarding the management of Antarctica, there has to be a consensus

The map contains the following labels:

South Atlantic Ocean · Bouvet Island · Indian Ocean · Prince Edward & Marion Islands · Subarea 48.4 · South Sandwich Islands · Subarea 58.7 · South Georgia · Area 48 · Subarea 48.6 · Division 58.4.4a · Crozet Islands · Subarea 48.3 · Subarea 58.6 · Subarea 48.2 · South Orkney Islands · Division 58.4.4b · South Shetland Islands · Subarea 48.5 · Division 58.5.1 · Kerguelen Islands · Weddell Sea · Division 58.4.2 · Subarea 48.1 · Division 58.4.3a · Heard Island & McDonald Islands · Division 58.5.2 · Division 58.4.3b · Area 58 · Subarea 88.3 · Subarea 88.2 · Area 88 · Ross Sea · Division 58.4.1 · Subarea 88.1 · Balleny Islands · South Pacific Ocean

0 500 1000 1500 2000 km

of all Consultative Parties. New nations regard consultative status as an important goal for which to aim, and the South Shetland Islands have become the principal area where new bases have been established – not necessarily because of their scientific value, but because access there is more straightforward than anywhere else around the continent. The Treaty also allows other countries to join in a 'non-consultative' capacity: that is, they can participate in the discussions, but not in the decision-making. The status of the countries involved is given in the table on page 251.

Scientific collaboration

Several scientific disciplines were represented in the IGY, notably physics, geology, biology and glaciology, and these were set to continue with improved infrastructure and transport. During the IGY, in 1958, the Scientific Committee on Antarctic Research (SCAR) was established by the International Council for Science in order

Above: The Convention on the Conservation of Antarctic Marine Living Resources was established in 1980, and is managed with reference to this Convention Area Map. (Courtesy CCAMLR)

to provide a forum for international collaboration. Soon plans were formulated for ice drilling, compiling cartographic and geophysical data from the whole continent, monitoring wildlife, and initiating international conferences.

As the Antarctic Treaty has evolved, so has SCAR, with SCAR providing formal advice to the treaty partners and stimulating measures to protect the environment and conserve nature. International collaboration in the 21st century is stronger than ever, and received a further boost through a new International Polar Year (IPY), which ran from March 2007 to March 2009. A significantly wider range of disciplines was developed across both the north and south polar regions, including the social sciences, and a particular effort was made to include early-career scientists. Over 40,000 scientists were involved across both polar regions, with many working in the Antarctic and Arctic. Whereas the early years of international collaboration had principally an Antarctic focus, it was recognised in the intervening period that many Antarctic scientific issues were global problems, such as the ozone hole, climate change and rising sea levels. Antarctic has thus entered mainstream media and public consciousness, and the work undertaken is vital in evaluating the impact of the continent on humanity globally.

SCAR's remit today, from its secretariat's office in the Scott Polar Research Institute in Cambridge University, is to initiate and coordinate high-quality and internationally collaborative research, not just on the Antarctic continent, but also in the surrounding Southern Ocean, that is relevant to understanding the entire global system. It also provides independent advice to Antarctic Treaty Consultative

Above: The coastal zone of the Ross Sea Marine Protected Area, viewed from Observation Hill, McMurdo Sound. A US Coastguard ship is in the process of creating a channel for access to McMurdo Station.

Meetings, the United Nations and the Inter-governmental Panel on Climate Change, amongst others. Indeed SCAR's interest in climate change science is a major focus today. It is recognised that a deeper knowledge of the region is needed, because it has become clear that human influence on Earth's climate through changes to atmospheric greenhouse gases and the carbon cycle, can be observed and monitored on all time scales in Antarctica. Improved knowledge of Antarctica is highly relevant to assessing future climate, ice-sheet, oceanographic and biological changes (Chapter 12).

Another key component of SCAR activities is what is known as 'capacity building'. This focuses on raising national scientific expertise, especially in emerging nations, and in promoting Antarctic science within the education sector and with the general public. In recent years, there has also been strong emphasis on encouraging women into Antarctic science. As recently as the 1950s, few countries allowed women to work within official Antarctic programmes. Nowadays, women play leading roles within SCAR and in the Antarctic community more widely: for example, as Directors of the Alfred Wegener Institute for Polar and Marine Research in Germany and the British Antarctic Survey. SCAR is particularly keen that such role models stimulate female students to pursue careers in science, in which they are currently under-represented. One illustration of the success of this approach is that the Association of Polar Early Career Scientists (affiliated to SCAR) has 55% female membership.

Increasing emphasis on environmental protection

The twelve early Antarctic Treaty Consultative Parties set about making the Treaty work in a harmonious way from the outset. SCAR, as a politically neutral non-governmental organisation, was involved from the beginning. It is this symbiotic relationship which has helped to make the Treaty a success. Although for more than a decade the Treaty was almost a 'closed shop', gradually new countries began to join. Emerging Consultative Parties became members of SCAR as they realised that decisions pertaining to Antarctica needed to be based on sound scientific evidence, particularly in the realm of conservation, about which little was included in the original Treaty. Thus, SCAR's first recommendation to be adopted by the Treaty was the 'Agreed Measures for the Conservation of Antarctic Flora and Flora' in 1964. These Measures were the start of a process that led to the initiation of hundreds of legally binding regulations, collectively referred to as the Antarctic Treaty System. Of these regulations, those under the 'Convention for the Conservation of Antarctic Seals' (1972), and the 'Convention on the Conservation of Antarctic Marine Living Resources' (1982) were of particular importance in the early years.

The objective of the Commission on the Conservation of Antarctic Marine Living Resources (CCAMLR), which is based in Hobart, in Australian Tasmania, is to

Above: Map of the Ross Sea Region Marine Protected Area. This highly productive area of the Southern Ocean became protected in 2017, and represents a drive by many organisations to protect large areas around the Antarctic continent. (Source: https://www.mfat.govt.nz/en/environment/antarctica/ross-sea-region-marine-protected-area/)

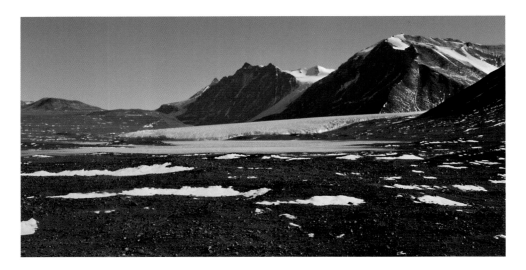

conserve Antarctic marine life. The Convention was signed in 1980 and came into force in 1982 in response to increasing commercial interest in fishery resources, especially krill. CCAMLR made provision for the conservation and sustainable use of krill, fin fish and other marine organisms in the region south of the Antarctic Convergence (or Polar Front), the natural boundary between the cold waters of the Southern Ocean and the warmer waters to the north (Chapter 7). Much of the area lies north of the 60th parallel, which is the northern limit defined under the Antarctic Treaty. The Convention has 25 'Members', including all the original Consultative Parties to the Antarctic Treaty. Krill being a key component of the Antarctic ecosystem (Chapter 8) meant that over-exploitation would have an adverse impact on such species as whales, seals, penguins and other birds. Whales and seals were already under stress from 20th century and earlier exploitation, and needed time to recover. CCAMLR practices an holistic ecosystems-based management approach to agree a set of conservation measures that determine how marine living resources are used. Harvesting of marine species is permitted, as long as it is carried out in a sustainable manner, and takes account of the impact of fishing on other components in the ecosystem. CCAMLR has research and monitoring operations in the Convention Area, and as such makes an important contribution to global food security. However, it has to overcome many challenges, not least by illegal, unregulated and unreported fishing from vessels belonging to countries that are not party to international agreements.

Another strand of CCAMLR activities is to establish Marine Protected Areas (MPAs) in the seas around Antarctica. Following agreement among members in 2002, it was proposed that a network of Marine Protected Areas be established by 2012. To do so has required a consensus of all the members, and this is proving to take many years. The first to be established was the South Orkneys MPA in 2009. However, a more significant milestone was achieved in 2017, when the Ross Sea Region Marine Protected Area,

Above: The Canada Glacier 'Antarctic Specially Protected Area' (ASPA) in the Dry Valleys of Victoria Land covers the glacier snout and the adjacent lake and land areas. This ASPA is part of the wider Dry Valleys Antarctic Specially Managed Areas (ASMA), which have been designated to facilitate international cooperation in research.

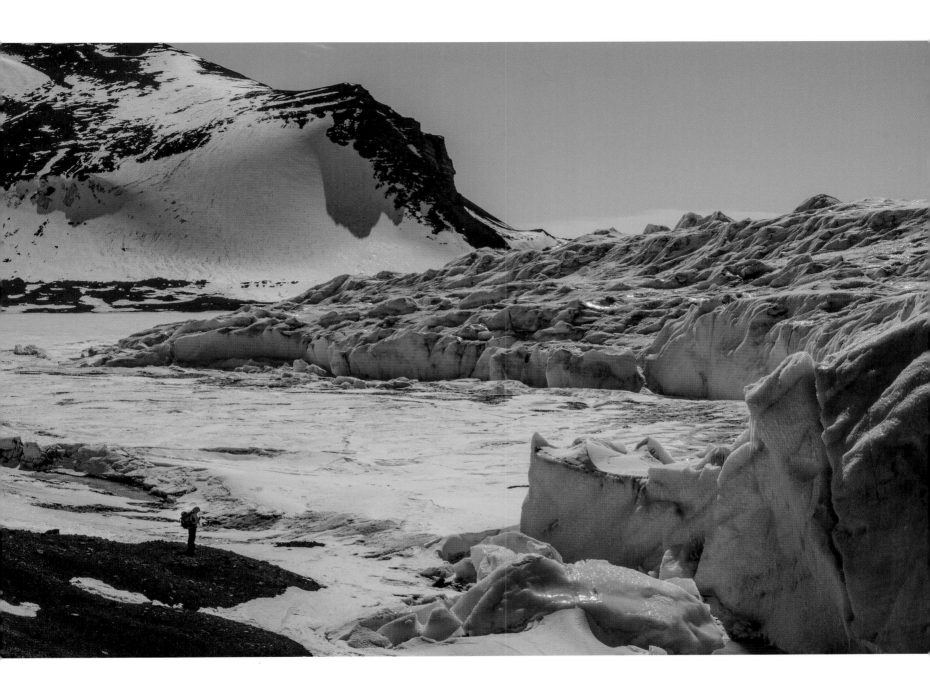

Above: Many land areas of Antarctica receive a high level of protection through ASPAs. Illustrated here is the Ablation Point – Ganymede Heights ASPA on Alexander Island, southwestern Antarctic Peninsula, which is a 180 km^2 (70 miles2) mountainous area on east side of Alexander Island. It is protected for its geological, glaciological, limnological and geomorphological interest. Moutonnée Lake is an epi-shelf lake connected to the open sea under the George VI Ice Shelf.

covering 2.06 million km² (795,000 miles²), entered into force on 1 December. This area, one of the most pristine environments on Earth, is four times the size of the UK and three times that of Texas. The Ross Sea is rich in nutrients, and is among the most productive in Antarctica. Large blooms of plankton and krill occur in spring and early summer, supporting huge populations of seals, penguins and whales. This MPA has been set to last for 35 years, and has three zones of varying levels of protection, including areas where no fishing is permitted and others where fishing is strongly regulated. Several other Marine Protected Areas are currently (July 2018) being considered. These are the East Antarctic, Weddell Sea and Antarctic Peninsula MPAs. Negotiations are prolonged because a balance has to be sought between conservation and the interests of fishing nations. Overall, CCAMLR has proved to be effective in managing Antarctic marine resources, by setting legal targets below sustainable levels. It also is proactive in chasing down illegal activity and proposing solutions to bird mortality through, for example, long-line fishing.

The question of potential mineral exploitation emerged in the 1970s, especially following the oil crisis of 1973, when some companies began to consider whether the Antarctic continental shelf had reserves of oil and gas, even though the technology for exploration in ice-infested waters had not yet been developed. The Consultative Parties agreed a voluntary moratorium on mineral exploration in 1977, pending the formulation of a suitable minerals management regime. With the rights of claimant nations suspended, this proved to be a difficult task, but ultimately, after reconciling many diverging opinions, the 'Convention on the Regulation of Antarctic Mineral Resource Activities' (CRAMRA or 'Minerals Regime' for short) was adopted by Treaty nations in 1988. The 'Minerals Regime' introduced strong environmental safeguards, and required consensus before an area could be exploited. However, for some countries outside the Antarctic Treaty System, these negotiations were considered to be a way for the original signatories to grab the benefits of resource exploitation. Some developing nations, led by Malaysia, raised the 'Question of Antarctica' regularly at the United Nations, and argued that the continent and its resources should be managed by the UN as the 'common heritage of mankind'. The Consultative Parties viewed this approach as unnecessary, as the Treaty was working well, and

other countries could join if they wished. Consequently, many new countries joined the Treaty through the 1980s.

Concurrently with the 'Minerals Regime' negotiations, various Non-Governmental Organisations were arguing that environmental protection of Antarctica was paramount, and that any framework for mineral exploration was incompatible with the Antarctic Treaty. They held the view that Antarctica should be regarded as a 'World Park'. Thus, when it came to ratification of the 'Minerals Regime', lobbying by Greenpeace globally and by the Cousteau Foundation in France, persuaded both Australia and France not to ratify the agreement on environmental grounds. With the Antarctic Treaty coming up for review in 1991, and with the Treaty parties now split on such a major issue, it was imperative that a comprehensive environmental agreement was agreed.

With considerable pressure from the wider public to protect Antarctica, a new way forward was sought to develop a regime that would include a ban on mining. The matter of environmental protection gained new urgency when the Argentinian transport ship, *Bahia Paraiso*, ran aground in January 1989 near Palmer Station (USA) in the Antarctic Peninsula, releasing 680,000 litres of hydrocarbons into the sea. Wildlife was badly affected by this event. Thus, in short order, the 'Protocol on Environmental Protection to the Antarctic Treaty' was signed in Madrid in 1991. However, it took until 1998 to come fully into force, when it was finally ratified by the last of the Treaty Parties. The Protocol includes a wide sweep of measures to regulate human activity on the continent, as well as providing procedures to settle any disputes. All activities relating to mineral resources, except 'scientific research', are banned until 2048. The measures introduced to protect the environment were described in six Annexes: I – Environmental Impact Assessment, II – Conservation of Antarctic Fauna and Flora, III – Waste Disposal and Waste Management, IV – Prevention of Marine Pollution, V – Area Protection and Management, and VI – Liability Arising from Environmental Emergencies.

Annex V designated two levels of environmental protection. First, Antarctic Specially Protected Areas (APSAs) were established to protect areas of outstanding environmental, scientific, historic, aesthetic or wilderness value, any combination of those values, or on-going or planned scientific research.

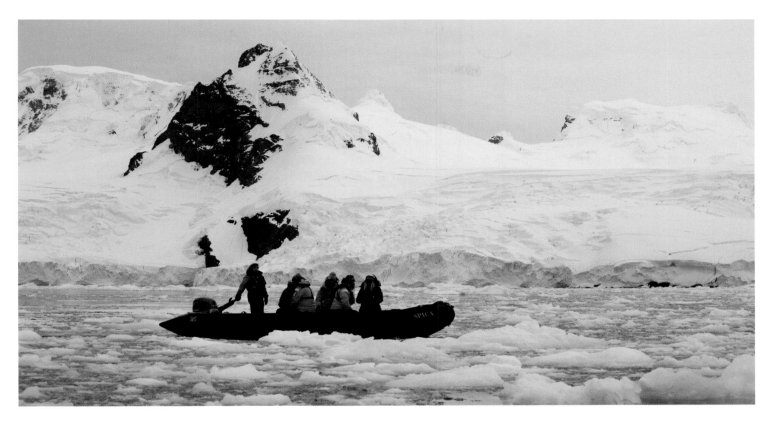

Above: Part of the experience for passengers on expedition voyages are cruises in Zodiac-style rubber boats amongst bergy bits, icebergs and sea ice, as here in Mikkelsen Harbour, western Antarctic Peninsula.

Secondly, Antarctic Specially Managed Areas (ASMAs) were intended to facilitate cooperation between nations operating in close proximity to one another, with a view to minimising environmental impacts.

Nations continued to join the Antarctic Treaty System, leading to a pressing need for a permanent Secretariat; this was duly established on 1 September 2004, and is based in Buenos Aires, Argentina. The secretariat provides a full record of the Antarctic Treaty System's deliberations, which are available online, as indeed are the records of its key observer, SCAR. Thus, today, Antarctica is well served by its Treaty, and benefits from a higher level of environmental protection than any other large region in the world. What the Treaty cannot protect Antarctica from, however, are indirect impacts, such as those of global scale arising from atmospheric pollution, for example ozone depletion, ocean acidification and greenhouse warming, as well as from marine pollutants such as far-travelled plastic and other waste.

Management of tourism

Coinciding with the expansion of scientific interest in Antarctica in the late 1950s came the initiation of a tourism industry. Chile and Argentina at this time were the

first to take large numbers of passengers to Antarctica, with over 500 people travelling by ship to experience the South Shetland Islands. Regular ship-based tourism began in 1966, when a Swedish-American environmentalist, Lars-Eric Lindblad, introduced the concept of 'expedition cruising', which involved sight-seeing, visits to penguin rookeries and an educational programme. Lindblad's first purpose-built expedition ship, the *Lindblad Explorer*, entered service in 1969, and became the precursor for similar operations by many other companies. Ice-strengthened ships of less than 200 passengers are allowed to land their guests ashore at designated locations using Zodiac-style inflatable boats. These ship-based operations do not require any infrastructure ashore, but they do provide a unique opportunity for visitors to enjoy the magnificent scenery and wildlife, as well as viewing historic sites and active research stations. Large cruise ships, typically with between 500 and 3,000 passengers, visit Antarctica from time-to-time on an on-board sight-seeing basis only, but these are more vulnerable than smaller vessels in uncharted waters and in heavy ice conditions.

The key organisation that oversees tourism in Antarctica is the International Association of Antarctica Tour Operators (IAATO), which was formed in 1991 'dedicated to advocate, promote and practice environmentally responsible private-sector travel to Antarctica'. From just seven tour operators in 1991, IAATO now has over a hundred member organisations from across the world. From the outset, IAATO has provided advice to the Antarctic Treaty System, and has been represented regularly at the Antarctic Treaty Consultative Meetings, where it presents a summary of tourist activity and associated statistics. Its aim is to develop the highest standards and best practices for tour operations in order to better protect the Antarctic environment. IAATO and the Antarctic Treaty partners have agreed that no more than 100 passengers should be landed in Antarctica from a given ship at any one time, and that ships with more than 500 passengers are not allowed to land passengers at all. Documents are available on the IAATO website for both operators and tourists, including: *Guidance for Visitors to the Antarctic*, which focuses on protecting wildlife, respecting Protected Areas and scientific research, safety, and keeping the continent pristine; and *Guidance for those Organising and Conducting Tourism and Non-governmental Activities in the Antarctic*.

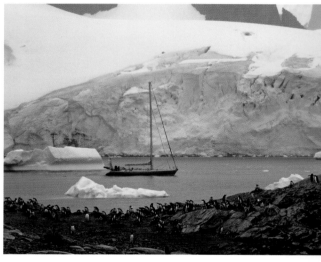

Approximately forty tourist vessels operate in Antarctica each summer, ranging in capacity from six to 500 passengers. In addition, yacht expeditions have become increasingly popular, both company and privately operated. The majority of expedition voyages take place in the Antarctic Peninsula – South Shetlands region. Passengers have the choice of sailing to Antarctica primarily from Ushuaia in southern Argentina, from Punta Arenas in Chile or from Port Stanley in the Falkland Islands. The crossing of the stormy Drake Passage is seen by many as an integral part of the Antarctic experience. However, a recently developed alternative is flying into an airstrip on King George Island in the South Shetlands, designed to optimise people's time in the Antarctic, although not always successfully because of fickle flying conditions.

Top: Expedition cruise ships, such as MV *Ocean Diamond*, give passengers unrivalled views of spectacular scenery, as here in Paradise Harbour, western Antarctic Peninsula.

Above: A yacht passing Couverville Island in the northwestern Antarctic Peninsula, representing an extreme form of adventure travel that is increasingly popular.

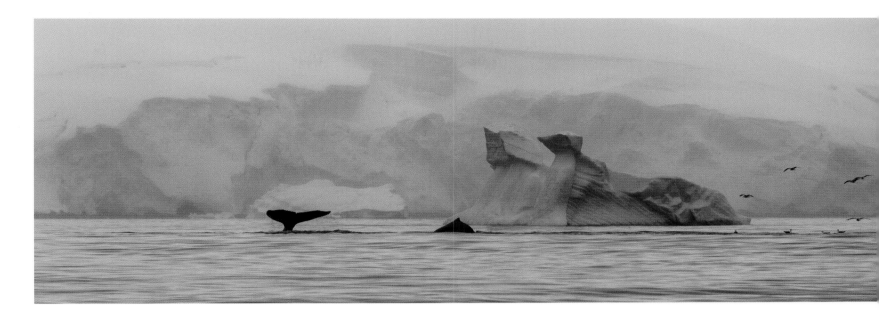

Many Antarctic Peninsula voyages are combined with a visit to the sub-Antarctic, notably South Georgia, which is particularly rich in wildlife. Only a small proportion of voyages, however, penetrate south of the Antarctic Circle. The season of operations runs from late October to March, when ice conditions are sufficiently reduced to allow shore landings. A few vessels use helicopters to take people ashore.

Other parts of the Antarctic continent are visited much less frequently, as the transit times, usually through heavy pack ice, are much longer; just to reach the coast may take a couple of weeks. Nevertheless, several expeditions each year visit the Ross Sea from Lyttleton or Bluff in New Zealand and Hobart in Tasmania, Australia. There have also been occasional departures from Cape Town, South Africa and Freemantle in Western Australia.

The highlights for visitors are usually shore excursions to penguin rookeries and elephant seal haul-outs, and Zodiac cruises to view icebergs and whales at close quarters. These visits are managed by IAATO, whose regulations allow one to three landings at any one site per day, lasting around three hours. Each site is mapped and described in detail and is subject to a detailed environmental impact and risk assessment. The numbers of people allowed ashore and staff-to-passenger ratios (typically less than 1:20) are also regulated. The intention is to avoid undue pressure and disturbance at any one site, giving visitors a better 'wilderness experience'. Shore visits are conducted and supervised by shipboard staff, who typically represent the disciplines of biology, geology, glaciology, history and photography. Areas for visitors are carefully staked out with tracks prepared in the snow to keep people safe from hidden hazards, such as crevasses, and to prevent them from disturbing animals. Some companies also offer overnight camping, mountaineering, skiing, diving and kayaking trips from expedition ships.

Above: Humpback whales, one of the many species of marine mammals that were heavily exploited in the 19th and 20th centuries.

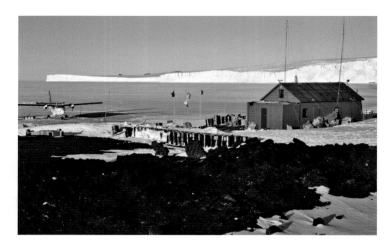

Planning expedition ship voyages in the polar regions is a considerable challenge, and flexibility is the key to a successful operation. Where a ship visit is driven largely by weather and ice conditions, so crew, staff and passengers alike may not know from one day to the next the locations of landings and Zodiac cruises. Sometimes, a vessel may be trapped in ice for several days, throwing out schedules. For many, this uncertainty takes some getting used to. Scientists refer to the uncertainties, last minute changes, and abandonment of plans associated with operations on the continent as the 'Antarctic Factor'.

Most shipboard-tourism is undertaken by companies that are members of IAATO. It is considered a legitimate activity within the provisions of the Antarctic Treaty System as long as the Protocol on Environmental Protection is adhered to. But is Antarctic tourism a good thing? Although ships burning heavy oil are banned, there remains the problem of local pollution from diesel engines and, of course, the output of carbon dioxide. There could be impact on penguin rookeries of large numbers of people visiting. There is the issue of what to do with waste. However, IAATO has regulations in place to minimise these impacts, and indeed some modern ships claim to be carbon-neutral. Although a few scientists and environmentalists object to such large-scale tourism, many view well-run operations as beneficial, because most visitors return home with an enhanced appreciation of all aspects of Antarctica and become ardent advocates for the protection of the continent and its surrounding seas. Furthermore, because changes in the Antarctic in response to global warming are more rapid than on most parts of the planet, even sceptics cannot easily ignore the evidence of climate change. Indeed, many retired scientists, with first-hand experience of monitoring these changes, contribute to the on-board education programmes. For them, once their arduous field days are over, the opportunity to share their experience and knowledge, and to raise awareness of contemporary environmental issues facing humanity, is a highly rewarding activity.

Above left: In the late 1980s, the environmental organisation, Greenpeace, established a temporary hut at Cape Evans on Ross Island, in order to check on the state of operations at McMurdo and Scott Base, and to reinforce its influence on the Antarctic Treaty.

Above right: Most of Antarctica is devoid of human activity and remains unknown, while other areas are infrequently visited. Here the vastness of Antarctica is represented by the world's largest glacier – the Lambert Glacier – Amery Ice Shelf System, as viewed from Fisher Massif, East Antarctica.

IAATO has maintained records of tour itineraries and site visits ever since its foundation. In the Antarctic Peninsula, some 200 sites and 20 research stations have been visited since 1989. Of these about fifty have only been visited once. Several sites receive about 10,000 visitors a year, with Port Lockroy, operated by the UK Antarctic Heritage Trust, probably receiving the most. Tourism reached a peak during the 2007-08 season, when over 46,000 visitors reached Antarctica. The number fell away to under 27,000 in 2011-12 following the 2008 world economic crisis, but at the time of writing there has been a steady recovery to within a thousand of the peak figures. Most visitors come from Western countries, but the Chinese market in particular is also growing rapidly. The latest figures by nation are illustrated in the table on the next page.

The trend in visitor numbers is likely to continue on a modest upward trajectory, as new specialist ships are commissioned, and with growth in the Asian market. Antarctica is a destination that is viewed by most people as very expensive, and therefore it is likely to remain a niche market, offered by a limited number of experienced education-focused operators.

Whereas the vast majority of tourism operations are ship-based, mention should also be made of land-based adventure tourism, which is offered by a handful of operators who are also members of IAATO. Although numbers of participants are small, at a few hundred a year, the activities are innovative and varied. The largest operation is based on Union Glacier, near the Ellsworth Mountains in West Antarctica, reached by aeroplane from South America. From here, with internal flight transfers, clients can ski the last degree of latitude to the South Pole, a distance of 111 km (60 nautical miles, 69 statute miles), ascend Amundsen's route up Axel Heiberg Glacier to the pole, or reach the pole from other starting points. Mountaineers can book onto climbing expeditions, with summits such as Mt Vinson, the highest in Antarctica, on the menu. One company offers a range of short-duration adventure activities in Dronning Maud Land, East Antarctica, with flights from Cape Town and luxury accommodation in Antarctica inland from the coast. As with ship-based tourism, these activities are designed to minimise environmental impact.

The above modes of tourism all offer first-hand experience of Antarctica, albeit with extremely comfortable facilities. Yet another way of seeing Antarctica is by means of an overflight using chartered aircraft. Originally pioneered in New Zealand and Australia, flights were suspended for many years after a crash on Mt Erebus in 1979, but have resumed from Australian cities recently. Businesses in other countries such as China and Argentina are exploring possibilities of day trips with landings, a potential market that is likely to grow in future if airstrips at national bases can accommodate the increased pressure.

The role of Non-Governmental Organisations (NGOs) in Antarctica

Of the many global environmental organisations which have an interest in Antarctica, only one, the Antarctic and Southern Ocean Coalition (ASOC), is working exclusively to protect the Antarctic continent and surrounding ocean. Founded in 1978 and based in Washington DC, USA, its mission is 'To protect the Antarctic and Southern Ocean's unique and vulnerable ecosystems by providing the unified voice of the NGO community'. The coalition embraces over thirty non-governmental organisations campaigning for environmental protection, and has been granted observer status at the Antarctic Treaty Consultative Meetings and at CCAMLR. The work by ASOC is undertaken under three headings: Antarctic environmental protection, wildlife conservation and governance. In addition, ASOC is currently focusing on three high-priority areas: climate change, krill conservation and Ross Sea preservation, the last topic embracing the now-implemented concept of a Marine Protected Area referred to above.

A number of the ASOC member organisations have their own campaigns in Antarctica. For example, the WWF (World Wildlife Fund) is seeking to improve the management of Antarctica's resources and safeguard its wildlife, establish a network of Marine Protected Areas covering at least 10% of the 20 million km^2 (8 million mile2) Southern Ocean, reduce illegal and unsustainable fishing practices, and raise awareness of the threats of climate change we all face. Donors to WWF have the opportunity to 'adopt a penguin', a scheme which raises money and educates at the same time.

Table: IAATO statistics for tourists visiting Antarctica in 2016-17 by nationality

Country	Total visitors		Visitors landing in Antarctica	
	Numbers	Percent	Numbers	Percent
USA	14, 893	33	11,339	30
China	5,289	12	5,148	14
Australia	4,488	10	3,827	10
Germany	4,172	9	3,682	10
UK	3,915	9	3,387	9
Canada	1,950	4	1,243	3
France	1,922	4	1,893	5
Switzerland	1,059	2	974	3
The Netherlands	842	2	-	-
Japan	-	-	618	2
Others	6,553	15	5,497	15
TOTALS	45,083	100	37,608	100

Another example of an effective campaigning organisation is Greenpeace, which is also a member of ASOC. Greenpeace's interest in Antarctica gathered pace during negotiations to set up the afore-mentioned 'Minerals Regime'. It even established its own science base in 1987 on Ross Island, Antarctica, very near to the historic Cape Evans hut of Scott. It operated for five years, before the base was totally removed. Pollution from the neighbouring McMurdo Station (USA) and Scott Base (New Zealand) was monitored, highlighting the need for those countries and others to take their environmental responsibilities more seriously. More importantly, Greenpeace was able to gain a legitimate say within the Antarctic Treaty System, and promoted the concept of a 'World Park' for Antarctica. In so doing, it helped Treaty nations establish the Protocol on Environmental Protection in 1991. With the continental area protected, Greenpeace has since been campaigning to protect the Southern Ocean. It identified krill-fishing as a growing threat, and is actively discouraging people from using krill, the oil of which is sold by many pharmacies for its omega-3, while krill fish-meal is fed to farmed salmon to provide the pink colour. Although encouraged by the establishment of the Ross Sea Region Marine Protected Area in December 2017, Greenpeace is seeking the creation of the world's biggest marine sanctuary in Antarctica, with emphasis in 2018 on the Weddell Sea, an area already being considered for a Marine Protected Area by CCAMLR.

Management challenges

The consensus among Treaty nations today is to treat the Antarctica continent, if not in name, as effectively a 'world park', by minimising human impact and invoking a strong set of environmental protection measures. Essential records concerning the health of the Earth system as whole are being obtained from Antarctica, as changes here are having a direct impact around the world, such as the ice sheet's contribution to sea-level rise and impact on ocean currents. Whereas the continent is now well protected, the same cannot be said for the surrounding oceans, where vested interests in fisheries are compromising efforts by most, but unfortunately not all, nations to create Marine Protected Areas. A significant amount of work needs to be done to protect the Southern Ocean which, despite the ravages of 19th and 20th century whaling and sealing, still remains one of the richest ecosystems on Earth.

Apart from fisheries management, a relatively new challenge is to manage the increasing demand from ship-board tourism and on-land adventure activities. These issues are explored further in Chapter 12. Above all, the majority of visitors wish to cherish the Antarctic landscape and its wildlife, as they provide a source of aesthetic inspiration and wonder in the beauty of our planet.

Below: The uniqueness and beauty of Antarctica provides visitors with an aesthetic appreciation of the continent, and therefore a desire to see it protected, rather than exploited. This water-worn iceberg is grounded off the north coast of Elephant Island, South Shetland Islands.

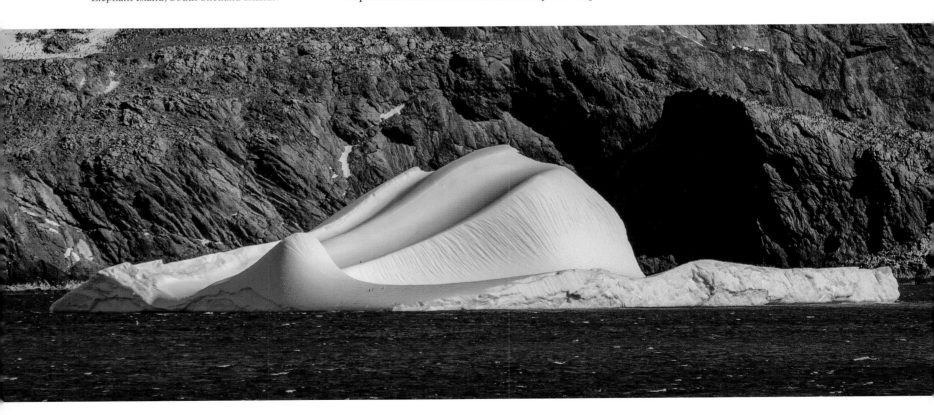

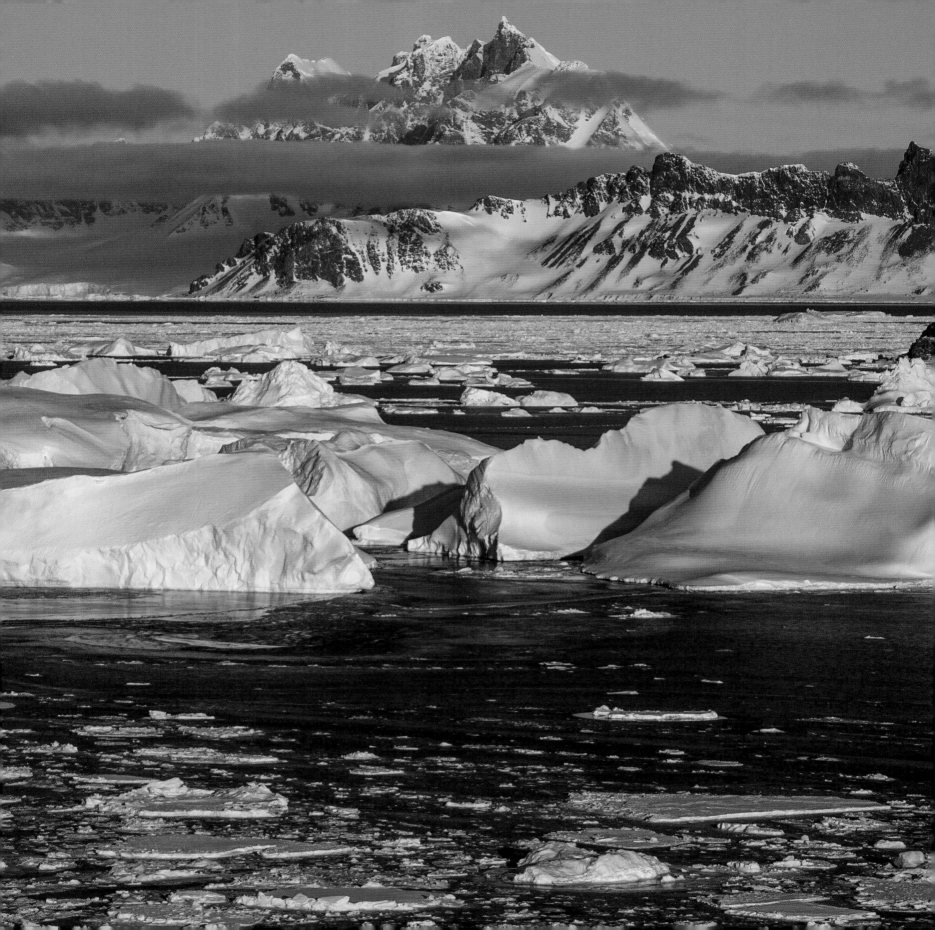

The Future of Antarctica

There has been a remarkable growth of interest in the Antarctic and Arctic in the forty or so years that we have been engaged in polar research. Both of us, as active scientists in this field, have given talks on the changing environment of the polar regions to groups ranging from primary school children to retired folk, and even to participants in the World Economic Forum in Davos. The evidence for change in the Antarctic and Arctic, especially over the past two decades, is compelling. We have witnessed this very directly in revisiting the same places over an extended period, and the wider case for change is based on a suite of scientific techniques that have been rigorously tested. We find it remarkable that there is still residual skepticism about whether such changes in the icy world are real. When challenged, as we and many scientists have done in the past years, the doubters display an almost total lack of engagement with scientific facts (which are usually specified with a clear methodology and error term). Over 99% of scientists accept the reality of recent climate change, and that it is linked largely to human-induced changes in the atmosphere. Our work has been to observe and monitor the changes that are taking place in the Antarctic and Arctic so that humanity may be better equipped to understand how rapidly and why change is taking place. This information provides a platform for deciding what we all need to do in the face of such demonstrated change.

JAD & MJH

The continent of Antarctica and its surrounding seas comprise the largest remaining undisturbed and genuinely wild part of our planet. Their future over the remainder of the 21st century is linked largely to two factors, one physical and the other geo-political. The first is the pace of human-induced climate change over the coming decades. The second is the ongoing presence of the Antarctic Treaty and its associated Environmental Protocol, and the level to which nations continue to respect the regulations that the treaty enshrines.

There is no indigenous human population in Antarctica, and year-round scientific stations are few and located mainly on the islands off the Antarctic Peninsula. Even in summer the footprint of scientists is small, and tourism from cruise ships takes place mainly on and around the Peninsula. Fishing in the nutrient-rich waters of the Southern Ocean is also controlled by international agreement through the Commission on the Conservation of Antarctic Marine Living Resources (CCAMLR), and mineral and hydrocarbon exploration and exploitation are banned. Science, tourism and fishing are each regulated through the Antarctic Treaty, its environmental instruments and the permitting arrangements of individual signatory nations (Chapter 11). Thus, at present, Antarctica has a uniquely protected status. A number of issues that may influence the future of Antarctica over the coming decades are explored in this concluding

Opposite: The western side of the Antarctic Peninsula and its adjacent islands are characterised by spectacular glacier-carved mountains, as in this view of Pourquoi Pas Island from the UK's Rothera Station on Adelaide Island.

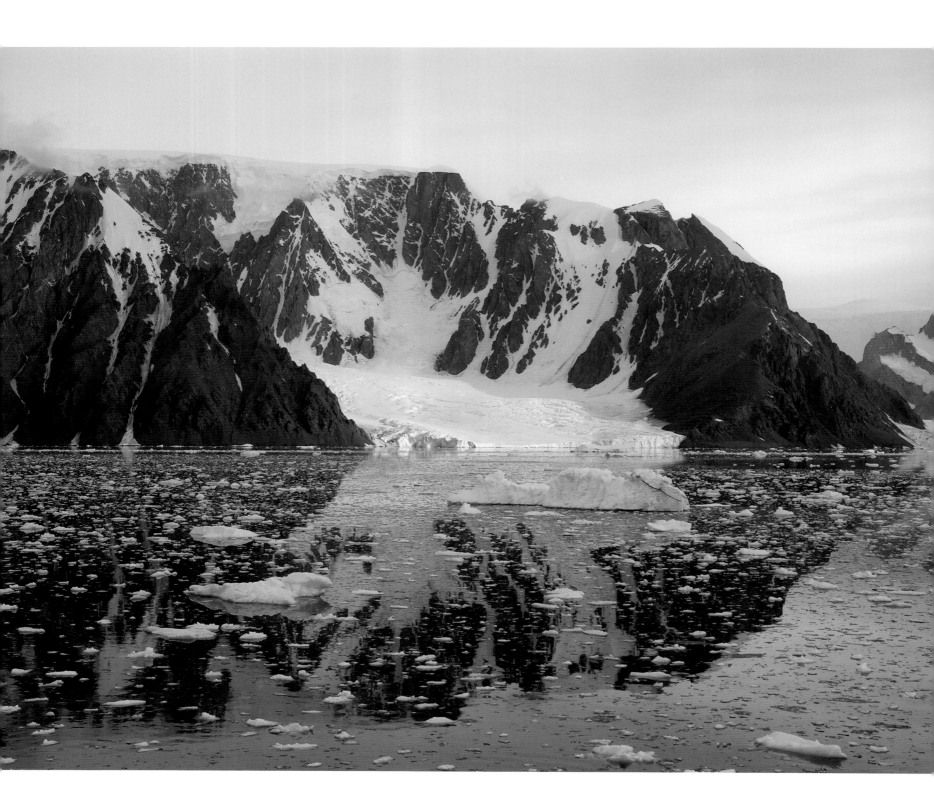

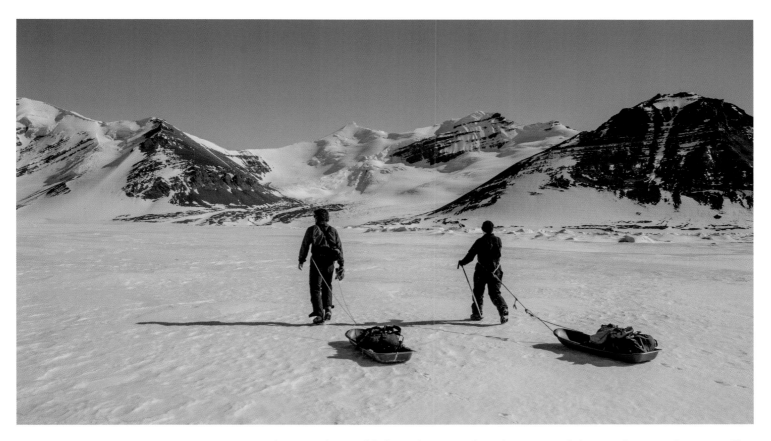

chapter, along with how the natural environment of the continent and surrounding seas may be affected by climate change over the 21st century.

Future environmental change in Antarctica

The likely direction of global temperature change over the remainder of the 21st century is in little doubt; temperatures will rise, the question is by how much. The answer is heavily dependent on the rate of production of greenhouse gases during the coming decades. Put simply, there are two end-member scenarios concerning human behaviour which provide lower and upper bounds on what is likely to take place. First, humanity may decide that activities (for example car use and jet travel) are largely curtailed, along with drastic reductions in fossil fuel burning – this appears a very unlikely scenario given the energy-hungry, consumer-based society present in many nations. Alternatively, fossil fuel use could continue unchecked and exacerbated by an increasing global population and economic growth – this also seems unlikely, although perhaps less so than the lower end-member, given the recognition of global warming as a scientifically established reality and attempts by many nations to move away from fossil fuels and towards renewable sources of energy.

Opposite: A cirque glacier flows into the waters of Bougeois Fjord, western Antarctic Peninsula.

Above: Many areas of Antarctica are protected under the Antarctic Treaty's environmental protocol. In such areas vehicular activity is not permitted. Here a geological party is using small sledges to carry equipment and samples across the frozen Ablation Lake, Alexander Island, southwestern Antarctic Peninsula.

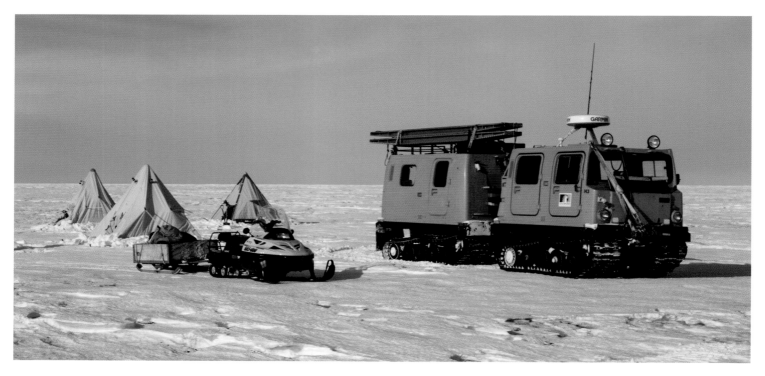

Thus, of the many scenarios on future greenhouse gas levels used in computer-model predictions of how much the global atmosphere may warm, a trajectory between these two extremes is most probable. In such a scenario, global average temperatures may rise by between about 2° and 4° C (3.6°-7.2° F) by 2100 (with extreme upper lower and upper bounds of approximately 1° C / 1.8° F and 7° C / 12.6° F for the less likely scenarios). For the Antarctic, simulations with the latest general-circulation computer models of the linked global atmosphere-ocean-ice system currently predict a warming of between about 1.5° and 5° C (2.7°-9° F) by 2100, with an accompanying increase in precipitation of up to 35%. These trends are already clearly apparent, as much of Antarctica has experienced warming of 0.1°C (0.18° F) per year, as measured by NASA. The increase, measured over twenty years, shows the Peninsula and West Antarctica to be most affected, even if central parts of East Antarctica have cooled slightly.

The effects on the Antarctic Ice Sheet of continued warming are likely to be further thinning and retreat of glacier ice, particularly on the Antarctic Peninsula and in some parts of West Antarctica. The prognosis for sea-ice change on a decadal timescale is also for reduction as warming proceeds, although the pattern of change around Antarctica is likely to be very variable and difficult to predict. Increasing snowfall in the interior of Antarctica may, however, offset the losses of ice from the continent to at least some extent, although precipitation change is generally regarded as being difficult to predict accurately. Even so, taken together with the projections of ice loss from Greenland, the large Arctic ice caps and from lower latitude mountains, global sea-level may rise by about 1 m (3.2 ft) by 2100, although model predictions have wide margins for error about this value. The collapse of a major drainage basin of the West Antarctic Ice Sheet, such as Pine Island or Thwaites glaciers, is regarded as unlikely on the time-scale of a few decades, but is a potentially serious possibility over the next century (Chapter 5). This could add a further 0.5 m (1.6 ft) to sea-level rise. Given the difficulties of making accurate predictions of Antarctic climate change over the decades to 2100, it is essential that particularly sensitive parts of the Antarctic Ice Sheet, and their changing extent, thickness and velocity, are monitored carefully so that signs of increasingly rapid change can be identified as soon as possible.

Changing climate and the Antarctic biota

There is increasing evidence that human impacts on a global scale are likely to have a considerable impact on Antarctic fauna and flora in the coming decades. Climate change and ocean warming are the most important of these impacts. We already know that the fastest warming part of Antarctica is the Peninsula, as meteorological records going back half a century indicate warming of 3° C (5.4° F) (Chapter 4). A consequence of this is the increasing frequency of rain at a time when penguin chicks are at their most vulnerable. The rookeries of Emperor and Adélie penguins north of 67° S may be lost through warming, and it is also evident that gentoo penguins are pushing south in

Opposite: top: A New Zealand glaciologists' field camp on the southern McMurdo Ice Shelf, Ross Sea region, with a Hägglunds tracked vehicle, snow scooters and pyramid tents.

Opposite bottom left: Marine biological work is a major component of many nations' research programmes. The purpose-built Bonner Laboratory at the UK's Rothera Station has a range of facilities for investigating fauna and fauna, including diving capability.

Opposite bottom right: A fisheries patrol vessel alongside at Port Stanley in the Falkland Islands. The management of fishing and fish stocks in the Southern Ocean is a important issue today and is likely to remain so over the coming decades.

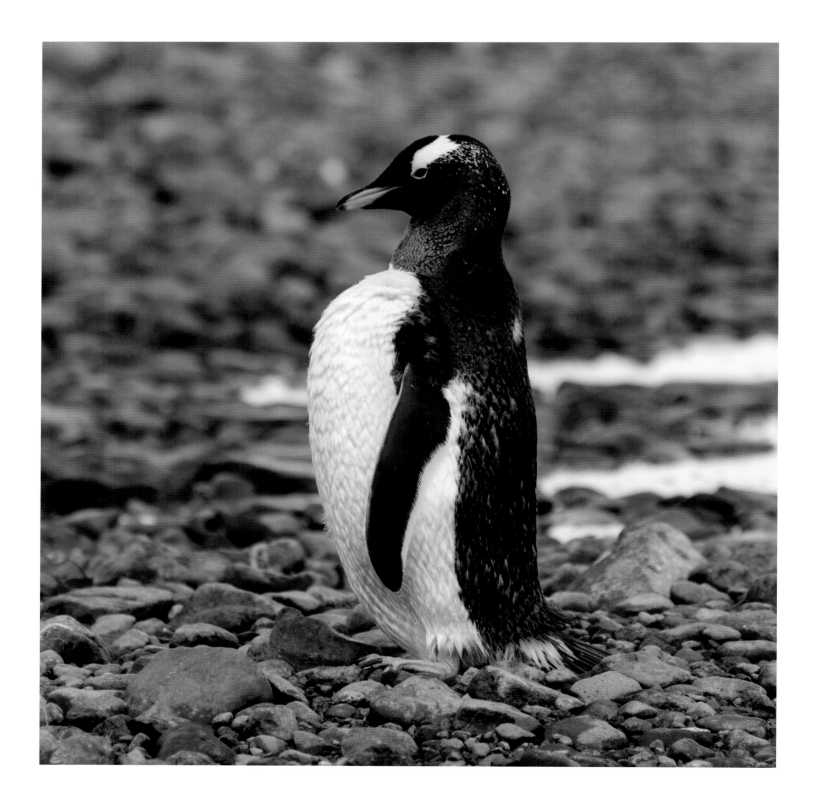

The Continent of Antarctica

Opposite: The gentoo is one of the several species of penguin found in the Antarctic Peninsula that can be frequently observed by cruise-ship passengers. Climate and oceanographic changes are allowing this species to expand southwards, in some case displacing Adélie penguin populations.

Above: As one of the fastest warming parts of the world, glacier recession is occurring at an unprecedented rate in the Antarctic Peninsula region. Here, on Livingston Island in the South Shetland Islands, recession of an ice cap is exposing new ground with large areas of buried stagnant ice, allowing the first signs of vegetation to appear.

their place. There is also the possibility of 'greening' of the more northerly parts of the Peninsula region, with expansion of mosses and lichens, and introduction of flowering plants, either carried in naturally by wind, or introduced accidentally by humans. As glaciers recede, new land will appear, ready for colonisation by plants and animals. This process is already well underway in the Antarctic Peninsula region.

Warming around Antarctica has, counter-intuitively, led to an increase in sea ice in some areas (Chapter 5) as a consequence of increased melting of land ice and the increased prevalence of fresh surface water with a higher freezing point. However, the long-term trend over the coming decades is likely to be for sea ice to decline, with a resulting loss of habitat for marine mammals and birds that rely on ice.

In the Southern Ocean, increasing temperatures are likely to result in shifts in the distribution of micro-organisms, and changes to ocean currents. The latter could have global consequences. Antarctic Bottom Water, which is formed beneath ice shelves and sea ice (Chapter 7), is a major driver of the world's ocean circulation. As sea-ice production declines, the circulation is likely to weaken since less dense Bottom Water is produced, thus having a considerable impact on marine communities around the world. The waters around Antarctica are also increasing in acidity as more carbon dioxide is absorbed from the atmosphere. We are therefore likely to see changes in the productivity and composition of krill and related micro-organisms and, inevitably, this will have consequences right through the Antarctic ecosystem (Chapter 8).

Invasion by non-native species

Until recently, the Antarctic continent itself, in contrast to many sub-Antarctic islands such as South Georgia and Kerguelen, appeared to have been little affected by invasions of non-native species, but this is beginning to change. Its isolation beyond the Southern Ocean has been a source of long-term protection that is now breached routinely by ship and air travel into the continent, implying that human rather than natural dispersal is the predominant future risk. A clear example is the recent spread of a non-native grass species, *Poa annua*. The grass, whose seeds were probably first brought to a research station on King George Island, has spread not only within the South Shetland Islands but also onto the continent in the northern Antarctic Peninsula. In the marine realm, a new threat associated with the warming of continental-shelf waters has been the arrival of king crabs, whose population has exploded to an estimated 1.5 million over the last decade or two in the deep waters of Palmer Deep close to the western side of the Antarctic Peninsula. Since crabs have an ability to crush their prey, the soft-bodied organisms on the sea floor are particularly vulnerable to predation.

Biosecurity measures to limit non-native species are set out by both the Antarctic Treaty System and IAATO; however, implementation is variable between national and commercial operators, and there is little ongoing monitoring of changes in small or microscopic organisms, sometimes described as 'non-charismatic' in comparison with large sea mammals and birds. It is thought that more than 200 of such non-charismatic invasive species are present on the continent, with most located in the South Shetland Islands. A warming climate, especially in the Antarctic Peninsula region, will also make Antarctica a slightly more hospitable environment for potential colonisation by new species. This change, itself driven largely by the burning of fossil fuels, combined with the varying levels of biosecurity at human entry points into the continent, means there is a real and continuing threat of species invasion into Antarctica, albeit mainly in the form of small plants and invertebrate animals.

Antarctic tourism

It is the icy wilderness and wildlife of Antarctica and its coastal margins that the majority of tourists to Antarctica come to see. In one sense, such visitors are eco-tourists, interested in unusual natural environments, the observation of wildlife and, often, in supporting conservation efforts. Encounters with penguins on land, or with whales from rubber boats, are closely controlled, but each visitor has the chance to see animals at close quarters in their natural setting. Most tourists also return home as long-term advocates of retaining Antarctica as a pristine continent. Given this, cruise-ship operators, most linked together under the voluntary code of practice of IAATO, want to minimise their environmental impact while introducing several tens of thousands of visitors each year mainly to the Antarctic Peninsula and its adjacent islands.

Below: A beach landing from a Zodiac rubber boat for expedition ship passengers at Elephant Point on Livingston Island.

Opposite: Passengers lining the bow of MV *Sea Adventurer* watch as the ship navigates slowly between an iceberg and the rock walls of Lemaire Channel, western Antarctic Peninsula.

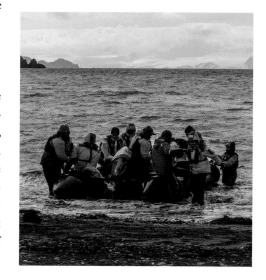

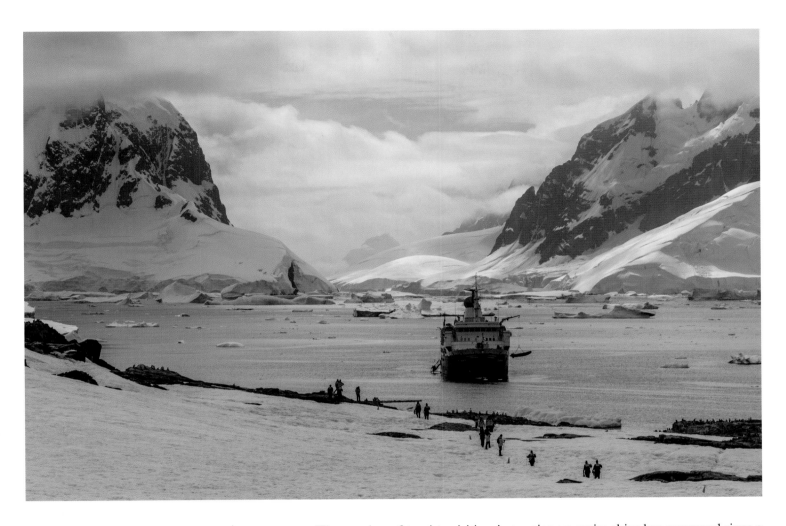

Opposite: Expedition ship operators and the International Association of Antarctic Tour Operators have agreed a wide range of landing locations around the Antarctic Peninsula, including this site of Neko Harbour on the west side, where penguin rookeries and calving glaciers dominate the scene.

Above: The expedition ship MV *Sea Adventurer* (now *Ocean Adventurer*), anchored off Petermann Island near the south end of Lemaire Channel (background). Passengers are following designated pathways to visit penguin rookeries.

The number of tourists visiting Antarctica on cruise ships has recovered since a marked down-turn in the aftermath the global economic crisis of 2008 (Chapter 11). It is likely that the Antarctic cruise-ship industry will continue to grow over the coming decades – a number of new vessels are already on order, most aimed at the 'expedition' market, with less than 150-200 passengers aboard who make regular excursions onshore. However, there is a view, based on the examination of trends in tourist visits to many global destinations, that the development of tourism follows a 'life cycle' of initial discovery and growth, followed by market consolidation and a plateauing in visitor numbers. For Antarctica, some have suggested that visits to the continent may level off after about 2030 or so.

Emissions from fuel burning by cruise ships will remain an issue, although the most polluting heavy fuel oil is now banned from the continent – a consequence has been that most large cruise-only ships no longer come to Antarctica. Operators must

ensure that everything brought into Antarctica is removed at the end of any visit. Nothing, including 'grey' water and human waste, should be left behind.

In addition, continuing care needs to be taken in assessing and monitoring the ongoing environmental effects of landings to view wildlife up-close. This is especially important, given that certain locations, such as Deception Island, are visited particularly frequently. Currently, there are only about 10 sites in Antarctica which receive in excess of 10,000 visitors per year, of which the museum and shop at Port Lockroy is one. The continuing role of self-regulation through IAATO is crucial to avoid environmental damage. Measurements of the continuing environmental impacts on decadal timescales will be important to maintain, along with a regulatory mechanism on how to respond to evidence of overuse and environmental damage.

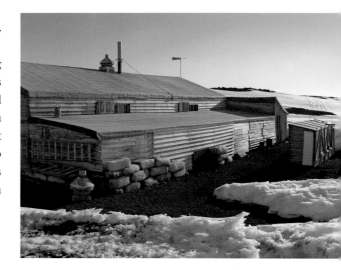

Heritage and preservation

Relics of past exploration and early whaling and sealing activities are scattered around Antarctica, focussed especially on the Antarctic Peninsula and its adjacent islands. The preservation of huts and associated historic sites around the Antarctic coast is likely to continue over the next few decades, based in part on the philanthropically supported activities of non-governmental organisations such as the UK and New Zealand Antarctic Heritage Trusts. As a further part of this heritage activity, key locations are being formally designated and protected as historic sites or monuments by the Antarctic Treaty partners. Conservation plans have been established for a number of huts and the careful curation of their contents is taking place. Maintenance will need to continue indefinitely, however, due to the action of wind erosion and drifting snow.

The Cape Evans and Cape Royds huts erected around McMurdo Sound by Scott and Shackleton have already been restored. Restoration is also ongoing at the Cape Adare hut on the northern tip of Victoria Land, established on Carsten Borchgrevink's *Southern Cross* expedition of 1898-1900. Douglas Mawson's huts in Commonwealth Bay, East Antarctica, are also receiving attention. In addition, several huts in the Antarctic Peninsula region, established and used by the Falkland Islands Dependencies Survey (now the British Antarctic Survey) during the 1940s and 1950s, are also earmarked for restoration, including those on Detaille, Horseshoe and Stonington islands.

Beyond the Antarctic continent, rich collections of artefacts, photographs, paintings and documents from the 'Heroic Era' of exploration in particular are preserved and displayed in a number of museums. Comprehensive collections are found at the Polar Museum of the Scott Polar Research Institute in Cambridge University, UK, at Canterbury Museum in Christchurch, New Zealand, and at the Fram Museum in Oslo, where they are available to both the public and to scholars researching polar history. In such museums, those unable to go to the Antarctic can

Opposite top: The preserved exterior of Scott's Cape Evans hut with renewed woodwork and bales.

Opposite centre: Erosion of the original wooden walls of the Cape Evans hut, exacerbated by the transport of sharp volcanic particles in high winds from the adjacent slopes of Mt Erebus.

Opposite bottom: Snow can get through minute cracks into buildings as 'spin-drift'. At Scott's *Discovery* hut, snow regularly penetrated the walls and built up inside prior to restoration work.

Photographs of the interior of Scott's Cape Evans hut show a series of artefacts that have survived from the 'Heroic Era' of Antarctic exploration and are now preserved in the hut. These include,

Clockwise from top left: a hot-water bottle; cooking pots and enamel cups; medicines that formed part of Dr Edward Wilson's medical supplies; a labelled sock belonging to Apsley Cherry-Garrard (a member of the *Terra Nova* expedition and author of 'The Worst Journey in the World'); kitchen supplies, baking trays and frying pans.

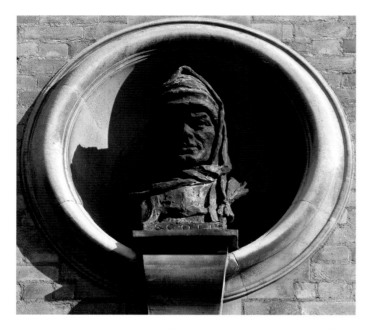

view original objects, including polar ships such as the *Fram* in Oslo, and the *Discovery* in Dundee, Scotland, and the large overland vehicles used by the Commonwealth Trans-antarctic Expedition in Christchurch (Chapter 9). Smaller items include Captain Scott's last letters, Ernest Shackleton's personal diaries and the sextant used by Frank Worsley to navigate the tiny *James Caird* between Elephant Island and South Georgia on the *Endurance* expedition (Chapter 9), as well as a range of polar clothing, sledging artefacts and food packets. Of a more experiential nature is the Antarctic Centre at Christchurch Airport in New Zealand, where visitors can sample a simulated indoor wind storm, go on a trip in a Hägglunds tracked vehicle, and encounter huskies and (non-Antarctic) penguins.

Pollution and new technologies

Whether it is for tourism or for research in Antarctica, human activity in terms of transportation to, and living on, the continent has an effect on the environment. Under the Antarctic Treaty, significant work has been undertaken already in removing rubbish accumulated, often over several decades, at research stations, and in making sure that further build-up does not take place (Chapter 11). Waste is now either removed at the end of each summer field season or is biodegraded.

In the cold Antarctic environment, energy generation has always been a necessary but polluting accompaniment to human presence. In this context, the use of renewable energy sources has developed over the last decade or so in particular and is likely to provide steady cuts in fossil fuel use on the continent into the future. Wind

Opposite top left: Bust of Captain Robert Falcon Scott, sculpted by his wife Kathleen, at the Scott Polar Research Institute in Cambridge University, England.

Opposite top right: The external façade of the Scott Polar Research Institute's 1934 building in Cambridge, which houses its Polar Museum and research laboratories. The bust of Scott can be seen in the centre. The latin words on the façade, translated as '*He sought the secret of the Pole but found the hidden face of God*', reflect the fact that the entrance hall of the Institute's Museum is a national memorial to Scott, Wilson, Bowers, Oats and Evans.

Opposite below: Captain Scott's last letter to his wife, Kathleen, written shortly before he died on the Ross Ice Shelf in March 1912 (©Scott Polar Research Institute). It reads:

> '*To my widow*
> *Dearest darling – we are in a very tight corner and I have doubts of pulling through – In our short lunch hours I take advantage of a very small measure of warmth to write letters preparatory to a possible end – The first is naturally to you on whom my thought mostly dwell waking or sleeping – If anything happens to me I shall like you to know how much you have meant to me and that pleasant recollections are with me as I depart –*
>
> *I should like you to take what comfort you can from these facts also – I shall not have suffered any pain but leave the world fresh from harness and full of good health and vigour – this is decided already when provisions come to an end we simply stop unless we are within easy distance of another depot. Therefore you must not imagine a great tragedy - we are very anxious of course and have been for weeks but our splendid physical condition and our appetites compensate for all discomfort. The cold is biting & sometimes angering but there again ~~with~~ the ...*'

Right: The sextant and two small watches used by Frank Worsley to navigate the tiny *James Caird* on the epic boat journey from Elephant Island to South Georgia in 1916 after the sinking of Shackleton's *Endurance*, displayed in the Polar Museum at the Scott Polar Research Institute. (© Scott Polar Research Institute)

Below: The *Fram* in its dedicated museum in Oslo along with numerous other polar artefacts. The ship was used by Amundsen on his successful attempt to reach the South Pole. The ship, belonging to the Norwegian explorer Nansen, was designed to ride up under pressure from sea ice, and successfully drifted across the ice-covered Arctic Ocean before sailing to Antarctica.

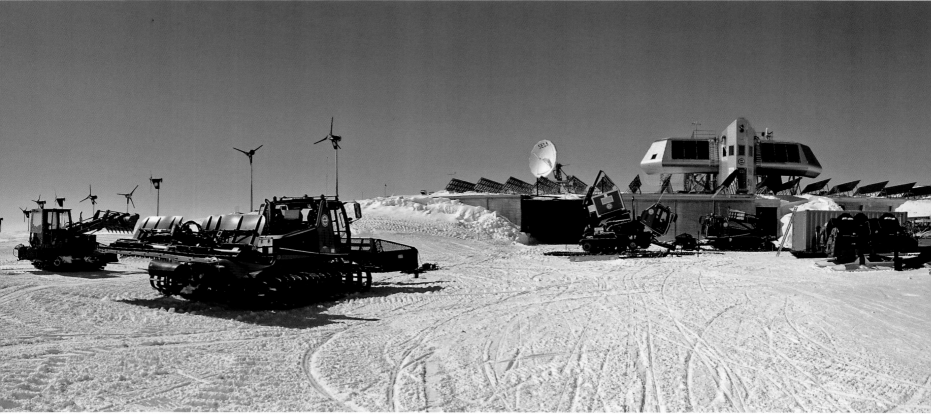

farms, like that providing power to New Zealand's Scott Base in McMurdo Sound, are an obvious renewable source of energy in this windiest continent. In the continuously light days of summer, solar energy is also abundant, and this fortuitously coincides with the greatest numbers of scientific personal in Antarctica and the operation of seasonal research stations. A key element in the utilization of renewables is, as elsewhere in the world, the need for improved battery-storage technology, to provide a reliable reserve of power in calm wind conditions and periods of cloud and darkness.

Many scientific stations in Antarctica now have solar panels and wind generators. Belgium's Princess Elisabeth Station, about 200 km (125 miles) from the East Antarctic coast in Dronning Maud Land, is a model of environmental sustainability with its zero-emission footprint. Wind as an energy source, especially during the period of winter darkness, has been deliberately maximized by the station's location on an exposed ridge affected by strong katabatic winds (Chapter 4), and is combined with effective small-scale implementation of smart-grid technology for optimal energy use on the base. In terms of travel over the ice sheet, experiments have also been undertaken with innovative kite technology, again using wind as an energy source.

Some pollutants, however, are likely to continue to arrive in Antarctic from beyond the continent. Relatively large plastic items are obvious contributors, but recent sampling of ocean water, beaches and even animal remains from Antarctica has shown that microplastics (pieces of plastic less than 5 mm / 0.2 in across) have reached the continent in ocean currents despite Antarctica's relative isolation south of the oceanographic convergence (Chapter 7). Microplastics come from both the degradation of larger plastic items in the ocean and from 'microbeads', which are very tiny pieces of manufactured polyethylene, often found as exfoliants in cosmetics and in toothpaste, that are too small to be trapped in water filtration systems. Microplastics are a now major pollutant in the oceans and are easily ingested but harmful to aquatic life.

It is only by international efforts to reduce the amount of microplastics entering the world's oceans that this pervasive form of pollution will be reduced. Early signs are that there is a growing political consensus aimed at action. There is also an encouraging precedent for nations making such enlightened decisions that has relevance to Antarctica. This is demonstrated by the banning of ozone-reducing CFCs in refrigeration under the Montreal Protocol and the recent scientific prediction that the Antarctic ozone hole may be effectively healed over the next fifty or so years as a result (Chapter 4).

The future of the Antarctic Treaty System

A key geopolitical consideration that is fundamental to the future of Antarctica is the resilience of the Antarctic Treaty, its Environmental Protocol and the associated Convention on the Conservation of Antarctic Marine Living Resources. It is no

Opposite left: Wind turbines above New Zealand's Scott Base in McMurdo Sound.

Opposite right: Solar panels are used frequently by scientists in field camps to take advantage of long daylight hours during the Antarctic summer.

Below: Vehicles, equipment and wind turbines at Belgium's Princess Elisabeth Station in Dronning Maud Land, East Antarctica. (Courtesy of Bryn Hubbard)

Left: Evelyn Dowdeswell views the flags of the Antarctic Treaty's founding nations, alongside a bust of the American Antarctic explorer Admiral Richard Byrd at McMurdo Station.

Below: The deployment of a Remotely Operated Vehicle (ROV) from the British research vessel James Clark Ross in Bourgeois Fjord off the western Antarctic Peninsula. The ROV and its instrument packages and cameras can operate down to the seabed through several thousand metres of water.

coincidence that the rapid growth in the number of nations joining the Antarctic Treaty System in the later 1970s and 1980s was when critical resource management discussions on fishing and minerals were taking place. Membership continues to grow, however, with Kazakhstan, Mongolia and Iceland the latest to join in 2015. This continuing expansion of member nations is, arguably, leading to a slow shift in viewpoint among the signatories, with some newer member nations having a greater interest in the long-term resource potential of the continent and its surrounding seas, especially in terms of fishing and mineral extraction.

The governance structure of Antarctic Treaty System itself is a low-cost operation in administrative terms, and continuing expansion in the number of signatory nations could lead to a slowing of the political process. Recent examples have been the failure to bring into force the Liability Annex to the Treaty Protocol and slow progress towards the designation of marine protected areas around Antarctica. Nonetheless, the designation of the Ross Sea region Marine Protected Area in 2017 has been an important recent success. It would be unfortunate if the Antarctic Treaty System came to be viewed as administratively slow and ineffective by some nations.

Although it is often assumed that the Antarctic Treaty expires in 2048, or has to be renegotiated at that time, this is not the case. In fact, the Treaty and the Environmental Protocol have no specified end date. However, it is specified

that any party to the Antarctic Treaty can call for a formal review of the 1998 Environmental Protocol, which includes a ban on all activities concerning mineral resources, after 50 years. Thus, 2048 has the potential to be an important year for the treaty, and may signal a test of its long-term resilience for preserving the Antarctic continent and Southern Ocean as the world's last true wilderness.

Concluding remarks

The Antarctic remains almost entirely wild and unspoiled, with the footprints of human activity for the most part soon expunged by wind and snow. It is worth remembering that it was only just over one hundred years ago that Captain Scott, Edward Wilson and Ernest Shackleton first penetrated into the interior of the continent of Antarctica on the *Discovery* expedition of 1901-04. In the relatively short time since then, scientists first began to map the continent and its icy carapace, and then to unravel the environmental processes that make the Antarctic Ice Sheet and the Southern Ocean key parts of the global climate system; new technologies allow even the huge and inaccessible water-filled cavities beneath floating ice shelves to be investigated. Thus, the Antarctic is important not just for its status as the last true wildness, but also because environmental changes there have a much wider significance through their effects on ocean circulation and sea-level rise globally.

Antarctica has claimed many lives over the years, as explorers and scientists have sought to understand more about this awe-inspiring continent. Although safety is regarded to be of paramount importance today, hazards remain – from exposure to wind and cold, hidden crevasses, unstable sea ice, changing marine conditions, aircraft and boating accidents, and even fire.

There is no doubt that Antarctica is a place that is inspirational for almost all who visit this remotest and coldest continent. It has been a privilege for the authors to have played a small part in taking forward the scientific understanding of the continent of Antarctica.

Footprints in the Antarctic snow – no-one ventured into the interior of the continent of Antarctica before Captain Scott's first expedition of 1901-04, only just over one hundred years ago.

Top: Herbert Ponting's photograph of ski tracks overprinting the trace of a penguin sliding on its belly, taken on Scott's 1910-13 expedition. (© Scott Polar Research Institute)

Above: The recent footsteps of a scientist have compressed the snow beneath. Subsequent wind action has remobilized the snow, leaving the denser and, hence, more resistant footprints to stand proud above the surface.

GEOGRAPHICAL INDEX

A

A (or Argus), Dome 95, 110

Ablation Lake 48, 68, 98, 101, 191, 193, 221, 233, 269

Adare, Cape 202, 237, 278

Adelaide Island 22, 28, 59, 60, 65, 71, 98, 112, 144

Adélie Land 35, 180

Admiralty Bay 68, 121

Aguirre Passage 231

Alexander Island 22, 45, 48, 49, 52, 112, 242, 257

Allen Hills 57

Amery Ice Shelf 21, 35, 55, 65, 96, 109, 128, 132, 158, 262

Amery Oasis 43, 119, 124

Amundsen Glacier 20

Amundsen Sea 64, 70, 80, 106, 107, 135, 136, 142, 143, 151

Andvord Bay 26

Antarctic 9, 14

Antarctic Circle 12, 28, 62, 114, 166, 198, 261

Antarctic Convergence 9, 12, 173, 180, 256

Antarctic Ice Sheet 12, 74, 83, 87, 89, 92, 100, 103, 105, 110

Antarctic Peninsula 10, 12, 17, 22, 32, 36, 44, 45, 49, 52, 63, 73, 98, 103, 104, 110,

Antarctic Peninsula 114, 124, 125, 128, 130, 154, 156, 159166, 216, 230, 261, 273, 274

Antarctic Plateau 65

Antarctic Sound 26

Antarctica 9, 10, 11, 12

Antarktikos 197

Anvers Island 13, 22, 63, 85, 93, 98, 112, 114

Astrolabe Basin 17, 21

Astrolabe Subglacial Basin 100, 110

Astudillo Glacier 87

Aurora Subglacial Basin 100, 110

Austfonna ice cap 93

Aviator Ice Tongue 90

Axel Heiberg Glacier 20, 31, 87, 207, 263

B

Back Cirque 98

Bagshawe, Mount 45, 242

Barne Glacier 78, 144, 197

Barrientos Island 51

Battye Glacier 124, 128

Beacon Valley 40, 122

Beardmore Glacier 20, 31, 33, 35, 41, 56, 87, 98, 101, 111, 204, 207

Beaver Lake 128, 193

Belemnite Valley 48

Bellingshausen Sea 64, 78, 88, 202

Bennett Platform 31, 234

Bird, Mount 50, 132

Black Island 59

Blood Falls 192

Bonney, Lake 126, 127

Booth Island 27, 70, 88

Borchgrevink Coast 90

Bourgeois Fjord 89, 204, 269, 284

Bouvet Island 24

Brabant Island 13, 17, 22, 93, 112

Bransfield Strait 22, 49, 52, 131

Brown Bluff 51, 57, 177

Brownworth, Lake 126, 127

Brunt Ice Shelf 155, 230

Byrd Glacier 20, 87, 89, 96, 197

Byrd Subglacial Basin 22

C

C, Dome 105

Campbell Submarine Plateau 140

Canada Glacier 256

Castle Berg 76

Castle Rock 52

Cathedral Rocks 32

Chapman Glacier 96

Cloudmaker, The 33

Coats Land 138, 227

Collinson Ridge 43

Commonwealth Bay 35, 66, 209, 278

Crater Rim 52

Croft Bay 24, 68, 120, 128, 133, 228

Crozet Islands 24, 184, 198

Crozier, Cape 161, 207

Crystal Sound 27, 28, 90, 135

Cuverville Island 26, 27, 194

D

Dallmann Bay 13

Danco Coast 31, 90

Danco Island 26

Debenham Islands 73

Deception Island 22, 24, 26, 49, 52, 54, 122, 131, 132, 169, 192, 198, 199, 215, 249, 278

Dellbridge Islands 92

Denison, Cape 154

Detaille Island 278

Devon Island 93

Discovery, Mount 9, 50, 59, 119, 132, 222

Drake Passage 12, 17, 26, 45, 56, 105, 135, 138, 140, 162, 163, 185

Dronning (Queen) Maud Land 97, 216, 217, 223, 263
Drune Hill 242
Dry Valleys, see McMurdo Dry Valleys
Drygalski Ice Tongue 90
Dunlop Island 38

E

East Antarctic Ice Sheet 11, 21, 55, 59, 87, 92, 96, 100, 101, 110, 115, 161
East Antarctica 104, 110
Elephant Island 14, 26, 48, 212, 213, 265, 280, 281
Elephant Point 84, 169, 175, 185, 199, 274
Ellesmere Island 93
Elliot Passage 98
Ellsworth Land 22
Ellsworth Mountains 20, 22, 26, 28, 31, 40, 45, 50, 97, 112
Eltanin Bay 78
Erebus Ice Tongue 90, 92
Erebus, Mount 9, 26, 28, 50, 87, 92,
Erebus, Mount 131, 132, 192, 197, 199, 202, 205, 223, 224, 234, 263, 279
Errera Channel 27
Evans, Cape 11, 13, 60, 76, 78, 92, 144, 262, 278

F

Ferguson Channel 185
Ferrar Glacier 32
Finger Mountain 45
Fisher Massif 55, 65, 109, 124
Flandres Bay 23
Fort Point 128, 130
Fossil Bluff 48, 240

Føyn Harbour 188, 214
Français, Mount 114

G

Gamburtsev Subglacial Mountains 20, 21, 110, 111
Gaudry, Mount 59, 231
George VI Ice Shelf 22, 48, 49, 96, 98, 101, 221, 224, 232
George VI Sound 145
Gerlache Strait 23, 26, 27, 28, 31, 80, 90, 114, 155, 171, 175
Girard Bay 83
Glossopteris Gully 43
Goudier Island 180, 217
Gourdin Island 163, 189
Graham Land 17, 49
Granite Harbour 38
Great Ice Barrier 90, 199
Greenwich Island 128
Grytviken 214

H

Haddington, Mount 131
Heard Island 24
Horseshoe Island 278
Humphries Heights 111, 122
Hut Point 75, 201, 202, 218, 244
Hydrurga Rocks 180, 186

I

Inexpressible Island 209

J

Jackson, Mount 22
James Ross Island 52, 87, 88, 106, 118, 119, 120, 130, 132
Jenny Island 28, 62, 65, 112
Joinville Island 26

K

Kerguelen Isles 24, 135, 140, 184, 198, 243, 274
Kerguelen Submarine Plateau 156
Khufu Corrie 48, 240
Khufu Glacier 242
King George Island 24, 26, 68, 121, 274

L

Labyrinth 114
Lambert Glacier 20, 55, 65, 88, 96, 100, 109, 110, 112, 132, 262
Larsemann Hills 130
Larsen A Ice Shelf 153
Larsen B Ice Shelf 153
Larsen C Ice Shelf 17, 153
Laubeuf Fjord 71
Law Dome 20, 87
Lazarev Sea 148, 228
Leat Glacier 83
Lemaire 132,
Lemaire 83,
Lemaire Channel 11, 26, 27, 48, 70, 88, 90, 109, 111, 112, 122, 274
Lion Island 85
Liv Glacier 11
Livingston Island 31, 84, 118, 192, 194, 199, 273

M

Mac. Robertson Land 35

Macquarie Island 24

Marguerite Bay 13, 28, 62, 137, 145, 146, 165

Marie Byrd Land 22, 32, 36, 50, 131

Marion Island 184

Matusevich Glacier 148

McGregor Glacier 31

McMurdo Dry Valleys 9, 20, 31, 55, 59, 92, 96, 98,

McMurdo Dry Valleys 100, 113, 114, 115, 124,
 125, 126, 128, 132, 223, 230

McMurdo Ice Shelf 9, 59, 68, 85, 87, 98, 99,

McMurdo Ice Shelf 101, 119, 168, 170, 202, 217,
 234, 239, 271

McMurdo Sound 11, 25, 26, 28, 36, 50, 60, 67,
 83, 144, 155, 178, 197, 217, 218

Melbourne, Mount 50, 132

Mikkelsen Harbour 177, 224, 259

Mill Glacier 101

Minna Bluff 59, 68, 87, 119

Morning, Mount 50

Moutonnée Lake 257

N

Neko Harbour 26, 114, 277

Neptunes Bellows 52, 131

Neu Schwabenland 216

Neumayer Channel 26, 63, 85, 98, 105, 121

Northern Victoria Land 23

O

Observation Hill 209, 210, 223

Olympus Range 42

Onyx River 95, 115, 126

P

Pagodroma Gorge 126

Palmer Archipelago 22

Palmer Deep 274

Palmer Land 45, 49, 96, 221, 224, 232

Paradise Harbour 26, 27, 87, 260

Patriot Hills 26

Paulet Island 203

Pensacola Mountains 57

Pensacola Pole Basin 110

Peter I Island 135, 199

Petermann Island 26, 152, 161, 186, 277

Pine Island 85

Pine Island Bay 85, 107, 156, 198

Pine Island Glacier 106, 107, 271

Pléneau Island 112, 114

Polar Plateau 20, 60, 68, 125, 207

Pole of Inaccessibility 26, 250

Port Lockroy 26, 214, 217, 263, 278

Pourquoi Pas Island 147, 186, 267

Prince Charles Mountains 32, 40, 43, 55, 57, 65,
 109, 119, 124

Prince Edward Island 24, 184

Prince Gustav Channel 23

Prince Gustav Ice Shelf 23

Princess Elizabeth Land 35

Princess Royal Range 60, 65

Protector Heights 90

Prydz Bay 35, 54, 186

Pyramid Peak 241, 242

Q

Queen Alexandra Mountains 35

R

Radok Lake 126, 128

Renard, Cape 109, 247

Roberts Massif 31, 55, 60, 68, 125

Ronne Ice Shelf 22, 158

Ronne-Filchner Ice Shelf 20, 95

Ross Ice Shelf 11, 20, 21, 22, 25, 73, 89, 90, 95,
 96, 111, 153, 155, 169

Ross Island 32, 35, 50, 52, 80, 202

Ross Orogeny 38, 40

Ross Sea 17, 22, 26, 28, 38, 50, 52, 54, 59, 68, 90,
 95, 99,

Ross Sea 119, 127, 130, 131, 132, 135, 137, 140,
 159, 167, 186,

Ross Sea 212, 258, 261, 284

Ross Sea Marine Protected Area 253

Rotch Dome 118

Rothera Peninsula 28

Rothera Point 157, 177, 186, 238

Royal Society Range 9, 207

Royds, Cape 80, 203, 205, 207, 278

Ryder Bay 65

S

Schirmacher Oasis 124

Schollaert Channel 93

Scotia Arc 24, 36, 48

Scotia Sea 24, 39, 52

Scott, Mount 161

Shackleton Glacier 21, 31, 40, 43, 55, 101, 233

Shackleton, Mount 83

Shambles Glacier 237

Shirmacher Oasis 20

Signy Island 215

Smith Island 17

South Georgia 24, 26, 36,

South Georgia 135, 175, 176, 184, 198, 199, 212, 214, 248, 261, 274, 280, 281

South Magnetic Pole 205, 207

South Orkney Islands 18, 24, 45, 71, 176, 191, 198, 19

South Pole, geographical 12, 13, 20, 26, 28, 31, 33, 35, 42, 55, 56, 59, 60, 71, 87, 90, 93,

South Pole, geographical 188, 197, 207, 210, 218, 219, 250, 263, 281

South Pole, geomagnetic 80, 81

South Pole, magnetic 20

South Sandwich Islands 18, 24, 39, 52, 137,199

South Shetland Islands 17, 18, 24, 45, 52, 54, 63, 84, 87, 98,

South Shetland Islands 100, 120, 121, 124, 125, 130, 131, 176, 191, 198, 230, 274

South Shetland Trench 49, 52

Southern Ocean 9, 12, 17, 24, 65, 87, 128, 135, 138, 141, 150, 226, 265, 273

Stonington Island 216, 278

Sub-Antarctic Islands 10

Swithinbank Moraine 101

T

Taylor Glacier 101, 115

Taylor Valley 113, 122

Terra Australis incognita 198

Terrapin Hill 48, 67, 118, 122

Terror, Mount 9, 50, 92, 132, 199

Thurston Island 18

Thwaites Glacier 106, 107, 271

Transantarctic Mountains 11, 12, 17, 20, 21, 31, 32, 40, 41, 44, 45, 50, 55, 56,

Transantarctic Mountains 57, 59, 66, 87, 89, 92, 96, 111, 124, 125, 132, 193, 232

Trinity Peninsula 23

Two Hummock Island 28

U

Ulu Peninsula 120

Union Glacier 26, 28, 97, 223, 263

V

Vahsel Bay 210

Vanda, Lake 126

Vega Islands 128

Vestfold Hills 20, 38, 100, 112, 126, 130

Victoria Land 32, 95, 156, 202

Victoria Lower Glacier 20, 127, 128

Victoria Upper Glacier 115

Victoria Valley 20, 126, 127

Vida, Lake 128

Vinson, Mount 20, 28, 112, 223, 263

Vostok Subglacial Lake 21, 101, 103, 110

W

Weddell Sea 17, 22, 66, 74, 95, 132, 137, 140, 141, 153, 212, 218, 219, 227, 264

West Antarctica 10, 17, 22, 39, 73, 104, 110

Whalers Bay 122

Whales, Bay of 90, 205

White Island 239

Wiencke Island 26

Wild, Cape 14, 213

Wild, Point 212

Wilkes Basin 21

Wilkes Land 64, 87

Wilkes Subglacial Basin 100

Windless Bight 84, 202

Winter Island 71

Wormald Glacier 59

Wright Lower Glacier 95, 115, 126, 127

Wright Valley 113, 114

SUBJECT INDEX

A

Agreed Measures for the Conservation of Antarctic Fauna and Flora 255
Aircraft 9, 24, 25, 31, 42, 67, 96, 109, 110, 147, 148, 221, 222, 223, 224, 232, 233
Almirante Brown Station 27
Amundsen-Scott Station 26, 71, 218, 230
Amundsen, Roald 20, 31, 87, 90, 111, 205, 207, 237, 281
Andes 35, 36, 39, 49
Antarctic and Southern Ocean Coalition (ASOC) 263, 264
Antarctic Bottom Water 141, 150, 273
Antarctic Circumpolar Current 138, 140, 141, 156
Antarctic Coastal Current 140, 155
Antarctic Convergence 9, 12, 173, 180, 256,
Antarctic Peninsula Ice Sheet 13, 96, 221
Antarctic Plate 36, 38, 39, 44,
Antarctic Treaty 10, 13, 193, 219, 248, 251, 252, 256
Antarctic Treaty System (ATS) 13, 159, 250, 255, 258, 274, 283, 284,
Arktowski Station 68
Artefacts 279, 280
Atlantic Ocean 135, 140
Aurora Australis (Southern Lights) 61, 80
Aurora expedition 209, 212,
Australian Antarctic Division 223
Australian Antarctic Expedition 35, 66
Australian National Antarctic Expedition 109

B

Barrett, Peter 9
Barrie, McKelvey 55, 109
Base A (Port Lockroy) 217
Base Orcadas 71
Beacon Supergroup 35, 40, 42, 43, 57
Beechey, R.B. 200
Bellingshausen Station 224, 230
Bellingshausen, Fabian von 199
Birds, flighted 126, 162, 184, 185, 186, 188, 189, 190,

Borchgrevink, Carsten 202, 237, 278
Bottom-water formation 141
Bowers, Henry 'Birdie'R 207, 209, 210,
Bransfield, Edward 199
Britannia, Royal Yacht 18
British Antarctic Expedition 33
British Antarctic Survey 221, 225, 232, 238, 255, 278
British Graham Land Expedition (BGLE) 73, 215, 216
British National Antarctic Expedition 32
British, Australian, New Zealand Antarctic Research Expedition (BANZARE) 35, 216
Browning, Robert 243
Bruce, William Speirs 71, 203
Bull, H.J. 214
Byrd, Richard E 87, 215, 216, 217, 284

C

Campbell, Victor 209
Canterbury Museum 278
Cape Evans hut 197, 209, 279
Cape Roberts Project 250
Carbon dioxide 141
Carlini Base 24
Casey Station 25, 38, 57, 87, 113, 132, 161, 223
Cenozoic Investigations of the Ross Sea (CIROS) 36
Charcot, Jean Baptiste 203, 204
Cherry- Garrard, Apsley 161, 207, 279
Christchurch, New Zealand 9, 25
Christensen, Ch. 214
CIROS-1 54
Climate change 9, 27, 52, 65, 221, 255, 267, 271,
Clissold, Thomas 76
Clouds 63, 65, 75,
Coal 41, 57
Colonization 273, 274,
Comandante Ferraz Station 230, 231
Commission for the Conservation of Antarctic Marine Living Resources (CCAMLR) 168, 194,
Commission on the Conservation of Antarctic

Marine Living Resources (CCAMLR) 255, 267
Commonwealth Trans-Antarctic expedition 78, 218, 219, 239, 280
Conservation 195, 278
Continental Antarctic Zone 166, 191
Convention for the Conservation of Antarctic Seals 194, 250, 255
Convention for the Regulation of Whaling 215
Convention on the Conservation of Antarctic Marine Living Resources 250, 255
Convention on the Regulation of Antarctic Mineral Resource Activities' (CRAMRA) 56, 258
Cook, James 32, 198, 247
Coriolis Force 64, 138
Cousteau Foundation 258
Crean, Tom 213
CryoSat-2 103

D

d'Urville, Dumont 180
Davis Station 38, 109, 113, 126, 132, 161, 175, 224
Davis, Peter Maxwell 243
Debenham, Frank 73, 243
Deutschland expedition 209
Discovery expedition 32, 52, 73, 75, 79, 201, 202, 203, 223, 279, 280, 285
Dowdeswell, Evelyn 52, 284
Drewry, David 83

E

du Toit, A 35, 56
East Antarctica 17, 73, 104, 110
East Base 216
Edgeworth David, T.W. 20, 204, 207
Edinburgh, HRH The Duke of 18
Eisenhower, President 249, 250
Endurance expedition 14, 26, 138, 146, 210, 212, 213, 280, 281,
Environmental changes 283, 285
Erebus, HMS 199, 200

Esperanza Station 178, 231
Evans, Edgar 207, 210
Evans, Stan 83

F

Falkland Islands 17, 25, 135, 224
Falkland Islands Dependencies Survey (FIDS)
 217, 238, 278
Ferrar, Hartley 32
Field living 225, 226, 231, 232, 233, 237, 238,
 239, 271
Filchner, Wilhelm 237
Fire hazard 230
Fish 167, 168, 169, 173, 190, 193, 271
Fitzsimons, Sean 59
Fossil Bluff Station 231, 232
Fram Museum 278, 281
Fram, MS 247
Fram, SY 205, 280
Français, SY 203
France 248
Frei Station 224, 230
Fuchs, Vivian 78, 218, 219, 239
Future environmental change 269

G

Gabriel Gonzalez Videla Station 231
General Bathymetric Chart of the Oceans
 (GEBCO) 36
Geological fieldwork 221, 240
Geological history 32
Gerlache, Adrien de 202
Glacial features 57, 68, 97, 98, 87, 88, 97, 98, 99,
 101, 269,
Glaciation 11, 54, 84, 85, 56, 95
Global sea-level 11, 18, 83, 103, 271
Global warming 100
Gondwana 35, 40, 41, 42, 44, 45, 50, 56, 132, 162
Gran, Tryggve 210
Greenhouse gases 10, 11, 106, 269
Greenland 83
Greenland Ice Sheet 22, 87, 89, 92, 104

Greenpeace 258, 262, 264
Ground-penetrating radar 240

H

Halley Station 74, 155, 230
Hartley Ferrar 202
Hektor Whaling Company 215
Heroic era 9, 13, 28, 200, 247
Hillary, Edmund 218, 219, 240
Home of the Blizzard 65, 66
Hurley, Frank 212, 214, 243

I

Icebergs 12, 127, 143, 145, 150, 151, 154, 155,
 157, 158, 159, 265
Imperial Trans-Antarctic Expedition 210, 218
Indian Ocean 12, 24, 135, 140
Inter-governmental Panel on Climate Change 255
International Association of Antarctica Tour
 Operators (IAATO) 26, 260, 261, 262
International Association of Antarctica Tour
 Operators (IAATO) 263, 274, 277, 278
International Geophysical Year (IGY) 13, 36, 71,
 217, 219, 228, 239, 248, 249
International Polar Year (IPY) 199, 253
International Union for Conservation of Nature
 (IUCN) 167, 194, 195
Isostatic rebound 112, 128, 130

J

James Clark Ross, RRS 17, 65, 70, 135, 226
Jane 199
Japan 249
Jubany 24

K

Kainan-maru, SY 209
Katabatic winds 59, 60, 66, 128, 150, 283,

L

Larsen, C.A. 214, 215
Last Glacial Maximum 104, 112
Little America III Station 215, 216

M

Mackay, Alistair 20, 205, 207
Malaysia 258
Map Bathymetric map of the Southern Ocean 137
Map of Antarctic bedrock 102
Map of Antarctica 18
Map of continental reconstruction 41
Map of ocean circulation 140
Map of plate tectonics 36
Map of territorial claims 248
Map of the Antarctic Peninsula 23
Map of the CCAMLR Convention area 253
Map of the Ross Sea Region Marine Protected
 Area 255
Map of the Scotia Sea bathymetry 36
Map showing flow of the Antarctic Ice Sheet 96
Marine ecosystem 12, 165, 167, 168, 169, 170,
 190, 191, 192, 193, 194, 274,
Marine Protected Area (MPA) 256, 258, 263, 265,
 284
Maritime Antarctic Zone 166, 191
Mars 57, 59
Maudheim expedition 219
Mawson Station 224
Mawson, Douglas 20, 35, 65, 66, 204, 207, 209,
 216, 237, 243, 278
McCormick, Robert 188
McMurdo Station 9, 24, 25, 26, 31, 50, 52, 66, 98,
 135, 147, 148,
McMurdo Station 197, 201, 203, 217, 218, 222,
 223, 228, 230
Mechanised transport 59, 219, 228, 233, 238, 239,
 240, 271, 280
Medical and hygiene 235, 236
Mertz, Xavier 209
Mineral resources 56, 57, 258, 285
Mirny Station 231

Montreal Protocol 11, 75, 283
Morning, SY 201
Multibeam echo-sounder 137, 138

N

Nansen, Fridtjof 205, 281
National memorial 281
Neumayer, Georg von 200
New Zealand 9, 44, 135, 248
New Zealand Antarctic Heritage Trust 278
Nimrod Expedition 20, 56, 80
Nimrod, SY 203, 205
Ninnis. Belgrave 209
Non-Governmental Organisations (NGOs) 258, 263
Nordenskiöld, Otto 32, 35,203, 237
Norway 248, 249
Norwegian-British-Swedish Maudheim expedition 217

O

Oates, Lawrence 207, 209, 210
Ocean Diamond, MV 260
Operation Deep Freeze 217
Operation Highjump 217, 248
Operation Tabarin 217
Ozone hole 11, 74, 75

P

Pacific Ocean 135, 140
Pack ice 142, 143
Palmer Station 199
Palmer, Nathaniel 199
Pangaea 41, 44
Pardo, Luis 213
Peary, Robert 205
Penguins 27, 51, 57, 112, 128, 154, 161, 162, 163, 177, 178, 180, 182, 186, 271, 273
Penola, MY 73
Polar Museum 278, 281
Polar Plateau 20, 60, 68, 125, 207

Polarstern, RV 138, 148, 227
Polynya 148, 150
Ponting, Herbert G 76, 173,197, 209, 243, 244, 285
Pourquoi-pas?, SY 203
Pressure ridges 9, 146
Princess Elisabeth Station 283
Protector, HMS 24, 228, 230, 231
Protocol on Environmental Protection to the Antarctic Treaty 284, 285
Protocol on Environmental Protection to the Antarctic Treaty 56, 57, 194, 250, 258

Q

Quest expedition 213

R

Radio-echo sounding 110
Remotely Operated Vehicle (ROV) 284
Resolution, HMS 198
Riiser-Larsen, Hjalmar 216
Ritscher, Alfred 216
Robin, Gordon 83
Rock glaciers 121, 124
Ross Orogeny 38, 40
Ross Sea Marine Protected Area 253
Ross, James Clark 50, 90, 175, 199, 200, 202, 215
Rothera Station 24, 25, 28, 59, 60, 65, 71,
Rothera Station 135, 146, 169, 175, 178, 186, 221, 223,224, 225, 226, 230, 231, 232
Royds, Charles 73
Rymill, John 17

S

Schwabenland expedition 216
Scientific Committee on Antarctic Research (SCAR) 13, 247, 249, 250,253
Scotia expedition 203
Scotia Metamorphic Complex 48
Scott Base 9, 50, 52, 84, 219, 222, 223, 228, 230, 283
Scott Polar Research Institute 73, 197, 278, 281

Scott, Kathleen 281
Scott, Robert Falcon 9, 20, 35, 60, 73, 75, 79, 202, 209, 210, 280, 281, 285
Scottish National Antarctic Expedition 71
Sea ice 9, 12, 142, 144, 150
Sea-level rise 104, 285
Seago, Edward 17, 18
Seals 128, 162, 169, 173, 175, 176, 177, 193, 199
Shackleton, Ernest 9, 14, 20, 26, 28, 31, 32, 33, 35, 56, 61, 80, 87, 98, 111, 138, 146,
Shackleton, Ernest 202, 203, 205, 207, 210, 213, 218, 237, 239, 243, 280, 285
Shirase expedition 209
Shirase, Nobu 237
Sinfonia Antartica 242
Sirius Group 33, 55, 114
Smith, William 199
Snowball Earth 128
South America 12, 44
South American Plate 39
Southern Africa 25, 40, 44, 249
Southern Annular Mode 73
Southern Cross expedition 202, 278
Soviet Union 248, 249
Space weather 80
Station F (Faraday) 71
Stone polygons 122, 124
Stromatolites 128, 193
Subduction 39, 45
Swedish South Polar Expedition 32

T

Tabular iceberg 70, 90, 93, 135, 136, 152, 159
Taylor, Griffith 166, 243
Terra Australis incognita 198
Terra Nova expedition 25, 28, 32, 35, 61, 76, 92, 207, 237, 239, 279
Terra Nova, SY 25, 73, 141, 197, 201, 244
Terrestrial ecosystem 165, 166, 167, 168, 190, 191, 192, 274
Territorial claims 10, 13, 248
Terror, HMS 199, 200
The Home of the Blizzard 209

The Worst Journey in the World 161, 207
Tourism 14, 26, 224, 259, 260, 261, 264, 274, 277
Trans-Antarctic Expedition (TAE) Hut 219
Troll Station 97

U

UK Antarctic Heritage Trust 217, 263, 278
UK National Antarctic Research Committee 247
United Kingdom 248
United Nations 75, 255, 258
United States 248, 249
US Antarctic Program 31, 218, 233

V

Vaughan Williams, R. 242
Vernadsky Station 71
Verne, Jules 243
Vince, George 203, 244
Volcanism 9, 24, 31, 39, 50, 52, 131, 132
Vostok ice core 161
Vostok Station 26, 59, 71, 105, 231

W

Wade, F.A. 36
Waste management 236, 280
Weddell, James 199
Wegener, Alfred 35
West Antarctic Ice Sheet 50, 78, 100, 101
West Antarctic Rift System 50
Weyprecht, Karl 199
Whales 162, 169, 170, 171, 172, 173, 199, 261
Whaling 198, 214, 215, 249,
Wild, Frank 212
Wilkins, Hubert 215
Williams Field 222
Wilson, Edward 243, 244, 279, 285
Wilson, Edward 9, 31, 35, 41, 52, 75, 79, 90, 161,
 172, 177, 201, 202, 207, 210
Wind turbines 280, 283
Women in Antarctic science 255
World Park 258, 264, 265

World Wildlife Fund (WWF) 263
Worsley, Frank 26, 213, 280, 281

Y

Yelcho, SS 212, 213

Z

Zehnder, Bruno 161
Zodiac cruising 26, 152, 259, 260, 261, 262, 274

SELECTED BIBLIOGRAPHY

Bernasconi, A., 2015. *Blue Ice.* Papadakis Publisher, UK. ISBN 978-1-906506-58-2.

British Antarctic Survey, 2012. *Antarctic Peninsula: a Visitor's Guide.* Natural History Museum, London. ISBN 9-780565-09308-2.

Cherry-Garrard, A., 1922. *The Worst Journey in the World.* [Reprinted by Penguin Random House, UK. ISBN 10-014309-38-5.]

Crane, D., 2005. *Scott of the Antarctic.* Knopf, New York, USA. ISBN 0-375-41527-0.

Fiennes, R., 2003. *Captain Scott.* Hodder & Stoughton, UK. ISBN 0-340-82697-5.

Florindo, F. & Siegert, M. (editors), 2009. *Antarctic Climate Evolution.* Elsevier, The Netherlands. ISBN 978-0-444-52847-6.

Fothergill, A., 1993. *Life in the Freezer.* BBC Books, UK. ISBN 0-563-36431-9.

Hambrey, M. & Alean, J., 2004. *Glaciers* (2nd edition). Cambridge University Press, UK. ISBN 0-521-82808-2.

Hansom J.D. & Gordon, J.E., 1998. *Antarctic Environments and Resources.* Addison Wesley Longman, UK. ISBN 0-582-08127-0.

Laws, R., 1989. *Antarctica: the Last Frontier.* Anglia Television & Boxtree, UK. ISBN 1-85283-247-9.

Liggett, D., Storey, B., Cook, Y. & Meduna, V. (editors), 2015. *Exploring the Last Continent.* Springer, Germany. ISBN 978-3-319-18947-5.

McGonigal. D. & Woodworth, L., 2001. *Antarctica: the Complete Story.* Global Book Publishing, Australia. ISBN 0-7112-2285-1.

McGonigal, D. & Woodworth, L., 2002. *Antarctica: the Blue Continent.* Frances Lincoln, UK. ISBN 0-7112-2476-5.

Scott J. & Scott, A., 2007. *Antarctica: Exploring a Fragile Eden.* HarperCollins, UK. ISBN 10-0-00-718345-3.

Shirihai, H., 2007. *A Complete Guide to Antarctic Wildlife* (2nd edition). A&C Black Publishers, UK. ISBN 978-0-7136-6406-5.

Soper, T. & Scott, D., 2013. *Antarctica: a Guide to the Wildlife* (6th edition). Bradt Travel Guides, UK & The Globe Pequot Press, USA. ISBN 978-1-84162-483-9.

Stonehouse, B. (editor), 2002. *Encyclopedia of Antarctica and the Southern Ocean.* Wiley, UK. ISBN 0-471-98665-8.

Tingey, R.J. (editor), 1991. *The Geology of Antarctica.* Clarenden Press, UK. ISBN 0-19-854467-7.

Walker, G., 2013. *Antarctica: an Intimate Portrait of the World's Most Mysterious Continent.* Bloomsbury, UK. ISBN 978-1-408-81110-8.

Walton, D.W.H. (editor), 2013. *Antarctica: Global Science from a Frozen Continent.* Cambridge University Press, UK. ISBN 978-1-107-00392-7.

Worsley, F.A., 1931. *Endurance: an Epic of Polar Adventure.* [Reprinted by Norton & Co., UK].

SELECTED WEBSITES

Antarctic Glaciers (**www.antarcticglaciers. org**). An independent website created by Dr Bethan Davis, which explains the science of glaciology, especially from an Antarctic perspective, with contributions from many colleagues (including MJH).

Australian Antarctic Division (**www. antarctica.gov.au**). Australia's official organisation for Antarctica, which has comprehensive summaries of all aspects of science, environmental management, politics, and living and working on the continent.

British Antarctic Survey (**www.bas.ac.uk**). The UK's official organisation for Antarctica, with a large body of helpful information about its science in a global context, the Treaty and other management aspects.

Cool Antarctica (**https://coolantarctica.com**). An independent website aimed at the wider public and schools, containing a vast amount of information of all aspects of science, history, politics and living in Antarctica.

Glaciers Online (**www.glaciers-online.net**). An independent website created by Dr Jürg Alean of SwissEduc with one of the authors (MJH), which is a photographic website of all aspects of glaciers, and flora and fauna of the polar regions and elsewhere.

Scientific Committee on Antarctic Research (**www.scar.org**). The international body which co-ordinates and facilitates research in Antarctica, and is the formal scientific advisor to the Antarctic Treaty System.

Scott Polar Research Institute (**www.spri. cam.ac.uk**). Directed by one of the authors (JAD) the Institute is part of the **University of Cambridge**, and is the oldest established research and information centre for the study of the Antarctic and Arctic, celebrating its centenary in 2020.

UK & NZ Antarctic Heritage Trusts (**www. nzaht.org** and **www.ukaht.org**). Charitable organisations devoted to the upkeep of historical sites, especially former bases, in Antarctica.

ACKNOWLEDGEMENTS

We thank the following for use of photographs, satellite images, diagrams and paintings: Nick Cox, Vicky Dowdeswell, Peter Fretwell, Jennifer Hirsh, Bryn Hubbard, Martin Jakobsson, Valerie Loeb, Robert Mulvaney, Eric Rignot, the Alfred Wegener Institute, the British Antarctic Survey, CCAMLR, GEBCO, the Portland Gallery, NASA, NOAA, the National Snow and Ice Data Center (NSIDC), The Open University, Papadakis Publisher, and the Scott Polar Research Institute. Paul Tyler also helped with the selection and identification of sea floor fauna imaged using the *Isis* Remotely Operated Vehicle offshore of Antarctica. We are also greatly indebted to Jürg Alean for processing many of the digital photographs and for advising on the remainder. Peter Convey, Daniela Liggett, John Smellie and Peter Clarkson offered many helpful suggestions on specific chapters and Peter Clarkson also compiled the index. We also thank Antony Smith of Aberystwyth University for producing many of the line drawings.

Lucy Martin (Picture Librarian) and Naomi Boneham (Archives Manager) at the Scott Polar Research Institute provided much help with photographs, paintings and drawings in the Institute's collection. We thank the Scott Polar Research Institute for the use of its copyright material and are pleased that half the Royalties from this book will go to augment the endowment funds of the Institute in support of its research and heritage activities.

Our home institutions have provided support during our Antarctic careers. In this context, we are grateful to Aberystwyth University, Liverpool John Moores University, the University of Bristol and the University of Cambridge. The Director and Staff of Gateway Antarctica in Canterbury University, Christchurch, New Zealand hosted JAD as a Cambridge-Canterbury Fellow during the final stages of writing this book. The Victoria University of Wellington and the University of Otago in New Zealand have similarly hosted MJH relating to various Antarctic campaigns.

Both of us have benefitted greatly from the support of many individuals during our research visits to the Antarctic and its surrounding seas. We thank the following colleagues in particular: Peter Barrett, Don Blankenship, Graham Chapman, Werner Erhmann, Chris Elliot, Sean Fitzsimons, Dieter Fütterer, Neil Glasser, Gerhard Kuhn, Robert Larter, Peter McCarthy, Barrie McKelvey, John Smellie, Brian Stewart, Bryan Storey, Paul Tyler and Peter Webb, along with many others who have helped us over the years. Our research and photography could not have been undertaken without the skills of the pilots of chartered helicopters and fixed-wing aircraft, the boat crews of both large and small research vessels, and the field assistants and mountaineers who have kept us safe during remote fieldwork.

The following organisations have also provided much valued field support: the Alfred Wegener Institute for Polar and Marine Research, Germany; the Australian National Research Expeditions; the British Antarctic Survey; Gateway Antarctica in Canterbury University, New Zealand; the New Zealand Antarctic Research Programme and Antarctica New Zealand; the US Antarctic Program; the *Isis* ROV team from the National Oceanography Centre, Southampton; the captains, officers and crews of the RRS *James Clark Ross*, HMS *Endurance*, HMS *Protector* and RV *Polarstern*; the UK Natural Environment Research Council; the US National Science Foundation; Quark Expeditions and the captain, crew and staff of MV *Sea Adventurer*.

Working with Alexandra Papadakis has also been a most enjoyable experience. Sitting with her discussing layouts for the various chapters has improved the book enormously and we are grateful for her support and encouragement throughout, and especially during the final stages of production.

Finally, it is a pleasure to thank our families for their support. Evelyn Dowdeswell has been to Antarctica with Julian, as a practicing scientist in her own right (as well as being married to Julian). Evelyn is pictured in this book on the summit of Castle Rock near Scott Base, during a geological field trip that she led. Vicky, their daughter and Mike's God-daughter, has also been to Antarctica, and a photograph taken on her visit to Elephant Island is included. Their son, Adam, has enjoyed field trips to the glacial landscapes of Wales with both Julian and Mike. We will also be forever grateful to our parents for their long-term nurturing and unconditional support of our education and careers.

JAD & MJH

ABOUT THE AUTHORS

Professor Julian Dowdeswell
Director of the Scott Polar Research Institute and Professor of Physical
Geography, University of Cambridge

Professor Michael Hambrey
Emeritus Professor of Glaciology, Department of Geography and
Earth Sciences, Aberystwyth University

Julian Dowdeswell has been Professor of Physical Geography and Director of the Scott Polar Research Institute in the University of Cambridge since 2002. He is also Brian Buckley Fellow in Polar Science at Jesus College, Cambridge. Julian graduated from the University of Cambridge with first class honours and studied for a Masters Degree at the Institute of Arctic and Alpine Research in the University of Colorado before returning to Cambridge for his Ph.D. He has also taught in Aberystwyth and Bristol universities, establishing the Centre for Glaciology in Aberystwyth and the Bristol Glaciology Centre. He was awarded a Doctor of Science degree by the University of Cambridge in 2016.

Julian has research interests in glaciology and glacial geology, studying the form and flow of glaciers and ice caps and their response to climate change, and the links between past ice sheets and the marine-geological record, using a variety of satellite, airborne and shipborne geophysical instruments. He has worked in many parts of the Antarctic and Arctic, and in mountain areas of the world, in a series of field research projects over almost 40 years. He has written over 350 scientific papers and eleven books, including several for general audiences. He has also lectured to wider audiences, from school children to business leaders and parliamentarians, on climate-change issues.

Julian has also represented the UK on a number of international committees concerned with science strategy and policy in the polar regions. These include terms as UK National Delegate to both the International Arctic Science Committee (IASC) and the Scientific Committee on Antarctic Research (SCAR), and as Chair of the UK National Antarctic Research Committee.

Julian has been awarded the Polar Medal by Her Majesty the Queen and has also received the Founder's Gold Medal from the Royal Geographical Society. In 2011 he was awarded the Louis Agassiz Medal by the European Geosciences Union. He received the IASC Medal of the International Arctic Science Committee in 2014 and the Lyell Medal of the Geological Society of London in 2018. He was recently elected a Fellow of the Learned Society of Wales and is an Honorary Fellow of Aberystwyth University.

Michael Hambrey is a graduate of the University of Manchester, with a BSc degree in Geography and Geology, and a PhD in Glaciology. He has held research positions at the Swiss Federal Institute of Technology (ETH) in Zürich, and at the University of Cambridge where he became a Fellow of St Edmund's College. He then moved to Liverpool John Moores University as Professor of Quaternary Geology, where he led the development of Earth Science and Physical Geography degree programmes. Lastly, he became Professor of Glaciology at Aberystwyth University and successively Director of the Centre for Glaciology and the Climate Change Consortium of Wales. He has also held Visiting Fellowships at the Victoria University of Wellington, the University of Otago and a Visiting Professorship at the University of British Columbia.

Michael's research interests have focused on the dynamics of glaciers (especially their structural attributes), glacial sedimentary processes, and interpretation of the past glacial geological record. This research has taken him to both polar regions, where he has had 12 field seasons in the Antarctic and 25 in the Arctic, as well as to major mountain ranges such as the Andes, the Himalaya, the Alps, New Zealand Alps, Alaska and Yukon. His research has yielded nearly 200 scientific papers, several edited books and a variety of books on glaciers and the Arctic for the wider public.

Michael retired from full-time teaching at Aberystwyth University in 2015, but continues to be active in research, writing, lecturing, guiding and running field excursions for the wider public. Specifically, for two or three months a year he serves as a lecturer and guide with Quark Expeditions, embracing expedition voyages to both the Arctic and Antarctic.

Michael has been awarded the Polar Medal by Her Majesty the Queen on two occasions, in 1989 and 2012. He is also a recipient of the SCAR (Scientific Committee on Antarctic Research) Medal for Excellence in Antarctic Research (2018), and has had *Hambrey Cliffs* named after him on James Ross Island, northeastern Antarctic Peninsula. He was elected a Fellow of the Learned Society of Wales and an Honorary Member of the Quaternary Research Association in 2017.

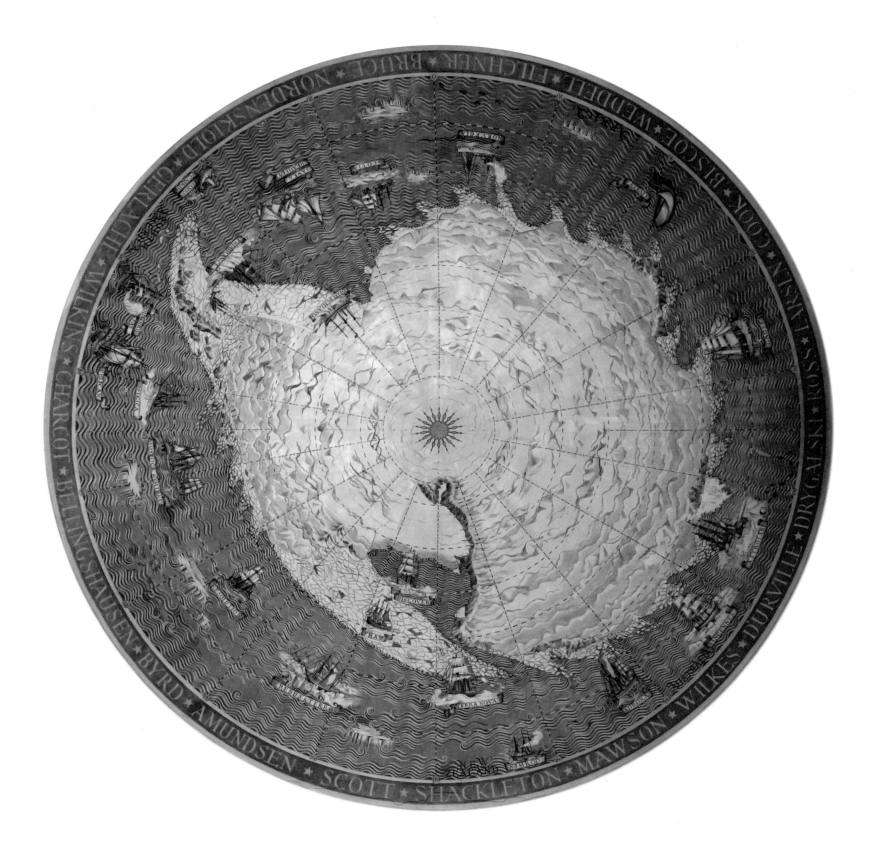